R

Ruskin in Italy

LETTERS TO HIS PARENTS
1845

EDITED BY

HAROLD I. SHAPIRO

CLARENDON PRESS OXFORD

1972

Oxford University Press, Ely House, London W.1

GLASGOW NEW YORK TORONTO MELBOURNE WELLINGTON
CAPE TOWN IBADAN NAIROBI DAR ES SALAAM LUSAKA ADDIS ABABA
DELHI BOMBAY CALCUTTA MADRAS KARACHI LAHORE DACCA
KUALA LUMPUR SINGAPORE HONG KONG TOKYO

PRINTED IN GREAT BRITAIN BY
WILLIAM CLOWES AND SONS LTD.
LONDON, COLCHESTER AND BECCLES

To the Memory of

William Clyde DeVane

PREFACE

T HERE is nothing worse than the editing of letters, as Geoffrey Tillotson once remarked, since they show how imperfect is our knowledge of the past. If this edition of Ruskin's letters prove useful and informative, therefore, it is due in large measure to the generous assistance I have had from a great many people. Mr. James S. Dearden put at my disposal not only the resources of the Ruskin Galleries, but his own extensive knowledge of Ruskin's life and work; Mr. Evelyn Joll made available his knowledge of Turner's drawings; Sig. Giampiero Lucchesi uncovered for me, in the archives of the Opera della Primaziale Pisana, much that was obscure; Miss Suzanne Mourot of the Mitchell Library, Sydney, helped me trace Ruskin's Australian connections; Mr. J. B. Trapp of the Warburg Institute showed me some of the pitfalls in art history; and Miss Elsie Reynolds of the Hofstra University Library tracked down some of the more elusive references in the letters. I am indebted also, for their patient attention to my puzzles, to Mr. Martin Butlin, Professor Beatrice Corrigan, Sig. Urano Castelli, Dr. Frank Taylor, Mr. Herbert Cahoon, and Mr. Christopher Lloyd. There are many other people from whose careful answers to my inquiries and from whose erudition I have benefited; they are too many for me to acknowledge individually here, though I am no less grateful to them. But I must particularly thank Miss Marjorie G. Wynne, who made all the arrangements for my use of the Beinecke Library's MSS. and on whose expert knowledge of manuscripts I constantly drew.

There are several other debts which I am very pleased to acknowledge. Ruskin's drawings in the letters present various problems of reproduction and I am deeply grateful to Mrs. Mary Masi and Mr. Ernest Angiullo for their generosity in giving their skill and so much of their time to making photographic prints fit for engraving. My debt to my wife Joan is beyond measure. She helped me at all stages of the preparation of this book and I consulted her critical judgment in all matters, great and small.

I am grateful, moreover, to the Beinecke Rare Book and Manuscript Library of Yale University for permission to publish this collection of letters, and grateful also to the Ruskin Galleries, Bembridge, to the John Rylands Library, to the Bodleian Library, and to the Pierpont Morgan Library for permission to include manuscripts in their possession. I am indebted to the Ashmolean

[vii]

Museum, the Birmingham Museum and Art Gallery, the Syndics of the Fitzwilliam Museum, and the Victoria and Albert Museum for permission to reproduce their Ruskin drawings. And I wish to thank the Ruskin Trustees and Messrs. George Allen and Unwin for permission to publish the previously unpublished Ruskin MSS. herein.

Finally, I wish to thank the trustees of Hofstra University for leave of absence, and the National Endowment for the Humanities for a liberal fellowship which enabled me to complete the greater part of my work.

CONTENTS

LIST OF PLATES

INTRODUCTION

On 25 March 1845, for the payment of £2. 7s. 6d. and on the recommendation of Mr. Watson of the War Office, the Foreign Office issued Passport No. 3185 to Mr. John Ruskin and servant for travel on the Continent. Ruskin, just turned twenty-six, was about to take his first journey abroad without his parents. His servant, John Hobbs, renamed George, was twenty. He was Ruskin's amanuensis as well as valet and, despite Ruskin's occasional annoyance with him, evidently a young man of ability and enterprise. On 2 April, the two young men left London for Dover and a tour of France, Switzerland, and Italy that lasted seven months.

Coaching was in its most glorious decade then, a glory soon to end, for railways were being built everywhere—even the dream of Venice was shattered by the construction of a line from Padua. It is significant that Ruskin himself, though he loathed railways and took the stagecoach to Dover, returned from Dover by train. However, posting was still the best means of travel, and to most places the only one. Ruskin travelled not by diligence, but in a rented carriage, which permitted a maximum of comfort and luggage. The carriage he used was a light calèche, requiring only two horses, with a top that could be folded back on sunny days and with a dickey, or rumble-seat, behind for George to ride on. He dined at the table d'hôte where he stayed any length of time, but on the road he generally had his dinner served in his room to avoid the diligence passengers, and though he did not take the best rooms, he always took good ones. Besides George, he had with him, from Geneva onwards, Joseph Marie Couttet, the Chamonix guide whom his parents had employed on their Alpine tour the previous year. Couttet relieved him of many of the annoyances of travel, acting as courier and factotum—haggling with the coachmen, bribing the customs men, repairing the carriage, gathering flowers about Fiesole to compare with those in paintings, looking after Ruskin's health and, in the mountains, guiding him over glaciers and even cooking. In short, Ruskin travelled in a style that was not extravagant, but was yet very fine.

He began the tour with two aims. One was to collect further examples of scenery for the second volume of his great work on landscape, *Modern Painters*, a volume which he hoped to provide with engraved illustrations. His other, and chief, aim was to study

Italian painting. In a way, this latter undertaking was a liberation from the burden a second volume of *Modern Painters* had become. In the first volume, published in 1843, and even more prominently in the Preface to the second edition the following year, he had committed himself to a continuation of that work—to a further consideration of landscape painting and to an elaboration of various themes there subordinated to the question of accurate representation. His diary shows that he was at work on the second volume as early as November 1843. He continued to work on it through March 1844, but he had apparently promised more than he was prepared to deliver. The MSS. of the first draft of *Modern Painters II* (the Hilliard MSS., now in the Pierpont Morgan Library), and in many ways the finished work itself, confirm this impression. *Modern Painters I* contains some shrewd generalizations about painting, but the large questions of what constitutes expressiveness in painting, of the relation between expression and representation, of the relation between painting and morality—the answers to these are only hinted at there, and the hinted answers are based on a very limited range of examples—limited in genre, number, variety, and quality. Now he had to prepare a full-scale examination of such questions and, despite the confident announcement of the Preface to the second edition of *Modern Painters I*, the MSS. of *Modern Painters II* show him fumbling. On 15 April he noted in his diary: 'I shall let my work alone till winter, and collect materials.' A month later, he left London with his parents for a three-month tour of Switzerland. He went abroad then to look at mountains, not at pictures, but on the way home, during a few days' visit to the Louvre, he had, as he wrote in his diary, a strong change wrought in him.[1] His appreciation of Italian painting quickened and he eventually decided to abandon his book until he should know more about it. The tour he began planning that autumn was both a liberation from the problems of his second volume and an opportunity to solve them. It proved a great journey of discovery, greater than he had anticipated.

On 3 April, a Thursday, Ruskin took the steam packet to Calais, paid the duty on his carriage, acquired francs, and began posting to Paris. Since his first aim was not scenery but Italian painting, his plan was to drive steadily southeast to Geneva, pick up Couttet, then drive straight south to Nice and along the riviera to Genoa, whose palaces were full of pictures. Accordingly, he stopped at Paris only for the Sunday, a day on which he did not travel, and then continued to Sens, Montbard, Dijon, and Champagnole. His pace

[1] *The Diaries of John Ruskin*, ed. Joan Evans and John Howard Whitehouse, 3 vols. (Oxford, 1956–9), I. 311. Hereafter cited as *Diaries*.

was deliberate, about eight hours a day on the road, doing on the average 100 kilometres per day. From Champagnole, he proceeded up the mountains to Les Rousses, the frontier town, and on to Geneva, where Couttet was waiting. The next day he began the drive south, stopping over at Annecy and then going along the lake and on to Albertville and Grenoble. At that point the drive ceased to be an easy run and turned into a not altogether pleasant adventure. From Grenoble to Gap proved to be a hard day's journey of sixteen hours through ugly country with washed out and rutted roads. The next day's journey to Digne was better and he rested there the Sunday, except for climbing the peak above the town, that Sabbath mountain which he assigns in *Praeterita* to Gap.[1] The following day's drive to Draguignan, however, was the longest and hardest of the entire tour. That part of Provence was *terra incognita* as far as the guidebooks were concerned. Murray's *Handbook for Travellers to France* (1843), for example, says nothing at all about it. The country continued to be dull and the roads bad, the irons holding the dickey snapped and it had to be repaired, fresh horses were hard to get—all in all it was a seventeen-hour stint. The drive to Nice the next day was pleasant, through Fréjus and down to Cagnes and along the blue bay of Antibes, and so was his leisurely drive through the orange and lemon scented air of the riviera, stopping at Menton, Oneglia, and Savona, and arriving at his first goal, Genoa, on 26 April, almost a month after leaving London.

For all its pictures, however, Ruskin remained in Genoa only three days. He found 'half the pictures copies—others bad—others injured or destroyed—others shut up'. It was Lucca rather than Genoa which first excited his admiration and stimulated his interest. He went to Lucca for the Fra Bartolomeos, and he examined them carefully, as he did the Aspertini frescoes, but what kept him was the architecture of the old churches, particularly of San Frediano, San Michele, and the Cathedral. He made notes on them, he drew them, and he even collected fragments that had fallen off the façade of San Michele to send home. It was the beginning of his serious study of architecture and of his determination to bring the world to admire and hence preserve the crumbling treasures of Italy.

From Lucca, Ruskin went directly to Pisa, where, in the Campo Santo, his serious study of painting began. He settled for two weeks into comfortable rooms on the north bank of the Arno and got right to work drawing the frescoes and making notes. His mind, he wrote his father, was marvellously altered since he had been in Pisa in 1840—'everything comes on me like music'. Everything included

[1] *The Works of John Ruskin*, ed. E. T. Cook and Alexander Wedderburn, 39 vols. (London, 1903–12), XXXV. 346. Hereafter cited as *Works*.

the buildings, for though his chief object in Pisa was the Campo Santo frescoes, his interest in architecture and architectural ornament was even greater there than it had been in Lucca. He measured the churches, made notes on them, drew them, and gathered fragments of the Baptistery to send home. And he extended his studies to domestic architecture, making several drawings of the Palazzo Agostini, even trying to obtain a ladder to get a closer look at its details. 'I am perpetually torn to bits by conflicting demands upon me', he wrote his father, 'for everything architectural is tumbling to pieces, and everything artistical fading away, & I want to draw all the houses and study all the pictures, & I just can't.' It was with extreme reluctance, therefore, that he left Pisa, but his main work on painting lay ahead in Florence.

Ruskin arrived in Florence on 29 May and remained almost six weeks, first at the Hôtel d'Italie, now part of the Excelsior-Italia, and then in lodgings off the Cathedral square. He liked the city itself little enough. 'There is no feeling about it', he wrote. 'Think what I will, it never touches me—the people are Leghorn bonnet-makers and one feels always in a shop.' But his long walks for exercise—generally up to Fiesole, or San Miniato, or Arcetri—were delightful and his picture work was increasingly exciting. He worked, of course, in the Uffizi and Pitti galleries and in the Accademia, but his greatest excitement came from, and his greatest energies were devoted to, the pictures in the churches and cloisters, especially those of Santa Maria Novella, San Marco, Santa Croce, and the Carmine. He had, too, in addition to all he was learning, the pleasure of minor triumphs and discoveries, the discovery, for example, that Raphael had copied his St Paul in the cartoon of *The Blinding of Elymas* from Masaccio's St Paul in the Brancacci Chapel, and the discovery that the altarpiece in Sant' Ambrogio whose sculptor was unknown to the monks was indeed by Mino da Fiesole. By 'speaking Italian'—that is by bribing him—he got the *custode* of Santa Croce to uncover the portrait of St Francis, then ascribed to Cimabue. He climbed the cupola of the Cathedral and was amazed to find that Brunelleschi had decorated the marble arches that support the lantern with '*pods* of *pease*—each twice the length of my arm, with three pease in each'. Though told he would have to obtain permission from the Pope, he managed to get into the nunnery of Santa Maria Maddalena dei Pazzi to see Perugino's grand *Crucifixion*. And an old engraver with whom he scraped acquaintance took him 'to private houses and inaccessible chapels and all sorts of places and showed [him] wonderful things', including Perugino's *Entombment* in the Palazzo Albizzi, a fresco which, though he mentions it in his *History of Oil Painting* (1847),

even Eastlake had been unable to see. On 7 July, 'crammed so full', as he wrote, that he could hardly think, and with the really hot weather coming on, he left Florence and headed for the cool mountains, to rest, to digest what he had seen, to consolidate his notes, and, fulfilling the second aim of the tour, to draw scenery for his book.

On his way he stopped at Bologna, Parma, Pavia, and Milan, looking at pictures and churches, and then continued through Como and Vogogna to Macugnaga, above the valley of Anzasca, 'a perfect Paradise for *feeling*', he wrote, and 'delicious to live in, all hay fields & cascades'. He arrived on 23 July and settled in for three weeks, living in a rude cottage, climbing the mountains, and drawing. On 11 August, for more various scenery, he headed back to Baveno, taking the long way round and stopping at Domodossola, Formazza, Airolo, and Faido, where he remained for three days in order to sketch the subject of Turner's drawing of the St Gothard, realized for him two years earlier. From Faido he went to Bellinzona, another of Turner's subjects, and took the steamer down the lake to Baveno, where he remained till the end of August.

At the beginning of September, with the painter J. D. Harding, who had come to Baveno to meet him, Ruskin left for Venice to finish his study of Italian painting. Their route lay through Como, Bergamo, Desenzano, Verona, and Padua, and they sketched as they went, arriving at Venice on 9 September. By that time Ruskin had begun to feel pangs of homesickness and his intention was to remain about two weeks. His chief work, he expected, would be with Titian and the Bellinis, and two weeks was all the time it would take. Harding, as a matter of fact, kept to the schedule, leaving for home on the 24th, but Ruskin postponed his departure twice and remained in Venice for five weeks. Two things held him: the condition of the buildings and his discovery of Tintoretto. He was distressed by the construction of the railway across the lagoon. He was distressed, too, to find that Venice was being modernized with gaslights, iron bridges, and brick buildings in the latest fashion. But he was filled with anguish at the condition of its palaces and churches, at the dilapidation they had suffered since he had been in Venice five years before and at the ruinous repairs that were being instituted—the finest architectural ornaments knocked off, marble façades stuccoed over, St Mark's scraped clean, 'monuments torn down & pavements up, the cloisters everywhere turned into barracks and the carvings defaced or repainted'. He immediately decided, therefore, to stay longer than he had planned in order to draw the precious details before they should be gone forever. With that he launched a serious architectural study, like the one he had begun in Lucca and Pisa. He drew, and he measured, and he bought

[xvii]

a series of Daguerreotypes of the buildings for their accurate record. A visit to the Scuola di San Rocco caused him to defer his departure further. He was, before that, convinced that Tintoretto would not keep him at all, but the great Tintorettos there were a revelation, showed him 'some totally new fields of art', and he set himself to study them carefully.

It was not until 14 October, then, that he left Venice. It was beginning to be quite cold and he was anxious to get home. His route lay through Padua, Verona, Brescia, Milan, then up the mountains to Baveno, and over the Simplon to Martigny, on to Vevey, where he dropped Couttet, along the lake shore to Nyon, and then Champagnole, Dijon, Montbard, and a retracing of the road he had come. He arrived in London on 6 November after an exhausting run home—he was ill from Padua to Brescia and again between Nyon and Paris—but with a full portfolio, and new stores of information, and profoundly altered feelings, at the end of a tour which determined the main lines of his future career.

An immediate consequence of the tour was the final shape of *Modern Painters II*, which appeared the following April. One must not take too seriously Ruskin's later declaration that, as a result of the tour, his second volume was not at all what it was originally intended to be. The MSS. show very clearly that its first two-thirds, concerning Beauty, was very much the sort of thing he had intended; but the last third, on Imagination, was indeed new. It was a subject he had expected to touch on; he turned it into a vehicle for discussing, in what was, after all, a treatise on landscape, the Italian religious painting that had so recently excited him, and into an attempt to reconcile that painting, so thoroughly iconographical, to the standard of empirical truth which he had proclaimed in *Modern Painters I*. Another consequence of the tour were changes in the third edition of the first volume, which appeared the following September, particularly the lengthy addition to the 'Foregoing Principles' chapter, with illustrations taken almost entirely from Italian painting. These developments heralded a lifelong concern with Italian religious painting. At a moment when he had pretty much exhausted what he had to say about landscape, he found new and larger fields to explore, worth devoting one's life to, and new gospels to preach, Giotto's and Tintoretto's, as well as the gospel of art according to Turner. The tour engendered, also, a lifelong concern with Italian romanesque and Gothic architecture, a concern which issued, four years later, in *The Seven Lamps of Architecture* and then in the three volumes of *The Stones of Venice*. And one can see in the tour, in the historical interest which these new concerns inevitably aroused, in his reading of Sismondi, in his

observations of men and manners, and in his increasing self-examination, the beginnings of his later social criticism. If, before the tour began, he had serious doubts about what he was to do with his life—and he seems to have had them—by the end of it he had confirmed his vocation.

The main outlines of the tour of 1845 have long been known and its importance to Ruskin's career has been pointed out by Ruskin himself and by his editors, biographers, and critics. Its immediate record remains in many drawings and in two surviving notebooks, but most impressively in the letters Ruskin wrote home almost every day. One hundred and fifty-eight of the letters survive; five, perhaps a few more, are missing. The surviving letters are now in the Beinecke Library of Yale University, in a blue calf binding made by Mansell in 1889, and bound together with several of Ruskin's later letters and with several letters of his parents. The volume was once in the possession of Alexander Wedderburn, but when he and Cook came to edit Ruskin's works they used the letters largely for illustration, printing only a third of them, very few in their entirety, and scattering them in several volumes. The complete collection has never before been published. Its value for our understanding of Ruskin's development as a critic needs no further comment. Its value as a biographical document is also great. Ruskin kept no diary in 1845. The letters are, in a sense, his diary, and a fuller and more continuous one than his actual diaries for other years—and in some ways more revealing for having an audience. Each significant occurrence is set down, his changing views are delineated, and his feelings traced; and though his enormously important relationship with his aging parents (John James Ruskin was sixty that year and Margaret Ruskin sixty-four) may escape ultimate definition, the letters contribute a good deal of evidence towards its understanding. Seventeen of the letters his parents wrote him during the tour survive, ten of them bound with his letters and seven in the Ruskin Galleries at Bembridge. In the Appendix, I print three of the former group in full, both for their intrinsic interest and as examples of the other side of the correspondence, and in the notes I draw on all the rest. I also print in the Appendix two of Ruskin's letters, written during the tour and heretofore unpublished, to W. H. Harrison, his editor and a friend of the family.

Besides its critical and biographical value, the collection has at least three further virtues. For one thing, the full record of the tour should be useful in analysing the art and structure of Ruskin's autobiography, *Praeterita*, in which the tour of 1845 is given a prominent place. It should act as a warning, too, against an error

writers on Ruskin have often made, accepting *Praeterita* as every-where accurate. To take a minor though characteristic instance, it was, according to *Praeterita*, Lord Holland, then Minister to Tuscany, whose influence got Ruskin into the nunnery of Santa Maria Maddalena, and *Praeterita* implies that Ruskin had nothing more to do with Lord Holland than waiting on him for this purpose. The letters show, however, that a bookseller got Ruskin into the nunnery and that Lord Holland solved a more serious problem, obtaining permission for him to draw in the gallery of the Pitti Palace; and though Ruskin was indifferent to Anglo-Florentine society, Lord Holland did have him to dinner at the Palazzo Ferroni, a signal honour, as Ruskin's father pointed out. 'Now you are out of Florence', he wrote on 15 July, 'I may say Lord Holland has an indifferent name chiefly for Inhospitality so it was quite a stretch of consideration to ask you to Dinner.'

Another virtue of the collection is its interest as a document in art history. In Italy, an era of more or less systematic 'restoration' of buildings and pictures had begun. It was a sign of the times that one of the topics discussed by the first Italian scientific congress, held at Pisa in 1839, was the best technique for restoring frescoes. The letters are a small but reliable record of what was going on. They contain, too, useful evidence about Turner's work and about Ruskin's own drawings.

Finally, and not least important, the letters taken altogether make a delightful travel book, for though written rapidly, they were written, among other things, to entertain. Interestingly, Ruskin's father seems to have perceived their literary merit and contem-plated publishing them. He carefully preserved them, of course, and put them in order. More than that, the originals are full of his markings. He numbered them, supplied missing dates and places in the headings, made notations on them for a copyist, underlined the passages to be copied, cancelled details to be omitted, and even inserted a word here and there. As a travel book, the letters are notable for the freshness of eye, despite the prejudices of his country and class, which Ruskin brings to the annoyances and pleasures of travel, to foreign sights and foreign manners, as well as to beautiful scenery and great art—a freshness that is remarkable in someone already so well-travelled. They are notable, too, for the liveliness and flexibility of their style, which conveys with equal immediacy the humour of a market-place quarrel and the awesome splendour of a religious procession in the Cathedral at Pisa, the comforts of a country inn and the fulness and majesty of the frescoes in the Spanish Chapel at Florence.

[xx]

Some remarks concerning the MSS. of the letters and my editorial procedures may be useful. Apart from the postmaster, three hands have written on the letters after their original composition. I have already pointed out John James Ruskin's contributions. His headings and his numbering of the letters I have ignored. I have noted, however, his directions to the copyist when they occur in the body of the letter and have also noted his significant interpolations. On many of the letters he wrote the date received, often the date answered, and sometimes the place received; wherever he did so, I have given the information in a note. In addition, a second hand, which seems to be Ruskin's own later hand, numbered all the sheets in the collection consecutively. The third hand is Wedderburn's, who made two kinds of insertions. He often wrote in words which, occurring at the edge of a page, he thought might be lost in the binding; this was certainly done before the letters were bound. Moreover, the sealing wax has been cut away from the letters, generally leaving a hole in the paper, and where words have thus disappeared he wrote them in, probably, too, before the letters were bound. I have not noted Wedderburn's insertions, though they confirm my conjectural readings where the letters have been cut. I have indicated my conjectures by means of square brackets. I have used square brackets, also, to indicate matter I have supplied in the headings.

In editing the letters, I have followed the rule of tampering with the original text as little as possible. I have everywhere followed Ruskin's capitalization and spelling. I have preserved his use of double inverted commas to mark quotations and have used italics only where he underlined. I have, besides, printed his significant cancellations, indicating them by means of angle brackets. All of his father's cancellations I have restored and I have noted the more interesting of them. I have, however, made the following alterations. Where Ruskin, on the resumption of a letter, put the new date or place of writing at the beginning of the paragraph, I have set them off as a sub-heading for ease of reference. Where he occasionally neglected to close a quotation or a parenthesis, I have silently supplied the marks. And where, as he usually did, he omitted accent marks in French and Italian words and omitted apostrophes, I have supplied accent marks when not doing so might cause confusion and, for the convenience of the reader, have generally supplied apostrophes, especially in names. Ruskin's stops are a more complicated matter because he ordinarily punctuated with a dot or a dash and used these marks arbitrarily and interchangeably to represent a variety of stops. To serve the reader's convenience and yet retain some impression of Ruskin's punctuation, I have

punctuated the letters on this system: where he used conventional punctuation, I have naturally followed him; where, at the end of a sentence, he used a dash, I have amended to a full stop or question mark as the case requires; where convention requires a semi-colon or colon, I have retained Ruskin's dash. I have made one other change in his punctuation. Ordinarily, he placed the punctuation mark before the parenthesis where we place it after; to avoid confusion, I have followed the latter practice.

A few final words on the notes. I have not given the addresses on the letters because all letters to John James Ruskin are addressed to 7 Billiter Street, London, his counting-house, and all letters to Margaret Ruskin are addressed to Denmark Hill, Camberwell, London. When John James Ruskin was travelling on business, the letters to him were, as a rule, taken out to Denmark Hill and sent on by Ruskin's mother. Where a letter is postmarked, I have given the earliest postmark and have Englished it. 'Catalogue' in the notes, unless otherwise indicated, refers to the catalogue of Ruskin's drawings in *Works*, XXXVIII; 'Bem.' refers to MSS. and drawings in the Ruskin Galleries, Bembridge, Isle of Wight. Some of the notes, not many I hope, may seem more extensive than is necessary to elucidate the text for the general reader, but I have felt obliged, where I had it, to supply relevant information of particular use to students of Ruskin.

1

My Dearest Father,

I got down here most comfortably by three o'clock with no other inconvenience than that of changing carriage at Tunbridge. I had one to myself all the way there. I stipulated for a back seat— and got one—opposite a very fine specimen of a blackguard, with his cap over one eye, and a bandage for a shirt collar. I studied him very carefully, & at last sketched him on the margin of Bell's "Expression",[1] while we stopped at Ashford—thus obtaining a valuable addition to the illustrations of the work. Two ladies in the Coffee room at Ship[2]—dined—talked of Paris—& *Naples*— one remarking to the other "you *will so* enjoy it"—gave the waiter twopence for the two—and started with a single carpet bag between them by the Boulogne steamer—to *stop* there, I presume.

Found Mr Birmingham[3]—or whatever his name is. Boat tomorrow at 6 morning—just right time—only George[4] says "What a time it'll be before we gets any breakfast—& I can't take any before I go—Sir!"

Dry, cold east wind & Sunny mist. Walked up after dinner to castle where I walked ⟨up⟩ with my mother seven months ago.[5] Town & hills—mixed up with drifting smoke—rows of poplars beside the river—a most exquisite study—quite as fine as Turner,

[1] Sir Charles Bell, *The Anatomy and Philosophy of Expression As Connected with the Fine Arts*, 3rd ed. (London, 1844). Bell (1774–1842) was a famous surgeon and anatomist and an amateur of the arts. An unpublished letter in the Bodleian Library (MS. Acland d 72) shows Ruskin reading the book as early as 26 Dec. 1844: 'I like a great deal of what he says, only I wish he would explain himself, and not leave me to guess out half.' He took it with him on the tour in order to review it for the *Quarterly Review* at the request of John Murray, the publisher, a project he later gave up (see Letter 61). Several references to this book and Bell's Bridgewater Treatise, *The Hand: Its Mechanism and Vital Endowments As Evincing Design* (London, 1833), appear, however, in *Modern Painters II* (1846).

[2] The famous hotel in Dover, fronting the harbour, at which he was staying.

[3] John Birmingham, one of the proprietors of the Ship Hotel.

[4] John Hobbs (1825–92), Ruskin's valet and amanuensis, called 'George' to distinguish him from Ruskin and his father, entered Ruskin's service in 1841 and remained with him until 1854. One of the notebooks Ruskin kept on the tour (MS. 5B in the Ruskin Galleries, Bembridge) is in George's hand.

[5] 23 Aug. 1844 (*Diaries*, I. 318). He had just returned from a Continental tour with his parents.

[1]

but wind too cold to draw, or I should have got a fine thing. Lectured three boys for a quarter of an hour on the sin of plaguing a frog. Made them look very grave & throw away their sticks. Gave them 6d. to buy marbles & saw the frog safe into a hole. Walked up to the turnpike whence I made my poetical sketch of Dover castle 10 years ago.[1] Got melancholy thereupon.[2] Walked down hill again, very sad because I hadn't anybody to come home to tea to. Didn't expect this so soon. Emptied all the tea into the pot—to banish care. Made it so strong that I couldn't drink it. Emptied the milk-pot instead.

I don't know what to do with my desk, now that I have got so much money in it. Wouldn't it be safer to keep my notes in my pocket? To be sure I must get gold at Calais, and then I can't.

Can't believe it is seven months since you sent me up Snargate street to look at the Duke of Wellington's letter.[3] It's nothing when it's gone. We must think thus of the six months coming— provided I go on. Perhaps I shall get very melancholy & come back after getting a look at the Alps. I feel quite well. I've fancied I had a little cold ever since Monday, but I daresay the French air will finally drive it off. I can only send a short note from Calais to-morrow—just to say I am safe over.

It's no use always sending love to my mother. Sounds formal. Kiss her for me. I want to write to Eastnor[4] as well—can't write more just now.

<div align="right">Ever your most affectionate
J Ruskin.</div>

If any letters come for me with CHP in the corner, they mean chess playing. Open them, please.

[1] Possibly the pencil drawing, *Dover Castle*, in the Vassar College Art Gallery.

[2] This sentence is heavily cancelled, no doubt by John James Ruskin for a copyist's benefit.

[3] Probably the letter displayed by Jacob Reuben in his Bazaar at Nos. 4 and 5 Snargate Street, Dover. Reuben had sent Wellington the unpaid account of his son, the Marquis of Douro, and received this reply: 'Field-Marshal the Duke of Wellington presents his compliments to Mr Reuben and begs to inform him that he is not the Marquis of Douro, neither is he the collector of Mr Reuben's accounts.' See John Bavington Jones, *Dover: A Perambulation of the Town, Port and Fortress* (Dover, 1907), p. 69.

[4] Charles Somers Cocks (1819–83), Viscount Eastnor, later 3rd Earl Somers, Ruskin's friend from their days at Christ Church, Oxford. He had visited Ruskin at Denmark Hill on 20 Feb. and Ruskin had called on him in town two days later. See Margaret Ruskin's letters to her husband, 21 and 22 Feb., in the Ruskin Galleries (Bem. L 1).

Calais. Thursday, 1/4 past 11 [3 Apr.].

My Dearest Father,

Glorious morning this—sea like a lake—a little too much easterly wind, but sun bright & all pleasant. Off at 1/2 past 6; over at 9— by the Ariel.[1] Baggage hardly looked at. Beautiful little breakfast[2] —chop & egg—could have eaten both double—didn't—to be in good order for travelling. Horses ordered at 12.

I never felt so little tired on arriving here. I never sat down once all the way over, but walked backwards & forwards talking to Captain. No other passenger. Then saw luggage through Custom house—the Sun on the quay regular old hot Calais feel. They will only give 25–30 exchange here, giving me 1265 fr. for my 50£— of that I leave 200 for carriage—they valued it at 600.[3]

I want to get all my accounts comfortable, bags &c, so shall not write any more just now. Love to my mother.

Ever your most affectionate
J Ruskin.

3

Montreuil. Thursday Evening [3 Apr.].

My Dearest Father,

I have had a delightful drive from Calais—cloudless sky, light wind, and carriage going beautifully—they trot up all the hills with it. The postillions will not take a sous less than the five[4]—and moreover two 8 mile stages have been changed into *nine* ones—and none of the nines into eights; but one gets on. No leaves on any of the trees yet, but air delightful. All cold gone. I was walking about the yard here after I got in at 1/4 to seven, to enjoy the soft feeling. Supped for fun with the diligence people who came in at seven—

[1] One of the mail packets.

[2] At the Hôtel Dessin. 'L. Dessin/Calais' is embossed on the notepaper of Letters 6–8, 12–13, 30, and 34.

[3] For the protection of French carriage makers, a deposit of one-third its value had to be paid on a carriage brought from England. Three-quarters of this deposit was returned when the carriage was taken across the frontier. See Letter 8, p. 14, note 2.

[4] The legally authorized charge for posting in France was two francs for each horse and one franc for the postillion per ten kilometres. Travelling in a calèche, requiring only two horses, Ruskin paid five francs, but his father may have expected the postillion's charge to be less because he drove two instead of the usual four horses.

very amusing, but not the sort of thing one would ha[ve li]ked to have travelled with.[1] Very beastly—English and All.

You need be under no apprehension about the carriage—it feels perfectly steady, light, & safe, the front & all about it quite manageable & pleasant—only by the by I fancy there will be some driblets of rain at the sides in wet weather.

I have a jolly wood fire burning beside me in the bedroom which I had last time here.[2] The waiters at Calais, & here, inquire most particularly after you.

I shall post this here,[3] because I suppose you will be anxious to know how the carriage does, but I shall be late tomorrow at Beauvais, & so, D.V., I shall write next from Paris. Tell my mother I lunched on a rusk and a quarter of a ginger lozenge & that the latter was prime.

<div style="text-align: right">

Ever your most affectionate Son,
J Ruskin.

</div>

<div style="text-align: center">

4

</div>

<div style="text-align: right">

Beauvais. Friday Evening [4 Apr.].[4]

</div>

My Dearest Father,

I got in here most comfortably, not tired, though this is the longest day I shall have, to Geneva. The carriage goes most pleasantly— one is not detained by the bother of the four horses,[5] one can trot faster down the hills, & best of all, one is comparatively free from dust. I wish you could have seen the light in the street at Montreuil this morning at six. Intense & lovely beyond description. Drove the two stages to Bernay (the place where the waiter ran so fast for the currants last year) and stopped to breakfast—at 8. Such a lovely breakfast—thick cream—fresh drawn radishes—new laid eggs—sweet butter—fried sole—tender cutlet. I wished for Serj. Talfourd[6] to appreciate and describe. On again to Abbeville— where, at the poste, I stopped half an hour to draw some trees.[7]

[1] The diligence was the Continental equivalent of the stagecoach and the cheapest way to travel. On the road, Ruskin usually dined in his room, the diligence passengers always at the table d'hôte.

[2] 21 Aug. 1844.

[3] Postmarked Montreuil, 4 April.

[4] Postmarked Paris, 6 April.

[5] The larger carriage the family toured in required four horses.

[6] Sir Thomas Noon Talfourd (1795–1854), prominent barrister, Serjeant-at-law since 1833, friend and editor of Lamb and Hazlitt, and himself an author. His *Vacation Rambles*, a record of his tours on the Continent, appeared in 1845.

[7] Probably the pen and wash drawing, *Abbeville, Poplars*, in the Ashmolean Museum, Oxford; reproduced in *Works*, XXI, Plate 67. Catalogue 1683.

Tell Mr Prout[1] I find their beauty quite intoxicating. Dull road & slow driving from Abbeville here. George says the wheels creak, but I don't hear anything myself.

<div align="right">Paris. Saturday, 5 o'clock.</div>

Wheels all right. Table d'hote at 1/2 past 5 and I have to dress, but I shall post this, to be sure. Got here quite comfortably—took wrong road from Beauvais—three stages of bad pavé[2]—but repaid, & more than repaid, by a most interesting road & line of villages. I am sitting in a comfortable though small room at Meurice's,[3] overlooking Tuileries—which look as much like an ants nest as any thing I ever saw that wasn't one. Very hot. George peony colour. Ran lightly over pavé & not at all tired. I find no letters here—shall enquire at post office. Passport given into bureau[4]— all right.

<div align="right">Ever your most affectionate Son,
J Ruskin.</div>

Too late for post, I found, on enquiry. I fear you will be anxious, but couldn't help it. I never felt so sudden a change from winter to high summer, as in this little run south, though I imagine you must have it warm now in London. I was out this morning at 7, in the most intense and delicious sunshine, sauntering about in the marketplace of Beauvais, enjoying the people & the gable ends— sat for half an hour looking up the cathedral choir—then another half hour looking at the blaze of morning light through the windows of St Etienne—then home to L'Ecu,[5] breakfasted, & off at nine. Two noble chateaux on this pavé road, standing on hills (Montmorency I believe), and a beautifully placed town on the Oise, Beaumont. I am more delighted than ever with the people, & the children, the latter especially—sweet studies some of them are. I found the caleche go lightly over the pavé, & am not half so much tired as after a day in London. I went down to table d'hote at 1/2 past five, which was mighty grand & mighty good, but as they keep one twenty minutes between the dishes, I only gave them

1 Samuel Prout (1783–1852), the watercolour painter, was a friend of the Ruskin family and a neighbour at Denmark Hill. He had himself made several drawings of Abbeville, exhibiting two of them at the Old Water Colour Society in 1845.

2 The right road from Beauvais to Paris was macadamized by then.

3 The Hôtel Meurice, 42 Rue de Rivoli. Here, where one could be confident about the quality of the company, Ruskin does eat at the table d'hôte.

4 Passports were not valid for travelling through or leaving France until signed by the Minister of the Interior. See Letter 5, where the passport is retrieved.

5 L'Écu de France, his inn at Beauvais.

<div align="center">[5]</div>

forty, which got me some salmon & roast beef, & then left them to finish as they liked; and went out to walk in the Tuileries. Nobody there then, but the statues. Sun setting. Very quiet & solemn. Red light all along the Seine under the Pont de la Revolution. I stood a long time in the grande place under the Obelisk—beside the fountains—trying to analyse the differences between french & English taste—& could not. There is something exceedingly grand about what they have done & are doing here[1]—vast, & well arranged, & in many respects finely felt, and in every way superior to anything we shall ever do—and yet there is always the imperfection, the paltriness, the corner of ordure, the moment of vanity, from which *we* are entirely secure. I fancy that our blunders are those of minds too much occupied with utilitarianism to be capable of sensibilities *at*all, vulgar from want of training—and the french blunders are those of minds which have actual *disease* mixed with their sensibility, vulgar from innate corruption.

There is a curious case of this on the base of the Luxor obelisk. Its ornaments on two sides are engraven representations of the embarkation and raising of it. Nothing is given but the machinery—no figures nor letters. Hence the effect is essentially hieroglyphical, and falls in with the sculpture on the obelisque itself in a way which *we* should never have thought of. *We* might have imitated the egyptian carving much more closely, yet we should have cockneyfied it instantly. The French do not imitate, but they put something whose principle is the same, and the result has a thoroughly Egyptian look. Yet, in the inscription, down they drop into Paris. This obelisque, they say, was transported from Luxor, & elevated on such a day by so and so, engineer (so far so good), then they conclude with

aux applaudissements d'un peuple immense!

We should never have fallen into so unfortunate a bathos.

I am afraid you will be anxious about the Swiss news.[2] I am not. I don't believe anything will trouble Geneva. Besides, Coutet[3]

[1] The extensive renovation and rebuilding of Paris during the 1830s and 1840s included the erection of many of its well-known monuments and public buildings. As part of the embellishment of the Place de la Concorde, the Luxor obelisk had been elevated there in 1836. The Madeleine (see below) had been consecrated in 1842. The Hôtel Dieu was under construction at its new site near Notre Dame.

[2] The continuing conflict between the liberal and clerical parties resulted in an outbreak of fighting at Lucerne on 31 March over the government's invitation to the Jesuits to teach at the seminary and organize public worship. The fighting at Lucerne lasted only a few days, but it threatened to spread to other cantons.

[3] Joseph Marie Couttet (1791?–1876?), a Chamonix guide and Ruskin's courier on this tour. The Ruskins had first employed him for their Alpine excursion of June–July 1844.

knows that I am to be at Champagnole on Thursday evening—if he sees any reason for alarm, I am sure he will meet me there—we shall turn back & go down by Bourg to Grenoble.

By the by, about vetturino's—I shall probably be obliged to take them on Genoa road—could you let me know what you think I ought to pay, about, per day,[1] in a letter to Geneva—just time to write.

<div align="right">Sunday morning.</div>

Still fine. Am just going to Champs Elysées to English service,[2] then to vespers in Madeleine. Don't like Notre dame—on account of the Hotel Dieu. Must post this at present however, in case of missing another day.

I have just got your letter. I don't exactly know when I shall get another. I suppose Geneva. I keep the money always in box— taking out twenty pieces[3] per day, until there is a surplus enabling me to miss a day. I have no trouble now whatever with the postillions. Whenever they haven't change I leave it paid for next stage, & I find them most *particular* in waiting for the next postillion & telling him so—so that I never need trouble my head. Your note of the sums at each stage has been most useful. That & the passport & account book go all comfortably into the breast pocket, and are always at hand, & my accounts are right to a centime. Write me plenty letters to Nice. I can't depend on being anywhere else.[4]

<div align="center">5</div>

<div align="right">Paris. Sunday, 4 o'clock [6 Apr.].</div>

My Dearest Father,

I shall probably send this from Sens, so you will see by the postmark I have got there.[5] I didn't like the notion of the dusty long walk, Champs Elysées way, so I turned aside like a fool to the

[1] A *vetturino* (Ruskin also uses the terms *voiturin* and *voiturier*) was a free-lance coachman, preferred by English travellers in Italy because of the inferior system of posting there. There was no regulation of his charges and how much one paid was a matter of experience and bargaining. The ordinary charge for conveying travellers in their own carriage, the *vetturino* furnishing horses, two meals a day, and rooms, was 12 francs a day per horse, 6 francs a day per passenger, and 4 francs a day per servant.

[2] At the Marboeuf Chapel in the Rue Chaillot, one of the three places in Paris where the English Service was performed. The minister, the Rev. R. Lovett, served without episcopal licence.

[3] Five-franc pieces, each worth about four shillings.

[4] The last two sentences are heavily cancelled, no doubt by John James Ruskin for a copyist's benefit.

[5] Postmarked Sens, 7 April. Answered 10 Apr.

Ambassador's[1]—and heard another abominable sermon. However I had been reading George Herbert all the morning & so took it as good temperedly as possible. After that, I walked into the Tuileries. Nothing there but Bourgeoisie—yet a very beautiful sight, as any other fullness of enjoyment is, of any animal—and certainly they seem very happy, and not to be thinking of other people nor vain of themselves, and the children beautifully good tempered. I did not see a single sour look in an hour & a half, though much rough play with even the very youngest. I was especially struck with the perfection of the art of skipping, as here cultivated. It seems to attain a mechanical precision whose clockwork velocity can be stopped by nothing but wilfulness, or fatigue.

I then walked into the Louvre, and found myself in a vast and closely packed crowd, drawn there by the *modern* pic[tur]es.[2] I first tried to back out, but found this not very easy, & then recollecting that I might as well get a glance at the state of French art before writing again,[3] I pushed forward.

I don't know what I should think, if I went there again & again, but my first impression was, of immense *pains taken*, and immense knowledge possessed, and all coming short of a good end, for want of an innate purity of feeling. Nevertheless I think the exhibition, except in landscape, *far* superior to ours. There is much that is execrable, much that is coarse, vulgar, & wrong, but comparatively little of what is weak. The labour is enormous. Five or six complete panoramas of battles, ten or twenty yards long, every figure painted in with the greatest possible care. Shipwrecks with elaborated crowds of five hundred men, and forest pieces with all the leaves put on numerically.

As a general thing, the difference between our french and English schools seems to me to be, that the French are working for fame, & not for money, and every man does his utmost and does what *he* thinks & feels to be best—but as most of them think wrongly & feel coarsely, the result is still very painful.

In *our* schools, every man is working for *money*, is doing as little as he possibly can to gain it, and is doing not what he thinks best, but what he thinks the public will like. Hence the result is commonly an utter abortion, with evidences however, here & there, of a pure and fine feeling, and capacity for better things, if it were cultivated and candidly exerted. The French are physically incapable of

[1] The church in the Rue d'Aguesseau attended by the British Embassy. Bishop Luscombe (Scottish Episcopal), chaplain of the Embassy, had built it, owned it, officiated in it, and charged strangers 1 franc admission.

[2] The Salon of 1845 had opened in March.

[3] i.e. before resuming work on the second volume of *Modern Painters*.

[8]

doing right, but come as near it as they can. We are capable, but want a vast deal of discipline first.

I have got my passport from the Bureau[1] and propose to start tomorrow at 7 for Sens. I shall leave orders to forward any letter coming after today, to Dijon. Love to my mother.

<div style="text-align: right">Ever your most affectionate Son,
J Ruskin.</div>

Has the box of bones in study been sent to Aclands yet?[2]

<div style="text-align: center">6</div>

<div style="text-align: right">Sens. Monday Evening [7 Apr.].[3]</div>

My Dearest Father,

Such an exquisite morning as I had to leave Paris. Notre dame and the Pont Neuf misty in the eastern light, & the Seine blazing beside the road all the way to Charenton till it half blinded me. I started from Meurice's at 7 precisely, and got in here at 10 minutes before 5. Ordered dinner at 1/4 to 7 and ran out & made a sketch in the market place, and then down to the river side (Yonne) to see Sun set. Such an avenue. Every tree a new perfection. Turners and better than Turner, at every step. I never saw anything so wonderful, so finished & refined in vegetable form. It is a lovely place this—we came upon it in the afternoon light, after a thundershower had just fallen on *it*—not on *us*—& brought out all the colours into the sunlight, & the sweet spring smells out of the ground. The rows of poplars beside the Yonne, & the slopes covered with Vineyards opposite are both exquisite in their way. I am not a bit tired— there is such room for stretching oneself in the caleche that nothing puts me out. Dust—Sun—Pavé—no matter—all goes easily. I could have gone on all night if I had liked.

1 See Letter 4, p. 5, note 4.

2 Henry Wentworth Acland (1815–1900), Ruskin's lifelong friend from their Christ Church days, was at Edinburgh, continuing his medical studies. He had, in March, accepted the Lee's Readership in Anatomy at Oxford, to begin in Michaelmas term. He later became Regius Professor of Medicine. An unpublished letter to Acland in the Bodleian Library (MS. Acland d 72; 27 Nov. 1844) suggests that the anatomical studies for which Ruskin had borrowed the box of human bones from him were related to preliminary plans for *Modern Painters II*: 'I am glad to perceive that there is more difference between skeleton & skeleton than between flesh & flesh. Richmond [George Richmond, the painter] has lent me a lady's foot, the contours of which are exquisite, finished to perfection. I am drawing it for the book.'

3 Postmarked Dijon, 10 April.

I begin to feel a little on the other side of the world now. I shall feel at home, comparatively, at Geneva or Venice, but this is such a quiet, outlandish, semibarbarous place. I got in at 1/2 past 5. Ordered some dinner, a roast partridge and rice pudding, and waited patiently. In about three quarters of an hour, up came some hot bread & water in a bowl. I sent that away, and waited another quarter of an hour—when the door opened and in came, in stately guise, the potatoes, Spinach, & rice pudding! The partridge being—pas encore bien cuit. However, when it *did* come, it was a very jolly bird—and the pudding which I kept warm at my wood fire was also very delicious. But I am plagued with the infernal German waiters— the young ladies won't come to wait upon me I suppose—and I get nothing but loggerheads of Germans to whom I am obliged to say everything twice over.

I had a dull drive today, though the country is pretty enough if the leaves were out, but there is not a single vestige of them yet, and the road went a long while through a tiresome brown oak copse that looked thoroughly English & wintry. The vines too have half of them been frozen, and cut down to the stumps, and all the coteaux look like heaps of mud with bits of black tea stuck all over them. The roads too have been a long while under water, and the diligences that first went over them afterwards have cut up all the *terre* into magnificent six inch deep ruts, which have been baked hard since by the sun, and I am terrified for the *springs* whenever we have to pass a cart. We gain however by not wanting a drag.[1] We have only used it four times since leaving Calais. But I find I can't get much more than 10 K. an hour—including changes—out of the fellows. Please tell my mother the Sugarplums are of most refined & exquisite quality—more peculiarly the peppermint & rose drops. But I can't venture on much lunch in these long travelling days, and have hardly yet made any difference in the look of any of the packages.

It came into my head, last night, that you might possibly be alarmed about the fighting,[2] and *might* have sent me a letter to Dijon, ordering me to go by Lyons. As in that case I should have been puzzled about Coutet, I wrote to M. Rufenacht,[3] last night,

[1] An iron shoe placed under the near hind wheel to slow the carriage when descending hills.

[2] At Lucerne; see Letter 4, p. 6, note 2.

[3] Alexandre Emmanuel Rufenacht, proprietor of the Hôtel des Bergues, Geneva.

desiring him to tell Coutet to wait at Geneva for me, and not go up the Juras, so that if I find any letter from you tomorrow at Dijon to that effect, I shall immediately write to Coutet to meet me at Grenoble, and so run down by Chalons & Macon. Only I shall have in that case to present one of Coutts notes[1] at Dijon, for fear of being fixed at the grande Chartreuse for want of money. So I am going off with my breakfast in my pocket at 1/2 past 5 tomorrow, to have time to arrange matters. I shall seal this & post it tomorrow the first thing at Dijon, if in time for that day's post. I just saved the post at Sens by having the letter ready.

This place looks very lovely, wintry though it be owing to the dark firs about the castle.[2] Do you recollect your little saunter with me in the evening, & the apricots in the smith's yard beside the Yonne? Nothing but bare twigs now, but as many Dogs as ever. Bow-Wow-Wow—it does one's heart good to hear the beasts all along the road. Such a doggy place I never saw nor heard. Love to my mother.

<div align="right">
Ever my dearest Father

Your most affectionate Son

J Ruskin.
</div>

<div align="right">
Dijon. Wednesday evening.
</div>

I found it was too late to post my letter—as the post leaves at 6 in the morning—so I open it to add to it. First, before I forget, I owe mr Bicknell[3] a guinea for a book, which please pay to him when you see him, & thank him for his note which I didn't answer.

2ndly, I find no letters here (to my disappointment), so I start tomorrow, D.V., for Champagnole. I got here at 10 minutes before one, after a wet drive, which tried the rainy qualities of the caleche pretty fairly. I can't say much for them, except that, though a great deal comes in at the windows, a great deal runs out at the doors. But it isn't at all the sort of thing for wet, and I shall make a point of avoiding travelling, as far as possible, on stormy days.

[I] am sitting in the very bedroom I had last time[4]—off the saloon—the house having hardly any one in it, they say I may as well have it as another—& I had a comfortable forenoon to look

[1] Circular notes, the equivalent of modern traveller's cheques, from the bank of Coutts & Co. They could be presented to any of the bank's correspondents. Ruskin seems to have carried them in £25 denominations.

[2] The château of the naturalist Comte de Buffon (1707–88), notable for its thirteenth-century tower.

[3] Elhanan Bicknell (1788–1861), an important collector of Turner and other British painters, lived near the Ruskins at Herne Hill.

[4] Probably at the Hôtel de la Cloche, near the Cathedral. The Ruskins had stayed in Dijon, 5 Aug. 1844.

over my papers &c, & rest, before starting for the Jura. But I feel lonely here, as is likely enough—so I shall at Geneva, and wherever I have been accustomed to have you with me. I can't believe it is seven months & more since I was here.

I met a man driving a young donkey *in* a char-a-banc today. I thought he meant to insult me, but couldn't stop to ask him on account of the rain.

I don't much like that house at Mont Bard. My bill there this morning was higher than at Meurice's. Meurice is really most reasonable in the way I managed it, but it is very uncomfortable, such a complete *machine*. One is never known there for anything more than "No 52".

I am afraid of the post office shutting if I write more tonight. Goodbye at present. I will have a letter ready to post at Geneva on my arrival.

<div align="right">Ever your most affe.
JR.</div>

7

<div align="right">Champagnole. Thursday evening [10 Apr.].</div>

My Dearest Father,

I think I shall post this before I leave, tomorrow,[1] as I shall probably sleep on the hill top,[2] and perhaps miss the post on Saturday at Geneva. I am sitting in *our* Sunday parlour,[3] with the marine prints round it, beside a capital fire, and altogether most comfortable. We left Dijon at 5 minutes before seven, after breakfast, and came straight on. Do you recollect the little fortified town of Auxonne, which is two stages from Dijon, and one on this side of Dole?[4] While the horses were changing I happened, by mere accident, to run up a street that led to the church, and found at its west end, one of the grandest portals I have seen in France.[5] I am going back there some day to draw it. Then as we came down the hill upon Dole, where the Jura first open, I had the loveliest effect upon th[em] I have ever seen—it was raining hard to th[e] south, and gradually, out of the black mass of cloud which shadowed the whole plain, the mountain forms emerged northward, into sun and blue sky, only veiled here & there with soft white remains of raincloud, and the

[1] Postmarked Champagnole, 11 April.

[2] At St Cergues (see below).

[3] At the Hôtel de la Poste. In 1844 the Ruskins arrived at Champagnole 3 Aug. and stayed there through Sunday, 4 Aug.

[4] i.e. on the north or Dijon side of Dôle, not the Champagnole side.

[5] The church is probably Notre Dame, whose sixteenth-century porch is notable for its many sculptures.

farther ranges vivid with snow. The woody plain be[y]ond Dole itself just touched with pale [s]unshine, the spires of the town dark against it. It grew more stormy as we got towards Poligny, but after a heavy shower, the sun came out again just as we began to climb the hill, glittering all over the wet green grass beside the convent, the violets in bright bloom by the road side. When we had got up, it grew wild again, just holding up long enough to let us see the piny ranges of the Jura loaded with snow—and then extinguishing everything in as pretty a storm of snow & sleet as you would wish to see. It just blew over as we drove up to the door here, at 1/4 past 5—and there was such alacrity on the part of the landlady, and such enquiries after Monsr & Madame, as made one feel quite at home. They lighted a fire in the sitting room, which is so clean and in such order it would be a credit to Lucy[1] herself—and a worked foot mat put below each chair—and its pictures—and sofa— & white marble table—& windows on two sides—make me wish I could carry it with me. At six o'clock, they brought me a couple of trout, fried, just out of the river, of the richest flavour—followed by a roasted woodcock on delicate toast, and a small, perfectly compounded omelette soufflée. In [o]rder to encourage the house, as well as to make that which was already near perfection absolutely perfect, I looked over the carte des vins, & finding half bottles of *sillery* mousseux at 3 fr, I ordered one, & it turning out very pure & in fine condition, rendered as I conceived the whole thing worthy either of Horace or Mr Rogers.[2] Meanwhile the sun was sinking gradually, and I was warned of something equally perfect in *that* direction & way, by seeing my champagne suddenly become *rose*. And a beautiful sunset it was—glowing over the pinewoods, and far up into sky, long after the sun went down. And as I came back to my soufflée & sillery, I felt sad at thinking how few were capable of having such enjoyment, and very doubtful whether it were at all proper in me to have it all to myself.

An hour afterwards, in came tea—silver teapot & sugar tongs— bread as light & white as sea foam—fresh butter—& mountain honey in the comb. And so there's a beginning of rural life for you.

I fancy I shall be very differently off tomorrow at St Cergues. The mountains are, as I told you, covered with snow—even the little hill to which we walked on the Sunday is quite white, and I shall have but a rough birth of it on the hill top. Tant mieux.

I shall get down to Geneva, D.V., early on Saturday morning, shall settle matters at bankers, consult with M. Rufenacht, &, if

[1] Lucy Tovey, the Ruskins' parlourmaid.
[2] Samuel Rogers (1763–1855), banker, poet, art collector, and celebrated host. Ruskin had been introduced to him the year before (see *Diaries*, I. 273–4).

[13]

I think affairs look ill then, I shall start at 12 or one o'clock, & get to Annecy for the Sunday, out of the way of these republicans.[1] But I don't want to do this unless I see reason, as I have worked pretty hard all the week, and should be glad to rest on Saturday.

I hope to get some letters at Geneva. I shall write as soon as I get there. Love to my mother.

<div style="text-align:right">

Ever my dearest Father,
Your most affect. son,
J Ruskin.

</div>

On my enquiring if there was any letter here for me (I half expected one from Coutet), the landlord brought me *your* one of last year, engaging rooms, carefully done up with others of the kind.

<div style="text-align:center">

8

</div>

<div style="text-align:right">

Hotel des Bergues [Geneva].
7 o'clock morning—April 12th.

</div>

My Dearest Father,

Here I am—all right—after the easiest run from Calais I have ever had—with a window looking, not on the town, but up the lake, which is lying grey in the morning cloud, the very essence and embodiment of all tranquillity. Coutet was here waiting my arrival, & we shall be off to Annecy today, I hope—it is but a four hours drive in the afternoon. I was too late for post office last night, & have just this minute sent off George to it.

It was very dark and cloudy when I left Champagnole at 10 minutes before 8 yesterday, and I thought we should have had storm all the way, but the clouds broke just as we crossed the bridge in the hollow of the ravine, and we had alternate shade & sunshine all day. When we got up to St Laurent, we found the whole country under half a foot of snow, and a very pretty notion of wintry air too—and at the top of the pass between St Laurt. & Morez, the snow lay two feet deep. At Morez, all was clear again.

George has just come back from post office without any letters. This makes me rather uneasy, for I fully expected some here, but I suppose I should have heard if there had been anything wrong. Please don't leave me so long again without any—send me some long ones to Nice.

Half way up to Les Rousses, the snow began again, and was lying a foot deep about the village. I got my 150 francs[2] without

[1] Another reference to the Swiss fighting; see Letter 4, p. 6, note 2.

[2] The prescribed three-quarters of the deposit on his carriage, paid in at Calais, was returned by the customs post at Les Rousses, the frontier town. See Letter 2, note 3.

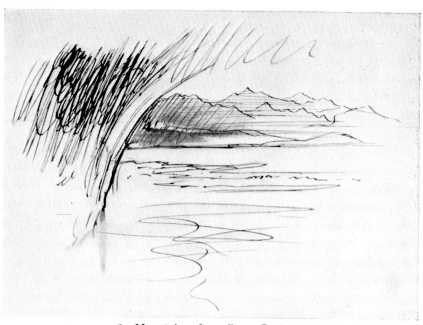

1. *Mountains after a Storm*. Letter 8

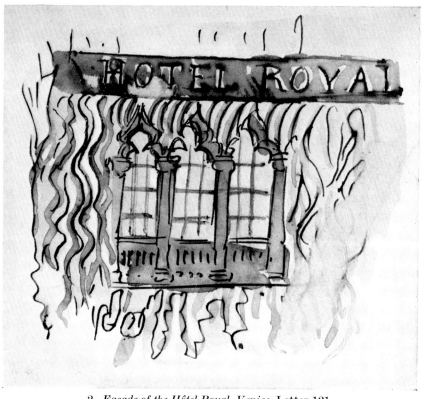

2. *Façade of the Hôtel Royal, Venice*. Letter 121

any trouble or delay and went on immediately. Beyond les Rousses, the road was just passable, and that was all, and to mend the matter the clouds came down about us, till it was almost as dark as in "London fog", and a steady shower of something which was not snow, nor hail, nor sleet, but something between rice & sago—soft round compact grains, about the size of barley, which would squeeze together in the hand almost like indian rubber, only without elasticity. With this the trunks were soon covered three inches deep. By the time we got to the top of the pass above St Cergues, it was as black as thunder—the snow there lay four feet deep beside the wheels, two ruts having just been cut for the diligences—the black pines looked still blacker underneath, by so much as they were loaded above with massy wreaths of snow, and buried below often up to their branches. This sort of thing continued all the way to St Cergues, and you could hardly conceive a more prettily *wolfish* bit of winter scenery, in its way, all along the road that my mother & I walked up beyond the post house last summer. She wouldn't much have liked the drive this time, for we got a pair of bad horses at Les Rousses, and the left hand one didn't like to have his feet in the snow, & was always pushing towards the middle of the road, & the right hand one was in consequence run so close to the right bank that our wheels were every now & then going up on the deep snow—and we had once or twice a decent chance of being laid softly into the white cushions on the other side, which would indeed have done us neither any earthly, nor any snowy, harm, but which nevertheless is not the sort of thing my mother likes. Well, things kept looking as black ⟨all⟩ about the posthouse, & it was mightily cold into the bargain. I saw there was no chance of a view, & it was not worth while risking being snowed up at St Cergues for the bare chance of a sunrise, so I ordered horses out. We had not driven down above half a mile before I saw a light breaking through the shower of sleet, & called to the postillion to stop. On it came— brightening till the black shower was seen against it like hair—and then something like a bright blue silk gown stretched in the air— which in an instant more, turned into the lake of Geneva—and then the shower drifted off eastward in one dense mass—and out came the Pays de Vaud into full sunshine, with the opposite moun- tains loaded high over their summits with masses of pure white cumuli—the place of the Mont Blanc indicated by the bright light reflected from its snows through the clouds covering it. The whole Chillon end of the lake was still buried in the storm—and the blackness was terminated by a fragment of intense rainbow out of which the mountains came as if seen through an arch (I am going to try to make a little reminiscence of it), so [see Plate 1].

[15]

Half an hour after this, we were down at the bottom of the hill, in the bright, hot sun of the pays de Vaud, feeling as if there weren't such a thing as snow or winter in the world—and the primroses! My stars. How they did come out along the meadows. We got in here at 1/2 past six. I was glad I had come down, for it grew gloomy again in the evening, and there was no view this morning.

I find the English post comes in at one o'clock, so I shall wait to see if there are any letters before I start for Annecy.

1/2 past 12. I have just got your most kind letter, which has made me quite comfortable—the clouds are all flying away, the horses are ordered at two, & I hope to spend a delightful Sunday by the quiet lake of Annecy.

The money is just coming from bankers with papers for me to sign[1] which I will read carefully as you desire. I want to finish my little reminiscence of yesterday before I see anything new, so I must say goodbye. I am delighted with your most just criticisms on Fielding.[2]

<div align="right">Ever your most affectionate Son
J Ruskin.</div>

Dearest love to my mother.

<div align="center">9</div>

<div align="right">Annecy. Sunday Evening [13 Apr.].[3]</div>

My dearest Mother,

You must really come here next year—it is the very place for you. Such a lovely lake—like one of the Cumberland ones, winding far up among steep hills, and winding, broad, easy paths above it—among orchards—and masses of walnut and Spanish chesnut—and trellises for vines. Only there are no leaves yet, but the grassy

[1] In addition to circular notes, Ruskin carried a letter of credit from the bank of Glyn, Hallifax, Mills & Co. At Geneva, he drew £50 from their correspondent Louis Pictet.

[2] Anthony Vandyke Copley Fielding (1787–1855), watercolour painter and President of the Old Water Colour Society. The family owned two of his pictures, and Ruskin had taken drawing lessons from him in 1835 and had praised him in *Modern Painters I* for his treatment of water and rainclouds. His father's criticisms were probably of Fielding's pictures in the British Institution Exhibition of 1845 (10 Feb.–17 May): No. 363, *View of Ben Slarive*, and No. 371, *View of Ben Vorlich*.

[3] At the top of the letter there is a note in John James Ruskin's hand: 'detained & not reced till 5 May'.

knolls all under the rocks are covered with primroses just as our fields are with buttercups—and violets mixed—the primroses as big as half crowns—and whole yards square of wood anemones as thick as they can cluster, and another flower which I never saw before, which comes out of a taper green sheath, something so—and the blossom is a cluster of lily like stars this shape, of pure blue, a beautiful thing, only I have no time to botanize on this journey, or dry them. But I never saw so delightful a place—in a month more it will be very Paradise—you must positively come & stop a day or two next summer—if not this— to meet me when I come from Italy.

What made you put that funny book of John Bunyan's[1] in the bag? You know it is not at all a thing in my way. It is very curious as an example of the way in which the Deity works on certain minds, but as a type of his general dealings it is a miserable one indeed. For it is physically impossible that such working should take place, except in a mind of extreme ignorance and ill training, as well as of undisciplined & vigourous imagination. A man who has general knowledge has always too many subjects of thought & interest to admit of his noticing every time that a text comes jingling into his head—and a man of disciplined mind would not suffer any such morbid fancies as Bunyan describes to take possession of him or occupy his attention for a moment. Much of Bunyan's feeling amounts to pure insanity, i.e. the unreined state of a strong imagination, watched & dwelt & acted upon as if its promptings were truth. His lying in bed in the morning to listen to the devil saying—Sell him. Sell him (of Christ)—is of this character. No man in his right senses but would have got out of his bed & gone to work, and no man of common power of self-discipline but would have employed his mind at once in a reasonable way had he been even obliged to lie still.

Now the imagination of George Herbert is just as vigourous, and his communings with God as immediate, but they are the imagination & the communings of a well bridled & disciplined mind, and therefore though he feels himself to have sold Christ over & over again for definite pieces of silver, for pleasures or promises of this world, he repents and does penance for such actual sin—he does not plague himself about a singing in his ears. There is as much difference between the writings & feelings of the two men as between the high bred, keen, severe, thoughtful countenance of the

[1] *Grace Abounding to the Chief of Sinners.* For the incident referred to below, see par. 139.

one—and the fat, vacant, vulgar, boy's *face* of the other. Both are equally Christians, equally taught of God, but taught through different channels, Herbert through his brains, Bunyan through his liver.

I am pulled up here for washing—we couldn't get any done at Paris, the washerwoman said the time was too short, & they observe Sunday here most religiously—by leaning all day against the posts by the river, smoking, and following the example of Celimene's marquis—"Je l'ai vu, depuis une heure, cracher dans un puits pour faire des ronds!"[1] So I must stop here tomorrow, and I am glad of it, for I hope to get a lovely study. The town itself is gloriously picturesque, even without the mountains—only the weather is very objectionable. The wind whistles tonight in a sad way.

I have not time to write more, for I want to prepare a letter for my father also to post either at Mont Meillan[2] or Grenoble on Tuesday—this I shall post tomorrow morning at once. I am quite well in every way, and have been so ever since I started. Had a walk up a decent bit of a hill today, & enjoyed it exceedingly—after reading the church service bang through to George & forgetting to pray for the King of Sardinia (heaven bless him—and confound the republicans).[3]

<div style="text-align:center">
Ever my dearest Mother

Your most affectionate Son,

J Ruskin.
</div>

Take care of your eyes.

<div style="text-align:center">

10

</div>

<div style="text-align:right">Annecy. Sunday Afternoon [13 Apr.].</div>

My dearest Father,

I left Geneva yesterday at two in the afternoon, and got here by half past six. I think it be the very loveliest drive I ever had in Switzerland—unless perhaps here and there beside the lake of Zug, or about Meillerie—and it is a drive too altogether after *your* own heart. The road ascends first on the flanks of the Saleve, to about 800 ft above the lake, so that looking back, you have the most

[1] Molière, *Le Misanthrope*, v. iv. The quotation is not exact.

[2] Montmélian.

[3] Charles Albert, King 1831–49, was notable for both his resistance to reform and his severe repression of the republicans. After leaving Geneva, Ruskin had, at St Julien, entered Savoy, then one of the Sardinian states.

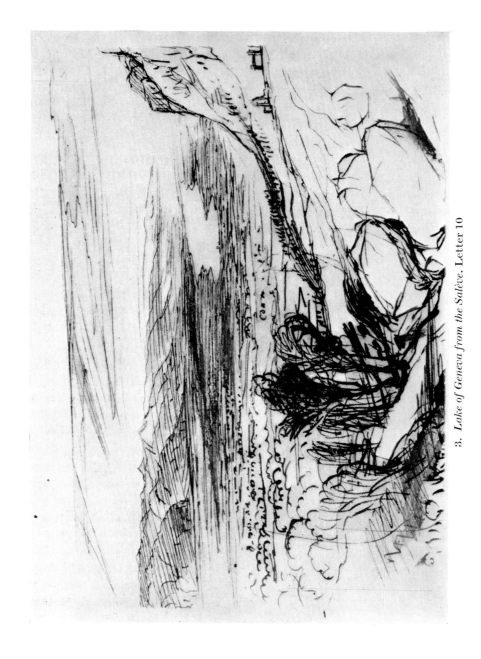

3. *Lake of Geneva from the Salève*. Letter 10

superb sweep of the pays de Vaud, with the lake of Geneva seen in perspective, and therefore its vast width shown—and all the pretty creeks & bays of its borders—and the whole line of the Jura, from the perte du Rhone to Yverdun—and the beautiful cliffs of the Saleve on the right—something so. [See Plate 3.]

Well, as soon as you get to the top of the hill, and turn your back on Geneva, you come on the whole range of the mountains of Chambery, with a multitude of inferior hills between you & them—rolling and undulating one behind another as you love to see them—and this in the afternoon, seen against the misty light of the setting sun, was beautiful beyond description. Then instead of going down, the road turns to the left, and winds on an elevated terrace all round the Saleve—commanding this exquisite view all the time—with a surface like a slate table—and lovely groups of cottages, & orchards and walnut trees scattered along it—until it brings you full in front of the great range of Alps running from Bonneville to Annecy—which run up to 6 or 7000 ft, in the most glorious precipices. These are at present loaded with snow, and took the sunset light as finely as the high Alps themselves. Then the road goes down to the Pont de la Caille,[1] which, though I had never heard of it before I saw it, is certainly the finest suspension bridge I have ever seen. It is thrown over a gorge in the limestone—cut by a torrent hardly to be heard—and showing through the perspective of its vista of cliffs the lovely ranges of the Annecy mountains. The cliffs go sheer down, with about 500 ft of width between them. A stone dropped from the bridge took 7 seconds by my watch before it touched the water. I have a second hand, & so could be quite accurate. Take out your watch, and look what a time 7 seconds is for a stone to be falling, & you will have some idea of the height. It is said, in the published account of it, to be 600 french feet above the stream—this is nearly 650 English. I guessed it ⟨at⟩ to be the height of Strasburg spire, but that is only 490. Be it what it will, it knocks the Fribourg ones altogether out of the field. It is 600 ft long, from tower to tower. You must certainly come here next year to see it, and what is more, you must come & stop a day or two at this place, for it is the loveliest lake I have seen in Switzerland. It is as like Keswick as can be, wanting the islands, and raising the Lodore cliffs to 4000 ft instead of 800, and the Borrowdale mountains to 8000 instead of 3000—and such heavenly colour—greens that look where the sun strikes as if they were part of a rainbow—& blues passing into purple in the deep water. And the town itself very interesting, full of pictures—running streams through it clear from the lake—wooden galleries—large grey chateau on

[1] Over the Usses beyond Cruseilles. It was opened in Sept. 1839.

rocks above[1]—& vast, gloomy arcades like cellar vaultings all through the streets. Many convent like buildings outside the town (covered with trellises for vines however, which looks more comfortable than spiritual).

<div align="right">Monday evening.</div>

Pouring rain nearly all day. No going out. Set to work in earnest for Murray,[2] & got on pretty well. I tried to write in the carriage, but I found I couldn't read owing to the sun being always in my face—and there was always something to interrupt, or to be thought of, and I was always feeling for my passport or my purse or counting my money, or quarrelling with the maitre de poste. It is an intense bore having to get along the road, with every soul about you tearing & gnawing to get as much out of you as they can. I detest it—it even makes me feel melancholy—one feels as if one weren't a human creature, but a sort of locomotive orange that everybody was suck-sucking at till they would leave nothing but the bitter & skin. Coutet says he must have 8 francs a day—and one, if I like, for his lodging—or to pay it if I please at inns—his board being the same as George, 4 francs. This also if I like I may pay to innkeepers for him—he wants 4 francs a day clear for himself. I fancy I shall do best to pay the five francs regularly & not be bothered with bills.

I intended going from here to Chambery, but I find the road there don't go by the lake, whereas there is another road which goes right round the lake shore—then crosses the hills and comes down into the valley of the Isere on the Cenis road—by which I get straight to Mont Meillan and Grenoble. So of course I take the hill road—it is only about five miles longer. I had hoped to get, by rising early, to Grenoble tomorrow, but I hear the wind whistling in a piteous way, and fear I shall be kept here at least till 10 or 12 o'clock. I could then only get to Mont Meillan. I shall post this wherever I get to, immediately.[3] I can't travel in heavy rain in this carriage, & these hill storms [are n]o joke.

There's the lie of the lake for you. [See Plate 4.] Pretty, isn't it? I wrote my mother yesterday.[4] I suppose she got my letter.

<div align="right">Ever, my dearest father,
Your most affe Son
J. Ruskin.</div>

1 Ruskin made a drawing of the château, Catalogue 89. For a reproduction of the engraving made from the drawing and printed in *Praeterita*, see *Works*, XXXV, Plate 22.

2 John Murray, the publisher. His work was on the proposed review of Bell's *Anatomy of Expression* ; see Letter 1, note 1.

3 Postmarked Albertville, 16 April. 4 Letter 9.

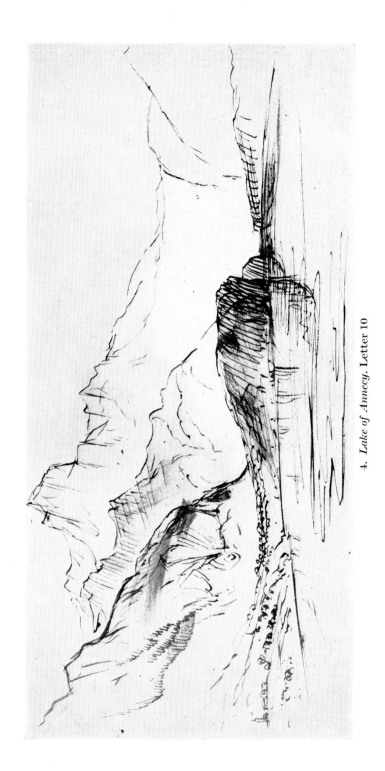

4. *Lake of Annecy. Letter 10*

Conflans, or Albertville.
Tuesday evening, 15th [Apr.].[1]

My Dearest Father,

I have been writing on two sheets at once, and have had to cut them up, so look at the numbers of pages.[2]

I have had such another glorious drive today—as never was!—by the shore of the lake of Annecy. Such a lovely shore—all walnuts & chesnuts, with ivy up the trunks and primroses & cowslips all over the roots—and sweet, winding English-like lanes all about and among them—with bits of wooden farms & cottages here & there, all covered over with trellises for vines, as well as some of the road, & even of the *lake*, for they actually build their trellises far out into, or over, the water, so as to form a sort of vinous boathouse—and the meadows slope up in the softest possible curves to the crags, steeper & steeper until out comes the rock, & up go the mountains 6 or 7000 ft. You *must* positively come here next summer. I couldn't start till half past eleven this morning, owing to continued rain, but it cleared up then & has been getting better ever since. When we had got to the head of the lake of Annecy, we came as usual to a marshy bit, and then the valley, though very grand, got comparatively ugly—the debris sort of thing you do not like—and this character increased upon us all the way here, so that as I drove into the town, I called out to George it was a nasty place, and I wouldn't stop, but would go on to Mont Meillan. Very luckily, I happened to be mighty hungry, so I ordered the horses to be kept for a quarter of an hour, & ran into the inn to get a chop. It was a nasty looking place enough—all smoke and bustle in the Kitchen—& I was congratulating myself on having determined to go on, when they brought up a dish of riz de veau with truffles which I liked the look of exceedingly. While I was discussing this, the waiter said something about a pretty view from the end of their garden. I finished the sweetbread, paid for it, ordered the horses, & went out to look. I got to the end of the garden, got across a bridge, got a glance down the valley of the Isere from the other end of it, ran back full speed to the Inn, asked if their beds were dry, & established myself till the day after tomorrow, if the weather be fine. Blessings on the riz de veau—if it hadn't been for it, I should have lost the finest valley view I ever saw. You cannot conceive the effect of the magnificent limestone ranges which border the valley of the Isere, loaded as they are fathoms deep with the winter snow, so that the

[1] Postmarked Grenoble, 17 April. Received 22 Apr.
[2] This sentence is inserted.

aerial qualities of great Alps are given to the noble precipice forms of the lower mountains—and the old town of Conflans, all towers & crags, comes in exactly where it ought, in glorious ruin. (N.B. the most miserable wreck of a town I know—mighty fine in distant effect, but heaven pity all who live in it.) Conflans used to be the chief place of the district, but it is now utterly gone to decay, and the town in which I am lodging, Alberville (formerly l'Hopital), on the other side of the river,[1] has taken all the blood out of it. There is a deserted chateau at Conflans, which will come into my study tomorrow—its master has just married the daughter of a man who, when young, kept the poste at Chambery, and got turned out for imposing on travellers—he became a soldier, went to India (this is the waiter's story), got to be captain, & colonel, allied himself in some way with one of the Rajahs, betrayed him to the English, got a great part of his fortune, returned & built a street and a chateau and [a fou]ntain at Chambery, and marries his daughter to the young Lord of this castle at Conf[la]ns.

<div align="right">Albertville. Wednesday evening.</div>

I have been drawing all day at Conflans, in lovely weather. I sent George into the town to look at it. He walked all through it & came back in great wonder and disgust, saying he had met just 6 living creatures in the town—two dogs, three chickens, and a man out of his mind.

I have been sitting all day with my back against a wall, & have got a pretty view certainly,[2] one which I believe I shall like exceedingly in a day or two, but the place is so lovely that one is disgusted with all one does on the spot. The vines must be exquisitely lovely here in their season—one great big rock like Bowder stone,[3] covered all over with a trellis as your lodge is, for the sake of its heat. Only they let the grass grow in their very vineyards. I think I never saw so vicious looking a population. The Italians are grand at their worst, and have energy & ferocity about them, and the Aosta people have actual disease to struggle with, but here is a whole townsful of people eaten up & rusted away by pure, vicious, idleness—every man you meet with a pipe in his mouth, and his

[1] L'Hôpital, across the Arly from Conflans, had just that year been re-christened Albertville in honour of King Charles Albert.

[2] Catalogue 548. The drawing of Conflans, with others made on the tour, was framed and hung at Denmark Hill. See Ruskin's letter to his father of 15 Feb. 1852, *Works*, XXXVI. 131.

[3] In Borrowdale, Cumberland. Samuel Lewis, *A Topographical Dictionary of England* (London, 1849): 'The largest detached piece of rock, entitled to the denomination of a single stone, in England; it is 62 feet in length, and 84 in circumference ... the upper part projects considerably over the small base on which it rests, and it is not unusual for parties of pleasure to regale under it.'

hands in his pocket, and a scowl on his brow—looking as if he could commit any crime, if he had bodily strength to compass it, or mental energy to contemplate it—a good deal of cretinism besides, but apparently more owing to dirt and laziness than to anything in the climate. I am off tomorrow morning early, and hope to post this letter at Grenoble. I am at the mercy of the postillions in the way of payment, for nobody here knows the distance to anywhere. I gathered some hawthorn today, & almond blossom. Heard the cuckoo, & lay on some mossy rocks till after sunset without being cold, besides sitting out all day. So I consider the summer begun.

A heavenly moonlight tonight, with only half a moon. All the snowy mountains as clear as by day. I forgot, didn't I, to answer about money—you gave me 60 pounds to start with. I have clear accounts of all. Those 60 pounds will I believe be just worked out tomorrow night. 10 went, all but 1/2 a crown, before I got to Calais.

<div style="text-align:center">

Ever my dearest Father,
Your most affectionate son,
J Ruskin.

</div>

<div style="text-align:center">

Grenoble. 1/2 past 4 [17 Apr.].

</div>

Delicious drive again; most perfect vine country—houses now completely Italian—corn all over the fields—vines in trellises above—exquisite mountain forms—if you have yet the liber studiorum from Turner you will find a most accurate study of the plain and mountains as you approach.[1] The grande Chartreuse mountains all over snow—shan't go. George says this place is a regular old rookery—it is not a very handsome town certainly

[1] 'Chain of Alps from Grenoble to Chamberi', Plate 49 of the *Liber Studiorum*, a series of seventy-one engravings from his drawings published by Turner in fourteen parts between 1807 and 1819. For a reproduction of this engraving, see Alexander J. Finberg, *The History of Turner's Liber Studiorum* (London, 1924), p. 195. The set of the *Liber Studiorum* Ruskin had ordered was not delivered until 30 July. His father announced its arrival in a letter to him at Vogogna: 'Foord [Ruskin's frame-maker] brought out Liber S. today 14 numbers—plates all clean newlike only in paper sewed but I put all after looking at them, in your Bookcase not to be touched. . . . I shall call & pay Turner.' Turner's price was 14 guineas. See the unpublished letter, 30 July–1 Aug., in the Ruskin Galleries (Bem. L 3). Note that Ruskin's set was not one of the fifteen sets of reprints made in June 1845, but was a set of proofs. See his letter to Dr. John Brown, 27 June 1846: 'You ask me if single impressions of the Liber Studiorum are to be had. I fear very few—and those not of the best subjects—which are usually picked up as soon as they come into the market. I have had great difficulty in getting even an imperfect set of the proofs. The whole work is to be had, but it is a recent issuing of impressions after the copper plates have lain by these (some of them) thirty years, and of course they are all very bad.' (The original letter is in the Bodleian Library, MS. Eng. lett. d 1, and is printed in *Works*, XXXVI. 60–2, but without this postscript.)

and the "Hotel des Ambassadeurs" mighty queer. Off tomorrow early for Gap. Just time for these few words—table d'hote at 5—not washed yet—post at 6—excuse blotchy seal.

12

My Dearest Father,

We have had a nice long job of it today, and I daresay shall have tomorrow—only I haven't made up my mind which road to take, for I can get no information from anybody about either. It was very wet last evening at Grenoble and I sat some time at the table watching a man in a mile long beard opposite me, who I thought every instant would kill himself with his own knife. Knife and fork, but especially the former brandished high over his head in the heat of discussion—now cutting No 7 in the air—now thrusting with deadly aim and effect at his opponents arguments (very nearly at their eyes) across the table—now delivering a playful "over the left" in derision,[2] to the great peril of the waiter—now rested pensively upright on his own plate, with the points just tickling his own neckcloth.

I went out afterwards in spite of the rain, but it is a miserable town—not a single point of interest about it, except the great fort & the view from it on the other side of the river.

Digne. Sunday.

This fort is to me a far finer thing than Ehrenbreitstein[3]—none of its walls are so high individually, but they run up the mountain in a regular staircase of 15 or 20 great bastions one above another. It must rise to full 1000 ft above the town. From near the top of this the view over Grenoble was very exquisite—Italian roofs—all ins and outs—river—two bridges like Florence—vine plain—mountains one behind another of wonderful forms.

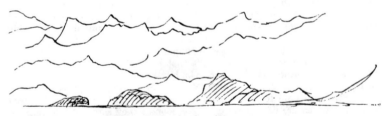

1 Postmarked Nice, 23 April. Received 30 Apr.

2 See Dickens's account of the gesture in *Pickwick Papers*, chapter 42.

3 The famous fortress opposite Coblenz, overlooking the juncture of the Rhine and the Moselle. The family had visited it on their tours of 1833 and 1842.

That sort of thing, little mounds below of 800 or 500 ft high. Wanted sadly to draw it. Couldn't—found I must be off early next morning. 12 hours to Gap. Started at 6. First stage very beautiful—level plain—hills in morning light. Came to a gap in the hills—drove through it. In ten minutes we were in a sterile country like Derbyshire, & not a vine to be seen, with our road seen mounting the hills in front nobody knew where.

We changed horses & began to climb. A barren, limestone hillside, no rocks—no verdure—no anything—mere ground. Horses hardly able to get up, so steep. Got out & walked leisurely up—two hours & a half, country getting uglier every moment. All this time, I had the mortification to see opening on the other side of the valley, the Gorge of Bourg d'Oysans, which is as magnificent as that of Gondo—with the road running through it from the place where we changed horses, Vizille, as level as a board. At the top of our two hours mounting, I happened to ask ⟨for a moment⟩ the postillion about this road (the pass of the Mont Genevre)—he assured me there was no snow on it at all and that in two days I might be at Turin. I was on the very point of making him turn his horses, but then thinking of my letters & money at Nice, my parcel for Lady H[1]—wishing also to see the Corniche pass again, and still thinking there might be fine country here, I gave it up and—worse luck—went on.

We changed again at the top of the hill, and on emerging from a ragged village, I found myself apparently on the barren hills of Moffat or Hawick—a dull, big, comfortless lake—no trees—no pines—no mountains—no rock foregrounds. Patches of ill cultivated fields—comfortless stone scotch looking cottages, and stone dykes—voila tout. Very much disgusted I leaned back in the carriage, took my Dante, & did not look out again till we had changed horses.

This change brought us in sight of some snowy peaks—not Alps, but well formed lower mountains covered with fresh snow. We went on for half an hour, & came to the brow of a hill, from which we had a view of which the following scratch gives you the plan.

a. a. a. are calcareous mountains of fine forms, which would have made a beautiful scene, but for their untoward foundations. b. b. is a great, barren, ugly plain, on a level with *us* after our laborious ascent, i.e. about 2000 or 2500 ft above the sea. c. c. are

[1] Lady Emily Hardinge, wife of Sir Henry, Governor-General of India, soon to be Viscount Hardinge. She was the mother of Charles Stewart Hardinge (1822–94), Ruskin's friend from their Christ Church days, then in India as his father's secretary, and of his half-brother, Sir Walter Charles James. See below and Letter 14.

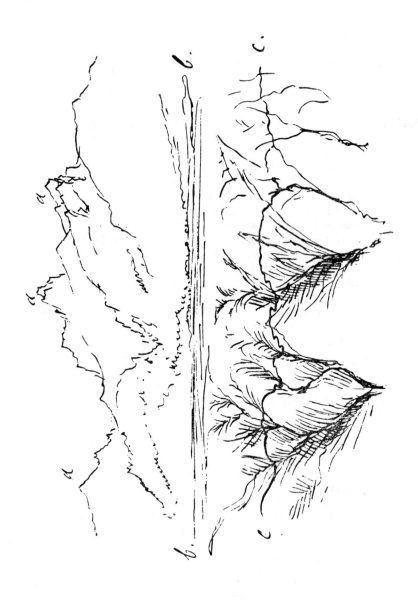

banks of gravel, pebbles, black slate, & mud, about 1500 ft in depth, going down to the river, which flowed below us—constantly crumbling away, & without a grain of soil or a vestige of vegetation upon them.

Imagine the valley of Chamouni with the *Breven* on *both* sides of it—filled up as high as the Montanvert with mud & gravel—and that then the Arve has cut a new and constantly enlarging furrow down to the bottom, through all this loose stuff, and you have the place exactly—you being placed on the top of the gravel, at one side, and having to get across the river to the top of the gravel on the other!

Down we went, & up we went, not quite to the top, but another hour and a half's climb—and then along a line of road like the black line from c. to c., for the gravel was there cut away right to the hillsides, & we had to go down into every gully & up again, so that our regular pace, including the trots down hill, was 4 miles an hour, and we were also kept a quarter of an hour waiting for the horses to come from the fields at every stage, so that, of 101 Kilometers which we had to do in the morning, there remained to us at 1/2 past 4 in the afternoon (we having started at six) exactly 38 to do.

We had by that time got to the end of this great valley full of gravel, and I looked anxiously for what would come next.

Nice.

(Tuesday evening—too late to get letters out of post or put any in—lovely weather.) We came to the brow of a hill, looked down on what I thought for a minute was a level gravelly plain, easily to be got over, but on a second glance, I saw its scale was enormous, and that its apparent ruts were deep vallies. We got down to it, slowly, and by bad road—ruisseaux like to tear the drag off every twenty yards—in about half an hour, and found ourselves in a country without mountains—without towns—trees—or rocks— all gravel—just cultivated enough to make it *not* sublime or curious, and on such a scale that every hole in it took us half an hour's walking to get in and out of. It got dark as we drew up at the last stage—or nearly so—all I could see when we started again was that we were going up again very fast, beside a wretch of a wide, scrambling, stony torrent which had washed the road away wherever it was level, and left only the hills, with its own bed between them by way of connection. Tired, & considerably disgusted, I shut down all the glasses & fell asleep.

[27]

When I woke, I thought it was morning, & I was just being pulled out of bed by somebody. The moon was shining gloriously in at the windows, but I thought there was more light than it accounted for. I looked out, rubbed my eyes again & again. The snow was five feet deep beside the carriage!!

It was now a lovely scene. We were in the middle of a vast elevated plain, which swept up on both sides to concave masses of undulating mountain defined against cold, starry sky. From these the snow had been drifted when dry, by the winter winds, so that it lay in wild, fantastic streaks & zones, with the dark earth between them, here as I said, five feet deep, presently none, the shadows of a few shattered and worn trees thrown far across its bands by the moon light—⟨Below⟩ in the extreme distance, there were spaces of clear, grey, Italian moonlighted sky, with long bars of white cloud, under which I saw the gleam & flash of the illumined edges of the high Alps. This refreshed me at once, as well as the high air (though it was bitter cold—I could not keep my feet warm with the glasses close shut), and I got in by 10 o'clock to Gap, as fresh as possible, after dragging down a steep hill for half an hour at a trot. Fish supper.

Next morning, up at 1/2 past 6. Raining softly. Breakfast and off. Rains harder. First stage. Rains tom cats & newfoundlands. Get to Sisteron, knowing nothing of the road, except that it is level & good. Sisteron is in a gorge cut by the Durance (you know the Durance—down at Avignon) through the limestone. You will find a faithful sketch of it in Harding's "sketches at home & abroad",[1] an upright, single arch bridge. I could just see the fortress through the rain. George must needs poke his head out from under his umbrella to look up ⟨just⟩ as we entered the narrow street behind the houses in the view—just in time to receive a *spout* into his mouth! you know the Italian roofs and their jets into the middle of the street—the street there so narrow that they came from both sides full on the carriage, as if they would have broken the roof in.

After this, and it rained hardest just at this moment, the clouds broke, & we got into Digne without farther trouble or wet. I gave you some account of Digne in my mother's letter.[2]

[1] James Duffield Harding (1798–1863), watercolour painter and lithographer. Ruskin took drawing lessons from him in 1841 and travelled with him later in this tour (see Letter 114). According to John James Ruskin's account book in the Ruskin Galleries (Bem. MS. 28), his father bought Ruskin Harding's *Sketches at Home and Abroad* (London, 1836) in Dec. 1841 for six guineas. It is a folio volume of fifty lithograph plates, without letterpress, and the view of Sisteron is on p. 10. The bridge is in the foreground, behind it rise the houses of the town, and behind them rises a high cliff on top of which stands the fortress.

[2] Letter 13.

I heard at Digne that it would take me two days to get here, & the first a twelve hours journey—cross roads. On Monday morning which was luckily fine, we started at five o'clock to the minute, and found ourselves in half an hour in a gravelly plain very like the Gap one, only looser, yellower, & smaller in scale. Beds of ochreous sand, yellow marl, pebbles, & black mud, with here & there a bed of the sand hardened into stone, and all the looser soil washed away from it, so that it lay like a great ship, stranded on a steep shore. Road made of the *round* pebbles close at hand, with here and there *sand* for variety—constantly up hill, & very narrow.

Waited for horses at first stage—can't tell how long. Reading—gave up looking at watch as no use. Came at last—got on again. Road a little harder—large stones lying on it in all directions—drag every quarter of an hour. At eleven o'clock we had done *two* stages, and I was beginning to think we were getting on very nicely, when without any visible or sensible cause, except a little gutter such as we had passed hundreds of, both the back irons of the dickey[1] snapped at the same instant, and George & Coutet in a condition of rapid subsidence, shouted to the postillion to stop just as we entered the village.

A nice noise there was immediately about the carriage. All the children running to see their faces in it. All the men coming to see what could be made out of it—and all the women to stare. Everybody speaking Provençal of which I could not understand a word—until Coutet swore at them in Marseillaise which sounded very repulsive indeed, until he had got an empty circle, examined the damage in peace, & sent for a smith.

The smith was stupid, & said he must "demonter la voiture". A long time was spent in trying to make him understand that two hooks would do, but he wouldn't. Coutet gave him up & went away into the town to buy cord, which when he had got, he fastened very cleverly to the remains of the irons, and then twisting with a strong stick so secured the dickey that it has served all the way here, & can be mended tomorrow properly. I took Coutet inside however, for if the cord had given way, both the other irons connected with the body of the carriage would probably have snapped too, & we should have had no end of work. George did well enough.

Well after an hour's delay, we were ready for the horses. They had just come in from the fields & had to be fed. The people were sulky at our managing with the cord, & wouldn't be hurried. At 1/4 to one, we started for our third stage of 29 Kil—with the valuable and interesting information from one of the byestanders

1 The exterior seat perched at the back of the carriage. See Ruskin's diagram in Letter 17.

that no "voiture en poste" had ever got to the end of it without breaking something.

A steep hill to begin with brought us onto the gravel again. All the sand & clay had now disappeared. Nothing was left but shingle of rolled limestone. I never saw such a wonderful country—a sea beach 200 ft deep, with barely enough soil to support a little corn here & there, one blade to every six inches of ground. 4 times we had to descend by zigzags to the very bottom of the beach where it had been cut into a chine by streams—& 4 times to reascend, the road about 8 ft wide, & in surface resembling that over the Albis. ⟨The fifth d⟩ The sides of these chines are cut full of little holes by the peasants, propped up with wood, into which they creep to keep out of the storms which occur here almost daily. The whole sky was grey & monotonous & threatening. No view. Nothing but shingle & blades of corn like rank scattered grass. I had never allowed anything to annoy me the whole journey, nor did I this. I kept on learning George Herbert—and laughing at Coutet who was fuming & fretting beside me. The monotony of the thing was a little enlivened by George's encountering & killing a small viper at the top of the last ascent. It made a very pretty spring at him, but it was too far off, & he finished it with stones.

The fifth descent at last opened the end of the vast gravel deposit which had caused us so much annoyance through three days journey. The blue jura limestone came out from under it, covered with what I thought was furze in the distance (for it looked exactly like Wimbledon common), but when we came up to it, I found it was all myrtle. This was our first harbinger of Italy. Half a mile farther, we came to a clump of ilexes, then to some stunted olives, and finally, George came up to tell me to look at "those pretty scotch firs" which were a few young stone pines.

At 1/4 past 5, we got to the end of our third stage (Three stages in 12 hours & a quarter!) and were told there were *no* horses to be had. By dint of bribery & patience (the effect of which on the minds of the byestanders was no doubt greatly enhanced by my sitting on the front trunks & making a careful study of a grove of plane trees with my sketchbook on the carriage roof for a desk), we got them at the end of an hour. Three (cheval de renfort),[1] a ragged Italian boy on the bare back of the leader, another running before to lead the leader, and all the children in the town running after and crying out & singing at the top of their voices. Vogliām montār—vogliām montār—vōḡḡliām—gliaā—gliaaāām montār. Their song

[1] On certain hilly stages the postmaster could require a carriage to take and pay for an extra horse or horses. A *cheval de renfort* was harnessed as a lead horse, centred between the off and near horses.

[30]

was interrupted by both the traces breaking as we turned the corner of the stable. They took ten minutes to mend, but we got finally off at 1/2 past 5[1] (26 K. to go to Draguignan). When we got up the hill out of the town I was a little surprised by the postillion's horse putting all his four legs together, preparatory to sliding down the other side of it—which feat after he had performed, with a constant inclination of his head to the wall and his tail to the pole, and thereby attained the level ground, he positively refused to mend his pace to anything beyond a leisurely walk, having been accustomed to go in a mill. George getting down & flogging him behind very ⟨perfectly⟩ perseveringly, and then the other horses, we succeeded (Coutet remarking that we had "trois chevaux et trois postillions") in dragging him a quarter of a mile by the collar, but as he resisted this operation very strenuously, & was a strong horse, so as to have us half a dozen times nearly into the ditch, and as the other horses were getting tired of pulling him, we gave him up, and went on with the remaining two.

Wednesday morning.

I have both your letters for this place. I am very sorry you were kept so anxious—if you look at my letter[2] again you will see I did not go by Avallon, but by *Montbard*. Now the day from Sens to Montbard is so long that I could not have put a letter in there, and I was up at 1/4 past 4 for Dijon—off at 1/2 past 5. I did not forget that my letters would be delayed as I went on, by the return distance, but I thought you would allow for this, especially as I said in each letter where the next would come from. I will write every day when I am travelling.

Bicknell's money was a guinea[3]—thank you for your account of the old Scotch lady, and for all your long letter. I will not forget either Walter's[4] gondola or Louise's[5] *something* which was to be left to my selection. What sort of beadbag do you mean—not those ugly friars?

I must make up my letter, for I have to call on Lady Hardinge & it is an heavenly day. I am off at one for Mentoni, whence I will continue my narrative, left off at the dismissal of the horse. We got here in the end comfortably & all quite well.

[1] i.e. half past six. [2] Letter 6.
[3] See Letter 6. [4] Unidentified.
[5] Louise Ellis (d. 1898), then a little girl, the younger daughter of Thomas Flower Ellis (1796–1861), lawyer and intimate friend of Macaulay. In *Praeterita*, Ruskin calls her the niece of Henry Telford, his father's business partner, but she seems actually to have been Telford's cousin; see E. L. S. Horsburgh, *Bromley, Kent, From the Earliest Times to the Present Century* (London, 1929), p. 196.

[31]

Tell my mother it is no use thinking of my mode of writing—it depends on whether I am sleepy, whether I have been angry with the postillions or the roads, or the waiters, or have a good fire or a bad, or a ricketty table or a steady one, or a long or short journey next day. I am just going to see after her acacia seeds.

I have plenty money—150 pieces here after [p]aying Coutet. I am going to Bankers to see how I can eas[ily c]arry the 50£ I don't want,[1] for I have to pay ye[t fo]r mending the carriage, & the drag, & the bill here, & though I ought after all that to have plenty to carry me to Genoa I am afraid of being thrown ⟨late⟩ out on the Sunday. And yet I ⟨know⟩ recollect Coutet has 10 napoleons,[2] so I shall get my money sent to Genoa by the bankers if I can. If there is anything forgotten, I will tell you of it in my Mentoni letter D.V. this evening.

<h2 style="text-align:center">13</h2>

Digne. Sunday, 20th April.[3]

My dearest Mother,

This morning, at 1/4 past 8, when as I imagine, you and my father were just sitting down to your luxurious breakfast in your library lighted by Turners, I was ⟨also⟩ in the middle of *my* breakfast in a little tiled room, with a wood fire crackling without any fender on the floor thereof, with a row of houses blocking up my window (instead of your pretty field), of which the one on the left in my sketch of the Jews quarter at Rome[4] is a favourable type (the hotel itself, du Petit Paris, being itself outside of precisely the same character), drinking coffee out of a Pewter cup without any saucer, and with the only small spoon in the house (which dexterously holding by the middle, I ate my egg with one end of it & stirred my coffee with the other)—with the collateral aid of a milk pot of brown porcelain, of the following graceful & Greek outline the handle being a solid projection something like a thumb, and the solid thickness of the proportion given. En revanche, the milk was hot from the cow, the coffee pure & strong, the butter fresh, the honey as white as lilies, and made from orange flowers, the tiles clean, the fire bright, and a sunshine on the plaster walls

[1] The £50 to be drawn at Nice on his letter of credit.

[2] The napoleon was a gold coin worth twenty francs, or about 16 shillings.

[3] Postmarked Digne, 21 April.

[4] Catalogue 1398. For a reproduction of this drawing of the Piazza Santa Maria del Pianto, made on 2 Dec. 1840, see *Works*, I, Plate 15. The drawing was given to the Italian nation by J. H. Whitehouse in 1932.

opposite enough to turn all the wood into marble, & all the plaster into gold.

This morning, at 1/4 past 12 or 1/2 past, when you were just in the middle of Mr Moore's[1] excellent sermon, *I* (having read the service first) was on a peak about 3200 or 3500 ft above this precious town, seeing as far as Marseilles on the one hand, and the chain of the Maritime Alps on the other. And a precious ugly view I had of it. I never saw so ugly a country as this in my life, except the Rhine—however it is well to have seen it once, & be done with it. The inhabitants too—and all the Provençals—extraordinary boors—with a language of marvellous originality—a lingual Punch—lemons from Italy, wine from Spain, sugar from nobody knows where. Many of the words are quite untraceable, at least by me, "ara", for instance, for "à present" (now)—which is Greek by the by, but only accidentally so—and "gaio" for peu (little). I heard a woman call to another just now, Aspai ma picciota (as tu vu ma petite fille), in which the aspai is I fancy a corruption of apercevoir, and the picciota is the Italian picciola. Many of the words are very grotesque & peculiar, a good many spanish, and the whole spoken with a spanish accent and sound. Coutet speaks it quite fluently, having learned it at Marseilles—which is convenient, for french is here an acquired language, and though generally, but imperfectly so. I have got into a kind of a fix here however. I find it is two pretty good days work hence to Nice, and that one must go round by Draguignan, where I shall have to sleep tomorrow night. I expected to get to Nice tomorrow, and to go by Castellane. N'importe—from Draguignan to Nice must be pretty, for it is across the Frejus mountains. I have a long letter for my father with an account of Grenoble &c., but I don't like to post it at these outlandish places lest it shouldn't go. I shall put it in D.V. on Tuesday evening at Nice, though I may be too late to get my own letters.

I have been more and more struck on rethinking and re-reading with the singular differences between Bunyan & Herbert. Bunyan humble & contrite enough, but always dwelling painfully & exclusively on the relations of the deity to his own little self—not contemplating God as the God of all the earth, nor loving him as such, nor so occupied with the consideration of his attributes as to forget himself in an extended gratitude, but always looking to his own interests & his own state—loving or fearing or doubting, just as *he* happened to fancy God was dealing with him. Herbert on the contrary, full of faith & love, regardless of himself, outpouring his affection in all circumstances & at all times, and never *fearing*,

[1] The Rev. Daniel Moore (1809–99), incumbent of Camden Church, Peckham Road, Camberwell (1844–66), and afterwards Vicar of Holy Trinity, Paddington.

though often weeping. Hear him speaking of such changes of feeling as Bunyan complains of:

"Whether I fly with angels, fall with dust,
"Thy hands made both, & I am there.
"Thy power & love, my love & trust
"Make one place everywhere.

Vide the three last lovely stanzas of "the temper"—p 48.[1] I think Bunyan's a most dangerous book, in many ways—first because to people who do not allow for his ignorance, low birth, & sinful & idle youth, the workings of his diseased mind would give a most false impression of God's dealings—secondly because it encourages in ill taught religious people, such idle, fanciful, selfish, profitless modes of employing the mind as not only bring discredit on religion generally, but give rise to all sorts of schisms, heresies, insanities and animosities—and again, because to people of a turn of mind like mine, but who have ⟨no⟩ less stability of opinion, it would at once suggest the idea of all religion being nothing more than a particular phase of indigestion coupled with a good imagination & bad conscience.

I have been out tonight talking to some of the people, who are sauntering about, as well as I can, for their French is so mixed with Provençal as not to be easily understood. They seem not unamiable, not blackguardly as at Albertville, but kept down by the poverty of a sterile country with no commerce. You cannot conceive anything so comfortless as the aspect of things. Not dirty—inside at least the houses seem exceedingly clean—but left without a vestige of repair or paint for these last hundred years—no glass in the windows—the supply of air being limited by their smallness—torn plaster for walls—loose tiles for roof—no signs of agriculture—no indian corn—no farming—no vines—no gardens—they live by shopkeeping & innkeeping. Their land does not reach an acre out of the town. They have no [r]oads almost through it. Their only mode of living is by mak[ing] clothes, utensils &c. for the country people round, and by selling them wine & so on at fair time & keeping skittle grounds on fête days. (George having torn his trowsers has bought a good strong looking pair for five francs.) The town is therefore half made up of miserable inns—Hotel du petit Paris—du Grand Paris—du Commerce—des Empereurs—des Ambassadeurs—du repos des Voyageurs, &c. &c. It is well to have seen the country. I will take good care not to come again, unless

[1] The stanza of 'The Temper' he quotes is the last one of the poem beginning 'How should I praise Thee, Lord?' The page reference fits both the second and third Pickering editions of Herbert's *The Temple* (London, 1838 and 1844).

something extraordinary happens. Love to my Father. I am very sorry not to have got sooner to Nice, but couldn't help it.

Ever my dearest Mother,
 Your most affectionate Son
 J. Ruskin.[1]

14

Mentone. Wednesday evening, 23rd [Apr.].[2]

My Dearest Father,

In the first place, will you tell my mother that I have got two packets of seeds for her, one of the only acacia in the garden, which the landlord declares has no smell, the other of a mimosa which has a most delicious one. I will take great care of them. I told him all about the double & single flowers, but he said there was only one acacia in his garden.

I got my money at Nice transferred to Genoa without any difficulty. They are excessively civil at Carlone's[3]—kept me talking a long time. I then called on Lady Hardinge, to warn her from Digne. She goes by the Col de Tende instead—a very pleasant person, only had half an hour for her, told her about Sir Walter & the baby[4]—she sent a note to ask me to dinner, but I couldn't go. Has a pretty room & pleasant view of the sea, but in the nasty modern part of the town, all chalk & fresco.

I go back to the day before yesterday,[5] of which there is not much more to tell, except that it grew dark as soon as we had sent back our third horse, & I shut up the carriage. Soon however we began to go rapidly down, & it grew warmer & warmer still as the evening wind dropped into the night, & I was obliged to open first one pane, then others, then all, and finally to throw the carriage back & open, just as the moon rose above the olive woods of Draguignan. The road was now hard and good—the olives, mixed with stone pine, threw their twisted shadows across it, and the ruined towers of an old fortress & town, 4 miles on the[6] ⟨side⟩ north of

[1] A postscript seems to have been cut off here at a later date, probably by John James Ruskin.

[2] Postmarked Mentone, 24 April. Received 1 May.

[3] E. Carlone et Cie., Glyn's correspondent at Nice. The transfer was of the £50 to be drawn on his letter of credit.

[4] Sir Walter Charles James (1816–93), created Baron Northbourne in 1884, was then M.P. for Hull. For a record of Ruskin's friendship with him, see *Diaries*, I. 211, 242, 253. He was Lady Hardinge's son by her first marriage and the baby was his daughter, Sarah, born 22 Feb. 1844. Lady Hardinge, about to return to Geneva, had been staying at Nice since late 1844, when illness interrupted her journey to join her husband in India.

[5] See Letter 12, p. 31. [6] Altered from 'this'.

Draguignan, began to rise against the moony sky, now soft & deep and full of Italian air. The last four miles were perfectly exquisite— all the light so clear & calm, and the white clouds so soft & warm— the frogs croaking merrily and loud, and a bird, I cannot tell what it is, that shrieks & wails all the night long, heard far off among the olives. We got into Draguignan at last, about 10 o'clock, and a couple of fried trout, followed by some sweetbread and asparagus, terminated very agreeably the hardest days travelling I recollect, putting bad roads, &c. all together. I don't know what I should have done without Coutet, not being able to understand a word the people said, but he was hail fellow with them all. They took him for a Marseillaise.

The next morning nobody knew, of course, anything about the road to Nice. They said they thought it would be best to go the two stages to Frejus, & then take the Esterelle—and so did I, for I was sick of roads I didn't know. I started at 6, expecting a sevenish day, but we ran the two stages to Frejus in no time, and glad was I when at 1/2 past 10 we came down on the blue water, with the cypresses cutting its clear horizon, & the lovely mountains of the Esterelle bright in the morning sun. And the next stage. You know what it was in the autumn—imagine it in spring. All the meadows about Frejus were white with large arums, with golden centres, mixed with a lovely flower like a dog rose, but growing on a low shrub, with a scent of the orange—I think it must be a sort of gem cistus—and another & larger variety of it of a rich purple was growing all through the copses, making them look like gardens of rhododendron. Then the laurustinus, full of bloom, and the most exquisite smell, arbutus (but not now in flower), & hundreds more— and above all, *cork* trees in quantities, which I don't remember noticing before. Down we came to Cagnes, and so all along the blue bay of Antibes—just before entering Nice we came on the first orchard full of orange trees in full fruitage, to George's entire electrification. I jumped up as soon as I saw them—he was half asleep when I called to him, but woke up. I only wish you had seen the mouth he made, worth half a pantomime.

I was very much puzzled at Nice whether to take a vetturino, or post it here. A vetturino with excellent credentials offered to take me to Genoa by Saturday evening—for 120 fr. and his buona mano.[1] I hesitated a long time, for it will cost me nearly 200 fr. posting, and all the bother of postillions besides. On the other hand, with the vetturino I should have had to sleep at *St Remo*, which you recollect, & Finale, which I knew nothing of. I was afraid I might catch a fever if I slept at such places, and finding also that he could not leave

[1] The gratuity paid a *vetturino* on his fulfilling his contract, commonly three or four francs per day. See also Letter 4, p. 7, note 1.

Nice till tomorrow, I gave it up—& here I am, in the middle of air which smells just like that out of the fruiterers in Thames street. The Corniche above Nice and Monaco is far finer than I thought, but then I saw it today in lovely weather, from a carriage perfectly open—cliffs & sea & sky seen at once. It is very superb, and the entrance here among the indian figs and heavy laden lemon trees, with crowds of peasantry coming home with their orange baskets full of yellow fruit & glittering leaves upon their heads, & the intense, purple sea are more to me than I could have conceived. What a change there is in me since I was here last[1]—then weak & weary & sick at heart & feeble in sight—now neither sun nor wind nor mountain air too much for me. I was sauntering about at Nice as carelessly in the sun as in the shade. I could sit in the open carriage at the top of the pass with no greatcoat and run out here for a walk before dinner without a moment's rest. I propose sleeping tomorrow at Oneglia, then Savona, then Genoa. I cannot I fear write every day, for the letters here must be paid to the frontier, and the post offices never open till 8. Tomorrow I should have stopped here till 8 at any rate, to have a morning walk among the oranges, but I shall have to leave Oneglia early for Savona, & so cannot write till I reach Savona. So with Montbard—look what a long day it is from Montbard to Sens[2] & then consider that I was off at 1/2 past five for Dijon to see if you wished my route changed, & you see I could not possibly write from Montbard. Nor do I understand why the gap should have been so long. I didn't write at Beauvais, & I was too late for the Paris post, from Beauvais to Paris is quite as far as from Mont Bard to Dijon—and I was into Dijon at 1/2 past one or one, I forget which. There was certainly no reason for my expecting [a] greater interval to take place in one case than in the [other].

The sea gets loud tonight, but the air is exquisitely warm on the Terrace outside my window. By the bye, don't think I am going to travel any more at night. In these two cases it was only my not knowing the roads that occasioned it. I will take good care not to do so in Italy.

<div align="center">

Ever my dearest Father,

Your most affectionate Son

J Ruskin (Pen all hairs,

bottom of inkstand).[3]

</div>

[1] The family's tour of Sept. 1840 to June 1841 was taken chiefly because of Ruskin's bad health. They were in Nice from 23 to 25 Oct. 1840 and went to Mentone on 26 Oct.

[2] i.e. from Sens to Montbard. Ruskin continues his explanation, begun Wednesday morning in Letter 12, of the delay of Letter 6, comparing it to the delay of Letter 4. The reason for the 'gap' seems to be that while Letter 4 was posted two days after Letter 3, Letter 6 was posted three days after Letter 5.

[3] Accounting for the smudgy signature.

Oneglia. Thursday evening [24 Apr.].[1]

My Dearest Father,

It is late tonight, for I have been working up a hurried sketch taken at St Remo, of a beautiful bit of palace & two splendid palm trees growing in the street, almost unique. Can't write a letter for I want to be off early in case of getting a subject at Albenga or any of the pretty places between this & Savona. Delicious travelling, not a bit too hot with the carriage open, road better, all but the bad hill at Ventimiglia. Countenances perfectly magnificent—very ugly often, but always grand and full of character. What fools our artists are, to be able to do nothing better, with such noble studies lying on every step, than their contemptible vendemmias and tarantulas with every gown clean and every coat whole. What a glorious thing is dirt—it tones colour down so—and yet our idiots of painters sketch in Italy as if they were studying models and dolls fresh washed in the Soho bazaar. Everybody idle & begging, except the women—some of these building houses & carrying bricks, others spinning, others gambling on the church steps for centimes, but none with their hands before them like the men. I will post another note the instant I reach Genoa.

Ever your most affectionate Son
J Ruskin.

Savona. Friday evening [25 Apr.].

My Dearest Father,

I cannot conceive why we took so long a time to get here, even allowing for bad weather and voiturinism. I started at 6 o'clock precisely this morning, & got to Albenga by 10. There I stopped three hours, desperately hard at work, but I have got what I think a most valuable drawing[2]—characteristic & very picturesque. I wish I could send it straight home with the letter. I was off again at one, and here by 1/4 past 5, posted your letter myself, ran out

[1] Postmarked Savona, 26 April. Received 5 May.
[2] Catalogue 51. In the Epilogue to the 1883 edition of *Modern Painters II*, Ruskin refers to the drawing as lost. See *Works*, IV. 346.

to look at the harbour, sat on the beach till 7, and now, 8 o'clock, have just finished my anchovy dinner. What a queer way they have of bringing things up. I never countermand anything, that I may see what they do. So today they brought me first rice soup and Parmesan cheese. Then anchovies, and mutton chops, the latter looking like fried apples—no vegetables. These being taken away, and plate changed, came green pease, like hotch potch. Finally a soufflée. At the tables d'hote it is a great bore, to see all the most delicious vegetables served after one's dinner.

I have had the most glorious weather today, and I can tell you that you saw the whole corniche line from Mentoni to Albenga to very great advantage. There are no high mountains, & the greater part of the rocks are gravelly & dry, and not of fine form. All the marbles are in this weather grey with dust and indistinguishable; whereas, by the rain, their colours are perfectly brought out. On the whole I was much disappointed with all after Mentone, until I got to Albenga, but there the valley runs up between very noble mountains, now covered with snow, and the coast road afterwards is delicious—the precipices & galleries very grand indeed, & the water more like an imagination than a fact. Still, it was grander in most respects, in the storm, until a point about six miles before we got here, where sweeping out of a Gondo like gallery, you open the whole gulph of Genoa, with its grand hills, as far as Sestri—Savona in the near bay—Genoa glittering on the opposite side of the gulph. The same view of Genoa is commanded from the port here, and I sat watching it, and, what I had never seen before, shoals of dolphins[1] of large size bounding along the quiet swells of the sea. It gave me some new ideas altogether.

<div align="center">Genoa. Saturday afternoon.</div>

I have all the three letters. I am much grieved at the letters not having gone from Annecy, but these will be the only ones lost. George it seems found the office shut, and having orders always to ask if the letters wanted payment, he came back to the Hotel, & asked *there*, when of course they said no, & he put the letter into the box. It was as much my fault as his, for I should have recollected Chamonix. Very luckily we happened to be too late for post at Albertville except by paying, so that you must have received that letter, and afterwards we were in France. All the Nice letters and to here, were properly paid. There is therefore no letter lost but

[1] John James Ruskin crossed out 'dolphins' and inserted 'Porpoises'. A line drawn through 'dolphins' in Letter 21 is no doubt also his.

one I wrote to my mother from Annecy,[1] full of abuse of John Bunyan, which is no great loss. I will write daily & post letters as often as possible myself.

Got here quite comfortably—no heat, just air that one likes to sit out in, and not to walk up hills in. A heavenly place it is. Not so the road here from Savona. The Storm was the making of it, in scenery. Very dull in fine weather.

<div style="text-align: right">

Ever my dearest Father,
Your most affee Son
J Ruskin.

</div>

Why do you plague yourselves so? You know if anything were the matter, good care would be taken that letters should go, that when you don't hear all must be right.

I can't write *tomorrow*—Sunday the office is shut. I have got Eastnor all right.[2]

<div style="text-align: center">

17

</div>

<div style="text-align: right">

Genoa. Sunday [27 Apr.].[3]

</div>

My Dearest Father,

I don't understand the way the letters have gone at all—your letter of complaint is dated Saturday, *19*th April, and it seems written with same pen throughout, and yet it says—here we are from Thursday to *Monday* without a line—do you mean that you ⟨can't⟩ couldn't then get a letter *till* Monday?—or was it written on upon the Monday, and did you get no letter then? My paid letter should have left Albertville at 6 o'clock on Wednesday morning, the 18th,[4] and you should have got it by Monday unless the cross posts cause loss of time, & then it might be till Tuesday. I posted a letter at Grenoble myself, on Thursday afternoon, which ought to have reached you on Tuesday.[5] You do not mention any letter from

[1] The two letters referred to are Letter 10, written at Annecy, but posted at Albertville, and Letter 9, to his mother. From France to England letters could be sent payable by the recipient; from Italy they had to be paid to the French frontier. In a letter of 22 Apr., Margaret Ruskin informed her husband that she had received notice 'that a letter was lying at Annecy which would be forwarded if 3*d*. were paid' (Ruskin Galleries, Bem. L 1). The letter was received on 5 May.

[2] His father's letter of 14 Apr. enclosed a letter from Lord Eastnor. See Letter 41 and Letter 1, p. 2, note 4.

[3] Postmarked Genoa, 28 April. Received 5 May.

[4] i.e. the 16th.

[5] Letter 11.

Champagnole. I think I wrote from there. You ought to get a letter from

Champagnole, posted on the 10th April[1]
Geneva	12th
Annecy, to my mother,	14th
Albertville,	15th
Grenoble,	17th
Digne, to my mother,	20th
Nice	23rd
Mentoni,	23 ⟨24th⟩
Savona,	25th ⟨26th⟩
Genoa,	26 ⟨27⟩th.

I am sorry I did not post letters at Gap & Draguignan, but as I had then only got your Geneva letter, in which no complaint about letters was made, and in which you had allowed very quietly for the Paris blank, I had no idea of the state you were in—and as I got into both places at 10 o'clock at night, after tremendous days, & was engaged also at Gap in getting a drag mended, and at Draguignan in consulting about broken dicky, I had no time to prepare letters, unless I had known them to be of consequence.

We got the dicky well mended at Geneva[2] for 12 francs. ⟨Coutet made them⟩ The parts broken were two bolts which fastened it to a piece of iron ab., which is connected with the spring, bc. The iron

which fastens to the body of the carriage (d) had not broken—only bent a little—so that the dicky had sunk back into the position indicated by the dotted line. Coutet made them fasten a strong iron bar from the iron a., passing under the dicky, to the same iron on the other side. They have hooked one bar over the other, so that no bolts are now used, and the dicky cannot possibly sink unless the bar ab. gives way. They say they sit much more comfortably than they did before. The iron bolts that broke were very bad & full of flaws.

We are put to great inconvenience by Mr Hop's[3] not giving us

[1] Letter 7, posted 11 Apr. The Digne letter, Letter 13, was posted 21 Apr. The Mentone, Savona, and Genoa letters, Letters 14–16, were posted 24, 26, and 27 Apr. respectively.

[2] A slip. It was mended at Nice; see Letter 12, p. 32.

[3] W. Hopkinson, the carriage maker in Long Acre from whom Ruskin had hired the calèche.

two drags,[1] for of course if the bottom happens to wear off in the middle of a journey, we have to use the drag itself, and as one cannot put on two bottoms one over another, this is constantly happening until the drag gets thin, & then the wings break. I paid 8 francs for a bottom at Nice—the wing broke on the hill above Mentone. I had to walk all down the hill, and pay 20 fr. for a new drag at Mentone. This new drag has a capital bottom, but I cannot tell how much of it will go on the Borghetto, & it is sure to wear off at some place where we shall have to use the drag itself a little while. I would get a spare drag, but then I should have a chain to make too, & I fancy the expense will be much about the same. I always put the hook on, so there is no *danger*, and I shall have no dragging roads after the Borghetto, until I pass the Alps again—which I propose doing by the Mont Genevre. I shall go up the Val d'Aoste, and part with Coutet at Cormayeur, then as there is no carriage road over the little St Bernard I must go back to Ivree—then to Turin, and in order to see the Genevre pass, I shall take that instead of the Mont Cenis, and so get the drawing that I want of Grenoble—then coming straight by Lyons & Bourges to Paris.

At Cormayeur I shall of course walk over to Chamonix by the Col de Bon Homme, and back to Cormayeur by the Col de Ferret. I must have Coutet back over the latter pass, & shall leave him to return from Cormayeur. All my mountain drawings I purpose making in the lateral vallies that run from the val d'Aoste up to the central chain of the Alps—Mont Velan—Cervin—Matterhorn, &c, & at Macugnaga (Mont Rose). Next year, when I have done my book,[2] we will all go together D.V. and have a rambling tour everywhere again.

I had such a desperate disappointment this morning. Went to hear a military mass. Band up to the *door*. Soldiers came in like a set of charity schoolboys, with no *muskets*, all at sixes & sevens. Twenty minutes of manoeuvring at altar. No music. Nothing heard but spitting. Walked out again same way, mixed with a rabble of crowd. Music forbidden for these two years past throughout Sardinia.[3] Every time one goes anywhere, one finds something

[1] A drag, the iron shoe placed under the near hind wheel to slow the carriage when descending hills, had wings or sides to keep it from slipping off; its bottom was a light plate welded or bolted to the shoe; and the whole was attached to the centre of the front axle by a strong chain. For further security, a large hook, attached to the front axle by another chain, was hooked round the rim of the wheel.

[2] *Modern Painters II.*

[3] The music forbidden was the playing of the band during the mass. See his diary entry for 25 Oct. 1840 on a similar mass in Nice: 'Military mass in St Francesco . . . strangely impressive. About the finest piece of music I ever heard adapted to brass instruments' (*Diaries*, I. 96).

altered for the worse, never for the better. They have spoiled the effect of some of the old houses on the quay too.

The Knife belonged to the Bond St Turnerman, Halkett,[1] or whatever his name is. Perhaps you might as well call & tell Turner I am inquiring after my book.

I heard such a desperate sermon at the English chapel today, and missed a beautiful mass for it and put myself in a bad temper for all day. Wet weather. Quite well. No heat. I am writing however at 1/2 past 9 at night with my window wide open beside me, the candles not stirring. They put the kettle and fire outside to keep warm, at tea time.

It is a divine place this. I feel [it ver]y much now. I only wish I could draw the faces.

How in the world they manage to keep their veils *snow* white in the dirty & narrow streets I can't conceive.

18

Genoa. Sunday [27 Apr.].

My dearest Father,

I forgot to say that I saw a fine instance of passion in the market on Saturday. One woman had lost her bench, and suspecting one of her neighbours of having stolen it, sent a police officer to her house. The officer searched & found it not. I luckily came into the market just as the insulted lady had begun her recrimination. She had reached the top of her voice however, even then, & went on without pausing for a second, with inconceivable volubility—rising every now & then almost to a scream—advancing to her antagonist and pulling her *own* hair with all her might—in her face—flinging up her arms to the sky as she retired—gasping for breath—but never stopping—for full ten minutes—the foam flying from her mouth so that one was obliged to keep to windward—the whole action very grand & dramatic. At last the voice cracked & gave way, but she instantly took the falsetto, & went on with that—but it cracked & cracked again—till at last she choked in a husky shriek—and after making several vain efforts to articulate—fell back like a person dying from suffocation into her chair, & burst into tears. It was a fine thing to see, for once. Her opponent sat all the while with her arms folded—looking at her, but not answering a word.

[1] Francis Halsted (1807?–79), printseller and bookseller, 108 New Bond Street. He sold the *Liber Studiorum* and other engravings of Turner's works.

[43]

3

I must post this here tomorrow,[1] for I have not found anything to keep me here, and I want all the time I have to spare for Pisa & Lucca. I have been in palaces all day.[2] Half the pictures copies—others bad—others injured or destroyed—others shut up. But I have seen *one* picture well worth coming here for,[3] & a bas relief of M. Angelo,[4] worth coming here twice for—& the cathedral is most interesting. I have got my money,[5] & hope to start at eleven tomorrow for Sestri. I am going at 1/2 past 6 to the gardens of the Palazzo Doria—which are as lovely as they are neglected & decayed —and I have a set of notes [to] write out fair before I go to bed, so I cannot write any more tonight. Love to my mother. I shall ask for letters again at post office before I go, and hope to find one saying you have got mine from Albertville. Write after this to Florence.

<div style="text-align:center">Ever my dearest,
Your most affectionate Son
J Ruskin.</div>

I have had such glorious music tonight—60 candles at high altar. Whole congregation joining.

<div style="text-align:center">

19

</div>

<div style="text-align:right">Sestri. Tuesday evening, 29th April.</div>

My Dearest Father,

I have still got notes to write, so that I cannot write a long letter. I have not in[qu]ired whether there be a post office here, but there must be something of the kind. I purpose, if it be fine, to stay here all tomorrow to make studies of stone pine. Next day I shall try to get to Spezia or Sarzana—if by rising early I could reach Massa, I

[1] Postmarked Genoa, 29 April. Received 6 May; answered.

[2] In one of the notebooks he kept on the tour (Bem. MS. 5A) Ruskin describes paintings in the Palazzo Durazzo, the Palazzo Brignole (Rosso), and the Palazzo Pallavicini. He also mentions 'another palace near this Durazzo' where 'there was a beautiful little picture given to A. Mantegna: Madonna, child, & angel'. For excerpts from his notes on the paintings, see *Works*, XI. 237–9.

[3] Probably Paolo Veronese's *Judith* in the Palazzo Brignole (Rosso), which he calls in his notebook 'a very grand picture'.

[4] A medallion of the Madonna clasping her dead Son, in the chapel of the Albergo dei Poveri. The attribution to Michelangelo is disputed. Ruskin sketched the medallion in his notebook (Bem. MS. 5A; the sketch is reproduced in *Diaries*, I, Plate 15) and refers to it twice in *Modern Painters II* (*Works*, IV. 138, 285).

[5] The £50 on his letter of credit transferred from Nice to Genoa; see Letter 14.

shall do so, & stop and draw thereabouts, getting always to Lucca for Sunday. How long I may stop there I cannot tell—there is so much of Fra Bartolomeo.

I had such a delicious half hour in the Doria gardens this morning—intense light & blue of sun & sea—the whole port and city seen over marble terraces & through black cypresses & groves of ilex—but all so neglected. The family *never* stay there—always at Rome or Paris—& the poor gardener seemed quite happy at having anybody to look at his cut hedges, for even strangers go not there now. My valet de place[1] wanted to keep me away, but I was determined to see the gardens at least. The palace is shut up, & full of lumber.

On the whole, you saw the corniche to very great advantage by seeing it in storm. The approach to Genoa by Savona side is ugly and arid in a high degree—all the rocks without colour—the road dusty—the [hou]ses slated—formal and Hammersmith like—the two villas which we thought so much of were so grown over with grass I could hardly see them. It is curious too how one may go on making false statements without intending it. There is not a single bridge over any torrent on the whole road, except the last which kept us so long just as we were getting into Genoa. The bridges had not been carried away—we went by the regular road—only we had more difficulty than usual, owing to the swelling of the torrents.

On the other hand, the road here from Genoa is exquisite beyond measure, and we formed no idea of it whatever in the bad weather. All the air scented. Nothing but oranges & lemons, vines, fig trees, cypresses, and blue water, in the most glorious softness of combination—and heavenly day—and gorgeous sunset.

Very comfortable here, and perfectly well.

Ever my dearest Father
Your most affee
J Ruskin.

20

Sestri. Wednesday evening [30 Apr.].
My Dearest Father,

I have got a glorious birth here, and must stop tomorrow too—couldn't go away on any account. Such a lovely place you never saw—though the rainbow effect you had on it was fine—yet the

[1] A local guide.

[45]

motion today of the flaky, silver edged, interlaced white clouds through the stone pines as they rose against the blue, and the heavenly sunset—mountain beyond mountain in a blaze of gold—were finer still, and I have such capital rooms, for nobody stops here now, almost. a. and b. are two rooms fronting the sea beach, e. and f. being windows commanding the whole sweep of the bay towards Genoa, and g. a window looking out on the rock promontory & its pines. c. is a double bedded room in which George & Coutet sleep, so that no one can come into my room but through theirs. h. is a bright little breakfast room with two windows looking out, over a garden full of orange trees, all up the Borghetto pass—with villas & cypresses and Apennines, which are the first to catch the morning sun. So that from h. I see the sunrise, & from e. the sunset.

The people who kept the inn when we passed,[1] are dead, and the inn is kept for their daughter—who I believe is only 14—by an old Genoese, who fought at Borodino and the Beresina, and is full of stories of Napoleon—and it is a charity to stop here, for there is no post house here now, & everybody goes on to Braco, and sleeps at Chiavari & Spezia. I can get horses however whenever I like, to take me to the first relais. I shall not get to Lucca by Sunday—must stop at Massa, lovely place.

I have been working all day like a horse, and have got a most valuable study of stone pine[2]—rock to sit on—under the shade of an ilex—no wind—air all that's right—just as hot as it can be to admit of one's doing anything—and never uncomfortably so. No chills in the evening. Air all scented by the pines & wild flowers—and the birds singing so loud you can hardly hear the sea. They are singing all about the village too, in honour of coming May—in circles—with flowers on their heads, & their arms about each other's necks—you may see the attitude in Raphael's Joseph relating his dreams, in my large book upstairs.[3] Love to my Mother.

Ever my dearest Father,
Your most affectionate Son,
J Ruskin.

[1] 4 Nov. 1840. The inn was the Hôtel Royal.
[2] Catalogue 1592. The drawing is in the Ashmolean Museum, Oxford, and is reproduced in *Diaries*, I, Plate 24 and in *Works*, IV, Plate 12.
[3] The picture is one of the fifty-two frescoes on scriptural subjects in the Logge of the Vatican known collectively as Raphael's Bible. The book is *Les Loges de Raphael*, engravings of the frescoes by J. C. de Meulemeestre.

Sestri. Thursday Evening, 1st May.[1]

My Dearest Father,

You will be wondering why you had no letter yesterday, but the post office was strictly shut all day—they are very pious here—when I sent George for some fresh water at 6 this morning he came back "here's a pretty go, sir—they've locked up the well and all gone to Mass!" I sent him to the river for some. It is Ascension day, and the artillery at Genoa has been rolling all day like thunder—the sound of the church bells all over the hills coming through the branches of the pines as I sat drawing—not a breath of air—and cloudless sky. I have got a beautiful study, and leave tomorrow morning for Spezia. I never left any place with so much regret on so short an acquaintance, since Low wood Inn.[2]

They wear the Genoese white veil here, and you would have been surprised at the beautiful effect of the[ir] l[i]ttle village church, when it was full. They are finely [feature]d too. I saw one very lovely girl today. They are a superb nation take them all in all. I would give the world to be able to draw figures—not a group in Genoa but would have made a perfect & grand study.

Everything suits me here; the sea beats the Rhone hollow for *beauty* of colour. There is a lividness about the Rhone, but this sea is the richest, deepest, purple blue—and in the caverns among the rocks at the foot of the promontory it is like enchanted water. I never saw sea urchins alive till today. George caught three—one red, one brown, and one of the purest geranium purple. I kept them walking about for half an hour in a basin, & put them back into the sea. All sorts of fish for dinner—turbot, mullet, sardines, anchovy, and others that I never saw—and the dolphins playing again this evening in the sunset. Love to my mother.

Ever my dearest Father,
Your most affectionate Son
J Ruskin.

[1] Postmarked Sestri Levante. Received 10 May.

[2] At Lowwood, Windermere. The Ruskins were there during a tour of the Lake District in the summer of 1830, a stay celebrated in Ruskin's childhood account of the tour, *Iteriad* (*Works*, II. 288–9).

La Spezzia. 2nd May.

My Dearest Father,

I posted a letter for you this morning at Sestri, and left my pretty rooms to pass the Bocchetta at 8 in the morning. I got here before 4. Everything, down to the little inn at Borghetto, looks much as it did five years ago,[1] only we missed, in the cloudy weather, a very glorious view of the Carrara mountains, and the Apennines in the duchy of Parma, from the top of the pass—and we were too late, I think, to see the very lovely view of the gulf of Spezzia as you come down the hill above it. It is interesting from the way it has always been admired by ancients as well as moderns—and from Byron's sojourn there—and Shelley's death. But I prefer infinitely, in every respect, the bay of Chiav[ari]. The hills are steeper here, but they are more like the [h]eavy forms about Plymouth—all the grace & varie[ty] of the Sestri hills is wanting, neither is the sea so pure, the coast is more sandy & weedy, neither have you the lovely ran[ge] of the maritime Alps to show their peaks against the west sky. I purpose posting this tomorrow at *Sarzana*. I intend to go on to Massa, but may be too late for post there—you will see by the Sarzana mark that I have got all right over the Magra.[2]

I am not suffering in the least from heat—it is just what I like, air that never feels *chill* and that, if you heat yourself in any way, never plays tricks nor changes suddenly, but is soft and safe by night & day. One never feels draughts.

Ever my dearest,
Your most affectionate Son
J Ruskin.

[1] 5 Nov. 1840.
[2] Postmarked Sarzana, 3 May. Received and answered 12 May. Five years earlier, the Magra, just before Sarzana, had been in flood, could not be forded, and the Ruskins had crossed by 'a nasty awkward ferry' (*Diaries*, I. 105; cf. *Praeterita*, *Works*, XXXV. 266–7).

<div align="right">Lucca. Saturday evening, May 3rd.[1]</div>

My Dearest Father,

I sent out in a hurry to the post office on my arrival here, in hopes that I might have a notice of your having received my Albertville & Grenoble letters,[2] but I find only the duplicate of the Genoa one—this keeps me a little anxious, for fear my mother should have got a notice from Annecy of my detained letter, and tormented herself ill or something—however it is no use fidgetting myself as well as you.

I am in glorious quiet quarters in this capital house,[3] and at last settled to something like rest. I pushed on here today, not because I found little at Massa & Carrara, but because I found *too much*. I can't recollect when we were there before, visiting the *church* at Carrara[4]—at any rate, it is a perfect gem of Italian gothic, covered with 12th century sculpture of the most glorious richness and interest, and containing two early statues of the Madonna, which gave me exceeding pleasure—besides Roman sculptures innumerable built into walls & altars. At Sarzana, or near it, there is a wonderful fortress of the Visconti,[5] full of subject, there are castles on every peak round the Magra valley, the church at Sarzana is most interesting, and the mountain scenery so exquisite about Carrara that I saw at once if I began stopping at all, I might stop all May. So I broke through all, with many vows of return, and here I am, among the Fra Bartolomeos, with every conceivable object of interest or beauty close at hand, delicious air, and everything as I would have it (except that the Marble front has fallen off one of the tombs of San Romano since I was here[6]). When I shall get away I cannot tell. I shall go first to Pisa, & then by *Pistoja* to Florence. Pistoja is an important town, and far better for sleeping at than Empolin.

[1] Postmarked Lucca, 4 May. Received 13 May.

[2] Letters 10 and 11. The Genoa one is a letter his father had sent him to Genoa, presumably the letter of 19 Apr. (see Letter 17). For the detained letter, see Letter 16, p. 40, note 1.

[3] In *Works*, XXXVI. 43, note 2 the hotel is identified as the Albergo dell' Universo because Ruskin stayed there in 1882. But it is more likely to have been one of the hotels listed in Murray's *Handbook for Travellers in Northern Italy* (London, 1842): the Croce di Malta, the Gran Bretagna, or the Albergo dell' Europa (though the last is called 'good, but dear'). In the 1847 edition, the Europa is no longer called dear, the Pellicano is added, and the Croce di Malta is called 'very good'.

[4] The church of S. Andrea. See Ruskin's note on it, contributed to the 1847 edition of Murray's *Northern Italy* (*Works*, XXXVIII. 326). The family passed through Carrara on 6 Nov. 1840.

[5] The fortress of Sarzanello, a 30 minute walk N.E. of Sarzana.

[6] 7 and 8 Nov. 1840.

You cannot conceive what *divine* country this is just now. The vines with their young leaves hang as if they were of thin beaten gold—everywhere—the bright green of the young corn sets off the grey purple of the olive hills, and the spring *skies* have been every one backgrounds of Fra Angelico. Such softness I never saw before. The air too is most healthy—one can do anything. I walked up to the Carrara quarries today at eleven o'clock—in cloudless sunshine—it was warm, certainly, but I did not feel the least oppressed—and yet I have been sitting out in front of the cathedral, watching the sunset sky & the groups of people, till it was all but pitch dark, without the slightest sensation of even *cool*ness.

It was lucky I came on here today, for this happens to be one of the only two days in the year on which the "Volto Santo di Lucca" is shown. It is an image of Christ, as large as life, cut in wood, and *certainly* brought here before the year 700.[1] Our William Rufus used to swear by it, "per volto di Luca," or per vultum Lucae. The body is dressed in paltry gold tissue, which has a curious effect ⟨as⟩ on a crucifix, but the countenance, as far as I could see it, by the candlelight, is exceedingly fine.

The people here are very graceful & interesting. Black & white veils beautifully thrown over the braided hair, and the walk, as well as the figure, and neck, far finer than at Genoa. To make amends, & balance a little on the other side, the postillions, dog-aniers, and country people, appear knaves of the first & most rapacious water. Never content, get what they will—always sulky—fifty people at a time holding out their hands to the carriage. Custom houses every five miles—one for passports, another for searching luggage, and all asking barefacedly & determinedly for money. I would give ten times the sum, willingly, to see something like self respect and dignity in the people, but it is one system of purloining & beggary from beginning to end, and they have not even the appearance of gratitude to make one's giving brotherly—they visibly & evidently look on you as an automaton on wheels out of which they are to squeeze as much as they can, without a single kindly feeling in return. I gave up the postillion payment to Coutet at Digne, finding it bothered me to death, & I am well out of it. Coutet has fights of a quarter of an hour at every stage, hereabouts—they end with *him*, in his giving half a paul too little, with *me* they would end in giving a paul[2] too much.

There was hardly any water in the Magra.

[1] It is kept in its shrine in the Cathedral and shown on 3 May and 14 Sept., the Festivals of the Holy Cross. Reputed to have been carved by Nicodemus and the face finished by an angel, it is probably a work of the twelfth century.

[2] Paolo, a Tuscan coin worth a bit over fivepence.

What in the wide world I am to do in—or out of—this blessed Italy I cannot tell. I have discovered enough in an hour's ramble after mass, to keep me at work for a twelvemonth. Such a church[1]— so old—680 probably—Lombard—all glorious dark arches & columns—covered with holy frescoes—and gemmed gold pictures on blue grounds. I don't know when I shall get away, and all the church fronts charged with heavenly sculpture and inlaid with whole histories in marble—only half of them have been destroyed by the Godless, soulless, devil hearted and ⟨sap⟩ brutebrained barbarians of French—and the people here seem bad enough for anything too, talking all church time & idling all day—one sees nothing but subjects for lamentation, wrecks of lovely things destroyed, remains of them unrespected, *all* going to decay, nothing rising but ugliness & meanness, nothing done or conceived by man but evil, irremediable, self multiplying, all swallowing evil, vice and folly everywhere, idleness and inf[ideli]ty, & filth, and misery, and desecration, dissipated youth & wicked manhood & withered, sickly, hopeless age. I don't know what I shall do.

One thing I must do, & that is get a permission de sejour, and then get leave from the monks to take tracings of these frescoes of Aspertini's,[2] for *they* are chipping off and fading away, and I have no doubt will be scraped off or whitewashed over when I come back again. I must have a study of this Lombard church too;[3] and then I must get some details of the church columns all over the town. You may send me some letters to Pisa, for I shall have to come back there even if I go to Florence, for a great fete at the end of this month. And yet perhaps it will be safer to keep on writing to Florence. How long do letters take?[4] I shall *certainly* not be able to leave Pisa till the 21st or 22nd, for I have to take tracings in the Campo Santo (if they'll let me). Dearest love to my mother.

Ever your most affectionate Son
J Ruskin.

[1] San Frediano. It was rebuilt during the first half of the twelfth century.

[2] Amico Aspertini (1475–1552). His frescoes are in San Frediano.

[3] His drawing of the interior of San Frediano, now in the Manchester City Art Gallery, is reproduced in *Diaries*, I, Plate 21. Catalogue 1044.

[4] The postmarks and John James Ruskin's notations of the receipt of the letters show that between Tuscany and London letters generally took nine or ten days.

Lucca. Monday, 5th May.[1]

My Dearest Father,

It is a woeful thing to take interest in anything that man has done. Such sorrow as I have had this morning in examining the marble work on the fronts of the churches. Eaten away by the salt winds from the sea, splintered by frost getting under the mosaics, rent open by the roots of weeds (never ⟨taken⟩ cleared away), fallen down from the rusting of the iron bolts that hold them, cut open to make room for brick vaultings and modern chapels, plastered over in restorations, fired at by the French, nothing but wrecks remaining—& those wrecks—*so* beautiful. The Roman amphitheatre built over into a circular fishmarket. The palace of Paul Guinigi turned into shops & warehouses. I shall have to go back to M[onte] Rosa, I think, or I shall get to hate the human species, [of] our days, worse than any Timon. Quite well, but no time to write a long letter today. I want all the light I can get.

> Ever your most affecte. Son
> J Ruskin.

<center>25</center>

Lucca. Tuesday [6 May].[2]

My Dearest Father,

You cannot at all conceive how comfortable I am in this excellent house, and lovely city. It is the best and cheapest hotel I have been in since leaving London. In the first place, I have a large two windowed bedroom, and a saloon, which is 10 by eleven of my paces (say two feet and 1/2 each), with a large grand piano, two wooden, and one marble, tables, silk covered arm chairs & sofa, marble vase, &c, together with George's and Coutet's rooms, for 8 fr a day. My breakfast is 1 1/2 (always two at other places), my dinner—of fish, two dishes of meat and one of poultry, potatoes, green pease, & artichokes or spinach or asparagus, & rice pudding—for *3* fr. I never have been charged less than four in the worst inns, if I had only a chop—my flask of Aleatico,[3] which I have, first because I like it very much, secondly because I conceive it is *very* good for keeping off Malaria, &c, and t[hirdly] for the good of the house, costs me two [fr.] more, and my tea one (always one & a half elsewhere), so that with two fr for servants, I stand, with every

[1] Postmarked Lucca, 5 May. Received 14 May.

[2] Postmarked Lucca, 6 May. Received 15 May.

[3] See *Praeterita*: 'A sweet, yet rather astringent, red, rich for Italian, wine—provincial, and with lovely basket-work round the bottle' (*Works*, XXXV. 356).

conceivable luxury & convenience, at 17 1/2 fr. per day, George's and Coutet's lodging included (I only give Coutet 4 fr. a day here, like George). I only wish the house were at Florence instead of Lucca —it is as clean as our own, & the rooms are away from the street looking into a garden full of oranges, oleanders & acacias. How I spend my day I will tell you tomorrow, for I have not time this morning to enter into description of details. Love to my mother.

<div align="right">

Ever my dearest Father
Your most affecte Son,
J Ruskin.

</div>

26

<div align="right">

Lucca. Tuesday evening [6 May].[1]

</div>

My Dearest Father,

Though it is getting late, and I have a great deal to write before going to bed, I must give you an account of the way I spend my day here. In the first place, I find it is no use getting up much before 6, for I only tire myself before the day is over. So at 6 precisely I am up, and my breakfast, in the shape of coffee, eggs, and a volume of Sismondi[2] is on the table by 7 to the minute.

By eight I am ready to go out, with a chapter of history read. I go to the old Lombard church of which I told you,[3] for the people hardly frequent this (owing to its age & gloom I suppose) & therefore I can draw there, ⟨among⟩ without disturbing anyone even during the mass hours. There I draw among the frescoes & mosaics (and with a noble picture of Francia over one altar)[4] until 12 o'clock. Precisely at 12 I am ready to begin my perambulations (with the strong light for the pictures) among the other churches, for the masses are then over, and I can get at everything. I usually go first to San Romano, the church of the Dominican monks where are the two great Fra Bartolomeos.[5] The Monks are most kind in every way, and pleased at my giving so much time to study their pictures. They take all their candlesticks off their altar, and bring me steps to get

1 Postmarked Lucca, 7 May. Received 16 May.

2 J. C. L. Simonde de Sismondi, *Histoire des Républiques Italiennes du Moyen Age*. The edition Ruskin used was probably a Brussels edition of 1838.

3 San Frediano; see Letter 23.

4 Francesco Francia (1450–1517). 'Assumption of the Virgin over an altar on the north side. An invaluable work, which I should have studied more but for the continual dark weather and bad position of the picture' (Bem. MS. 5A).

5 *God the Father with Mary Magdalene and St Catherine of Siena* and the *Madonna della Misericordia*. In his notebook, however, Ruskin calls the latter 'an utter failure in every respect' (Bem. MS. 5A). Both paintings are now in the Pinacoteca of Lucca.

close to the picture with, and leave me with it as long as I like. And such a heavenly picture as one of them is—Mary Magdalene & St Catherine of Sienna, both kneeling, the pure pale, clear sky far away behind, and the auburn hair of the Magdalene, hardly undulating, but falling straight beside the pale, pure cheek (as in the middle ages), ⟨falls⟩ and then across the sky in golden lines, like light. Well, from San Romano I go to the Duomo, where there is a most delicious old sacristan, with the enthusiasm of Jonathan Oldbuck,[1] and his knowledge to boot, and perfectly enraptured to get anybody who will listen to him while he reads or repeats (for he knows them all by heart) the quaint inscriptions graven everywhere in Latin (dark, obsolete lettered Latin), and interprets the emblems on the carved walls. After two hours work of this kind, and writing as I go, all I can learn about the history of the churches, and all my picture criticism, I go home to dine—dinner being ready at two exactly. At three I am again ready to set to work, and then I sit in the open warm afternoon air, drawing the rich ornaments on the facade of St Michele.[2] It is white marble, *inlaid* with figures cut an inch deep in green porphyry, and framed with carved, rich, hollow marble tracery. I have been up all over it and on the roof to examine it in detail. Such marvellous variety & invention in the ornaments, and strange character. Hunting is the principal subject—little Nimrods with short legs and long lances—blowing tremendous trumpets—and with dogs which appear running up and down the round arches like flies, heads uppermost—and game of all descriptions—boars chiefly, but stags, tapirs, griffins & dragons—and indescribably innumerable, all cut out in hard green porphyry, & inlaid in the marble. The frost where the details are fine, has got underneath the inlaid pieces, and has in many places rent them off, tearing up the intermediate marble together with them, so as to *uncoat* the building an inch deep. Fragments of the carved porphyry are lying about everywhere. I have brought away three or four, and restored *all* I could to their places.

After working at this till 1/2 past five or so, I give up for the day, and walk for exercise round the ramparts. There, as you know, I have the Pisan mountains, the noble peaks of Carrara, and the Apennines towards Parma, all burning in the sunset, or purple and dark against it, and the olive woods towards Massa, and the wide, rich, viny plain towards Florence—the Apennines still loaded with snow, and purple in the green sky, and the clearness of the Sky here

[1] The title-character of Sir Walter Scott's *The Antiquary.*
[2] Three drawings of the façade, Catalogue 1040-2, are in the Ashmolean Museum. See Plate 5 for one of them; the others are reproduced in *Works*, III, Plate 1, and IV, Plate 1.

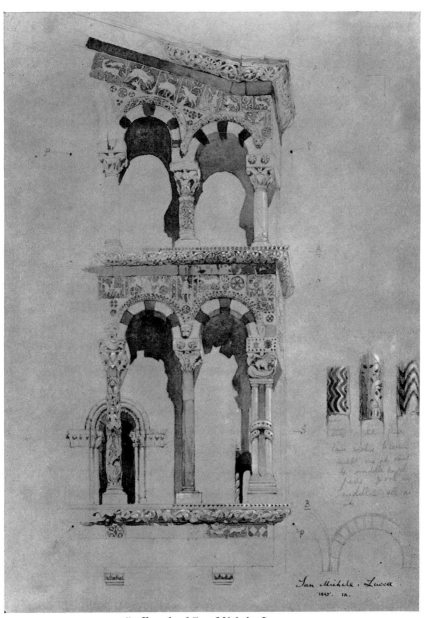

San Michele. Lucca
1845. JR.

5. *Façade of San Michele, Lucca*

is[1] something miraculous. No romance can be too high flown for it—it passes fable.

Finally, when the rose tints leave the clouds, I go and spend a quarter of an hour beside the tomb of Ilaria di Caretto. It is in the cathedral. She was the second wife of Paolo Guinigi, Signore of Lucca in 1430. He left the Lucchese several good laws which they have still, but in a war with the Florentines he was betrayed by his allies, and died in prison at Pavia. The tower of his palace-fortress is overgrown with copsewood, but the iron rings to which his horses used to be fastened still are seen along the length of street before it, and the hooks by which the silken draperies were suspended on festa days.

This, his second wife, died young, and her monument is by Jacopo della Querce, erected soon after her death. She is lying on a simple pillow, with a hound at her feet. Her dress is of the simplest middle age character, folding closely over the bosom, and tight to the arms, clasped about the neck. Round her head is a circular fillet, with three star shaped flowers. From under this the hair falls like that of the Magdalene, its undulation *just* felt as it touches the cheek, & no more. The arms are not folded, nor the hands clasped nor raised. Her arms are laid softly at length upon her body, and the hands cross as they fall. The drapery flows over the feet and half hides the hound. It is impossible to tell you the perfect sweetness of the lips & the closed eyes, nor the solemnity of the seal of death which is set upon the whole figure. The sculpture, as art, is in every way perfect—*truth* itself, but truth selected with inconceivable refinement of feeling. The cast of the drapery, for *severe natural* simplicity & perfect grace, I never saw equalled, nor the fall of the hands—you expect every instant, or rather you seem to see every instant, the last sinking into death. There is no decoration nor work about it, not even enough for protection—you may stand beside it leaning on the pillow, and watching the twilight fade over the sweet, dead lips and arched eyes in their sealed close. With this I end my day, & return home as the lamps begin to burn in the Madonna shrines; to read Dante, and write to you. I am falling behind with my notes however, & therefore tomorrow as you know what I am about, I will not write unless I meet with anything particularly interesting—but the day after. Love to my mother.

<div align="right">

Ever my dearest Father
Your most affe Son
J Ruskin.

</div>

[1] Ruskin wrote 'is here is'.

Lucca. Friday morning [9 May].[1]

My Dearest Father,

All going on just as I described to you, only yesterday was very wet, & lost me a morning, but to make amends gave me a sunset worth two, with golden mist all about the olive woods. By the bye, do you recollect the morning we left la Spezia in 1840, how misty it was over the gulph? The morning I left it this time was the *very* counterpart—the mist, the dew on the vines, & the dead calm, soundless sea. And hear Rogers.[2]

> Day glimmered, & beyond the precipice
> A sea of vapour rolled. Methought we went
> Along the utmost edge of this our world.
> But soon the surges fled, and we descried
> Nor dimly, though the lark was silent yet,
> Thy gulph, la Spezzia. Ere the morning gun
> Ere the first day streak, we alighted there.
> And not a breath, a murmur. Every sail
> Slept in the offing. Yet along the shore
> None unemployed, as at the noontide hour.

And Dante says[3]

> Tragge Marte *vapor* di val di Magra,
> Ch'è di torbidi nuvoli involuto,

only the epithet torbidi don't apply to Spezia.

Does not my journey from Digne to Draguignan remind you of the 41st of Isaiah? "I will plant in the *wilderness* the myrtle & the oil tree—the fir tree & the pine"—v. 19.[4]

There is an exquisite star window at the end of the church of St Michele, carved like lace. The French nailed up against it, destroying all the centre for ever, a great Louis-quatorze escutcheon (which these wretches of Lucchese haven't spirit enough to

[1] Postmarked Lucca, 9 May. Received 19 May.

[2] Samuel Rogers, *Italy, A Poem* (London, 1830), pp. 223–4, ll. 1, 5–14, the opening of the section entitled 'The Feluca'. Ruskin omits the parenthetical ll. 2–4 and alters at the end, which reads: 'Yet along the shore/Great was the stir; as at the noontide hour,/None unemployed.'

[3] *Inferno*, XXIV. 145–6. Cary's translation: 'From Valdimagra, drawn by wrathful Mars,/A vapour rises, wrapt in turbid mists.'

[4] See Letter 12, p. 30.

pull down), with "Libertas" upon it, and they have mosaiced a tricolor into the middle of an inscription of the 15th century in the cathedral. I'm only afraid they haven't human soul enough ever to be damned.

Love to my mother.

Ever my dearest Father
Your most affectionate Son
J Ruskin.

I shan't get to Pisa till Monday.

28

[Lucca.] 10th May.[1]

My Dearest Father,

I could not get any information about the time letters took to reach England, and so I am obliged to send you your birthday letter *on* instead of for the day. I am afraid you will not spend a very happy one without me, and I am sure I wish I could come home for a day or two and then come back to go on with my work. I intended to send you a verse or two I wrote at Conflans,[2] but I can't finish them to my liking—there is a hinge wanting or so here and there, and they want oiling all over to keep them from creaking—you shall have them soon. I don't know how it is, but I almost always see two sides of a thing at once, now—in matters poetical—& I never get strongly excited without perceiving drawbacks & imperfections which somehow one lost sight of when one was younger. When I see an olive tree, for instance hereabouts, though I may perchance think of the scriptural expressions concerning it, or the triumphal [use] of it, I am just as likely to remember the outside of a shop in St Giles's—"Fine Lucca Oil"!! and an orange tree, instead of carrying me to the south, is just as likely to take me in spirit to the gallery at Astley's[3]—"China or Harrange?"!! I cannot make up my mind whether the poetry or prose of life be its humbug, whether, seeing truly, there be most to feel, or most to laugh at. Yesterday as I was drawing at St Romano, a finely faced beggar came in with a dog in a string. He went to the holy water font, and crossed himself with an expression of devotion almost sublime, while at the *same instant*, the dog bestowed some water of a different kind on the *bottom* of the marble vessel so revered at the top. It was a perfect

1 Postmarked Lucca, 10 May. Received 19 May.
2 See Letter 35.
3 Astley's Royal Amphitheatre, in Westminster Bridge Road, specialized in equestrian spectacles and was notable, too, for its clowns and acrobats.

[57]

epitome of Italy as she *is*. One hardly knows which hath upper hand in her, saint—beggar—or beast.

It is high time for me to leave this place, at any rate, for having unadvisedly given away a handful of rubbish which they gave me for a franc, among the *middle* class, I find them multiply like mosquitoes, and I cannot stand for a minute in the street without becoming the centre of a group of supplication about as earnest as ⟨get⟩ the saints themselves get in an average way.

I hope the 10th of May is finer at Denmark Hill than it is here. I was *driven* down from the roof of San Michele yesterday by the cold wind, and we have had two showers of *hail* this morning. I have been very much hindered in my work here by dark days and rain— and latterly by the *cold*. I certainly did not expect to be unable to stand & draw in Italy for cold in May. God bless & preserve you for me, & me for you, my dearest Father.

<div align="right">

Ever your most affectionate Son
J Ruskin.

</div>

Two o'clock. I have just drunk your health in Aleatico.

<div align="center">

29

</div>

<div align="right">

Lucca. Whitsunday [11 May].

</div>

My Dearest Father,

After being considerably delayed on my way to Mass this morning by a military band playing the Polka, with great spirit & effect, I had a great treat at the cathedral, which as you know is a fine building for ceremonial effects—some five & twenty priests on *each* side of the Altar and all in crimson, & a bishop with no end of mitre, and a crosier too heavy to hold which he was obliged to stick into a candle holder, painted glass in plenty behind—perhaps you forget it—it is very vivid & fine—music of the highest quality, and all the covers off the pictures, Fra Bartolomeo's lovely St Stephen & St John in a side chapel,[1] and a black mask flitting about here & there behind the pillars like any bravo—you would have enjoyed it very much. Congregation very qui[et] and pious, more well dressed people on their knees than on[e s]ees usually. It rains now, 3 o'clock, & I imagine may continue, but I am obliged to post this immediately or it will not go[2]—⟨I start⟩ otherwise, as I shall have a quiet afternoon I would have written a longer letter. I have written to nobody except a word to Henry Acland since I left home. I say

[1] *Madonna and Child with St Stephen and St John Baptist* in the Cappella del Santuario.

[2] Postmarked Lucca, 11 May. Received and answered 20 May.

all I have got to say to you. I start D.V. for Pisa tomorrow at 8. There is something very splendid there on the 25th, but if I can get my work done I shan't wait for it or I shall get into too hot weather—not at Florence—it isn't hot enough for me there yet—but in July at Parma & Milan. However, I daresay the Campo Santo will keep me at work for a fortnight, & if so, I will not lose the illumination of the whole city for two days.

I take a voiturin to Pisa—he is to take me for 25 paoli in 2 hours & a half. Half price of posting, & saves all bother with blackguards of postillions.[1] Love to my mother.

> Ever my dearest,
> your most affectionate Son
> J Ruskin.

It's clearing up, I think. I shall go to the promenade—such a jolly band—30 men, not counting the drummer.

30

Pisa. Monday, eleven o'clock [12 May].[2]

My Dearest Father,

I have your two letters here, but I think you are mighty lazy to send me such a short bit of a thing after three scolds—however I am very glad to get it and find you are all right again, and I expect some long ones at Florence.

Let me look over the longest one however, to answer the queries. After this, write to Florence. ⟨until⟩ I will tell you when to send to Bologna. I cannot tell yet which inn I shall go to at Venice. I am inclined for the Leone Bianco—the view fr[om] Danieli's is not romantic enough for me,[3] but I shall ma[k]e enquiries at Florence.

I will mind Foreign quarterly.[4] I don't like Schneiders at Florence,[5]

[1] According to Murray's *Northern Italy* (1842), p. xiii, Italian postillions 'are rough articles, and are generally churlish and discontented, give them what you may'.

[2] Postmarked Pisa, 12 May. Received 21 May.

[3] The Leone Bianco was on the Grand Canal near the Rialto bridge and the Palazzo Grimani. Danieli's, then as now, was on the Riva degli Schiavoni, near the Ducal Palace.

[4] *Foreign and Colonial Quarterly Review*, which became in 1844 the *New Quarterly Review or Home, Foreign and Colonial Journal*. The reference is probably to the alarm of its correspondent in Switzerland in the Apr. 1845 issue (V. 551): 'No conception can be formed of the intestine warfare now prevalent amongst us, save by those who are eye-witnesses of it. The Jesuits and their expulsion form the only topic of conversation. We shall scarcely avoid a civil war, unless the other States of Europe intervene.'

[5] Murray's *Northern Italy* (1842) says, 'Schneiders has greatly fallen off', and puts it next to last on its list of hotels. The Hôtel Balbi, or d'Italie, is listed first.

and have given Millingen[1] my address at Balbi's. I have answer from him saying all will be right, sent to Lucca. I will send something immediately for the plate. I must have £21 for it,[2] and pray do anything you like with all you have of mine.[3]

Archdeacon[4] all right. Moon[5] all right. I think there is a bundle of receipts if any question should arise, in the cupboard in the study, or else Ann[6] has them. I find the landlord has left L'Ussaro, and taken this, the Tre Donzelle, changing name to Hotel Peverada. It is on the Arno, which is much better for me as there is to be a glorious illumination here of the whole town.

I am perfectly well, and have had a regular draught of all that is divine out of the cathedral already. I have read myself thirsty, & my mind is marvellously altered since I was here[7]—everything comes on me like music—and I am mighty well, & don't care a farthing about sun or heat or anything else. Coutet warned me especially against eating figs. I was looking at Vasari yesterday, & saw that Fra Bartolomeo died of doing so.[8] Coutet is up to a great deal—he insists on my never touching water without a squeeze of lemon in it, says there is always chance of its being putrid otherwise, & you can't conceive how capital lemonade is when the lemon is just off the tree. At dinner I put some Aleatico to the water & I feel decidedly better for it. Love to my mother.

<div align="right">
Ever my dearest

your most affe son,

J Ruskin.
</div>

[1] James Millingen (1774–1845), archaeologist and a leading authority on ancient coins. He had settled in Florence, but was preparing to return to England when he died on 1 Oct. 1845.

[2] Though he later gave up the plan, Ruskin hoped to provide engravings for the second volume of *Modern Painters* (see Letter 40). The reference here seems to be to a drawing for the book, probably for the engraving by John Cousen listed in John James Ruskin's account book (Bem. MS. 28) under Nov. 1845: 'Cousins Leafage £20 Inses 8/9' (see also Letter 47, p. 92). The first of Ruskin's books to be illustrated, however, was *The Seven Lamps of Architecture* (1849), which contained his own etchings. The first to contain engravings was the first volume of *The Stones of Venice* (1851).

[3] His father may have suggested having some of Ruskin's drawings framed. See Letter 11, p. 22, note 2.

[4] Perhaps Julius Charles Hare (1795–1855), Archdeacon of Lewes and a notable collector of books and pictures.

[5] Francis Graham Moon (1796–1871), printseller and publisher, in Thread-needle Street. The reference may be to payment for *The Holy Land*, the series of lithographs from drawings by David Roberts which Moon published, beginning in 1842, and to which Ruskin had subscribed.

[6] Ann Strachan, the servant who had been Ruskin's nurse, rather than Anne Hobbs, George's sister, also a servant, but regularly referred to as Hannah.

[7] 9–11 Nov. 1840.

[8] Giorgio Vasari, *Le Vite dei più eccellenti pittori, scultori e architettori.* See the Life of Fra Bartolomeo.

Pisa. Tuesday forenoon [13 May].[1]

My dearest Father,

I have just been turned out of the Campo Santo by a violent storm, and sit down in my little room in a state of embarrassment and desesperance—if one may coin a word to express not despair, but a despairful condition. For the frescoes are certainly much injured even *since* I was here, and some heads have totally disappeared since the description was written for Murray's guide,[2] and while for want of glass, and a good roof, these wonderful monuments are rotting every day, the wretches have put scaffolding up round the baptistery, and are putting modern work of the coarsest kind instead of the fine old decayed marble. I do believe that I shall live to see the ruin of everything good and great in the world, and have nothing left to hope for but the fires of the judgment to shrivel up the cursed idiocy of mankind. I feel so utterly powerless too myself. I cannot copy a single head, and I have no doubt that, if I want to take a tracing, for which you know it is necessary to put the paper *upon* the picture, I have not the slightest doubt but these conservators, who let the workmen repairing the roof drop their buckets of plaster over whole figures at a time, destroying them for ever, will hinder *me* with my silky touch & fearful hand, from making even so much effort at the preservation of ⟨all⟩ any one of them. And their foul engravers are worse than their plasterers—the one only destroy, but the other malign, falsify, & dishonour. You never saw such atrocities as they call copies here. And as if they didn't do harm enough when they are alive, the tombs for their infernal rottenness are built up right over the walls and plastered up against them as in our parish churches, *two* frescoes of Giotto torn away at one blow to put up a black pyramid![3] It is provoking too that I feel that I co[uld do a] great deal if I had time, for the lines are so archaic & simple that they are comparatively easily copiable, and I could make accurate studies of the whole *now left*, about the 40th part, but it

[1] Postmarked Pisa, 13 May. Received 22 May.

[2] *Handbook for Travellers in Northern Italy* (London: John Murray, 1842). This, the first edition, was written by Sir Francis Palgrave, who, in his account of the Campo Santo, himself notes the extensive damage to each fresco. Most of the frescoes were ultimately destroyed by an allied bombardment in 1944.

[3] The Giotto frescoes are those devoted to the story of Job, now attributed to Taddeo Gaddi. Ruskin marked the insertion of monuments in them in his notebook (Bem. MS. 5B): 'Of the six pictures, which he painted, three above & three below, the two western ones, which reach the extremity of the Campo Santo were destroyed, all but one or two passages, by Algarotti's monument which bears date 1764. A fragment of the lower one would have been left, as of the higher one, or the right of it, but this has since been utterly destroyed, to its last inch, by the tomb "Francesco Antonii *Puccinellii*" bearing date 1808.'

would take me a year or so. Giotto's Job is all gone—two of his Friends' faces and some servants are all that can be made out.[1] I should like to get a study of some little bit, but don't know what to choose nor where to begin. I think I shall go off to Florence in despair. Why wasn't I born 50 years ago. I should have saved much, & seen more, & left the world something like faithful reports of the things that have been—but it is too late now.

Confound their thin paper. I've written on two sheets[2] and haven't time to write over again. Give my love to George Richmond[3] and ask him what the d. he means by living in a fine house in York St painting English red nosed puppets with black shoes & blue sashes, when he ought to be over here living on grapes & copying everything properly.

The weather is very unfavourable to me—it was very draughty in the Campo santo, so that I could not sit to draw, and then a thunderstorm came & it is now most dark & gloomy.

I am quite well however, and when the rain came I was luckily taken to a collection of pictures belonging to an antiquary here who superintends all the publications (Rosini,[4] I think)—he came to me, and has told me a great deal, though I find *he* does not feel the art that he has, except as it is curious historically, or rare accidentally. But he has great traditional and technical knowledge of pictures, and a divine collection. I have seen the first ⟨genuine⟩ Fra Angelico there that I have yet met with, & most genuine & glorious; a first rate Pinturicchio, a Gentile Bellini, a divine Perugino, and a most pure Raffaelle[5]—all in one day—and I feel thrown on my back.

I am quite well however, and the views & walks are most precious. Poor little Santa Maria della Spina—they want to pull it *down* to

[1] The fresco referred to is the *Patience of Job*, also known as the *Friends of Job*.

[2] This paragraph is written on the back of the first sheet. The rest of the letter is resumed on a third sheet. With this letter Ruskin begins a new lot of letter paper, embossed 'Bath' and apparently bought in Pisa.

[3] George Richmond (1809–96), portrait painter. Ruskin met him at Rome in Dec. 1840 and the two became lifelong friends. Richmond lived at 10 York Street, Portman Square.

[4] Giovanni Rosini (1776–1855), poet, novelist, dramatist, literary critic, art historian, director of the Accademia di Belle Arti, and professor of Italian literature at the University of Pisa. The 5th edition of his *Descrizione delle pitture del Camposanto di Pisa* was issued in 1845.

[5] In 1882 part of Rosini's collection was put up for sale, 74 pictures valued at 76,160 lire. The sale catalogue, *Catologo dei Dipinti Classici esistenti nella collezione del celebre Prof. Rosini in Pisa* (Pisa, 1882), lists only one picture which matches Ruskin's list, a Perugino *Vergine col Bambino*, tavola, 33 × 25 cm. There is also a School of Raphael *Sacred Family*, copper, 10 × 9 cm. Ruskin's description in his notebook of the tomb of Ilaria di Caretto notes that her 'head-dress, precisely the same in every particular, occurs in a figure on the left hand of a picture of Gentile Bellini's which I saw today in Signor Rosini's Gallery' (Bem. MS. 5A).

widen the quay, but as they say in King Lear[1]—That's but a trifle here! I've no doubt it'll be done soon.[2] God preserve us, & give us leave to paint pictures & build churches in heaven that shan't want repairs.

<div align="right">

Ever my dearest,
your most affectionate Son
J Ruskin.

</div>

<div align="center">

32

</div>

<div align="right">

[14 May.][3]

</div>

My dearest Father,
I have been hard at work in the Campo santo all the morning, and have got on very fairly I think—mighty pleasant air, shady & soft light & all right. I have taken the hardest possible way—pen outline on plain white paper. If I can do that, I can do almost anything, & one is not bothered by fear of rubbing out in carrying home; what I get, I get securely. Two thousand pounds would put glass round the whole of the campo santo, & preserve all that remains of the frescoes, & our government give 2500 for a rascally Guido not worth sixpence.[4] Seriously I am going to write to Richmond & Sir R Inglis[5] & [a]nybody else I can think of, and see if I can't get [a] subscription set on foot—2000 pounds [only to] save Giotto, Simon Memmi, Andrea Orcagna, [Antonio] Veneziano & Benozzo Gozzoli![6]—and there will not a fragment be left in thirty years more unless it be done.

[1] v. iii. 295.

[2] The level of the quay was eventually raised, and in 1871 the church was torn down and rebuilt at its present level.

[3] Postmarked Pisa, 15 May. Received 24 May.

[4] The National Gallery bought two Guidos as a pair in July 1844, *Lot and His Daughters Leaving Sodom* (N.G. 193) and *Susannah and the Elders* (N.G. 196), for a total price of £2,940.

[5] Sir Robert Harry Inglis (1786–1855), M.P. for Oxford University and Antiquarian of the Royal Academy. The previous year he had commissioned Ruskin to make him a drawing; see *Diaries*, I. 262 ff. and Letter 76, p. 135, note 1.

[6] For Giotto, see Letter 31, p. 61, note 3. To Simon Memmi, known now as Simone Martini, were attributed the *Assumption of the Virgin* over the entrance, now attributed to the anonymous Master of the Assumption in Chiaravalle Abbey, and the three upper scenes from the life of San Ranieri: *Conversion of S. Ranieri, S. Ranieri in the Holy Land,* and *Temptations and Miracles of S. Ranieri,* now attributed to Andrea (Bonaiuti) da Firenze. To Andrea Orcagna were attributed the *Triumph of Death* and the *Last Judgment and Hell,* now attributed to an anonymous Tuscan master. The chief frescoes by Antonio Veneziano are the three lower scenes from the life of San Ranieri: *S. Ranieri's Return to Pisa, Death of S. Ranieri,* and *Miracles of S. Ranieri.* The chief frescoes by Benozzo Gozzoli are twenty-three scenes from the Old Testament.

I shall probably not write tomorrow, as I shall have to go at 12 o'clock to my virtuoso friend[1] again, and am falling sadly behind with my notes.

Ever my dearest
Your most affect. Son
J Ruskin.

Pisa. Wednesday—two o'clock—dinner on table.

Thursday morning.

You would have had this yesterday but for George's not doing as he was bid. Their rascally post office here only opens from 5 to 7 after two o'clock, and I don't know if it opens in the morning, yet—but as from 5 to 7 are also open hours in the Campo Santo, which is a mile if not a mile & a half from the post office, I could not frank the letter myself, but ordered George to do so at 5 o'clock & then *come* to me. The Gentleman came at 1/2 past five, & said nothing. I took it for granted he had done as I told him, & worked on till 7, and walked leisurely home, & at 1/2 past seven, out he pulls the letter. "Oh, I must go over with this, now"—quite coolly, & when I asked him why he hadn't done as I told him, "he found it shut at five and he *thought* I should want [him][2] to come away, and he *didn't know* it shut at seven, &c." I shall not give him another letter to post on the journey, but you must not even now ever calculate on regularity. If I find the office shut this morning I shall be obliged to trust this to Coutet today, and though he is not likely to miss anything that he is told, I never feel secure but when I do it myself.

Your ever affectionate
JR.

33

[Pisa.] Thursday evening [15 May].[3]

My dearest Father,

I was obliged to trust my letter to Coutet this morning—the post office here is never open, but I have no doubt he would put it in right. I have been hard at work in the Campo Santo, and have got not only very great insight into the thing by dwelling upon, but

1 Rosini.
2 Omitted by Ruskin.
3 Postmarked Pisa, 16 May. Received 26 May; answered.

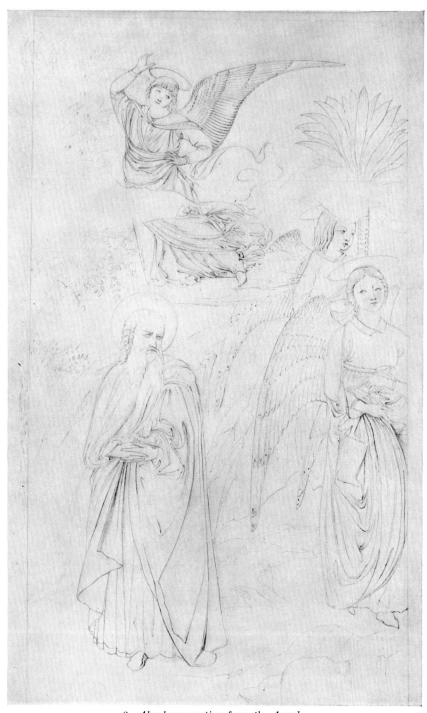

6. *Abraham parting from the Angels*

have a very pretty outline to carry away, of a very lovely passage. You cannot guess how these men must have read their bible, how deeply the patriarchal spirit seems written in their hearts. I have been drawing from Benozzo's life of Abraham, which is as full & abundant as the scripture itself—*nothing* missed, though a good deal added. Little Ishmael *fighting* little Isaac, to Sarah's great indignation, being one of such passages, a comment on the "saw the son of ⟨Hagar⟩ the Egyptian mocking" of the Bible[1]—but this is succeeded by the most heavenly Hagar in the Wilderness. I shall set to work on her tomorrow. Today I have been finishing a sketch of an easy bit to get my hand in (easy because small & well made out) —Abraham parting from the Angels when they go towards Sodom.[2] It is a beautiful observance of the scriptural history that while *three* angels came to Abraham, only *two* came to Sodom at Even.[3] In the fresco, the central angel is rising, looking back however towards Sodom with his hand raised in the attitude of condemnation, afterwards adopted by M Angelo in the Judgment.[4] The *two* angels turn towards Sodom, one with his eyes steadfast on the city, the other looking back to Abram. The latter turns away, with his hands folded in entire faith & resignation, but with such a quivering distress about the lips and appeal for pity in the eye, that I have had the tears in mine over & over again while I was drawing it. The plaster on which is this passage has already risen in a blister from the wall, & will be blown into the Arno in dust before the year is out.

I have got a sketch of a head of Antonio Veneziano, which I hope to finish tomorrow, & then begin some more important passage. I have got leave to get upon the roof of S. M. della Spina, to draw the details before they throw them into the river, & my friend the Professor[5] called here tonight & sat talking for a full hour. I am not without hope of getting leave to make some *tracings* in the Campo santo—through him. I was with him in the morning, seeing more pictures—a Leonardo[6] among others—and he made me a present of an original tracing off a picture of Giotto's, of the very highest beauty.

The churches are full of pictures of great interest too. Luckily for me, the town itself affords no temptations, so I can give all my time to them. There is no out of door subject here.

[1] Gen. 21: 9. This scene and Hagar in the Wilderness are in *Stories of Isaac*, also known as *Abraham's Sacrifice*.

[2] See Plate 6. The scene is the upper right-hand corner of *Stories of Hagar and Abraham*. The drawing, Catalogue 797, is in the Ashmolean Museum.

[3] Gen. 18: 2 and 19: 1.

[4] The gesture of Christ in the Sistine Chapel fresco.

[5] Rosini.

[6] There is no Leonardo in the catalogue of the 1882 sale of Rosini's collection.

All right and comfortable, just going to work. I shall ask for letters at Post office today in case of your having sent any. I don't know when I shall get away from here. I think the Campo santo about the most important thing to study thoroughly in Italy at present, for it will soon be all gone—and I can cut off from the mountains. As for heat, I get up every day quite anxious to feel whether I can draw sa[fely] without catching cold. To do it justice, t[h]ere is no fear of *this* in the air here, for it is always mild & dry, but so cool that I can run all the way from here to the cathedral, nearly a mile, without heating myself.

I shall probably not write tomorrow as George has a letter to send—he shall send that.

<div style="text-align:right">Ever my dearest Father
Your most affe. son
J Ruskin.</div>

<div style="text-align:center">34</div>

<div style="text-align:right">[Pisa.] Sunday morning, 18th May.[1]</div>

My Dearest Father,

All goes on just as usual—breakfast at 7, to work at 8, work till one, or on Thursdays & Saturdays till 12, when I go to call on the professor Rosini and see more pictures. Dine at two, to work again at three always in Campo Santo, stop at five. Walk about town or as yesterday up on the roof of La Spina to get the details. Then up tower to see sunset on Carrara mountains, home at 1/2 past 7 or 8, tea & write till 9 1/2, or longer if I am'nt sleepy, bed at 10. Can't get up before 6. I want sleep to rest my eyes, which however are always better when I am working than when I am travelling.

The only inconvenience of this place is, that being in a dead flat, five miles from any hills, I can't get a good walk in the evening, for I am a little afraid of being out in twilight among the flat corn-fields or vineyards because they are all nearly level with the river & I think marshy, so that I am confined to the stupid Lung' Arno, or the square in front of the cathedral, or the streets. There are no nice rampart walks as at Lucca, and the streets are all very dull, except the dirtiest. I have found some fine things in the dirty quarters, but one can't *walk* there pleasantly, nor with much benefit to one's health in the way of air. At Florence things are better— one has always the hills San Miniato way. However, I can't stir from here for a week yet. I haven't one third seen the Campo Santo,

[1] Postmarked Pisa, 18 May. Received 27 May.

and I have only been twice round the cathedral (I never saw such a cathedral in my life—there is not a line in it stands straight), and I have not *entered* another church, except San Paolo Ripa d'Arno (for music), and they are all full of pictures, nor seen the academia,[1] and the bronze doors of the cathedral[2] alone are worth a week's study. Keele[3] would appreciate them, for the borders of flowers and fruit make one's mouth water. It is the most wonderful thing I ever saw—the hard bronze is made by the grand treatment of the sculptor to look as soft as plums, or as crisp as cucumbers. First, sticking right out ready to be gathered is a great olive branch covered with olives, then a bit of ⟨oak⟩ ilex and acorns, then apple tree with clusters of apples, then grapes, every species that grows in Italy—small, round, & long, and pointed, all so detached from the door that they look ready to fall into a basket. Then come french beans, & broad beans, in the pod, & split open, with the seeds seen, then plums, orlean & magnum, then walnuts, then oranges, then a whole bed full of *cucumbers*, and glorious little birds and lizards fluttering and springing through all, and all this treated with a grandeur that makes every seed sublime. The beans in particular are something tremendous, and the nuts, especially the filberts, overpowering.

But the Campo Santo is the thing. I never believed the patriarchal history before, but I do now, for I have seen it. You cannot conceive the vividness & fullness of conception of these great old men. In spite of every violation of the common, confounded, rules of art, of anachronisms & fancies the boldest & wildest—Lorenzo de Medicis figuring as an Egyptian Sorcerer, and Castruccio degl' Interminelli[4] coming in over and over again long before the flood, and all the patriarchs in the costume of the 13th century—n'importe. It is Abraham himself still. Abraham & Adam, & Cain, Rachel & Rebekah,[5] all are there, the very people, real, visible, created, substantial, such as they *were*, as they must have been—one cannot look at them without being certain that they have lived—and the angels, great, & real, and powerful, that you feel the very wind from their wings upon your face, and yet expect to see them depart every instant into heaven; it is enough to convert one to look upon them—one comes away, like the women from the Sepulchre,

1 The Accademia di Belle Arti, at the end of the Borgo Largo, no longer exists. For some of Ruskin's notes on paintings there, see *Works*, XXXVIII. 327.

2 The doors he describes are those of the façade, by followers of Giovanni da Bologna and representing scenes from the life of the Virgin and the life of Jesus.

3 The Ruskins' gardener.

4 Castruccio Castracani (1281–1328), soldier of fortune, became Signore of Lucca in 1316. His family were the Antelminelli; Ruskin's spelling is Sismondi's.

5 Adam and Cain are in frescoes by Piero di Puccio, the others in Gozzoli's.

"having seen a vision of angels which said that he was Alive."[1]
And the might of it is to do all this with such fearless, bold, simple truth—no slurring, no cloudiness nor darkness—all is God's good light, and fair truth. Abraham sits *close* to you entertaining the angels—you may touch him & them—and there is a woman behind him bringing the angels some real, *positive* pears, and the angels have knives and forks and glasses and a table cloth as white as snow, and there they sit with their wings folded—you may put your finger on the eyes of their plumes like St Thomas, and believe.[2] And the centre angel has lifted his hand, and is telling Abraham, his very lips moving, that Sarah shall have a son. And there is no doubt on Abraham's face, only he holds his knife hard for wonder and gladness. And Sarah is listening, holding back the curtains of the tent.

I am hard at work on Giotto's Job.[3] I shall get it I believe, the full g[roup] of eleven figures, by Tuesday morning, and then I shall [hav]e a bit of Simon Memmi, the conversion of St Ranieri—he is a youth preparing to play on a lute to a circle of Florentine maidens, just giving each other their hands to dance, and there passes by a palmer, and one of the maidens lifting her hand in jest says to St Ranieri—Wilt thou not follow the angel? And St Ranieri accepts the sign and follows him. This is very high, & I have not been up to it yet, but I think it is very fine, and I want to do a bit from each master, that I may learn their differences of manner. Benozzo I have done, & Giotto I am doing, then I have Simon Memmi, Antonio Veneziano, & Andrea Orgagna.

I want to write to Liddell[4] today, and I have two services to go to, so I can't write any more.

<div align="right">Ever my dearest Father,
your most affe Son
J Ruskin.</div>

I didn't get any letters at post office. Are there none from Macdonald?[5] By the by, I saw in looking over letters at Genoa, three lying for "Robert Findlay".[6]

[1] Luke 24:23.

[2] John 20:25. The scene described is on the right of Gozzoli's *Stories of Hagar and Abraham.*

[3] The *Patience of Job*, now attributed to Taddeo Gaddi.

[4] The Rev. Henry George Liddell (1811–98), Greek Reader in Christ Church, compiler of the famous Greek lexicon, later Dean of Christ Church. He had encouraged Ruskin's interest in early Italian painting.

[5] William Macdonald Colquhoun Farquharson (1822–93), who took the surname Macdonald in 1841 on succeeding to large Perth and other properties. His mother was an old friend of Ruskin's father.

[6] Perhaps Robert Austin Findlay (b. 1808), son of the Rev. John Findlay, who had married Ruskin's parents in Perth.

George and Coutet are mig[htily] tired of this place already, and indeed for them it is a dull town enough. I gave them leave to go to Leghorn yesterday—takes 25 minutes and costs a paul—they came back at two o'clock much pleased with the port &c—nothing there for me—I shan't go. I see the town capitally from the top of the leaning tower. Love to my mother.

35

[Pisa.] Monday Morning [19 May].[1]

My Dearest Father,

I never saw such weather in my life. I couldn't stand about the cathedral last night—it was too cold—and now it is pouring of rain. I send you on the other side a few verses[2] written at Conflans— addressed to the lazy people there. I don't know whether they are fit for anything or not, but I couldn't polish them to my liking at all.

I am very much divided in mind about this stupid illumination here.[3] They build a great palace of fire on each of the bridges, and all the big houses opposite are already lost in a forest of scaffolding, and the tower on the Ponte a Mare[4] is lined in every machicolation & will look mighty fine, and it only comes once in three years. On the other hand, I don't care two farthings for all the illuminations in the world, and to lose two days (coming from Florence & returning) for a lot of lamps is too bad. It is on the 15th of June, so I should have to come from Florence. Send me some real decent letters to Florence. Is *nobody* writing to me—nor an't there any news of anybody? All the way from Geneva I haven't heard anything but complaints of letters not coming.

Ever my dearest
your most affe.
JR.

Have you in heaven no hope—on earth no care
No Foe in hell, ye things of stye and stall
That congregate like flies, and make the air
Rank with your fevered sloth—that hourly call
The Sun, which should your servant be, to bear
Dread witness on you with uncounted wane
And unregarded rays from peak to peak

1 Postmarked Pisa, 19 May. Received and answered 28 May.

2 See below. The poem was published in Heath's *Book of Beauty* for 1846 under the title *Written Among the Basses Alpes* and is printed in *Works*, II. 238–9.

3 In honour of San Ranieri, Pisa's patron saint.

4 The Torre Guelfa at the northern end of the bridge.

Of piny-gnomoned mountain moved in vain.
Behold, the very Shadows that ye seek
For slumber, write along the wasted wall
Your condemnation. They forget[1] not, they,
Their ordered function and determined fall,
Nor useless perish. But *you* count your day
By sins, and write your difference from clay
In bonds you break & laws you disobey.
God!—who hast given the Rocks their fortitude
Their sap unto the Forests, and their food
And vigour to the busy tenantry
Of happy, soul-less things that wait on thee,
Hast thou no blessin[g w]here thou gav'st thy blood?
Wilt thou not make thy fair Creation whole?
Behold, and visit this thy vine for good.
Breathe in this human dust its living Soul.

I am getting a bad habit of giving things a moral turn which makes them sound *nasal*.

36

Pisa. Monday evening, 19th May.[2]

My Dearest Father,

All goes on right and comfortably except that I rubbed one of Job's friends eyes out *five* times this morning. Confound Giotto—he is hard[er] to copy than anybody I have tried yet, for as simple as he looks. I got stuck in a palm tree too for half an hour—couldn't do it at any price—and then the *hands*. They are as badly drawn as they can be, but there they are all full of life and feeling, running out at the very fingers ends. If I draw the hand as well as I can, it isn't *like*—if I draw it rudely and badly, the rudeness and badness is all mighty like, but the *feeling* is all gone.

I shan't write tomorrow—going to professor Rosini again. I enclose a note of his—the direction may amuse you. He is a celebrated man and has written books by wholesale.

> Ever my dearest
> Your most affecte Son
> J Ruskin.

[1] Printed in *Works* 'forgot'.
[2] Postmarked Pisa, 20 May. Received and answered 29 May.

[Pisa.] Wednesday, 21st [May].[1]

My Dearest Father,

I have made a drawing from Giotto at last,[2] which I consider worth any money—it is as Giottesque as can be, and I have learned a vast deal in doing it, only it has taken me a terrible time. I am perpetually torn to bits by conflicting demands upon me, for everything architectural is tumbling to pieces, and everything artistical fading away, & I want to draw all the houses and study all the pictures, & I just can't. You know the fine old brick palace here,[3] on the quay. It is very nearly all over with it. They have knocked a great hole in the middle to put up a shield with a red lion and yellow cock upon it for a sign of a consul, and they have knocked another at the bottom to put up a sign of a soldier riding a horse on two legs, with inscription All—Ussero—Cafè—&c, and they have knocked down the top story altogether, & put a whitewashed wall instead, and they have filled up one of the windows with bricks, and as the necessary result of all these operations the whole building has given way and is full of fearful rents and curves and broken arches. It can't possibly stand much longer, and all that we can hope for is that it may fall on as many of these people's heads as possible (to revenge itself)—however, its end is near, and I want to get a study of it & I haven't half done the Camp. Sant. and I ought to make some notes of the cathedral architecture to compare with my Lucca study,[4] and I ought to get away o' Monday at any rate. I picked up two French artists[5] in the Campo Santo, who, for Frenchmen, talked very like human beings, and they tell me that at Venice in June, July & August one can neither see nor sleep for mosquitoes —one *hum*. Add bug to the description, to include other vermin, and perhaps one gets the foundation of the story, but I shall inquire at Florence. They had been studying the old paintings of the right sort for two years & gave me some useful renseignemens—they say I ought to have a *month* at Padua—that there is nothing at Bologna, which I am glad of, for I don't like the place.

[1] Postmarked Pisa, 22 May. Received 31 May, answered 2 June.

[2] Catalogue 1312, a drawing of the *Patience of Job*. The reference to a palm tree in Letter 36 shows that he drew the right half of the fresco.

[3] The Palazzo Agostini.

[4] i.e. with his notes on the churches and cathedral of Lucca in Bem. MS. 5B.

[5] Possibly Eugène Paul Dieudonné (b. 1825) and Ernest Auguste Gendron (1817–81). Dieudonné is mentioned in *Praeterita* (*Works*, XXXV. 362) in connection with Florence, but Ruskin may have met him previously in Pisa. James S. Dearden, Curator of the Ruskin Galleries, Bembridge, has turned up a portrait of 1845 which shows Ruskin between two young men he believes to be Dieudonné and Gendron.

Poor dear old Baptistery—all its precious old carving is lying kicking about the grass in front of it—the workmen are *wonderful* at the "knockin' down", like Sam Weller.[1] Where there used to be black marble they put up common stone painted & varnished—but it don't matter. All's one for that[2]—the old baptistery's gone. I have picked up some of the old bits for love, and shall send 'em home to MacCracken[3] in a box with the Lucca fragme[nts].

I wish to heaven this town were inhabited b[y] bats and monkeys instead of these men. I h[ad] rather see the cathedral front covered with apes hung by their tails than with the things they have put up there today. There is a fete forsooth today, and they have put up garlands over the bronze gates with pendants—paper and dead leaves tied up with green and gilt fillets—looking precisely like two big bell pulls. The children come to look at the bell pulls and stand *on* the bronze doors. I saw one young scum of the earth lay hold of the wing of the devil to help himself up, & stand on the *head* of a Mary Magdalene for five minutes. Love to my mother.

<div style="text-align:right">

Ever my dearest
your most affectionate Son
J Ruskin.

</div>

Thursday morning.

38

<div style="text-align:right">

[Pisa.] May 22nd. Fete of San Raniero.[4]

</div>

My Dearest Father,

By a very pretty coincidence, I was at work all this morning upon Simone Memmi's painting of the conversion of that saint in whose honour they have been at work some four or five days adorning the cathedral. He is the protecting saint of Pisa. I gave you a little account of the painting, but it was wrong in several respects, for I had not then been up to it, and it is impossible to make out the faded colours from below. The circle of Florentine girls are not preparing to dance, but dancing, though the motion is so "still & quiet"[5] that from below it is not felt—but *such* dancing. It does not come upon you at once—the figures seem at first a little stiff—

[1] *Pickwick Papers*, chaps. 37 and 38.

[2] *Richard III*, v. iii. 8, and *I Henry IV*, II. iv. 172.

[3] The firm of James and Robert McCracken, shipping agents, 7 Old Jewry, specialized in shipping and storing works of art and were agents by appointment to the Royal Academy. One of their correspondents in Pisa was Ruskin's landlord, Ferdinand Peverada. For the fragments from San Michele, Lucca, see Letter 26.

[4] Postmarked Pisa, 23 May. Received and answered 2 June.

[5] *Henry VIII*, III. ii. 380.

but gradually, as the figures on the tapestry animate themselves in Lovel's Dream,[1] they grow into life as you look, until you can see the very waving of their hair. This is only the case with the highest art—it tells its tale with such slight touches that you must give your mind to it wholly before it speaks.

Vasari's words respecting it are—I have left him in the campo santo with my drawings, so I can't tell you exactly, but he says— San Raniero (un bel giovane), playing on the *psalterio, fa ballar* a alcune fanciulle bellissime per la costuma del tempo, et ogni altre cose[2]—or some such thing. They are only four—one has a light golden diadem, another a crown of laurel, the third a white veil, the fourth, a girl of fourteen or 15, nothing but her own golden hair waving with her motion. They join hands in the most lovely way possible, the hand falling by the side, with the back turned forwards, and holding only by the little finger, the other fingers falling in soft curves. The dresses are tight to the neck & arms, and very long so that the feet are not seen—only the soft wave of the dress indicates the closing of the circle. The lips of all are *just* open, drawing breath. It is the most perfect study of Desdemona motion, of that which is at once most buoyant, chastised, & ladylike, that I have ever seen. ⟨and⟩ It puts the wild, vulgar, windy dancing of the Greek sculptors to an incomparable Shame. Well I was working at this all the morning, with the incense and the sound of the organ coming constantly from the cathedral in light gusts, mixing strangely with the apparent life of these sweet figures that have danced and breathed there these six hundred years. George came to tell me there were grand things going on, but I couldn't stir, haven't half time enough as it is. Came back again after dinner, but at last I was turned out; the campo santo closing on fete days at five. And then I went to the cathedral, just as they were beginning the great afternoon Service & procession of St Raniero.

You recollect the cathedral; you know it is very dark, and that there are forty massy columns of granite up the nave—but perhaps you forget that at the end of it, over the altar, there is an enormous mosaic of Christ, at least 60 ft high, designed by Buffalmacco,[3] on a gold ground—perhaps also you forget that the windows, though small, are filled with painted glass of the most splendid kind.

[1] Scott, *The Antiquary*, chap. 10.

[2] 'Makes some young girls dance who are most beautiful for the costume of the time, and everything else.' The passage referred to is in the Life of Simone Memmi, now called Simone Martine and Lippo Memmi, and reads: 'fa ballare alcune fanciulle, bellissime per l'arie dei volti e per l'ornamento degli abiti ed acconciature di que' tempi.'

[3] Possibly a slip. In *Modern Painters II* he follows the usual attribution to Cimabue.

Under the mosaic, at the high altar, there were lighted two great equilateral solid pyramids of candles—ten candles each side, consisting therefore of fifty-five candles each. Between them, a diamond of 36 candles, and above a confused mass of about 30 more. It threw the mosaic almost into candle light, but at the west end, twenty-one narrow windows above the bronze doors were lighted by the afternoon sun right through, burning in all their colours, a fiery jewellery. Two full orchestras at opposite sides of the choir, the organ, and the most sweet voiced choristers, pouring out constantly the most divinely variable music, winding through the wilderness of columns in blasts and gusts and bursts of trumpet—never ceasing—while down the steps of the altar, supplied constantly, no one saw whence, came the great procession, black masks and white, a *mile & a half* long when it got into the streets. I saw nothing at Rome comparable to it, and I am almost glad you were not there—it would have excited you too much. Two great bronze angels stood right against the blaze of fire from the altar, dark and quiet & colossal, pointing up to the enormous mosaic of Christ, who sits in judgment, with the hand raised, awful beyond conception, the more so being seen in the twilight of the vault, half hidden by the clouds of incense that filled it. Flashes of light entered when the curtains of the entrance rose, and the columns gleamed along the nave suddenly, and then were lost again, and when the mighty music ceased within, it was taken up outside by the soldiers trumpets. Nor were the people themselves less interesting, all in their full fete dress, half the women in pure white, veils of lace to their feet and the black hair bound in knots & wreaths like the old frescoes. All the bells of the leaning tower clashed & roared together, not in chimes but in one tremendous continued peal which as I past underneath it drowned the whole force of the two military bands *beside* which I was walking, though you might hear among them the deep tone of the sweetest of them all, which sounded when ⟨they brought out⟩ the body of Ugolino was brought out from the Torre della Fame.[1] I never saw anything so solemn—the spectacles at Rome were only gorgeous, but this was sublime, for the cathedral is the most perfect building conceivable for effects of the kind—dark, and labyrinthine, and yet illumined by mighty

[1] For Ugolino, starved to death with his sons and grandsons, see *Inferno*, XXXIII. The source of the story of the bell that sounded when his body was taken from the tower is obscure. Ruskin may have associated the story of Ugolino with the tradition, repeated in Murray's *Northern Italy* (1842), that the 'best toned' bell, the fourth, was tolled when a criminal was taken to the place of execution (p. 452); or, more likely, he may have had the story from an Italian guidebook or a local guide.

frescoes and rich with wreaths of sculpture and embossed with gold, & sanctified by the great vision of Christ, seen always and from all parts, of such size as in cold blood seems almost preposterous, but when you are excited, its colossalness harmonizes with everything you feel, & the expression of the countenance is something from which you cannot turn nor escape.

I haven't time to write any more, for I was kept out late last night—the procession took about two hours to pass through the streets and then there was an evening service when they returned. I didn't get back till nine o'[clock], and couldn't write all then for I was tired & s[leepy], and we had a crashing thunderstorm in the night which kept me awake for an hour & George overslept himself this morning. I ought to be at the Camp Sant now.

<div align="right">Ever your most affecte Son
J Ruskin.</div>

Friday Morning.

<div align="center">39</div>

<div align="right">[Pisa.] Saturday [24 May].[1]</div>

My Dearest Father,

I haven't a moment this morning. I am making my resumé in the Campo and can't write fast enough, so much to note. I have had hard work to get the M[em]mi, but I have done it at last,[2] as close [as] a tracing, and now if anybody wants to know how a lady dances, I can show 'em. I know more about it than all the dancing masters in London. All I can say is that I think St Ranieri's conduct, breaking off in the middle of his conquest to go and be a saint, ungentlemanly in the extreme, and so thinks the proud little puss with the golden hair.

The Arno rose five feet last night, and is going down like the Arve at Chamonix. All well—love to my mother.

<div align="right">Ever your most affectionate Son
J Ruskin.</div>

1 Postmarked Pisa, 24 May. Received and answered 2 June.

2 Scene from the *Conversion of S. Ranieri*, Catalogue 1313. Ruskin's pencil drawing is in the Ruskin Galleries, Bembridge (Bem. 1440). In *Praeterita*, however, he mentions a coloured sketch of the scene which he afterwards destroyed (*Works*, XXXV. 355).

<div align="center">[75]</div>

4

[Pisa.] Sunday morning [25 May].[1]

My Dearest Father,

Of all the inclement Mays I recollect I think this has been the worst. Since I left Sestri I have not had one really fine day, and here I have been completely prevented by the wind from getting out of doors studies, and even from standing long enough about the cathedral to have its architecture. Yesterday in the campo Santo I had to put up a piece of matting to shelter me from the wind. On Thursday night we had an awful thunderstorm, which went away to Florence and caused the Arno, as I told you, to rise, not five feet, but I see now by the marks on the stones, nine. I never saw so furious a current as at 10 o'clock on Friday night—it had risen up to the level *b* in the bridge arches, its usual one being at *a*, and from the consequent narrowing of the space it foamed at the piers like a sea wave, and

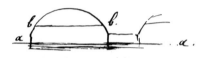

long lines of clotty foam caused by the bridge above (I suppose) came coagulating and writhing down in the moonlight, each the breadth of a road—it was quite horrible. Today again it is cloudy and dull.

I saw some of their improvements going on in the campo santo— yesterday they were going to put up a monument to some apothecary,[2] and so their workmen came and knocked a great hole in the wall, of course every blow of the hammer causing the fresco plaster, already loose, to detach itself more & more from the wall, and tearing down at the same time half of what remained of the outline of a head of Antonio Veneziano. Then they put up a slab with the apothecary's name upon it and saying that it was a great pity he was dead (*I* think it's a pity that anybody here is left alive), and then they knocked down some more fresco to put up his bust. This they put up so as to conceal all that they had left of the Antonio head, and then they filled up the whole with wet plaster, and plastered away half a yard more of the old fresco decorated border on each side, to make the wall flat, and so they left it to damp all the painting above and prepare it for tumbling off next time. But they won't let me take tracings—not they.

I shall certainly get into the habit of swearing in Italy. I am beginning to do so mentally to a considerable extent.

1 Postmarked Pisa, 25 May. Received and answered 4 June.
2 The monument, to the botanist Gaetano Savi, was removed about 1934.

Yet there is some salt of humanity left yet in some of the children. There was a little brat of a boy of three or four pawing the bronze doors the other day, and his sister of eight or nine, ran & stopped him with "Ah—guarda La Madonna chi fa a Giesù!" throwing herself into the attitude of prayer with such quickness & grace & feeling, that it was quite a little bit of Simon Memmi to see.

Also, to his honour be it recorded, that the Custode of Santa Maria della Spina won't take any more pauls!!

1/2 past 10. I got in a rage at having no letters [and] sent to Florence for them on Friday, & [I] have just got all, and glanced over, & best thanks for writing so much & for your excellent & truthful criticism of exhibitions.[1] I assure you I never touch paper but with a view to my book—either to learn something or actually do something—the drawing I took at Albertville was actually for the engraver—& the same at Sestri.[2] I have stopped nowhere at Coutet's instigation—*he* can't bear stopping. I must send off this or you will not get it properly. I will answer tomorrow. I leave Wednesday D.V. for Pistoja. Love to my mother.

<div style="text-align:center">

Ever my dearest Father
Your most affectionate Son
J Ruskin.

</div>

You can show my letters to whom you like. I write for *you*, and it is you who are judge of what you like to be seen, unless I say to the contrary.

<div style="text-align:center">

41

</div>

Pisa. Sunday evening, 25th [May].[3]

My Dearest Father,

I sit down to glance at the parts requiring answer in all your letters. I have your Pisa one with the rest. I will write to Genoa for the Bristol one. I got there only two, one short—from

[1] The Exhibition of the New Society of Painters in Water Colours had opened 21 Apr., the Exhibition of the Society of Painters in Water Colours (Old Water Colour Society) had opened 28 Apr., and the Royal Academy Exhibition had opened 3 May.

[2] For these drawings, see Letter 11, p. 22, note 2 and Letter 20, note 2.

[3] Postmarked Pisa, 26 May. Received 3 June; answered 4, 6–7 June.

London, 17th April—the other with Lord Eastnor's—dated 14th April—& the third, a duplicate of the Lucca and Pisa ones about the Annecy letters—written just before leaving for Bristol.

I take first yours of the 29th April. 1st, I will do all I can at the Monte Rosa about Letters, but I believe that all will be to send Coutet or George with a letter down to Domo d'Ossola twice or three times a week. Otherwise you will probably have none.

I got my money at Les Rousses all right,[1] but I shall require what is ready for me at Florence—vide page 5 at once at X.[2] I spend here in the Inn 17 fr. a day, for I find it impossible to dine at table d'hote —chiefly, here, because the Campo Santo is only open in the afternoon from 3 to 6—and the table d'hote hour being four, would just cut off my whole afternoon—but in general, I find it takes a full hour to get one's dinner, and *then* one gets an unwholesome one— with a chance of draughts into the bargain, for they never let you choose your chair. In my own room I have what I like when I like, and can read—or rest—all the time; moreover all the good rooms in these Italian Inns are in suites, so that I cannot get a decent bedroom such as I could be comfortable in, unless I take a parlour as well. Now I have here two large rooms for George & Coutet, an anteroom, a pleasant bedroom to the front, and a saloon with two windows, two tables, bookcase & sofa (one window to the ground with large balcony—and both commanding the whole Lungo L'Arno, Santa Maria della Spina and the Ponte a mare and Torre Guelfa), all for 10 pauls (six fr. or rather less) a day (they give 17 pauls and a half for 10 fr.), and it is much better for me to pay five shillings for this than 3 and 6d for a single close bedroom at the top of the house, where I could never either get at my own servant, or at the waiters, or at anything else. My dinner and strawberries— with lemonade if I am thirsty—cost me 6 pauls—breakfast 3— Tea 3—Aleatico every *other* day, 3—servants two fr. But I am very expensive in sightseeing. I go up the tower every other night to see the sunset. I have to pay the Campo Santo keeper handsomely for my all day long stay there. I am always poking into churches and paying monks for telling me when I ask about the painter of a picture—"non si sa, è molto antica!"—and finally I am very expensive in guide books and prints. I buy all I can lay my hands on—no matter how bad, they serve me for scratching notes on and references which would otherwise be a mere mass of confusion. I shall give up the guide books however. I wanted today to know the use & history of a number of strange stones built into the quays of the Arno, which have square mouldings and holes that seem to have

[1] The 150 francs deposit on his carriage. See Letter 8, p. 14, note 2.
[2] Below, p. 81. This last clause is an insertion.

supported masts, besides an inscription that I couldn't read. Away I went to my guidebook, and after hunting for some time for the "Lungo l'Arno", for there is no index, I obtained as a reward for my labour the following information.

"Ciunque giunge ai Lungarni di Pisa non può non provare quella piena d'indefiniti sentimenti che si risvegliano all' aspetto di cosa rara e stupenda. L'occhio non sa su quale oggetto primieramente arrestarsi—il regal fiume che in due parti divide la citta, e per corso dolcemente inclinato muove tranquillo al mare, i nobili edifizi che quinci e quindi fiancheggiano (&c.), tutto insomma è un incanto!"[1]

But nothing about my stones! But to go back to your letter. I keep my book, I assure you, most strictly in view, but it is a most bitter feeling to me to see every day all that is beautiful vanishing away—just as I am coming to an age capable of in some measure recording it. Thus in the campo santo—the Giotto is so very nearly gone that I took two days extra to get a perfectly accurate line of it, though all the facts I wanted for my book I could have got at with a far less careful one, and again, I stop here till Wednesday, merely to draw this brick palace,[2] because I expect it to be destroyed when I return, and there is nothing precisely like it in Italy that I know of (my guide book never even notices it, though it tells me all about the "uffizio dei *fossi*"—*sewer* office next door), but this will not often happen, and among the hills I shall neither climb nor ramble, but work constantly for my book & that only. Besides, you cannot guess where I may stay. You see I only stopped a *night* at *Geneva*—and a whole day at *Conflans*—two days only at *Genoa*—and more than a week at *Lucca*. I have my doubts whether I shall stop more than a[3] day at Bologna, but I think it probable I may go again to Pistoja from Florence & stay a week there. If I find myself getting too hot, and if they tell me Venice is unhealthy in ⟨June⟩ July, I shall miss Bologna, go by Modena & Parma to Milan & Monte Rosa, and ⟨return⟩ go to Venice the first week in September, and then straight home over Splugen or Stelvio.

I go back to your letter of 29th with account of Watercolour.[4] I

[1] 'Whoever arrives at the Lungarni of Pisa cannot fail to feel that flood of indefinite sentiments which are awakened at the sight of a rare and wonderful thing. The eye does not know on which object to tarry first—the regal river which divides the city in two parts, and through a gently inclined course moves tranquil to the sea, the noble buildings which here and there border, etc., all, in short, is an enchantment.' 'Ciunque' should be 'chiunque'.

[2] The Palazzo Agostini. See Letter 37.

[3] Ruskin wrote 'a' twice, at the end of one page and at the beginning of the next.

[4] The Exhibition of the Old Water Colour Society.

[79]

am exceedingly glad you have got a Hunt[1] of the kind you describe—
nothing in modern art could be so useful to me, next to Turner.
His interiors are the most wonderful and artistical things in the
society, and I think of having lessons when I return. The Prout[2]
will I know look feeble in the glare of the Room, but be assured
the others are too harsh, not *it* too feeble. You will like it all the
better at home. I shall write to Blake[3] to thank him for enquiries.
I was exceedingly amazed to see the prices those modern pictures
fetched at the sale,[4] compared with some old ones of great value
next week—a Corregio valued at 4000 going for 160.[5] It is all very
well to abuse Dutch people—and I shall never rest till I have brought
them down—but Corregio is another affair—& Parmegiano—and
this is too bad. Callcott's cattle piece is not worth 50£.[6] I am sorry

[1] William Henry Hunt (1790–1864). The picture was No. 68 in the Old
Water Colour Society Exhibition, *Interior, with Still Life*, and the price paid was
15 guineas. Ruskin's father described it in a letter to him of 26 July (Bem. L 3):
'An interior of a part of a stable, no stalls appearing but a Window, not of
Glass but of Horn, & a Cask & a Can & a Rope & a Great Coat, a few cabbages
& Carrots, & all the rest a wall more elaborately painted than built—a wall of
highly worked texture & various complexion, in fact a very interesting wall (I
do not think there has been such a wall since the days of Pyramus & Thisbe).'
It seems to be the same picture as No. 174 in the 1879 exhibition of Prout and
Hunt (*Works*, XIV. 378) and is now at Brantwood, Coniston.

[2] Samuel Prout's *Hôtel de Ville, St Quentin, France*, No. 67 in the Old Water
Colour Society Exhibition, listed in its catalogue as from a sketch by Ruskin
(probably the lost drawing of 1842 mentioned in *Praeterita*; see *Works*, XXXV.
316; Catalogue 1467). His father paid twenty-five guineas for it.

[3] William Blake (1775–1853), a Life Governor of the British Institution since
1818 and a Director since 1838, owner of Turner's *Fountain of Fallacy* (British
Institution, 1839). For Ruskin's developing acquaintance with him in 1844, see
Diaries, I. 267 ff.

[4] The Christie's sale of George Knott's collection on 26 Apr. The prices of the
modern British pictures were considerably higher than even Christie's had
anticipated. Clarkson Stanfield's *Mazorbo and Tercetto in the Gulf of Venice*, for
example, fetched 405 guineas, his *Castello D'Ischia* 680 guineas, David Roberts's
Baalbec 360 guineas, William Mulready's *The Widow* 400 guineas, and C. R.
Leslie's *Scene from the Vicar of Wakefield* 650 guineas.

[5] On 3 May Christie's sold the collection of old masters belonging to Sir
George Hayter, Painter in Ordinary to Her Majesty. The prize of the collection,
No. 83, supposedly a Correggio *L'Homme Sensuel*, sold for 150 guineas, though
Christie's expected 3,000. No. 65, a Parmegiano *St John the Evangelist*, for which
500 guineas was expected, was bought in for 36. The reason for the low prices
is given in the report of the sale in the *Athenaeum* of 10 May, which called the
collection 'a room-full of pictorial rubbish. So far from a Raffael, a Correggio, a
Parmegiano, a Titian, a Perugino, or work of any other first-rate master, it
did not contain even a "capital specimen" of any inferior one, nor yet a good
copy of either!'

[6] Sir Augustus Wall Callcott (1779–1844). The painting is presumably *An
English Landscape*, No. 71 in the sale of the Knott collection. Christie's expected
565 guineas, but it fetched the highest price in the sale, 950 guineas.

to hear Fielding & Tayler[1] are so bad, but it is just what I should expect. Your description of Tayler's heroines admirable. I wish you could see Simone Memmi's ladies beside them—the little proud one with the bright hair especially. My word—how she carries her head—for St Ranieri is evidently beginning to play slower, and she arches her brow and just lifts the under lip, at his audacity in not minding what he is about.

Your next letter is dated 3rd May—before going farther, I have only this, and one on the 10th & one on the 13th. You name one on the 7th which I haven't got. And I don't understand a bit how you could be from Thursday to Monday without a letter when once you had got my Mentone one. You ought to have got one from— No, by the bye I couldn't post any at Oneglia, & I see you had my Savona, so it is all right.[2] But—I say—I don't understand this a [bi]t—you say, "if you find the 50£ transferred to Geno[a a]nd *the Genoa 50* enough for Florenc[e]." I hadn't any 50 at Genoa! The only credits named on my list are Louis Pictet Geneva, Carlone Nice, Plowden Florence (*100£*), Ulrich Milan, Holme at Venice. I only at Genoa got the 50£ transferred there from Nice, and of that, when I reach Florence, I shall not have more than 100 fr left. I have always Coutts 50.[3]

Thanks for account of new watercolour.[4] I will not write on bits again, but thought them easier read than great wide page.

I can't write any more tonight. I will write to J. Richardson,[5] and to Mr Harrison.[6] Very glad to hear of my cousin's being safe home. I am delighted to hear of your coming to Annecy and Carrara next year. But you *never* mean to go by Digne??? you say same road—all among the gravel? Better take the Genevre from Grenoble, or else Avignon.

X

[1] Copley Fielding showed 44 pictures in the Old Water Colour Society Exhibition; Frederick Tayler (1802–89) showed 13, including No. 268, *Gipsy Girl.*

[2] See Letter 14, p. 35, note 2 and Letter 15, note 1.

[3] For his letter of credit, see Letter 8, p. 16, note 1. For Coutts' notes, see Letter 6, p. 11, note 1.

[4] The Exhibition of the New Society of Painters in Water Colours.

[5] Ruskin's Croydon cousin, John George Richardson (b. 1803), eldest child of Margaret Ruskin's sister, Bridget. He had emigrated to Sydney in 1829, married, and become a prosperous draper; and he had just returned permanently to England with his wife and children. He was in poor health and died that October. See Margaret Ruskin's letter to her husband, 22 Apr. 1845 (Bem. L 1), and his letter to W. H. Harrison, 16 Oct. 1845 (Bem. L 5).

[6] William Henry Harrison (1792?–1874), a friend of the family, editor of the annual, *Friendship's Offering* (1835–41), and from 1841 through 1870 a clerk in the Crown Life Assurance Company. He was himself a minor author, had seen Ruskin's poems and *Modern Painters I* through the press, and continued to edit Ruskin's MSS. and proofs until 1870. For Ruskin's letters to him during this tour, see Appendix.

I am very sorry to hear about Harriet.[1] I hope it is not so serious as before.

Pouring of rain tonight again. Love to my mother.

> Ever my dearest Father,
> Your most affectionate Son
> J Ruskin.

Quite well.

I have got the letter of 7th May all right.

42

[Pisa.] Tuesday, 27th [May] morning.[2]

My Dearest Father,

I never saw such weather in my life—hard rain all yesterday—and this morning. I can't do my precious old house—but I have got a beautiful campanile & cloister of convent where St Thomas Aquinas lived & preached,[3] & today I shall go to the Campo Santo once more—off tomorrow for Pistoja—next day I must get to Florence, after seeing what there *is* at Pistoja to be seen. I haven't really time to write a word, for my notebook is full of sentences which will be incomprehensible to *me* in a week, & which I fall a page back in every day—but I merely can note about Turner. I have all your letters. I had read the 7th May one with the others, but afterwards it had got into a corner.

I see in your letter of the 7th you say you were disappointed by Turner,[4] but in that of the 10th you were charmed—this is all right,

[1] Harriet Tovey, sister of Lucy (see Letter 7, p. 13, note 1) and also a maid. She was apparently ill and temporarily left the Ruskins' employ. An entry of 2 June in John James Ruskin's account book (Bem. MS. 28), under 'Servants Wages', reads: 'Harriet leaving £3.18.9.' An entry of 1 Jan. 1846 under 'Charities & Gifts' reads: 'Dr for Harriet 85/.'

[2] Postmarked Pisa, 27 May. Received 5 June; answered 6–7 June. On the outside of the letter, John James Ruskin noted the receipt on 10 May of a Plate, probably a Ruskin vignette given to Cousen to engrave (see Letter 62).

[3] The Dominican church of Santa Caterina. In his notebook (Bem. MS. 5B), Ruskin remarks on the wooden 'lecturing desk or pulpit from which St Thomas Aquinas preached' in the church. The desk is still there, but the story that St Thomas once lived or even preached there is without foundation.

[4] Turner had six oil paintings in the Royal Academy Exhibition that year, all but one of them now in the Tate Gallery, London: No. 50, *Whalers—Vide Beale's Voyage, p. 163*; No. 77, *Whalers—Vide Beale's Voyage, p. 175* (now in the Metropolitan Museum, New York); No. 117, *Venice, evening, going to the ball*; No. 162, *Morning, returning from the ball, St Martino*; No. 396, *Venice—noon*; and No. 422, *Venice—sunset, a fisher.*

just as it should be. It is the same with everything truly Good, from Turner to Giotto. I was disappointed at first with the latter's work here—now I think it the finest thing in the whole cloister. Mighty fellow—he did it at my age.

I still say exactly what I said before leaving—that with the exception of Dudley, Winchelsea, Gosport, Richmond, & Llanthony,[1] I should always be willing to *take* new lamps for old ones; but on no sacrifice, never giving two for one, or anything of that kind, but only adding the esteemed value of the new work to the price we paid—but that I should be sorry to lose *any* of my drawings for oils, or for anything in the world but what Turner is now doing or has done within two years of watercolour from his own sketches.[2]

I rather value Derwent because it was at Keswick that I first recollect ever feeling nature or loving it, but even that should go for a good Swiss drawing—but I don't *want* to part with *any*—and pray let nothing make you *sacrifice* 10s. of their value.

German countess excellent sense.[3]

You will be surprised at the rubbish I send home from here to Maccracken,[4] but it is for love of the *old* baptistery and for an everlasting memorial & witness of Pisan barbarity.

[1] Turner watercolours in Ruskin's collection. John James Ruskin's account book (Bem. MS. 28) records the following purchases: Jan. 1839, 55 gs., *Richmond, Surrey* (now in the Lloyd Bequest, British Museum); Dec. 1839, 60 gs., *Gosport* (Agnew's Turner Exhibition, 1967); Jan. 1840, 55 gs., *Winchelsea* (Lloyd Bequest, British Museum); Apr. 1840, 60 gs., *Harlech Castle* (from 1902 to 1919 on loan to the Metropolitan Museum from George W. Vanderbilt's collection); May 1840, 70 gs., *Nottingham* (now in the Nottingham Museum and Art Gallery); Aug. 1840, £50, *Oxford* (see Letter 68, note 4); July 1841, 70 gs., *Warwick* (now in the Whitworth Art Gallery, Manchester, No. 1700); Apr. 1842, 45 gs.?, *Richmond* (*Yorkshire,* probably the one exhibited at the F.A.S. in 1878; see *Works,* XIII. 430–1); March 1843, £55, *Dudley* (now in the Lady Lever Art Gallery, Port Sunlight, Lancs.), and 75 gs., *Llanthony* (now in the collection of Kurt Pantzer, Indianapolis); June 1843, 70 gs., *Derwentwater* (Lloyd Bequest, British Museum), 75 gs., *Kenilworth* (in the Munro sale at Christie's, 1877), and 100 gs., *Land's End* (*Longships Lighthouse,* now in Lady Agnew's collection).

[2] Ruskin already owned five of these late Turner drawings (the price of each was 80 gs.). Of the ten finished watercolours of 1842, two were made for Ruskin, *Coblentz* (now in the Cincinnati Art Museum) and *Lucerne Town* (now called *Lucerne from the Walls* and in the Lady Lever Art Gallery); and one, *Constance* (Agnew's Turner Exhibition, 1967), his father bought in June 1843 from Turner's agent, Griffith. Of the five finished watercolours of 1843, two were made for Ruskin, *Goldau* and *Pass of Faido, St Gothard* (both in Agnew's Turner Exhibition, 1967). And he had ordered four of the finished watercolours Turner proposed making this year (see Letter 47).

[3] Possibly a reference to a story by Karl Gutzkow, 'Die Selbsttaufe', which had appeared in the annual, *Urania,* published at Leipzig, and which was summarized at length in the *Athenaeum* for 12 Apr. (p. 355), in a review of German annuals.

[4] See Letter 37, p. 72, note 3.

Ahi Pisa—vituperio delle Genti
Del bel paese dove il sì suona.

— —

Muovasi la Capraia e la Gorgona—[1]

I read this always with infinite gusto. Capraia & Gorgona are seen beautifully from the leaning tower, like Capri & Ischia from Naples. Can't write more today, and tomorrow I start at six for Pistoja and so can't post letter till I get there. You may not get it for two days.

[Ever] my dearest
Your most affe Son
J Ruskin.

43

Pisa. Wednesday morning, 29th [i.e. 28th May].[2]
My Dearest Father,
 I think I never was so sorry to leave Mont Blanc as I was to leave the above cloister yesterday. I came back & back again to peep at it through the door grating though all the time fencing with the water spouts off the roof. I intended to have been off very early this morning to get an afternoon at Pistoja, but I am obliged to wait till nine to get my passport viséd. When I haven't got it myself I am fidgetty enough about it, but when I have it in my desk I forget it altogether—luckily I thought of it the last thing or I might have been turned back from Lucca.[3]
 I had a nice piece of work to get my old house[4] yesterday— luckily the weather was *warm* enough for the first time here, but everything else against me except temperature—and that indeed, the other way. First instead of getting to work early in the morning,

1 *Inferno*, XXXIII. 79–80, 82; the beginning of Dante's curse on the Pisans: 'Ah Pisa, shame of the people/Of that beautiful country where "sì" sounds . . . /May Capraia and Gorgona move . . .' Capraia and Gorgona are islands off the Tuscan coast.
2 Postmarked Pisa, 28 May. Received 6 June; answered 6–7 June. Printed at the top of the notepaper, a heavier grade than the rest of the paper bought in Pisa, is a lithograph (4·9 × 8·6 cm.), evidently a lithographic transfer of a copper engraving of the Campo Santo interior by the Pisan engraver Ranieri Grassi (b. 1799). The design is similar to that of the same subject in the second volume of his *Descrizione Storica e Artistica di Pisa* (Pisa, 1837).
3 In going from Pisa to Pistoja, both in the Duchy of Tuscany, Ruskin passed again through the Duchy of Lucca, which did not become part of Tuscany until 1847.
4 The Palazzo Agostini.

it rained till 8, and then I had to wait for the quay wall to dry. Then out came a sun which even Coutet (who held the umbrella) could hardly bear—a *rain* sun of the hottest. Presently that went in and up came half an hour of strong west wind that was like to blow all my brushes into the river—books & umbrella & all. Then it began to rain again, and in the middle of the rain came half a dozen boats towed by men on the top of the wall so that I had to jump up every two minutes. Then sun again & so on, but I have got it in spite of all —a dashing sketch of its shadows, and architectural ones from which I could build, of its details—the *lowest* I have down to the smallest rosettes, and the uppermost I should have had if I could have got a ladder, but I hunted all over the town and couldn't get one!

I'm never satisfied now with my architectural sketches unless I have measures & details, and I don't know how architects get these, but I find it not so easy a thing to measure columns especially, and the rate of bulge bothers me to death. I got floored in the Lombard church at Lucca[1] altogether.

I shall post a letter tomorrow morning D.V. at Pistoja before I leave for Florence.

44

Pistoja. Wednesday Evening [28 May].

My Dearest Father,

I have had a heavenly drive from Pisa—one vista of vine and blue Apennine, convents and cypresses—and I have just come in from an evening walk among the stars and fireflies. One hardly knows where one has got to, between them, for the flies flash, as you know, exactly like stars on the sea, and the impression to the eye is as if one were walking on water. I was not at the least prepared for their intense brillian[cy]. They dazzled me like fireworks, and it was very he[avenly] to see th[em] floating over field beyond field un[der] the sha[dowy] vines.

This is a wonderful place. It is odd. I never knew till tonight where *pistols* got their name from. It is the most untouched middle age town in Tuscany, and its churches are quite perfect—or at least free from any intentional injury—on the outside. *In*side they are whitewashed & barbarized of course, but one may thank heaven here for *any side*.

I came by Voiturier—we are to get to Florence tomorrow, buona mano included for 50 fr, from Pisa. I leave here DV at one, and hope

[1] San Frediano. See Letter 23.

to get to the farthest point of my journey by 5 afternoon. I post this here.[1]

Stopping today for voiturier I dined on the road. I had macaroni soup, an excellent beefsteak, a dish of fresh cut asparagus, cheese, a bottle of lemonade, and wine of course, ad libitum, for two pauls & 1/2, say 13 pence—this isn't dear; but it is curious how barbarous they are. They asked me if I would have any frutta. I asked them what they had. "Dei *Piselli* signor." I didn't know what that meant & said I would have some. Up came a dish of green pease in the shell, raw.

You never say how you are in your letters. Love to my mother.

> Ever my dearest Father
> Your most affecte Son,
> J Ruskin.

45

<div align="right">Florence. May 29th.[2]</div>

My Dearest Father,

I am out of post paper—excuse this till tomorrow. Here I am at last, looking out on the Palazzo Pitti, and our old friend Schneiders,[3] and the house of Galileo,[4] but all seen to mighty disadvantage through the dull grey tones of a rainy evening. I got here pleasantly at five, after spending a pleasant forenoon at Pistoja, which is a town of deep interest, but yet one that I don't like, & where I do not think it necessary to return. The hotel[5] is nothing particular—it looked odd, within twenty miles of Florence, to have one's milk for tea set down in a bottle—made one feel like Hagar in the wilderness[6]—only hers was a water bottle.

I am not pleased with the Tuscan and Lucchese population. The beggars are as great a nuisance as the mosquitoes, and the Doganiere are mean fellows. Coming from Pisa here, there was ⟨one⟩ a Dogana on leaving Tuscany, another on entering the Lucchese territory, a quarter of a mile farther on. At both of these there is a barrier to pay, and at the second, Coutet put his head into the carriage. "Faut il les laisser visiter, ou leur *parler Italien?*" Parlez Italien, by all means, said I. I can't be stopped in the sun here for these oilmen. A couple

1 Postmarked Pistoja, 29 May. Answered 11 June.
2 Postmarked Florence, 31 May. Answered 11 June.
3 The hotel on the Lungarno Guicciardini by the Ponte alla Carraia.
4 At Arcetri.
5 Probably the Hôtel de Londres, just without the city.
6 See Letter 33.

of francs being administered, the baggage was let alone—but again at the gate of Lucca itself, first passport man, then dogana man, fumbling about and determined not to let you pass till he had got a franc. Then passport again, at going out of Lucca. Then passport and ⟨duty to pay⟩ no only ticket to show at going out of Lucchese territory (as big as Hyde Park). Then passport, duty to pay, and dogana man quite rampant, leading of trunks &c in spite of franc, at entering Tuscany—finally in a shower of rain at the gate here, up came an ill looking fellow of a doganiere. "Bisogna visitare—signor." I spoke a little "Italian" to him and he let us pass. But this, though of no *real* inconvenience is worrying from the tone of it and frequency & uselessness and absurdity of it, in a fifty miles journey.

On the whole, these little states are much more troublesome than the big ones. At leaving France at Les Rousses, no one would take a farthing nor loo[k a]t anything. At entering France at Grenoble, they were [rather] troublesome, but wouldn't take. At entering Sardinia a[t Nic]e they kept me half an hour in examining all my books, but gave no trouble about anything else, and wouldn't take a farthing. At Monaco they stopped us until they got something —same at leaving Monaco. Again at entering duchy of Modena—and everywhere since, it has been nothing but begging.

It is curious that at Pistoja they have a complete series of marble pulpits of all dates, richer than any to be met with elsewhere, the best of them[1] beating the celebrated one in the Pisan Baptistery[2] all to shivers. I have no doubt it is the finest pulpit in the world. There is a singular thing on the Hospital front, a series of bas reliefs in *coloured* porcelain by Luca della Robbia,[3] which have of course the most vulgar effect conceivable, looking like the commonest signpost barbarisms. And yet, if you struggle with yourself, and look into them, forgetting the colour, you find them magnificent works of the very highest merit, full of the p[u]rest sculptural ⟨merit⟩ feeling, and abundant in expression, grace of con[cepti]on and anatomical knowledge.

I hope to find one or two more letters lying at post office for me tomorrow. The first place I shall go to here will be the tomb of Giotto.[4] The second, the convent of St Mark, the dwelling place of Fra Angelico.

They say they have had no fine weather here since October. They want to charge me too much for rooms here.[5] I daresay I shall

[1] By Giovanni Pisano, in the church of Sant' Andrea.
[2] By Nicola Pisano, Giovanni's father.
[3] The frieze on the Ospedale del Ceppo, representing the Seven Works of Mercy.
[4] In the Duomo.
[5] At Balbi's, the Hôtel d'Italie, on the Lungarno near the church of Ognissanti.

[87]

leave them and go to an inn that I see Murray recommends as quiet and cheap & comfortable in the piazza Sta Trinita.[1] I hate these big hotels where your waiter is a gentleman, and where they bring you a pat of butter for breakfast of the size of a shilling.

love to my mother, congratulate her on my being safe here.

<div style="text-align: right;">

Ever my dearest
Your most affe.
J Ruskin.

</div>

46

<div style="text-align: right;">

Florence. 30th May.[2]

</div>

My Dearest Father,

I have not done anything here today, for I had to write up my Pisan notes, and it has been thundering & raining & blowing like fury, and the Arno going up and down as if it had tides.

I got a fair half hour to walk to the tomb of Giotto, and spent another by the seat of Dante,[3] looking at Giotto's campanile. But there is beyond all doubt a demon of repairs pursuing me, & I cannot escape it. The first things I set eyes on here were workmen chipping about the Ponte Vecchio. I hoped to myself that my evil spirit would be content with that, & would let me alone. Not a bit— the next thing I saw was a great piece of matting round the pedestal of Benevenuto's Perseus,[4] and the next—woe is me—*two* tiers of *scaffolding* on two sides of Giotto's campanile. Still I kept my temper, for the campanile is so vast that this does not *very* much hurt it, & the workmen are not doing—as far as I can see—harm, but cleaning the mosaics. But when I went a step farther—Do you recollect the street that used to run from the post office to the cathedral, or baptistery—very narrow & Italian, all full of crimson draperies & dark with old roofs? Judge of my horror, when on turning the corner, I beheld, as it seemed, the Rue St Honoré at Paris—with a whole row of confectioner's shops fresh gilt, & barbers between, and "Parfumerie et Quincaillerie"—within ten yards of Brunelleschi's monument![5] They have actually pulled down the whole street & built a new one instead—and a fit one it is for these Italians as they are now—full of bonbons, segars, and pomatum. And actually, when in total despair, I was walking home with my eyes on the

[1] The Hôtel d'Europe. 'For moderate persons, it is perhaps, one of the best in Florence.' Murray's *Northern Italy* (1842), p. 485.

[2] Postmarked Florence, 31 May. Answered 11 June.

[3] On the south side of the Piazza del Duomo.

[4] Benvenuto Cellini's, in the Loggia dei Lanzi.

[5] The great cupola of the Duomo.

gutter, wishing that I could wash the whole population of Florence down with it into the sewer, I was aroused by nearly tumbling over one of the parapet stones of the divine old church of Or San Michele which they have got scaffolding on both sides of at once. I think verily the Devil is come down upon earth, having great wrath because he knoweth that he hath but a short time.[1] And a short time he will have, if he goes on at this rate, for in ten years more there'll be nothing in the world—but eating houses and gambling houses, and worse—and then he'll have nothing more to do. The french condemned the convent of St Marco, where I am just going (Saturday morning), and all the paintings of Fra Angelico were only saved by their being driven out. If I ever write anything that this foul world will listen to (which unless I get more wicked or more foolish I suppose I never shall) and don't black those Frenchmen's faces for them to some purpose, I wish my tongue may cleave to the roof of my mouth.

I didn't get any letters yesterday—oughtn't I to have had some?

I saw Mr Millingen[2] in the afternoon—a funny little, old, useless, body who lent me a guide book with nothing in it, and a map without any names. He says there's nothing here that I can't see whenever I like—and so I thought, by "speaking Italian" at least, and so I shall do; if I get into any difficulties I must trust to Eastnor's letter[3]—not to Mr M., who says "nothing degrades a nation so much as an aristocracy." I don't know what degrades a nation, but I know that for a man, living as he is within forty miles of Pisa, not to know that the frescos are disappearing—is pretty considerable degradation.

<div style="text-align:right">

Ever my dearest Father
Your most affectionate Son
J Ruskin.

</div>

47

<div style="text-align:right">

Florence. Saturday evening, 31st May.[4]

</div>

My Dearest Father,

I received today, just after posting yours, your delightful letter of the 19th enclosing Mr Turner's, & I hasten to reply to the principal points in that & your former letters before I ramble away again.

1st, as to letters received, I have put away the earliest sealed up & cannot refer just now, but I have in my desk 7th May, 10th May,

[1] Revelation 12:12.
[2] See Letter 30, p. 60, note 1.
[3] An introduction to Lord Holland. See Letter 16, p. 40, note 2 and Letter 56.
[4] Postmarked Florence, 1 June. Answered 11 June.

13th May, & I had 3rd May—the Genoa letter I expect tomorrow or next day. As to future places of direction I am at the time being in much doubt, because I have not decided whether to go to Venice first or last, but I hope to remain here until 1st July. I shall know better what time I may want in a week, & then will let you know. If I left here on the 1st July, I could get through Bologna, Modena, Parma, Pavia, & Milan to Domo d'Ossola in I think about 17 days. I could then, allowing a full month for Monte Rosa, reach Venice, doing Padua on the way, by the 1st September—though thus I should have a hot fortnight of August at Verona & Padua. I could then leave Venice by 15th or 18th Sept. for home. Otherwise, I could get to Venice from here, doing Bologna & Modena in about a week, & leave Padua & Venice for Parma & Milan, about the beginning of August, getting to Monte Rosa by the middle of August, and leaving Cormayeur for home on the 25th or so of September. Either way wouldn't do for Gordon,[1] to whom, before I received your letter with note of his visit, I had sent a single line which he will be, or ought to be, very savage at, telling him he mustn't think of me at all, as I can't tell where I shall be—or when. The great bother is the out of the way lie of Parma, which I must go to for an artist whom I hate, Correggio. But I shall know much better next week.

You asked me what were the ordered subjects of Turner. 1st, Schwytz from Brunnen, Mythen in distance (Lake Lucerne), second, Lake Lucerne by Sunset, with the chain of the Alps. Third, Gorge of St Gothard above Altorf in storm. 4th, Rapperschwyl over lake of Zurich.[2] I am most delighted at the way you spend your time after dinner, and at the Slaver's[3] growing upon you, and at your enjoying all that you do. You do not state my assertion rightly about your caring for nothing but execution—you care beyond measure for *feeling*, for force of chiaroscuro, for majesty of form, and for *play* & *brilliancy* of colour. All these are high & some of them

[1] The Rev. Osborne Gordon (1813–83) had been Ruskin's private tutor in 1839 and 1841 and remained a lifelong friend. In 1845 he was appointed Rhetoric Reader and the next year Greek Reader in Christ Church.

[2] Of these four finished Swiss drawings, which Ruskin had commissioned that year, Turner made only the first three (see Letter 102, note 3). His preliminary sketches for them are in the Turner Bequest, British Museum (CCCLXIV. 375, 338, 283), but the whereabouts of the finished drawings are mysterious. Ruskin eventually exchanged the *St Gothard above Altorf* with H. A. J. Munro for one of Munro's 1845 drawings, *Fluelen*, and at one point Ruskin indicates that he included the *Schwytz from Brunnen* in the exchange; see *Works*, XIII. 206 and 476, note.

[3] Turner's *The Slave Ship* (R.A. 1840), now in the Museum of Fine Arts, Boston. Ruskin's father bought it for him as a New Year's present in 1844. The price was 250 guineas.

the highest qualities of art. But the thing which I think you do not quite feel is *quality* and *tone* of individual colour, that particular quality which sets Titian as a colourist so high above Rubens, & this I think you only do not care for because your attention has never been much directed to it, and because we have hardly *any* pictures in England which could exhibit it in a striking degree. For all the Guido & Caracci school, all the Dutch school (except the grand *old men*, Van Eyck & his fellows), and the English school ⟨universally⟩, ay, and all moderns to boot are totally devoid of it. And it is chiefly for this quality—which George Richmond first taught me to feel, & which every day here I feel more & more—that I value all Turner's modern works so highly. Hunt again obtains some very solemn qualities of this kind, which are to me most instructive. The interior bit[1] will however be quite enough.

There is a sort of Harrisonian sound about the Athenaeum extract,[2] but come from whom it will, I am very grateful & glad to see it in the paper, and to find that I really *have* done some definite *good*, besides getting compliments. I expected not so much. I don't understand the *sales* at all—my book[3] hasn't had much to do with that, for it praised none of the artists who sold so high. I am very glad to see Harding's sky noticed,[4] for he was afraid of it, & I pushed him on, and told him to put more fire and smoke into it, and you see it has done him good.

Sunday morning.

If the opal be not gone, and T.[5] will give me 4.10 for it again if I don't like it, I think it would be worth retaining, for such things are not to be had for love or money. I have been inquiring for a specimen for five years everywhere & have never seen one. But it comes now when my head is in other matters—& if it be gone it does not matter a straw—perhaps better.

1 See Letter 41, p. 80, note 1.

2 W. H. Harrison (see Letter 41, p. 81, note 6). The extract Ruskin's father had sent was from the review of the Old Water Colour Society Exhibition in the *Athenaeum* for 3 May, p. 438.

3 *Modern Painters I*.

4 The review in the *Athenaeum* singled out No. 26, *Berne, Switzerland* by J. D. Harding, for special praise: 'The sky is brilliant, original, and daring enough to furnish matter for a chapter for the Under-graduate [*Modern Painters I* was issued anonymously as 'By a Graduate of Oxford'], if he have any admiration to spare from Mr. Turner.'

5 James Tennant (1808–81), dealer in minerals at 149 Strand, teacher of mineralogy at King's College since 1838. In 1853 he became professor of geology at King's. Ruskin was informed by his father in a letter of 20–1 Aug. (Bem. L 3) that 'the Marquis of Breadalbane I suppose has got the opal & Venice is the best place to find one I have heard'.

Cousins engraving[1] may be safely sent here and I will send it back with remarks, but I cannot give it the final touching till I get home, on account of damage in carriage.

I haven't forgotten about Alpine vignette,[2] but somehow I can't write a bit here in Italy. I usually write at night when I go to bed, and here I am always as sleepy as a cat by the fire. I will try to do it however now I am settled. There was an ass of an Englishman giving a ball here last night, hanging red rags all up t[he stair]case. I thought perhaps they would have scraped me awake, [but] I never heard a word of it. We ostentatiou[s] English idiots spend thousands of pounds a month abroad in hanging dirty bedcovers and sticking Venus's without clothes on up Hotel passages—and if I were to ask for a guinea to put a pane of glass into the Campo Santo, they would say "they couldn't spend their money on foreign institutions," blast them. I went to San Marco today and saw the first thing I have seen in Italy done for good—a glass put before a fresco of Angelico's. To make amends—six candles put within six inches of a noble Fra Bartolomeo, which they had dropped over at the bottom & smoked charcoal colour at the top. I saw the Chamber of Savonarola however, and a great many well preserved Angelicos—well preserved barring whitewash, for of course they don't cover them when they clean the ceilings, and they have dropped plaster down the Madonna's cheeks till she looks like a painter & glazier after a day's work.

I walked into the Medicis chapel for a quarter of an hour afterwards, and then spent the afternoon in Or San Michele, by the carved shrine by Andrea Orcagna, which I had never seen before. And my present impression is, from what I have seen of Orcagna in the Campo Santo[3] & here, that Giotto, he, & Michael Angelo are three great piers of an artistical Ponte della Trinita, which everybody else has been walking over ever since. But there is one man more, to whom I go first thing o' Monday morning, Masaccio, of whose place I have yet no idea. But I think all *other* art is derivative from these men—Raffaelle & all, except the colourists, which is another affair altogether.

At 1/2 past 5, I shut up shop, & after running up Giotto's campanile not for the view, but for love of Giotto, and his heavenly building—God bless him—and down again—and just bowing at M. Angelo's tomb in Santa Croce, not to pass a second day in

[1] John Cousen (1804–80), an engraver both Turner and Ruskin used frequently. For the engraving, see Letter 30, p. 60, note 2.

[2] His father had asked Ruskin to write him a poem, a request which produced *Mont Blanc Revisited*; see Letter 56.

[3] See Letter 32, p. 63, note 6.

Florence without doing so—I ran away up and down the hills on the other side of the Arno, all among the olives and figs, as hard as I could, till 8 o'clock, & this I shall do every day, for I can't go on without proper exercise, as I did at Pisa.

I take mighty good care on roofs &c, & everywhere. Love to my mother.

<div align="right">

Ever my dearest father
Your most affectionate Son
J Ruskin.

</div>

I go to Masaccio on Monday, to Santa Maria Novella Tuesday, to Medicis chapel Wednesday, & then I shall begin to see my way a little.

You needn't fear my writing too much. I don't know what I should do if I hadn't somebody to grumble to, but I don't write to anybody else. I haven't even to Turner yet.

48

<div align="right">

[Florence.] Monday morning [2 June].[1]

</div>

My Dearest Father,

I haven't time to write much this morning, but I forgot to tell you to tell my mother not to plague herself about writing—but to save her eyes, to come to Annecy with, and that I don't expect any answers—and I only haven't written lately because I couldn't write two letters in the day, and thought you liked your letter regularly at Billiter St.[2]

I find there are nice walks here on both sides of the town, and the Fiesole road, though very dusty & dead, really is yet [for] that reason, & being up hill, very healthy, so I can get [as] much exercise as I want or like. No heat yet to speak [o]f. Pray tell Mr Harrison I am infinite[l]y obliged for his kind letter, and to write me as many more as his charity will extend to. I want very much to answer him but I can't just now—only tell him to write on good average thick paper, for the thin paper tires my eyes; & I had rather pay a franc or so more.

<div align="right">

Ever my dearest Father
Your most affe Son
J Ruskin.

</div>

1 Postmarked Florence, 2 June. At the top of the letter, 'Need not be copied' is written in John James Ruskin's hand.

2 All of his letters to his father are addressed to 7 Billiter Street, the premises in the City of John James Ruskin's sherry firm, Ruskin, Telford & Domecq. The site is now occupied by Lloyd's.

[Florence.] 2nd June, Monday.[1]
Two—waiting for dinner—bad hotel.

My Dearest Father,

After being kept off and on for three days here in a fine room with promise of less, I find they can't suit me at all—they want 16 pauls a day for their rooms, after beating down—in fact they are all too fine here for me. I inquired at the Europe,[2] but that was worse, and then I went away and have got me lodgings in the Cathedral square,[3] looking bolt on Giotto's Campanile—facing *east*, so that I have the *morning* sun, & no other—at the rate of 25 dollars[4] a month, or about 8 pauls a day. They charge me 11 pauls a day here for meals. I shall be able to get them for 6—then I should have had to give the servants here nearly two francs a day, & much less than that will do with George & Coutet to wait—so [I sh]all give George a little waiting as you wished—all that [I lose] is the standing of the carriage here, which will not be [mu]ch. The great advantage is that I have Giotto's tower & Brunellesco's dome always before me & so need never lose time in wet weather, and moreover am off the Arno— and all chance of malaria—and exactly in the very centre of the town, within just *one* minute's walk of the Piazza del Gran duca,[5] south (with post office & great gallery[6]), the Chapelle des Medicis, west, the convent of St Mark north—and *two* minutes of Santa croce, *east*. If that don't beat Todgers's,[7] what will? Only, I shall have but three weeks of it, for I can't get in till next Monday, and I am just hesitating whether to go into the back room of the same house, which I can have immediately, or to stay here for the six days. I shall have a writing made up, to be sure of my game. I saw an Englishman at the place, just leaving, said they were the honestest people he had met with in Italy.

I went to Masaccio[8] this morning the first thing. I think there ought to be some sympathy between us, for you know he was called Masaccio from his careless habits of dress & absence of mind.[9]

[1] Postmarked Florence, 3 June.

[2] See Letter 45, p. 88, note 1.

[3] At 732 Corso degli Adimari; see Letter 57.

[4] The Spanish dollar, then current in Italy, was worth 9½ to 10 pauls or something over 4*s*.

[5] The Piazza della Signoria.

[6] The Uffizi.

[7] Mrs. Todgers's Commercial Boarding House in Dickens's *Martin Chuzzlewit*.

[8] His frescoes in the Brancacci Chapel of the church of Santa Maria del Carmine.

[9] See Vasari's Life of Masaccio.

And I was not disappointed. It is a strange thing to see struck out at once by a young man, younger than myself (for Masaccio died at 26), that which Michael Angelo came to Study—reverently and as a pupil—& which Raffaelle not only studied constantly, but of which in his cartoons, he copied one of the figures for his St Paul.[1] I am going to get a sketch of Masaccio's head, which is there, painted by himself.[2] It is a kind of mixture of Osborne Gordon & Lorenzo de Medicis (the Magnifico).

I worked on Orcagna in the afternoon, & then walked up to Fiesole. As I was coming down again, I found myself, unexpectedly, standing on the *very* spot, at the end of the cypress avenue, where five years ago—I stood, refusing to look at the Giottos in the little chapel,[3] and running up to this point to see the mountains. What a wonderful change in me since then. Then, I was quite exhausted with the *drive* from Florence. *Now*, I had *walked* there merely by way of uncramping my limbs in the evening, and was plotting with Coutet how to get up a bit of Apennine a mile or two farther on, and ⟨a thousand⟩ 500 feet higher, tomorrow, and that without considering it as a *walk*, merely a *turn*. Then, I hardly had heard Giotto's name, & cared for him no more than for so many signposts. Now, I had spent half the remains of my forenoon (after Masaccio) before three saints of Giotto's in a chapel of Santo Spirito,[4] and look for him everywhere, the first thing & the last.

I am horribly sleepy & can't write any more.

love to my Mother.

ever my Dearest Father
Your most affecte Son
J Ruskin.

Why in the world should you think I shouldn't recollect your birthday?

[1] Compare St Paul in Raphael's cartoon of *The Blinding of the Prophet Elymas* (then at Hampton Court, now in the Victoria and Albert Museum) with Paul in the Brancacci Chapel's *St Paul Visiting St Peter in Prison*, now attributed to Filippino Lippi, though Paul's figure is thought to have been begun by Masaccio.

[2] According to Vasari, St Thomas, the last figure on the right of the central group in *The Tribute Money*, is a self-portrait.

[3] Probably the chiesetta of S. Ansano. The incident, on 23 Nov. 1840, is recorded in *Diaries*, I. 113.

[4] The polyptych in the second chapel on the right of the choir, now attributed to Maso di Banco.

[Florence.] Wednesday, 4th June.[1]

My Dearest Father,

I am to get into my nice lodgings this afternoon, the other people having given up—many thanks to them—and I have them till 4th July for 250 Pauls or, as I make it, about 137 fr, which considering its central situation and that I have two rooms for George & Coutet, is not much over the mark, though I dare say in cheap Florence I might have got it much lower.

I went yesterday to Santa Maria Novella, and was very much taken aback. *There* is the Madonna of Cimabue,[2] which all Florence followed with trumpets to the church—*there* is the great chapel painted by Orcagna,[3] with the last judgment, at least 500 figures—*there* is the larger chapel[4] painted with 14 vast and untouched frescos, besides the roof, of Domenico Ghirlandajo—*there* is the tomb of Filippo Strozzi[5]—*there* is a great crucifixion of Giotto[6]—there finally, are three *perfectly* preserved works of Fra Angelico,[7] the centre one of which is as near heaven as human hand or mind will ever, or can ever go. Talk of chiaroscuro and colour—give me those burnished angel wings, of which every plume is wrought out in beaten gold in zones of crimson & silver colour alternately, which play & flash like, and with far more rainbow hue about them, than the breasts of the Valparaiso birds,[8] which however will give you some idea of the effect and power of light in them—and then the faces, without one shadow of earth or mortality about them, all glorified. I went to the Academia delle belle arti afterwards, merely to see if they had anything comparable to it, but they haven't, and I have no doubt of its being ⟨about⟩ Fra Angelico's masterpiece. It is not large. I have been very much disappointed with his large works, for though a saint, he was evidently not equal in artistical power to the other men of his time—he is exceedingly unequal, often

[1] Postmarked Florence, 5 June.

[2] In the Rucellai Chapel; it is now attributed to Duccio and is in the Uffizi Gallery.

[3] The Strozzi Chapel; the frescoes are now attributed to Orcagna's brother, Nardo di Cione.

[4] The chancel, or Cappella Maggiore.

[5] By Benedetto da Maiano, in the chapel to the right of the chancel.

[6] Then on the church's entrance wall, now in the sacristy.

[7] Reliquaries in the sacristy, now in the Museum of San Marco: *Annunciation and Adoration of the Magi* ('the centre one'), *Coronation of the Virgin,* and *Madonna della Stella.*

[8] South American hummingbirds which, in two glass cases, adorned the Ruskin drawing room; see *Works,* XXXV. 99.

failing from want of power (not of feeling), which happens of course most frequently in his largest works, and he is also a man, strange as it may seem to say so, of singularly *bad* taste naturally—exalted by the purity & intensity of his religion—so that one is always liable, in the middle of his finest things, to see something which provokes, or which makes you smile. His habit of never retouching adds most violently to these defects, for if he had had twice *his* actual power of realizing his divine conceptions, it would have been impossible but that he should fail of doing so at once in *some* of his figures, and as it is, with great weakness of hand & limited knowledge, & moreover leaving every touch as first done "that it might be according to the will of God,"[1] the result is that two out of three heads are failures, and every here & there comes one which is quite painful or absurd. But the *one* in four pays for all, and these select passages, especially in his smaller works, stand altogether alone in art. No other man can be named with whom to parallel him for a moment. Beside them Perugino is prosaic—and Raphael sensu[al]. I a[m go]ing to try to draw a little St Margar[et] fro[m hi]m,[2] for my mother, and I shall outli[ne] this annunciation[3] (which I have never seen engraved nor heard spoken of—it is kept among the relics in a case of gold in the sacristy of Santa Maria Novella), and that is all I shall be able to do, I fear—if I can do that, I shall be very happy.

I spent a glorious afternoon in the old Academy, all among the pictures which you see hanging up in my study. I felt quite at home. Love to my mother.

<div align="right">Ever my dearest Father
Your most affe. Son
J Ruskin.</div>

I am going to devote today to Perugino, going in search of him at Santa Maria Maddalena first & then at l'Annunziata. Raffaelle & M Angelo were great fellows, but from all I can see they have been the ruin of art. Give me Pinturicchio & Perugino & you shall have all the Raffaelles in the world.

What made you fancy I should forget your birthday?

[1] See Vasari's Life of Fra Angelico.
[2] From the predella of the *Annunciation* reliquary.
[3] His drawing of the Madonna is in the Ruskin Galleries (Bem. 1114) and the engraving made from it is reproduced as the frontispiece of *Works*, VII. Catalogue 86.

Piazza del Duomo, Florence. June 4th.[1]

My dearest Father,

I have today yours of the 26th May, with Mrs S.[2] & Punch,[3] the latter *capital*. I *fancy* however, I don't know why, that something in my letters has annoyed you—however I haven't a moment to write tonight, for I am quite tired with writing the enclosed two, which read, & then send, please, sealing Mrs S. with my crystal seal at home, and ⟨sending⟩ enclosing G. R.[4] *open*, inside of it, as sent at present. Here I am i[n] my delicious little room—heavenly air, and all th[e cathedra]l rising against the starlight. I have been qui[te nulli]fied today at Santa Croce—such masses of fresco, [T]addeo Gaddi & others—such abundant feasts of pictures half unknown, to be sifted out—and fin[all]y Giotto's large last supper,[5] his very chef d'oeuvre—*where* should you think—on the wall of a *carpet* manufactory, once the ⟨old⟩ refectory—but of all that tomorrow—best love to my Mother.

Ever my dearest Father,
Your most affect. Son,
J Ruskin.

I have the Genoa letter too today.

[1] Postmarked Florence, 5 June.

[2] Emma Martha Shuttleworth, widow of Philip Nicholas Shuttleworth (1782–1842), Warden of New College and Bishop of Chichester. Her letter asked about a drawing master for one of her daughters and Ruskin, who had known the family at Oxford, replied by referring her to George Richmond.

[3] The review of the Royal Academy Exhibition in the 24 May issue (Vol. VIII, p. 233). See Letter 52, p. 100, note 2.

[4] George Richmond. Ruskin's letter to him is printed in *Works*, XXXVI. 46–7.

[5] Now attributed to Taddeo Gaddi. The refectory is now the Museo dell' Opera.

[Florence.] Thursday, 5th June. Two o'clock.[1]

My Dearest Father,

I have, as I told you, the lost Genoa letter, but there is only in it of particular information the notification of tax upon Governors of Christ's hospital. If the portraits were to be good ones, it would be another matter.[2]

I have been looking over the others too, which give me such nice accounts of Academy. Roberts's figures I particularly objected to,[3] to himself, but he does not feel what is right strongly enough to venture it. I am sorry about what Griffith[4] says of Turner, but I won't believe it until I have clear proof. He painted four pictures for *sale* of the sketches and none were so good as the Coblentz or Lucerne, or Constance, or Bicknell's lake Lucerne, all commissions—nor as Monro's ⟨Lucerne⟩ Zurich.[5] I subscribed to reading rooms, & went yesterday to look for what you told me in Blackwood[6]

[1] Postmarked Florence, 6 June. Answered 15 June.

[2] Ruskin was elected a Governor of Christ's Hospital on 8 May 1840. On 15 Apr. 1845 the Court of Governors resolved that application be made to the Queen and Prince Albert to allow their portraits to be painted for the Hospital and that the Governors be invited to subscribe 5 guineas each to defray the expense. Francis Grant (1810–78), the fashionable portrait painter, was engaged to do them, and the portraits now hang in the dining hall of Christ's Hospital, Horsham.

[3] David Roberts, R.A. (1796–1864), specialized in architectural subjects and in the 1845 exhibition showed No. 34, *Ruins of the Great Temple of Karnak—Sunset*, and No. 405, *Jerusalem, from the Southeast—the Mount of Olives*. In remarks on Roberts added to the third edition of *Modern Painters I* (1846), Ruskin complains of his 'insertion of the figures as violent pieces of local colour unaffected by the light and unblended with the hues around them' (*Works*, III. 225–6).

[4] Thomas Griffith of Norwood, a man of independent means and himself a collector of Turners, had for several years been Turner's agent for the sale of his works.

[5] All the drawings are of the series of ten finished watercolours Turner made in 1842. For *Coblentz, Lucerne,* and *Constance*, see Letter 42, p. 83, note 2. The *Lake Lucerne* made for Elhanan Bicknell is now called *Brunnen* (Agnew's Turner Exhibition, 1967). The *Zurich* made for H. A. J. Munro (d. 1864) of Novar, Rosshire and Hamilton Place, Piccadilly, one of the most notable Turner collectors, is now in the Lloyd Bequest, British Museum. Ruskin reassures his father—evidently worried about having bought a pig in a poke in commissioning the four Turner drawings from sketches (see Letter 47)—that the four exemplary finished drawings of the 1842 series (see *Works*, XIII. 477) were not so good as these 1842 drawings commissioned from sketches.

[6] Probably the article on J. C. L. Simonde de Sismondi's *Études des Sciences Sociales* (3 vols., Paris, 1837) in *Blackwood's Magazine* for May, Vol. LVII, no. ccclv, pp. 529–48.

& quarterly.[1] Neither had come. They were "expected"—a month after time! The whole town seems asleep, no ideas or desires in anyone's head but eating & smoking, begging, or cheating. The sketches of Turner in Punch have given me quite an idea of the pictures, but the critique is but shady.[2] I could [do][3] with a much more laughable one.

I don't want life of Correggio—don't care a farthing about him. Very glad to hear of Twig's[4] arrival or expected arrival—shall be glad of his acquaintance.

I don't think the Italians have soul enough to feel anything about foreigners paying for their buildings.[5] If the English would give the money, they would *take* it fast enough. They whitewashed Giotto's portrait of Dante[6]—the government wouldn't pay to have it cleaned off, but it permitted some English & Germans to subscribe & do it. In the same way they have turned the refectory of Santa Croce into a ⟨cotton⟩ carpet manufactory, & the government does nothing to save the frescos. Of course the dust & machinery will soon conclude the business.

I am delightfully off in my ⟨new⟩ lodgings—as cool as possible, but there is no heat yet. I can walk about anywhere—all day. Love to my mother.

<div align="right">

Ever my dearest
Your most affe. Son
J Ruskin.

</div>

I see you cry out against Howard.[7] He is not only R A, but *professor* of painting to the Royal academy—and lectures on Michael Angelo.

[1] Probably the review of Richard Ford's *A Handbook for Travellers in Spain* (2 vols., London, 1845) in the *Quarterly Review* for June, Vol. LXXVI, no. cli, pp. 137–9. The review opens with a criticism of Murray's *Northern Italy*.

[2] The review of the Royal Academy Exhibition in *Punch*, Vol. VIII, p. 233, contains the following critique: 'No. 77 is called *Whalers*, by J. M. W. Turner, R.A., and embodies one of those singular effects which are only met with in lobster salads, and in this artist's pictures. Whether he calls his picture *Whalers*, or *Venice*, or *Morning*, or *Noon*, or *Night*, it is all the same; for it is quite as easy to fancy it one thing as another.' The sketches are two small rectangles, each with several squiggles, one labelled 'Venice by Gaslight—Going to the Ball' and the other 'Venice by Daylight—Returning from the Ball'. See Letter 42, p. 82, note 4.

[3] Omitted by Ruskin.

[4] A little white terrier just acquired by his father.

[5] See Letter 32.

[6] Now attributed to Giotto's school, it is in the fresco of the Last Judgment on the altar wall of the chapel of the Palazzo del Podestà (Bargello). The chapel's frescoes had been rediscovered in 1840.

[7] Henry Howard (1769–1847). In the 1845 exhibition he showed No. 179, *Incident from Scott's Anne of Geierstein*, and No. 219, *Sketch from Southey's Thalaba*.

I ran into the great gallery[1] today for the first time, but after our own Elgins, its Greek things are not worth a glance. Good lot of pictures to be run through, but won't take me long, except an Angelico or two, and some of the early men in the first quarter of it. I spent an hour and a half before a Fra Angelico—& hadn't enough of it neither. I learned how *ladies* dance from Simon Memmi—and I saw *angels* dancing today—and so I know how *they* do it. I wish you could see one of Angelico's, either dancing or singing. One that I saw today—Vide Supplement.[2]

One that I saw today had just taken the trumpet from his lips and, with his hand lifted, listens to the blast of it passing away into heaven. And then to see another bending *down* to clash the cymbals, and yet looking up at the same instant all full of love.[3] And their wings are of ruby colour & pure gold—and covered with stars—and each has a tongue of fire on his forehead, waving as he moves. I say *he*—and his—but that is wrong. For they are of no sex. Their hair flows in ringlets, and their eyes are the eyes of doves, but their majesty and power are ineffable. You can't use pronouns to them— any way.

Raffaelle's madonna in the tribune[4] isn't bad—neither—but it is much more human. Still, it is far finer than I thought—beats the Paris one[5] all to nothing.

53

[Florence. 6 June.][6]

My Dearest Father,

It really was most fortunate for me that the Landlord of the Italia was an overcharging scamp (though we may just as well remember the fact), for otherwise I should not have got into these very nice quarters—it is really a great luxury to see the form of the cathedral against the night sky, & to be able to saunter in the great square in the twilight without having a riverside walk home. As

[1] The Uffizi.
[2] A small enclosed sheet on which the rest of this letter is written. At this point in the letter there is a note to a copyist in John James Ruskin's hand: '(Go to No 71 X) a little bit to finish this then come to end of this No 70.' On the enclosed sheet he wrote: 'This joins 5 June Letter 1845.'
[3] The angels are on the frame of the Tabernacle of the Linenweavers, now in the Museum of San Marco.
[4] *Madonna del Cardellino.*
[5] *Virgin with Child and Little St John* (La Belle Jardinière) in the Louvre.
[6] Postmarked Florence, 7 June. Answered 16 June.

for the saving, the people here supply me with everything, at the rate of Breakfast 1 1/2 paul, Dinner 4 p., Tea 1 p., Bottle Aleatico when I want it, one p., Lodgings 250 p. to the 4th July. That is, 14 1/2 pauls, or 8 fr a day. The standing of the carriage is 25 p. more, making it about 7 and sixpence a day altogether. But would you be so good as to write me here what I ought to give the servants for making my bed & cooking—of course George waits. And please ask my mother which of my rooms wants a rug, or a bit of carpet, for I want to buy a bit made under the Last Supper of Giotto,[1] partly for memory of the place, partly to keep me well up to the boiling point against the nation and its ways—for I will not forgive them.

I past such a forenoon today—trying to do something, and always stopping for a quarter of an hour every time I looked up at my original, the Fra Angelico in Santa Maria Novella.[2] It is in the Sacristy, and the priests wheel its glass case out for me, and make me very comfortable, but it is such hopeless work. First of all, the whole background is solid with gold, so wrought up with actual *sculpture* that he gets *real* light, not fictitious, but actual light, to play wherever he wants. For instance in the angels' wings. Commonly artists only indicate, even the most laborious of them, the general run of the plumes, so— &c. But Angelico does them so— every single ray of the feather being cut *into* the gold, so that as you move, the light plays about upon every plume just as on a dove's neck—and the eyes are painted with a ruby coloured enamel—and the plumes themselves are shaded with this ruby colour, as I have shown—and then, wherever they are dark, a blow is given with a blunt gouge which causes a hollow circle of burnished gold that glitters like a star—and the rays round the angels' heads are done in the same way, so that you never see the light twice in the same place. Of course it is impossible to draw it— it can only be worked out by the jeweller. If this were the accompaniment of bad drawing, one might despise it, but when the *colours* themselves are as pure as the jewellery, and when the faces for which all is done ⟨are⟩ look as if the mere being *near* them were enough to turn the picture into gold, its effect to me is most divine.

It is curious to see how Angelico *reserves* himself for high subject. In every one of his pictures, all the saints are superior to any of the men—and all the angels superior to any saints—so that unless there be a madonna or angel in the picture, you never see his strength

[1] See Letter 51. [2] See Letter 50.

[102]

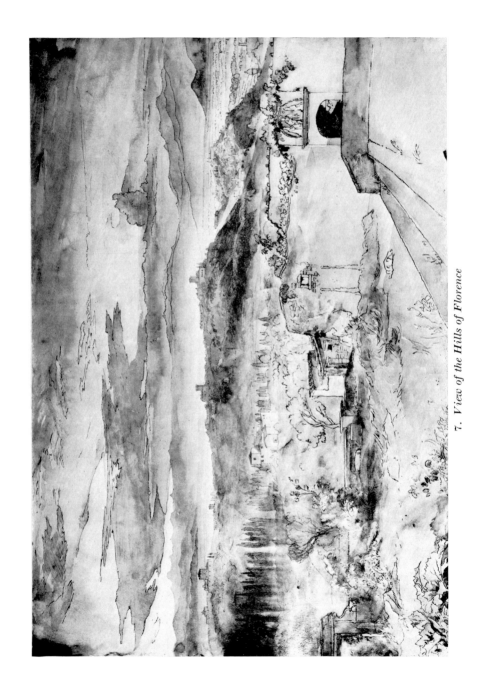

7. *View of the Hills of Florence*

put out. He will not paint angelic men. His men are clay, and his angels are spirit. Hence his pictures of earthly subject are often disagreeable or ludicrous, and always poor. But the moment he touches the clouds, he is all himself.

That Millingen is a funny old fellow. I can't make him out. I went to him today, because I can't get into a nunnery which I want to— they have got a Pietro Perugino in their cloister,[1] and he had never heard of it! I shall see what he can do for me now. The monks outside vow I must have leave from the Pope.

I get pleasant walks here in the evening, though the country is much too villa covered to be very artistical—there are no rich foregrounds nor much disorderly vine—all is pruned pretty close & looks *neat*, except a cypress walk or two—one up behind the Palazzo Pitti, and one—my favourite—up to St Miniato. But they all seem healthy, & are well frequented, so that one is always safe. Very different from Pisa in this respect.

The air was very delicious today on the hills—& the birds have all Italian voices—mellow and sweet & pure—and sing everlastingly. I have got a pretty outline of the hills[2] with Galileo's house on them, & the Val d'Arno, with Cajano—the place where Bianca Cappella perished[3]—and the Carrara mountains behind. Those Carrara Peaks form the whole glory of the mountain line—at Pisa, Lucca, La Spezzia, & here. Can't write any more tonight.

<div style="text-align:center">

Ever my dearest
your most affectionate Son,
J Ruskin.

</div>

One is *just* beginning to enjoy an ice now & then, but for anything I see or feel yet, one might stop all summer here, for the churches are as cool as possible all day. Love to my Mother.

[1] The great fresco of the Crucifixion in the chapter room of Santa Maria Maddalena dei Pazzi.

[2] See Plate 7. Catalogue 723, now in the City Art Gallery, Birmingham.

[3] Bianca Cappello, a famous beauty, was mistress and second wife of Grand Duke Francesco I. They died in 1587 at the Medici villa of Poggio a Caiano, supposedly made by Francesco's brother, Ferdinand, to swallow poison they had prepared for him.

[Florence. 7 June.][1]

My Dearest Father,

I have today your letter of condolence on my long want of letters, but I knew it could not be otherwise as I had altered my route. I never vex myself about contingencies or conjure up evils. What says George[2]—Either grief will not come, or if it must, Do not forecast. For while it cometh, it is past. Away distrust—my God hath promised—he is just. Vide "the Discharge". Thanks also for extracts from comfortable Italy. I don't know what he means by the ancients avoiding supper[3]—what is coena Latin for it—one meets with the word oftener than any other. Juvenal mentions the sleepless nights after eating peacock.[4] Horace was kept waiting for his supper in the Pontine marshes.[5] Nevertheless, I never take any, but live here much as at home. Breakfast at seven—a single egg & bread and butter. Dinner at two—always a little soup & bouilli, which everybody takes here & so I believe it is right, *one* dish of meat, a pudding, and no desert, a glass and a half wine. Work till 1/2 past five, then walk till eight. I come in very thirsty and have my tea and 18 strawberries—never touch any other fruit. If I took my dinner later, I should be knocked up in the *fore*noon & lose the *after*noon—if I took my tea at five or 6 before walking, I should still come in thirsty and the end would be two teas—or ices—or something. I watch myself very carefully, and am always ready to stop if I find bad taste in mouth, or anything else. But my appetite is so good & regular, which is not usually the case with me in Italy, that I have no fear.

I am not going to Pisa. I merely wrote to you in case you might *wish* me to go.[6] I had rather *not* myself—can't bare their rubbishy candles—and have quite little enough time here.

I gave myself a regular setdown today—with Fra Angelico. Did an angel's face seven times, and did—*for* it. Never was so plagued in all my life—got as hot as fire—and came away at last feeling as if I had been beaten all over—partly with the effort, & partly with the excitement of the heavenly thing before one—it isn't good for one

1 Postmarked Florence, 8 June. Answered 16 June.

2 'Herbert' inserted here by John James Ruskin. Ruskin quotes, inexactly, the last stanza of 'The Discharge' from *The Temple*. The third line reads properly: 'And while it cometh it is almost past.'

3 A. C. P. Valery, *L'Italie confortable. Manuel du touriste* (Paris, 1841), p. 1: 'Le voyageur devra se garder du souper, périlleux surtout dans les lieux humides ou voisins de la mer, et que la sagesse des anciens avait évité.'

4 Apparently a reference to *Satires*, I. 142–3.

5 *Satires*, I. v. 7–9. Actually, Horace waited while his companions supped.

6 See Letter 35.

at all—just like *too* good music. I believe I shall have to give it up. I wasn't fit for anything else, so I sauntered into the Palazzo Pitti to look at the Salvators which I was rather curious about. I was disappointed exceedingly as I walked through the rooms. After the frescos I have been among, the pictures looked like rubbish, and most of them, thanks to the cleaners, I find *are* so. Nothing is left of Titian's Magdalen but a lock or two of curly hair—and her box.

But for Salvator—I was so thoroughly disgusted that I could hardly bring myself to stand before the pictures. I could not, by the by, have come from a more unfortunate school, for him, but I never thought he was such a mindless charlatan, such a sanguinary ruffian—his battle pieces[1] are fit for nothing but signs over a butcher's shop—it is pollution to look at them—and his two celebrated marines[2]—!! But you see if I don't give it him. I'll settle his hash for him this time.

The Raffaelles are very well, but the Tribune one[3] is the thing. There are some Peruginos that will detain me a little in the Pitti—for the rest, I shall knock it off fast enough—and much need, for every cloister of every convent here is glowing with treasure.

Sunday morning [8 June].

I had a delicious afternoon to make amends for my morning's failures—among the cypresses by Galileo's house. There isn't much valuable study however out of doors here—no foregrounds, all too trim.

Among all the misfortunes caused by my repairing demon,[4] it has done *one* little good—they have got the inside of the Cathedral quite into order here, and its noble coloured glass, which, singularly, I do not recollect[5] noticing before, makes it very noble. At Santa Croce too the glass is most gorgeous, and I had no recollection of it. I am just waiting for your reply, which I imagine I shall have in a week or so now, about the different routes for Venice,[6] before I settle—of course as I shall be three weeks here yet, you have still time to send me word of how you would think it best to manage. I am inclined however to take the mountains first, as it will give me a little time to arrange & digest what I have learned here, before

[1] In his notebook (Bem. MS. 5B), Ruskin lists 'Two Battles' by Salvator Rosa in the Pitti, but there is now only one still attributed to him, with a supposed self-portrait in the lower left-hand corner.

[2] For Ruskin's criticism of them in his notebook, see *Works*, III. 517–18, note.

[3] See Letter 52, p. 101, note 4.

[4] See Letter 46.

[5] He first wrote: 'I recollect not'.

[6] See Letter 47.

I throw mysel[f into] the colouring school. D.V. as I have my Lodgings till the [4th Ju]ly, I shall give them a paul or two for the Sun[day] and le[ave] on Monday 6th—and so you can calculate the latest for writing here. I have now therefore just four we[eks], which gives me only three days for each important object—thus,

Pitti—3 (where I have to copy a bit or two of Salvator)
Great Gallery 3 (I have done nearly half of it, in two),
Santa Maria Novella, 3—to finish Angelico if I can, Domenico
 Ghirlandajo's frescoes, & Orcagna's,
Gallery of Academy, 3 (not quite enough),
Santa Croce, 3, Taddeo Gaddi & Giotto, and a wonderful fresco of
 Ghirlandajo,
St Mark's convent ⎱
 & Annunciata ⎰ 3, Angelico & Andrea del Sarto,
Carmine & Santo Spirito, 3, Masaccio & Perugino.

With three days to spare—sure to be lost among other things, and no time left for the Medicis chapel. Still I find my Michael Angelo opinions pretty settled & comfortable, & don't want so much for him.

55

[Florence.] Sunday evening [8 June].[1]

My Dearest Father,
 I shall write to my mother tomorrow. I should have done so today, but thought, of a sudden, that you might fancy I had been unwell at Sta. M. Novella if I didn't write to Billiter St.
 I never see anything nice on Sundays here—the English church[2] comes just at the mass times, and I stop in the rest of the day, and make it a rest—except that I walked [to F]iesole this evening.
 Coutet has [s]ome queer acquaintance—he went the other day to pay a visit to a countess, a niece of Napoleon's, a Corsican, whom he had taken up the Montanvert. She *was* living at Bologna, but one day, having quarrelled with her coachman, she drew a pistol and shot him, for which the Pope sent her out of his dominions, so she lives here and came to the ball I told you of at the Hotel d'Italia.[3] Coutet says she is as big as a butcher, and that when he had to give her his arm on the Montanvert, he would as soon have

[1] Postmarked Florence, 9 June.
[2] Behind San Marco. Built by subscription, it was opened in Nov. 1844 and the price of admission was three pauls. Divine service was performed at 11 a.m. and 3 p.m.
[3] See Letter 47.

carried the mule. She had a servant, a Balma,[1] from Chamonix, that Coutet went to ask after.

Love to my mother. Quite well.

<div align="right">
Ever my dearest Father,

your most affe Son

J Ruskin.
</div>

George has a long letter from Lucy[2] with a capital account of a trip to Calais.

<div align="right">
Monday morning.
</div>

Mighty cool & shady it is always in the mornings here. I forgot to answer your query about the verses—you read quite right—servant, piny.[3] It is useless putting off longer in hopes of being in the *vein*, which I never am, by any chance now—so I shall just sit down tonight & write you a verse or two the best I can, for Chamouni, & send them in my mother's letter—but they are sure to be bad.

56

<div align="right">
[Florence.] Monday Evening, June 9th.[4]
</div>

My Dearest Mother,

This day last year, I spent the afternoon sound asleep at the foot of a cascade on the Tete Noire. *This* afternoon I spent in right hard work among the cypresses of San Miniato—but in air of very nearly the same quality, for it was fiercely warm that day in Chamonix. I came home a little earlier than usual to write to you, and do my father's verses, and as ill luck would have it, found a note from Mr Millingen asking me to come over; which when I had done, I found all that he had to tell me was that he couldn't get me into the convent at *present*.[5] Mr Molini[6] is worth a dozen of him—he says he has no doubt of getting the archbishop's leave tomorrow. However, I find there is difficulty as well about getting to draw in the Pitti, and Millingen forgets everything I tell him, so I shall call on Lord Holland[7] tomorrow, and try what Eastnor has done for me. All this however has taken up time, and I had my father's verses to do when I came in—and mighty bad ones they are—but he must take 'em, with my love, for want of better. I am getting far too methodical to write poetry now, and a little too pious—as you will

[1] Balmat, a family of famous Chamonix guides.
[2] Lucy Tovey, the Ruskins' parlourmaid.
[3] See the poem in Letter 35, lines 5 and 8.
[4] Postmarked Florence, 10 June. [5] See Letter 53.
[6] Bookseller in the Via degli Archibusieri, formerly librarian to the Grand Duke, and a partner in the firm of Molini's in London (see Letter 119, p. 195, note 2).
[7] Henry Edward Fox (1802–59), fourth Baron Holland, Minister to Tuscany, to whom Eastnor had provided Ruskin with a letter of introduction.

<div align="center">

[107]
</div>

5

see by the tone of them—and perhaps a shade too modest into the bargain, as you will perceive by my comparing myself to Moses & Elijah in the same couplet.[1]

But the fact is, I really *am* getting more pious than I was, owing primarily to George Herbert, who is the only religious person I ever could understand or agree with, and secondarily to Fra Angelico & Benozzo Gozzoli, who make one believe everything they paint, be it ever so out of the way. I am fully persuaded that the Virgin was sitting under a golden canopy twenty feet high, with a crown of stars on her head, when the angel came to her, because Fra Angelico says so. (I shall write next page in two to make shorter lines for you. I would write better, but it is very late already, & I haven't time.)

You know it is quite impossible to be always among saints without feeling better bred for it—and today I was all the morning among a host—not of mere saints—but of downright Virtues, in the Chapelle des Espagnole of Santa M. Novella, where the two friends, Simon Memmi & Taddeo Gaddi—friends because fellow pupils of Giotto—and equally venerating & loving their master, worked hand in hand, each trying to set off and adorn the other's work, that Vasari[2] exclaims in a pretty burst of feeling—"Oh noble souls, that without ambition or envy did love each other so brotherly, and were glad each in his friend's honour, as in his own." And there are all the Virtues and sciences sitting side by side about St Thomas Aquinas[3]—and each Virtue has beneath her, her favourite saint— and each science her keenest votary. There is Charity—not our hospital charity with three babies strangling her—but divine charity, clothed in red for blood, & with a flame of fire upon her head, and a bow in her hand, and under her is St Augustine—and there is faith guarding Christ's flock,[4] and a pack of wolves driven away, by a whole troop of *black & white* dogs, who bite very hard indeed, so that the wolves roar again—and the black & white dogs who look very sensible about the face, are the Dominicans— *Domini-canes* (Ask my father) who wear as you know black & white robes. And there is Music,[5] or rather St Cecilia, and under her is Tubal Cain, beating on his anvil with two hammers & starting at the change of sound—and there is—but there isn't anything that isn't there—and all so beautiful & pure—and seen by the soft cloister light, for it is in the chapter house that opens off the *green*

[1] The verses were *Mont Blanc Revisited* (*Works*, II. 233 ff.). For the comparison to Moses and Elijah, see stanzas ii and vi.

[2] In his Life of Taddeo Gaddi. The frescoes are now attributed to Andrea da Firenze.

[3] Left wall, *Triumph of St Thomas Aquinas*.

[4] Right wall, *Way of Salvation (Church Militant and Triumphant)*.

[5] *Triumph of St Thomas Aquinas*.

cloister, so called because of the *green* frescos of Paul Uccello (Paul *Bird*), who painted all the Old Testament there[1]—only inferior to Benozzo Gozzoli's. The outpouring of *mind* in these frescos is something marvellous. The Pitti palace is such paltry work after them—such labour of oil & varnish over a single head—while the brush of the great old men is rolling out creation after creation— hosts of solemn figures & mighty spirits—all in the pure air & bright light—and all not as if ⟨they came for you⟩ you came to *look* at them, but as if *they* came to speak to you. In Orgagna's frescos at St Maria Novella, there must be five or seven hundred figures. In Ghirlandajo's perhaps three, or three hundred & 50. In Paul Uccello's, the same—in Memmi's two hundred—in Gaddi's 150. Say 1400 in all—and these all full lengths—grand & full of character, half of them actual portraits of great men—and then think what the few rubbishy heads & shoulders in the oil galleries look after it. Well might M Angelo say oil painting was only fit for children.[2]

Tuesday morning.

Summer is come at last (mosquitoes & all). Such a lovely sun as shines in at my window, after glittering and glancing over the marble carving of the Campanile—and yesterday as I was studying among the trees, the mosquitoes kept me company all the time. I didn't calculate on this enemy. I shall certainly have to save myself among the snow when I have done with Florence. Not that it is too hot. It is warm, but not oppressive, and in the churches always cool. I do not feel half the *heaviness* of heat here that I do in London, and last night when I came back from Mr Millingen, with the new moon up, seen through the arches of the Ponte Vecchio, it was quite divine.

By the by, you needn't have sent me a medicine chest. I never saw such a pretty thing in my life as the "spezieria" of Santa M. Novella. The monks are the apothecaries of Florence, and there is room after room opening off the cloisters in the most exquisite order & taste—a very toy of bottles and shelves—and a lovely garden in the middle buried in rose leaves, where they grow all they want. It is very curious to see the shelves and drawers and jars of an apothecaries shop exactly under, & touching the bottom of, frescos by Taddeo Gaddi, and with a vaulted roof above, & monks behind the counter.

Would you tell my father that if he thinks it best for me to go to the Alps at once, to write to *Gordon* at Linly Hall, near Broseley,

[1] Only four of the frescoes are still attributed to Uccello himself.
[2] See Vasari's Life of Sebastiano del Piombo. Vasari's word, however, is 'infingardi', idlers.

Shropshire, and apologize to him for the letter I sent which I ordered to be paid, but which couldn't be paid, I found afterwards, & to tell him that after the 15th July, I am to be found at Val Anzasca, or near it, for a month & that I will leave a letter for him at the post office Domo d'Ossola, saying where to find me, and that if he can take the mountains first, we will go to Venice together in September. And send me word about my carpets. Give my love to Richard Fall,[1] and say I haven't written to anybody *yet*, but will, and give my love to Anna Anderson,[2] and say I haven't written to anybody yet, but will, and give my love to Louise Ellis[3] & Walter—and regards to everybody—and remember me to all the servants—& put Tug[4] in mind of me, and give Cyrus[5] some biscuit for me, for there isn't any other way of touching *his* feelings, and tell *Twig*[6] something about me—and so, with dearest love to my Father, believe me my dearest Mother

<div align="right">
Your most affectionate Son

J Ruskin.
</div>

By the bye, mind you don't *write*. I understand quite well why you don't like writing to me, and don't, & take care of your eyes.

<div align="center">

57

</div>

<div align="right">
[Florence.] June 11th.[7]
</div>

My Dearest Father,

I have today your letter of the 2nd June, with all its complaints—but why do you make yourself so uncomfortable? I always enquire at Post office the last thing before leaving any town—and I only do not enquire often when there is little chance of letters, because the office people get careless in looking and might miss one. I have all you mention—Genoa 23rd April, Pisa 13th May, Pisa 29th May. I never make myself uncomfortable when I know that the letters are going all right and that I only don't get them because I am kept after my time. If, for instance, I weren't to hear a[nyth]ing *here* for a week or a fortnight, I should be anxious, [but] at Pisa I knew I couldn't get the letters. I should have se[nt] for them before I did,

[1] A friend since childhood, when they were neighbours at Herne Hill, Camberwell. For an account of him, see *Works*, XXXV. 138–9 and 441.

[2] The young daughter of the Rev. Matthew Anderson, who had become Vicar of St Paul's, Herne Hill, the year before.

[3] See Letter 12, p. 31, note 5.

[4] The Ruskins' dog.

[5] A pet rook?

[6] See Letter 52, p. 100, note 4.

[7] Postmarked Florence, 12 June. Answered 21 and 24 June.

<div align="center">

[110]

</div>

had I not feared a confusion with Post offices which actually happened, for a letter of yours was sent to Pisa from Florence while I was at Pistoja—or rather the day ⟨after⟩ I got here—and I didn't get it back for two days—then sent me by Mr Peverada.[1] I sent at last because I thought there might be something requiring answer.

I am quite sure you must find my hand horribly bad, the reason being chiefly that when I can't keep awake to write about art, I *can* to write to you—being more interesting—and so write sometimes with the pen dropping out of my hand, and always very fast, or I could not write so much, and also I am drawing all day which spoils the hand fearfully.

Best thanks for Punch,[2] which is capital & will do the Academy a great deal of good. It is odd enough, in the picture they fall on Collins for.[3] *I* attacked him about his perspective, and spent an hour in trying to get a rule or two into his thick head—uselessly. Oh—about Venice I will do exactly as you and my mother think best, & there is plenty of time to write about it. The time lost is as you will see by my former letter, only the difference between these

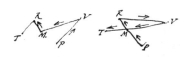 two *routes*, P. parma, V. Venice, R. Mont Rosa, M. Milan, T. Turin, for I should spend just the same time at each place whether I went one way or the other.

I don't care a straw about the heat, but the mosquitoes begin to bother me considerable already in drawing out of doors. I got the enclosed today[4]—of course I must go—but I shan't get into many such scrapes if I can help it. A decent *time* though, better than evening, though it loses my afternoon's work. Love to my mother. What does Harriet[5] do after leaving us?

<div align="center">

Ever my dearest
your most affecte son
J Ruskin.

</div>

If you like to write now to 732, Corso degli Adimari, Au second, I shall be sure to have your letters as soon as they come.

[1] Ruskin's landlord in Pisa.

[2] A second review of the Royal Academy Exhibition, wickedly funny at times, which appeared in the 31 May issue (Vol. VIII, pp. 236–7).

[3] William Collins, R.A. (1788–1847). The review singles out his *Undercliff, near Ventnor, Isle of Wight* (No. 126): 'As the artist has R.A. at the end of his name, we must conclude that the picture is quite correct, and we therefore must conclude that the horizontal line is not quite so horizontal as people are in the habit of thinking it.'

[4] A dinner invitation from Lord Holland for the following day.

[5] Harriet Tovey; see Letter 41, p. 82, note 1.

My Dearest Father,

We are getting it piping hot at last, tant mieux. George came in this morning with his great round eyes deader than usual saying he felt "quite like a fool". I said I was very glad he had such correct feelings upon *any* subject. Oh Sir—he said—think of them at home walking in the acacia walk, and eating as many strawberries as they like, and having all the ⟨curtains⟩ blinds down in the library, and here are we without a breath of air, and mustn't *eat* anything!!! For I had told him, what is very true, that he mustn't touch fruit of any kind now the hot weather has begun.

Horribly stupid affair at Lord Holland's yesterday—party of nine, and a fool of a lady. I had no opportunity of speaking about what I wanted—however I shall go & call, a[nd] may do it then. Lord H. young—a little of the exquisite—but I daresay amiable enough in his way. Nice cool rooms after dinner, open ever[y] way, vines and geraniums coming up through the floor and all over the ceiling—birds—fish—fountains—everything that can flutter or splash—& orange garden below. I have got my admission to the *Convent* through Molini.² Millingen is good for nothing—quite in dotage—recollects nothing that is said to him or that he has said. I didn't catch any name yesterday but Vivian, and as there were no nice people it didn't matter. George has a letter to send tomorrow, so unless something particular occurs, I shall not write till Saturday. I would miss the letter you can't get, on Sunday, if I knew which it was exactly, but I don't. Love to my mother.

> Ever my dearest
> Your most affe Son
> J Ruskin.

59

My Dearest Father,

Though I wrote today, yet as your letter with Mr Harrison's just received requires answer I send this too. Of course do all that you like with poems. Lady B⁴ just as good as any one. I have neither

¹ Postmarked Florence, 13 June. Answered 24 June.

² See Letter 56, p. 107, note 6.

³ Postmarked Florence, 14? June. Answered 24 June.

⁴ Marguerite Countess Blessington (1789–1849), hostess, minor author, and editor of *The Keepsake* and Heath's *Book of Beauty*, annuals in whose 1846 numbers four of Ruskin's poems were printed. See *Works*, II. 236 ff.

pride nor pleasure in them, but they will not I think, *hurt* me, nor my book. They aren't bad, though they are not goo[d].

H's motto very good—as for title I don't Kno[w]—suppose "written among the Italian Alps, or among the Basses Alpes, 1845"?[1] the pines separate it from Rome. I am puzzled about a title for the last I sent[2]—the one given won't do, and I can't think of a better unless you say, Written on the Jura, 1845—which is a lie. I felt it on the Jura, however.

I write to Gordon immediately, telling him to write me here, with his probable address (on the 1st July).

Dearest Love to my mother.

Ever your most affect Son
J Ruskin.

No one is to have the vignette[3] for less than 20 g.

60

[Florence.] Sunday Morning, 15th [June].[4]

My Dearest Father,

I ordered George to post his letter yesterday. Presently he came to me with his eyes open. Please Sir—I gave it to *Coutet* and he has posted it last night! so I suppose you got three letters same day.

I think I am pretty well out of my difficulties now. I never was so plagued at any place in my life—everybody sending one to everybody else. I have got Lord Holland's card & recommendation to see drawings with & get leave to draw in Pitti, though by the by they don't give leave to make notes ⟨with⟩ in a book in one's hand of forms or shades, which is just what one wants to do, but one must *name* a picture, and go in regularly & copy it. I name one, and if I don't, when I am once in, get the others, it's a pity. But I am not sure yet, of getting leave.

The Churches are the best game by far—the priests are as polite as can be, and let me do anything.

I am excessively disappointed with the two great galleries. Both are full of all sorts of rubbish, and the large, statue one in particular has such horrible modern French & Italian daubs hanging about everywhere that it quite torments one & shakes one's faith in all

1 See Letter 35 and note 2. Harrison supplied the motto from Matthew 20: 6: 'Why stand ye here all the day idle?'

2 *Mont Blanc Revisited*; see Letter 56. It was not published until 1849.

3 Probably a Turner vignette.

4 Postmarked Florence, 15? June. Answered 24 June.

the great art. I have only as yet found two Claudes in Florence,[1] but there are some grand Salvators I hear at a private palace.[2] I think the Tribune Raffaelle improves with keeping, but the Elgins ha[ve] spoiled me for all sculpture but M. Angelo. The Venus[3] gives me no pleasure whatsoever—the average statue of the gallery I never look at. But the M Angelos I can tell a mile off, and I am never tired of them, they put strength into one—when I am quite wearied & can write no more, I go to them and they refresh me.

Still, except when I am in the old churches, I don't like Florence. There is no feeling about it. Think what I will, it never touches me— the people are Leghorn bonnetmakers and one feels always in a shop. It is too busy to admit of emotion of any kind—busy about nothings. No one here cares a farthing about art, or anything else that is good. The country is covered with villas of broken English & dissipated Italians. All the roads are between walls—you can go into a vineyard if you like, if the gate is open—no one ever says anything—but one vineyard is just like another, & the view always the same green plain spotted white. One can't walk except when it is too dark to see, and then the streets are so horribly crowded (there being no footway) that one can think of nothing but the carriages, and how to get out of the way. The Italians are very barbarous. I see they have got today at the Theatre "Il Diavolo e la sua sorella, Spettacolo Terribilissimo". Yesterday I saw in large letters affiché, MACBETH. I went up to see how they advertised Shakespeare & read as follows. "Morte del Terribile MACBETH—Gran Sultano di Persia!!" to be followed by "Michel Agnolo e Rolla—Dramma di gran sentimento!"[4] Love to my Mother.

<div align="right">

Ever my dearest Father,
Your most affe Son
J Ruskin.

</div>

[1] *Landscape with Rural Dance* and *Seaport with the Villa Medici* in the Uffizi.

[2] The *Showing of Christ* and the *Baptism of Christ* in the Palazzo Guadagni, on the Piazza S. Spirito. For Ruskin's description of them in his notebook, see *Works*, IV. 265–6, note.

[3] The Medici Venus in the Uffizi.

[4] *Michel Agnolo e Rolla* was a translation of Charles Lafont's one-act play, *Le Chef d'oeuvre Inconnu* (Paris, 1837).

[Florence.] Sunday Evening [15 June].[1]

My Dearest Father,

I enclose a letter[2] which you will not like to forward, but I can't help it. It explains itself—there is however another reason which I cannot give Murray, that on reading Sir C. again & again, I find it loose in plan, and often, to my notion, wrong—and Murray told me he wanted as favourable a review as possible to serve the widow—and I can't write what I don't think. I see my hand gets worse & worse—it is from my way of holding the pen. I must posit[ively] alter it, and hold the right way, for this won't do.

We have thunder every afternoon now. I lost three afternoons last week—two by storms—one at Lord H's[3]—but we had a marvellous sky last night in consequence, blue & red behind thunder clouds.

I want to write some of my book in the evenings now, so that my letters may be a little shorter. I want to develope some new points while I have the things for reference near me. Tonight I merely write short because I have been doing Murray's letter, which perhaps you will be kind enough to seal with my crystal Seal & send.

Monday morning.

I begin my hard work in the Gallery today, must be there by 9, so I can't get the letters, if there be any, out of the Post office before I send this. Love to my mother.

Ever my dearest
Your most affectionate Son,
J Ruskin.

62

[Florence.] Monday Evening, 16th June.[4]

My Dearest Father,

I was very sorry, when I got your kind & pleasant letter today of the 6th June, that it would receive for answer my *un*pleasant one of this morning, with Murray's letter in exchange for Coutts notes,

1 Postmarked Florence, 16 June. Received 25 June; answered 26 June.
2 To John Murray, the publisher, declining to review Sir Charles Bell's *Anatomy of Expression*; see Letter 1, p. 1, note 1.
3 Lord Holland's.
4 Postmarked Florence, 17 June. Answered 27–30 June.

but it can't be helped—and this afternoon, it being wet, I went to see my convent picture,[1] which, as it was very important, I was obliged to sit down and write my notes about at once—otherwise, as I could not write there, I should have had it pushed out of my head—and now I have hardly any time left to answer the many points touched upon in your letter—but will tomorrow.

First however, I never go to the Casino[2] here to walk, but always up to Fiesole, or San Miniato, or Galileo's villa—and I am very cautious about ladders, and always try their steps thoroughly, and hold well with hands. I was up today in St Mark's Convent to see an old worm eaten crucifix, where nobody but bats can have been these ten years, and the dust lay as it does on a muddy road in summer.

It isn't very easy to tell you exactly where to write, for I cannot in the least tell how many days—or how few—I may want at Parma, Piacenza, Modena, or Pavia, but as I propose leaving here on the fifth July, you may safely send me a letter on the 26th June to Bologna, and on the 28th to Parma, and after that to Milan, till the 5th or 4th of July, unless you think it better for me to go to Venice first, & then address Padua & Venice. I will not stop an hour longer in the mountains than I can help, but last year I went there for refreshment & feeling, not for work. I shall not climb except for exercise, shall work hard all day, drawing.

If I took the Funstermunz, and down the Rhine per steamer, & railroad from Cologne, I could be home in 15 days from Venice, but it is a line of route I hate. You will be still able to answer my to-morrow's letter ⟨from⟩ to Bologna with safety, and you can think of another way, running straight from here to Venice, where I could get by Monday, 13th July, and then returning from Domo d'Ossola to Parma, Milan, Pavia, &c. in September. Then, according to the route you think best, you must write either to Venice or to Parma. I have lots of money. I don't like these circular notes though—they fidget me about my desk, & I have no place to keep the *letter*[3] in but my drawing box, & it has got so spotted & dirty that I am ashamed to present it.

About Arnold & Florence I will write fully this evening (Tuesday). You saw *some*thing of what I felt in my last letter, but that is owing to the people, not the city—the place is most divine &

[1] Perugino's *Crucifixion* in S. Maria Maddalena. For part of Ruskin's notes on the fresco, see *Works*, IV. 322, note 1.

[2] The Cascine, the public park running along the Arno at the western end of the city.

[3] The *lettre d'indication*, identifying the bearer and containing a list of the bank's correspondents.

heavenly, and if it were inhabited by serpents & lizards instead of these human creatures, would be altogether glorious. Arnold is a paltry fellow with his Figs.[1]

The Ahi Pisa is in Dante[2]—it is the curse of Ugolino. Dante sees him in hell, frozen in ice, but feeding for ever on the Scalp of the Archbishop Ruggiero, who was the cause of his fate. Ugolino, at Dante's approach & question, raises his head, wipes his bloody lips on the hair of his enemy, and opens slowly into the description of his last hours in the Torre della Fame, closing with this fearful burst of malediction—no, by the by, the curse is Dante's & not Ugolino's, who keeps his terrible calmness throughout—Vide Cant. 33rd. Dante always shows himself as singularly exciteable & full of Passion, while the ghosts that speak to him speak like statues in agony— their passions are eternal. Note especially the divine passage about Francesca di Rimini, where Francesca, describing her last day on earth, closes with the calm pause—Quel giorno, non piu vi leggemmo avante—and her lover weeps silently, but Dante falls fainting for pity—E caddi, come corpo morto cade—Ch. 5th.[3]

But when am I going to—as you say, & it nine o'clock nearly. I am truly glad to hear of your troubles at Xerez being at last settled.[4] I hope from the good omen of [it] being on your birthday they will be permanently so.

Vignette[5] may wait till I come home, though if Cousins is any hurry, you need not mind sending the *plate* as he can throw off another to compare it with on return, but take care of the drawing.

> Ever my dearest Father,
> Your most affe Son,
> J Ruskin.

Dearest love to my mother.

[1] See Arthur Penrhyn Stanley, *The Life and Correspondence of Thomas Arnold, D.D.*, 2 vols. (London, 1844), II. 394, Arnold's description of the scenery on the road from Florence to Rome: 'the vines, figs and olives over all the country, and the luxuriant covering of all the cliffs and road-side banks, the wild fig, and wild vine'.

[2] See Letter 42.

[3] *Inferno*, V. 138–42.

[4] Troubles with John James Ruskin's partner in the sherry business, John Peter Domecq (1796–1869). As late as the first week of July, he considered sending one of his clerks to Xerez to oversee Domecq because his letters were not having their desired effect. See Margaret Ruskin's letter of 8 July 1845 to her husband (Bem. L 1).

[5] See Letter 42, p. 82, note 2. For Cousen, see Letter 47, p. 92, note 1.

63

[Florence.] Tuesday evening, 17th [June].

My Dearest Father,

I sit down to tell you more particularly how I feel in Florence. All that you remember is most true, and to any one who has feeling, all these things are most precious, so long as you can have peace about them. But Florence is the most tormenting & harassing place to lounge or meditate in that I ever entered. Get into the current of people in Cheapside on the right side of the way and you are carried along in comfort, and may be as absent as you like. But everybody here is idle, and therefore they are always in the way. The square is full of listless, chattering, smoking vagabonds, who are always moving every way at once, just fast enough to make it disagreeable, and inevitable, to run against them. They are paving, repairing, gaslighting, drumming, from morning till night, and the noise, dust, tobacco smoke, & spitting,[1] are so intolerable in all the great thoroughfares that I have quite given up stopping to look about me. In fact it is dangerous to do so, for the Italian carts always drive *at* anybody who looks quiet. Out of the town it is a little better, but everything of life that you see is entirely void of sympathy with the scene. If there were a shadow of costume or character left in the people, if there were one ray of intelligence left in the vapid faces of the upper classes, I should not complain. But there is no costume, except the great ugly Leghorn hat, there are *no* pretty faces—I have not seen one since I left Lucca—there are no vestiges of the old Florentine face, nothing but French beards, staring eyes, and cigars sticking out of mouths that only know the exercises of eating & spitting. In the galleries, you never can feel a picture, for it is surrounded if good, by villanous copyists, who talk & grin, & yawn, & stretch, until they infect you with their apathy, and the picture sinks into a stained canvass. One sometimes gets a perfect moment or two in the chapels or cloisters of the churches, but the moment anybody comes it is all over. If monk, he destroys all your conceptions of monks—if layman, he is either a French artist with a peaked hat and beard for two—or a lazy Florentine who saunters up to look at what you are doing, smokes in your face, stares at you, spits on what you are studying, & walks away again—or perhaps, nearly as bad as any, it is an English cheesemonger & his wife, who come in, and remark, as happened to me the other day while I was looking at the gates of Ghiberti, those which M. Angelo said were fit for the gates of heaven.[2] Two English

[1] The word is cancelled, obviously by John James Ruskin.
[2] The bronze doors on the eastern side of the Baptistery. See Vasari's Life of Ghiberti.

ladies came & stopped before them. Dear me—said one—how dirty they are. Oh, quite shockin'—said the other, and away they went.

Neither, if even in early morning you can get a quiet hour, is the town itself free from incongruities that destroy all feeling. The palaces are grand beyond all that I ever dreamed of, and I am never tired of looking at their big stones. But there is not a single house left near them of the old town. They stand among new shops, and Parisian rows of Rue Castiglione houses—they are gutted inside & whitewashed—their windows are filled with green blinds and coarse framework and fat English footmen lounge at their doors. I don't know how other people feel, but I *can't* feel a bit, through all this. I look on the thing merely as so much interesting matter for study, but it never raises emotion. Now I complained of the way St Michel was left at Lucca, but yet, melancholy as it is, it is better so than as they do things here. All that remains at Lucca is genuine—it is ruined, but you can trace through all what it has been, and the ruin of it is very touching—you know that those are the very stones that were laid by the hands of the 10th century. But here, in Giotto's campanile, they are perpetually at work chipping & cleaning, & putting in new bits, which though they are indeed of the pattern of the old ones, are entirely wanting in the peculiar touch & character of the early chisel. So that it is no longer Giotto's—it is a copy— a restored picture—of which parts indeed remain, but ⟨all⟩ whose power of addressing the feelings as a whole, is quite gone. You will ask what I would have, if I would neither have repairs, nor have things ruined. *This* I would have. Let them take the greatest possible care of all they have got, & when care will preserve it no longer, let it perish inch by inch, rather than retouch it. The Italian system is the direct reverse. They expose their pictures to every species of injury, rain, wind, cold, & workmen, and then they paint them over to make them bright again. Now the neglect is bad enough, but the retouching is, of course, finishing the affair at once. At the church within 10 feet of me while I write, that of the misericordia, a bit of old Giotto gothic, they let the d-d[1] hawkers of prints and ribbons make a shop of its porches, stick bills against its sculptures, & drive nails between its stones to hang clothes upon. When this has gon[e on] long enough, they will pull the church down, or reface it in the modern style.

Take them all in all, I detest these Italians beyond measure. I have sworn vengeance against the French, but there is something in *them* that is at least energetic, however bad its principle may be—

[1] The word is heavily cancelled, no doubt by John James Ruskin for a copyist. At the top of the second sheet of the letter, John James Ruskin wrote, referring to his system of numbering the letters, 'copy first No 83 No 1'.

[119]

but these Italians—Pah—they are Yorick's skull with the worms in it—nothing of humanity left but the smell.[1]

To do the Grand duke[2] justice, he is I believe an excellent man, and does everything that he thinks good for his people, i.e. he pardons everybody that does anything wrong, until his prisons are choke-full, and he is bringing Tuscany into a state little better than the Pope's territories. They manage better at Lucca—cut off eight heads there at once, a fortnight ago.

I haven't time to write more this morning—Wednesday—and I have expressed myself very badly, for I was half asleep.

<div align="right">Two o'clock [18 June].</div>

I shall send my letter at two[3] instead of in the morning, as it gives me time to get yours if there be any. I have just met Mr & Mrs Pritchard[4] in the gallery—going to Switzerland tomorrow—they didn't know of Gordon's change of route—she is looking very well—he seems a nice person—but I can't write any more. Only, please send me to Bologna, they'll come by post well enough, two cakes of Newman's[5] *Warm* Sepia. Soho Sq. take care you get the right shop. Love to my mother.

<div align="right">Ever my dearest Father
Your most affectionate Son
J Ruskin.</div>

<div align="center">64</div>

<div align="right">[Florence. 19 June.][6]</div>

My Dearest Father,

I must do as you say and send only a bulletin today, for I am quite overwhelmed with business. I have scraped acquaintance with an old engraver, the man who did the Vita di Cristo[7] in my study, the large book from Fra Angelico. I drove him up to Fiesole

1 *Hamlet*, v. i. 196 ff.

2 Leopold II.

3 Postmarked Florence, 18 June. Received at Chester, 28 June; answered 29–30 June.

4 John Pritchard, married to Osborne Gordon's sister.

5 James Newman, Artists' Colourman, 24 Soho Square.

6 Postmarked Florence, 19 June.

7 *La Vita di Gesù Cristo: dipinta da Fra Giovanni da Fiesole, detto il Beato, lucidata dagli originali che si conservano nell' I. e R. Galleria Fiorentina Delle Belle Arti* (Firenze, 1843), engraved by Giovanni Battista Nocchi. For Ruskin's poor opinion of the originals, set down in his 1845 notebook, see *Works*, IV. 100, note. They are now attributed to an imitator of Angelico.

yesterday, and he took me to private houses and inaccessible chapels and all sorts of places and showed me wonderful things and a fresco of Perugino's[1] that nobody ever has heard of, and such a jolly one too—and you know I [got] into the convent, through Molini, though it is so ho[rr]ibly strict that the nuns are never *seen* by any one, at windows or anywhere—it is part of their vow— and I have found a chapel *all* painted by Gozzoli[2]—Adoration of Magi—a procession as long as Bluebeard's[3]—over the hills and up and round them prancing horses and glorious riders—and no end of treasures and in short I can't write any more—love to my mother.

Ever my dearest
your most affe Son
J Ruskin.

Thursday, two o'clock.

65

[Florence.] Friday, 20th June.[4]

My Dearest Father,

I have today your delightful letter of the 11th with its capital song for George—only really the passport affair[5] was not his fault, as he would never dream of asking any questions about that any more than about my money affairs. I find it better to do and think of everything myself, and am only angry with him when he disobeys direct orders as about the letter. I don't want his head, but his hands. The Passport only kept me two hours.

I see by your present letter you think it best to take Switzerland in August—& so do I—but I shall see ⟨how⟩ what you say in your next letters before I fix altogether. I shall not go by Mantua, a[n]d the only marshy place I have to cross is Pavia, where if I fin[d i]t hot I shall not stay more than a night. You have plenty time to answer this to Milan, where you can say which you think the best way to return. If I returned by Geneva or the Mont Genevre, I should do

1 A fresco of the Entombment in the Palazzo Albizzi. For Ruskin's description of it in his 1845 notebook, see *Works*, IV. 325–6, note.

2 The chapel of the Palazzo Medici-Riccardi.

3 A reference to the popular Christmas Pantomime by George Colman the Younger, *Blue Beard, or Female Curiosity* (London, 1798). See the stage directions for Act I, scene i (p. 6): 'A Romantick, Mountainous Country. . . . Abomelique and a magnificent train, appear, at the top of the Mountain—They descend through a winding path:—Sometimes they are lost to the sight to mark the irregularities of the road. The Musick grows stronger as they approach.'

4 Postmarked Florence, 20 June.

5 See Letter 43.

Milan in returning from Venice, as I must pass it then, rather than just now, for the sojourn in the hills will give me time to digest a little. I feel crammed so full just now that I can hardly think— like the awkward position that boys get into occasionally with a magnum bonum—so big in their mouth that they can't turn it. It is wonderful too how little one is capable of doing—a month sounds a good deal, but it melts like ice when it comes to a fortnight. I have hardly drawn here at all, found that to see and to think over what I saw, took all my time, but I have some illustrations for my book from the bad Salvators in the Pitti which *must* be done at once.

How was it, when we were here, that we never thought of going up the cupola of the cathedral—it is as wonderful as mont Blanc. I hadn't the smallest idea of its real size, and I am sure nobody has who hasn't climbed it. I was in the brass ball last night, but the wonderful & valuable thing to me, is ⟨that B⟩ the ornament that Brunellesco has chosen for the huge marble arches that support the lantern above the dome. He wanted broad, vast & grand lines —not pettiness or prettyness, but sublimity. And what do you think he has taken as the grandest forms he could get? *Pods* of *pease*—each twice the length of my arm, with three pease in each. Is not this curious?

Though you have the English Dante,[1] always compare it with my Italian one, for it is incomparably the most untranslateable book I ever read in my life. I have been studying Giotto's portrait of him[2] this morning—solemn, even awful. I never saw anything so grand, and the other unknown heads about it equally fine. Of course they whitewashed them here, but some English & Americans paid to have it picked off again, & to them we owe the most interesting work in Florence. Love to my mother. I am very very glad to hear she is better.

<div style="text-align:right">

Ever my dearest Father
Your most affe.
J Ruskin.

</div>

I am very sorry to hear about Ritchie.[3] I hope he is getting better.

Today, I was poking about churches & found in St Ambrogio, a glorious fresco—all burned & smoked—in a little sacred, idolatrous chapel, with an altar piece which I was quite certain was by Mino da Fiesole. Well, I called the sacristan, and half a dozen more monks one after another. What was the picture—who by? Non si sa. Molto

[1] Cary's translation.
[2] See Letter 52, p. 100, note 6.
[3] Henry Ritchie, one of John James Ruskin's clerks.

antica. Who was the altar piece by? Non si sa. What did the fresco represent? V'è un miracolo del Santo Sagramento. What miracle? Not a soul of them could tell me any thing about it. Was the altar piece by Mino? No.

I wasn't satisfied, made them light me some candles, and after a little search, I showed them Mino's name in a corner, OPVS MINI—he never puts more. Then they were highly delighted, for a work of Mino's is of great value—and very rare. The fresco is the chef d'oeuvre of Cosimo Rosselli, and most magnificent.[1] This may give you some notion of the intellectual condition of Florence.

66

[Florence.][2]
My Dearest Father,
I must be short again today. I find out things everyday that quite confuse me and make me not know where to turn myself. Please ask George Richmond whether he knows Lord Lindesay,[3] and what sort of a person he is—the artists here talk very much of what he is going to do & write about old art—and send me the results of your enquiries to Milan, as they may in some degree influence me in the direction I give to parts of my book. I have got a most amusing book to rest myself with at teatime. I have made acquaintance with a Franciscan in the Franciscan convent,[4] and he has lent me out of the convent library a huge quarto volume [of] the miracles of St Antonio of Padua, and another of the life of

[1] The chapel is at the left of the choir and is dedicated to a miracle of 1230, wine left from the mass turning to blood in the chalice. Rosselli's fresco of a crowd adoring the relic (*Miracle of the Holy Blood*), on its left wall, was detached in 1964 and removed to Forte di Belvedere. Mino's marble tabernacle holding the relic is still in the chapel; his signature is carved at the lower left of the central plaque.

[2] Postmarked Florence, 21 June.

[3] Alexander William Crawford Baron Lindsay (1812–80), author and book collector. A copy of Richmond's reply is contained in John James Ruskin's letter to his son, dated Edinburgh, 8 July 1845 (Beinecke Library, Yale University): 'I know Lord Lindesay & as far as I have that honor I like him very much & I think Mr John would like him too. His book as I understand is to be a History of Christian art from the revival of painting up to the time of Raphael. He has been years about it & I expect from what I know of the man that it will chronicle a very elaborate account of the early masters whose works he loves intensely & admires as an expression of the Christian Mind through art as its Vehicle. He is something of a mystic on this subject & deep in all that the Germans have written on it.' The book was *Sketches of the History of Christian Art*, 3 vols. (London, 1847). Ruskin reviewed it for the *Quarterly Review* of June 1847; see *Works*, XII. 169 ff.

[4] Santa Croce.

St Francesco d'Assisi, his founder—quite delicious. But I don't know what to do at all. I haven't time if I draw to see half the things—and I must draw too, for my book—a fortnight seems nothing. However, go on the 6th I must & will, D.V.

Love to my mother.

Ever my dearest
your most affecte,
J Ruskin.

Saturday, 21st [June].

<div align="center">

67

</div>

[Florence.] Sunday morning [22 June].[1]

My Dearest Father,

Here is another week gone, and I have nothing to show for it—the mere seeing & thinking takes up all one's time, and there is so much to be read and worked out that it is quite impossible to draw, except the little studies for my book. I regret this the more because unless I draw a bit of a thing, I never arrive at conclusions to which I can altogether trust. It is getting rather too warm for drawing too—the least hurry or effort puts one in the middle of the day, into a heat which admits not of touching paper without spoiling it. I had rather walk up hill in full sun, than copy the things here—they are so beautiful & one has to try so hard, that it *takes it out* of one uncommonl[y]. I had some good exercise too last night—making hay up at [Fie]sole in the Franciscan convent[2] with the monks. I assure you, when the Franciscans do work, they work to purpose. Then I rested in their garden under the cypresses of "the top of Fesole" waiting for the moonrise—to descry new lands, rivers or islands in her spotty globe[3]—and so walked back into Florence with the fireflies flitting about all the way. They are getting thinner now, however—their season is passing, & I think they love not moonlight. Before it rose they were very beautiful.

Although it is too hot to draw, there is nothing oppressive in it. I go everywhere in any sun, without the least feeling of fatigue—only in continual perspiration. It can't be the sort of thing to get fat upon, but I am always as hungry as possible, & heat never hurts me so long as it does not take away appetite.

They are going to have one of their rubbishy festas here—horse races & chariot races & fireworks. I shan't go to anything, unless I

[1] Postmarked Florence, 22 June.

[2] San Francesco.

[3] *Paradise Lost*, I. 289–91. Milton wrote 'Mountains' rather than 'islands'.

get a comfortable window for the fireworks, which I rather like, but I can't be bored with their races. I shall go up the dome of the cathedral & draw the pease,[1] out of their way.

I am afraid my letters will be rather short now, for I must really write to one or two people or they will be quite angry. Love to my mother.

<div align="right">
Ever my dearest Father

Your most affe Son,

J Ruskin.
</div>

68

[Florence.] Monday, 24th [i.e. 23rd] June.[2]

My Dearest Father,

I received yesterday your pleasant letter of the 13th June—about opal[3] and Oxford.[4] I am very glad the Oxford does not go at 50, for I was provoked with Jennings[5] for always sneaking & worming about what *we paid* as if we wanted to make a profit on it—now I don't want to make a farthing of profit, but I told him over & over again—⟨that⟩ "Oxford is worth 70 guineas to *me*, and it shall *not* go for less—if it were offered at 65 I should buy it"—and I should have been horribly vexed if you had let it go [at] a low mark to anybody. The opal does not at al[l] matter—if it comes, well—if not, my head, as I said, is taken up with other matters.

Those fools of likeness finders do immeasurable harm to art—there is nothing in the world but is *like* something else—and any idiot can see likenesses—but it requires wise men to see differences. Harding's sky[6] *is* however too hard.

I will take care of malaria, but I find as yet, though the *Italians* complain of the heat, & keep fanning & icing, it does me no harm whatsoever—the only inconvenience is the frequent moisture of hand & foot, which perhaps will thin me a little as it does jockeys,

1 See Letter 65.

2 Postmarked Florence, 23 June. Received at Carlisle.

3 See Letter 47.

4 Turner's watercolour, *Christ Church, Oxford*, bought in Aug. 1840 for £50 (see Letter 42, p. 83, note 1). On 6 Feb. 1846, according to an entry in John James Ruskin's account book (Bem. MS. 29), he bought a 'Turner Righi' for £80, giving this drawing, at a value of £50, plus cash. The exchange was with H. A. J. Munro of Novar (*Christ Church, Oxford* was in the Munro sale at Christie's in 1877). The 'Righi' was *Rigi at Sunset*, one of Turner's 1842 Swiss drawings, now in the National Gallery, Melbourne.

5 Robert Jennings, publisher, book and print seller, 62 Cheapside. He had published Turner's *England and Wales* engravings.

6 See Letter 47, p. 91.

but I have no fear of anything else. It will be well however as you say, to take the hills first, for fear of some sudden malaria that one could not calculate on.

You can write after receiving this, for the last time to Milan, afterwards to Domo d'Ossola. Love to my mother.

<div style="text-align: right">

Ever my dearest father
Your most affe. Son,
J Ruskin.

</div>

I can't get a window for fireworks under twenty pauls, so shan't go. I've bought some plates instead.

69

<div style="text-align: right">

[Florence. 24 June.][1]

</div>

My Dearest Father,

Yesterday I received your kind letter of the 14th but, not expecting one, mine was posted before. I had quite forgotten all about the letter which I thought had been written under some little feeling of annoyance.[2] I fancy it was one of those that were written to Florence when you didn't know where I was, or when I should get your letters, and so wrote as one naturally does when one cannot tell if one's letter is for one's friend or the postmaster. At all events I saw by the next I was wrong, & forgot all about it, and can only say I fancied it just as my mother fancied I was ill at Sens or Montbard. I was perhaps a little more easily alarmed because I know that you often do not speak about things that displease you for fear of hurting me, and I thought this might be still more the case while I [wa]s ⟨here⟩ abroad, and so I thought of the accidental manner of a hurried letter as if it were caused by some such feeling. I cannot ref[er] to the letter just now, for it is packed up with the others, but I can I daresay discover it by the date afterwards. It was certainly *not* the Punch that did it.

I saw the fireworks after all—got a seat for five pauls, on the houses of Ponte Vecchio—the pretty thing being the arches of the bridges all lighted round, & the innumerable boats gliding about with lamps. The fireworks very poor, but the illumination of the cathedral dome and of the Palazzo Vecchio very noble, owing to their using lamps with strong reflectors to throw the light on the walls, which made the marble of the cathedral look perfectly transparent & full of fire, and the great tower of the Palazzo the

1 Postmarked Florence, 24 June. Received at Edinburgh 5 July and answered.
2 See Letter 51.

same. Perpetual buzz till two in the morning. I send two letters today, one to Louise Ellis and the other to Anna Anderson,[1] with orders that they are to be shown or sent to my mother, but I send them straight that they may have Florentine postmark and all. I think I may give more pleasure by these letters than by any others I could write. Love to my mother. Why don't Macd-d.[2] write to me?

> Ever my dearest father
> Your most affe Son
> J Ruskin.

70

[Florence. 25 June.][3]

My Dearest Father,

I have been bothered to death by their confounded fetes, these two days. Buzz—buzz—bang—bang, all day & night, dust & crowd & nuisances of every kind—no getting into any churches—galleries all shut, and yet the sort of thing that one can't exactly leave and set off for the country, for I wanted to see how this cathedral looked full—& there was the grand duke & duchess & everybody blazing with diamonds, and orchestras not to be counted and everything that could please the rabble besides. But it is a vile rabble—they do nothing all their lives and so have no pleasure in doing nothing in honour of St John—they can't enjoy a fete—they push & stare, but it is no pleasure to them. The country people however, who came in crowds, were better pleased, & pleasanter to see. But I got in a rage at last, and went away up to San Miniato, where in the lovely old ruined church[4] (which I see now for the last time, for it is going to be "restored") I spent a happy afternoon, and came down in the twilight, just in time to be covered with dust by the trampling & shoving of the crowds returning from the races, & to have the air of the vines driven out of my lungs by their filthy segars.

[1] See Letter 12, p. 31, note 5 and Letter 56, p. 110, note 2. Anna's letter is characterized by Margaret Ruskin in a letter of 5 July to her husband (Bem. L 1): 'It is long with an account of how he is sitting while writing to her, some accounts of Monks Legends & of the first music he heard in Italy, the creaking of his own carriage wheels the second, barking of Dogs at Mont Bard, everybody in the place appearing to be dog keepers and thirdly the Cicadas Song . . . it is written entirely for a child's amusement.'

[2] Macdonald; see Letter 34, p. 68, note 5.

[3] Postmarked Florence, 25 June.

[4] San Miniato al Monte.

Hear what Sismondi says of the present Italians—no, I haven't time to quote just now. I'm going to send a line to my mother tomorrow, & I'll quote it in that—love to her.

Ever my dearest Father,
Your most affect. Son
J Ruskin.

71

[Florence. 25 June.]¹

My Dearest Mother,

In the quarterly review for April I found today a paper which quite did me good—the review of Gally Knight's Architecture.² It describes my antiquarian feelings to the very letter. I find I am become Jonathan Oldbuck,³ to all but the shoebuckles, and what it says about restoring & *destroying* might have come from my indignant pen itself—not quite viperous enough though, for me. I don't know, take it all in all, that I have often spent a more unhappy time in its way than my past three weeks in Florence. I have been working very hard ⟨at⟩ under the perpetual sense of accomplishing nothing. I have been developing stores ⟨of⟩ upon stores, heaps on heaps of things that I cannot explore nor learn. I have been discovering at every step new darknesses—about me— new incapacities in myself. I have been digging wells like Abraham's servants & I can't drink. I have been rolling stones from their mouths—and have nothing for my pains but a fight with the herdsmen,⁴ in the shape of gallery keepers and priests—& then added to all this, there is the sorrow of seeing a whole nation employed in destroying the most precious of its heritages, and sinking deeper & deeper every day into apathy, ignorance, & sensuality. The result of which is, that I am much less Catholick than I was because the priests burn the pictures with their candles, and much more republican than I was, because the race of Giotto & Orcagna & Dante were a very different people from those of the

¹ Postmarked Florence, 26 June. Received 5 July, according to his mother's letter of that date (Bem. L 1), and sent on to his father at Edinburgh.

² *Quarterly Review*, LXXV. 334–403, a review of several architectural books, chiefly of Henry Gally Knight's *The Ecclesiastical Architecture of Italy*, 2 vols. (London, 1842–4).

³ Scott's Antiquary. The review opens with a long look at Jonathan Old-buck's antipathy to destroying the historical record by restoring or even re-pairing buildings.

⁴ Gen. 26 : 15–20.

present day—& I do honestly believe the Grand duke to be one of the best of monarchs, but the Italians are certainly not made to live under either emperors or Kings. If you could but see, as I do, near & close, the mighty crowds of the dead that stand in countless portraiture on the walls of the Novella & the Carmine—grand, thoughtful, self commanding men—soldiers, statesmen, poets, Fathers of the Church—that seem not out of place though standing among the prophets & the saints of elder time—& then, leaving the dark cloisters for the sunshine, you see in the place of these, pale, effeminate, animal eyed, listless sensualists, that have no thought, or care, or occupation, or knowledge, or energy—and when you think that the former were all born & educated in a pure, restless, republic, & the latter under a good King!—It shakes one's English prejudices a little.

Hear what Sismondi,[1] living in Italy, says of the Italian youth. "Un jeune homme Italien *ne pense pas* et ne sent pas meme le besoin de penser—son oisivité profonde serait une supplice pour un homme du Nord."

The state of ignorance of the priests too is very wonderful. One of them the other day, couldn't recollect, for a minute, who it was that appeared with Moses at the Transfiguration.[2] With all this I think the Italians have heart, capacity, & spirit—as great as ever. But the thorns have sprung up & choked them,[3] and all that one does now to raise them or excite them is but throwing fire among thorns—you have but the crackle for your pains.[4]

I am just at the uncomfortable point now of giving up half a dozen things in despair & going to draw at the Palazzo Pitti. I have been kept a week in getting ⟨that⟩ permission, for though they allow every villanous copyist to work & sputter away in their splendid rooms to make copys for fashionable fools of English, they could not think of allowing an artist to make notes in his sketchbook as he passes. All that I can get is leave to study a certain picture for a certain number of days.

I intended to write a long letter, but I can't, for I have some things to note that came into my head this evening in the chapel of Masaccio.[5]

I will enquire about your tree at Vicenza, but I am more likely to meet with it at some nearer place. Coutet has made me a capital collection of plants from the hills about Fesole, and they will be

[1] In the final chapter of his *Histoire des Républiques Italiennes.*
[2] Matt. 17 : 3 ; Mark 9 : 4.
[3] Matt. 13 : 7.
[4] Cf. Eccles. 7 : 6.
[5] The Brancacci Chapel in S. Maria del Carmine.

useful, as many of them are the originals of flowers in the old pictures.

By the by, don't think by my bad writing that I am more careless with you than with little girls. I write more carefully to them that I may not set them a bad example. Love to my Father.

Ever my dearest Mother,
Your most affectiona[te So]n
J Ruskin.

Thursday morning, 26th July [i.e. June].

It requires a good deal of courage, mind you, to work as I am working at present—obliged to take a shallow glance at everything & to master nothing. I am not studying a branch of science in which I feel steady progress, but gathering together a mass of evidence from a number of subjects, & I have to think before every thing that I see of its bearings in a hundred ways. Architecture—sculpture—anatomy—botany—music—all must be thought of & in some degree touched upon, & one is always obliged to stop in the middle of one thing to take note of another, of all modes of study the least agreeable & least effectual.

For instance, I am going now to the Palais Pitti. I have to look at its stones, outside, & compare them with the smooth work of modern building—when I go in, I shall sit down to study a bit of Rubens for an illustration of my book—this Rubens leads me into a train of thought respecting composition diametrically opposite to that which would be induced by a Raffaelle. But I must look at a certain number of pictures today, or I shall not see them at all. These are again full of flowers, of which I cannot state whether they are truly drawn or not until I go to my field book & find their originals—then I want their names & find myself plunged in a sea of botanical difficulties. In the middle of these minutiae, I perhaps come on a work of M. Angelo & must clear my mind of everything of the kind before I can take him *in*—or understand him in the least—& so on, for ever.

72

[Florence.] Friday, June 27th.[1]

My Dearest Father,

I hav[e] not much to report upon, at present being at work quietly in the Pitti. I never was so bored at any place about getting leave to do things—these people make use of authority merely to

[1] Postmarked Florence, 28 June. Received and answered 9 July, Edinburgh.

⟨get in⟩ put obstacles in the way of everybody who loves art, & to yield their best things up to the mercies of plasterers and slaters. The priests have nailed two big lamps right int[o M]asaccio's frescos, splitting all the wall, and then [th]ey have the audacity to ask *me* when I am touching an engraving, whether I have "leave from the Marchese Montalvi." The Grand duchess takes her favourite picture out of her room that it may be exposed to the murder of a shop copyist—for two months—and yet I cannot make a line in my sketchbook as I walk through the rooms without being attacked by the custode. No blame to the Grand duke—he wants to encourage art—but in the first place, he don't know what art is, and secondly, he don't know how to encourage it. So he neglects the finest things in Florence—which is perhaps a mercy—for he has what he thinks the finest things cleaned & retouched. I am quite mad with the people here. I don't know where to turn for anger & pity—the monkey that touched up Buffalmacco's pictures[1] ⟨was⟩ and painted everything green, was a gentleman and a scholar compared to them. The only place here where one can be comfortable is St Mark's. They value their pictures there & take care of them, & yet let one get at them in peace, & I have had many a quiet, resting walk through their corridors, where no one ever comes, & where the work of Fra Angelico gives religion to every corner, & makes a temple of it.

You must still write to D. D'ossola. My best way I think, on the whole, will be to stop quietly there, not going into the Val d'Aoste, & make my way quietly to Venice towards the end of August, keeping among the hills until I get there. Love to my mother.

Ever my dearest Father
Your most affe Son
J Ruskin.

I have your letter of the 17th, many thanks. The Shylock[2] I know well, it is very glorious. Give my love to Macdd.[3] if you have him again.

[1] See Vasari's Life of Buffalmacco.

[2] Turner's oil painting, *Venice, The Grand Canal* (R.A. 1837), now in the Henry E. Huntington Library and Art Gallery, San Marino, California. According to his account book (Bem. MS. 29), John James Ruskin bought it on 27 Apr. 1847 for £840, through the printseller, Thomas Rought.

[3] Macdonald.

[Florence.] Saturday [28 June].[1]

My Dearest Father,

I hav'nt an inch of time this morning, nothing to say that can go in small compass, except that it isn't a bit hotter here than in England—unless one chooses to stand in the sun. I shouldn't care a bit if I had to stop here all the su[m]mer long—the churches are always pleasant, only I wis[h] they were a little lighter.

I intend to *leave* Coutet at Monte Rosa, as it is no use dragging him about Venice. George & I get on perfectly well—passports & all.

Ever my dearest
Your most affe
J Ruskin.

Love to my mother.
Don't be savage about having to pay for this scrawl, for when I am at Monte Rosa, they can only come twice a week or so, I fear.

<div style="text-align:center">

74

</div>

[Florence.] Sunday morning, 29th June.[2]

My Dearest Father,

I received yesterday your most pleasant letter of the 19th, with George Richmond's, to whom I have written by this same post[3]— there was nothing much in the letter, or I should have let you see it. I am very very sorry to hear of his loss. Thank you also for the extracts from Italie confortable,[4] which are very useful. I always send Coutet here for water—first to Sa[nta] Croce, but Lord H.[5] told me it had been comparatively spoiled and that the well of the Carmine was better, & so I found.

[1] Postmarked Florence, 28 June. Received and answered 9 July, Edinburgh. On the back there is a note in Margaret Ruskin's hand: 'I tell John that two lines saying he is safe and well is worth more than he can calculate.'

[2] Postmarked Florence, 29 June. Answered 12 July.

[3] Ruskin's letter to Richmond is printed in *Works*, XXXVI. 50–2.

[4] See Letter 54, p. 104, note 3. The extracts no doubt included the advice (p. 90) as to where drinkable water was to be found and the warning that use of house-wells produced the *teint plombé* and liver complaints.

[5] Lord Holland.

I was up the Cathedral last night again, drawing the Pease at the top for my book. I wish I could send something home for the engravers, for I fear I shall be detained by them—when the book is ready.

Very glad to hear of Mr $\begin{cases} \text{Campbell's?}^1 \\ \text{Cockburn's?} \end{cases}$ Turning to Turner. I was defending him in the Pitti yesterday. Always at my post you see. I hope he is as busy for me as I for him. What do the infernal french princes—with their beaux arts & libertas over church doors, & pulling down St Mark's Convent—say to him?[2]

The monks are early risers—that's one good in them. I was in Sta Maria Novella at 5 o'clock yesterday, & they were singing away like cicalas, only a little hoarser.

I wish I had had some more distinct directions about Carpet,[3] but I will do my best. I intend to have one with some Furies upon it, typical of the vengeance to be taken on the people who allowed it to be *made*. Love to my mother.

<div align="right">

Ever my dearest
your most affectionate
J Ruskin.

</div>

<div align="center">

75

</div>

<div align="right">

[Florence. 30 June.][4]

</div>

My Dearest Father,

This summer is an inconceivable one altogether. There is not the least feel of Italy about it. The sun is sometimes hot if you choose to let it come on your back, but there is none of the soft air nor pure light—always windy or cloudy or thundery, worse than England. It does very well for me however, as it enables me to work without lassitude, only it is often too dark in the churches.

By "speaking Italian" I saw on Saturday what I think the most interesting picture in Florence. It is only shown to the people once a year, always kept behind a gold cloth. It is a *portrait* of St Francis,

[1] His father had evidently written 'Mr C.' If he meant Cockburn, it was probably Robert Cockburn, John James Ruskin's old Edinburgh friend, the well-known wine merchant.

[2] Perhaps a reference to Turner's brief trip to France in May. Turner had apparently become acquainted with Louis Philippe and his family when they resided at Twickenham. See A. J. Finberg, *The Life of J. M. W. Turner*, 2nd edn. (Oxford, 1961), pp. 408, 411.

[3] See Letter 53.

[4] Postmarked Florence, 30 June. Received 9 July; answered 12 July.

taken from the life by *Cimabue*,[1] and not only is it interesting from its subject, but from [its] being perhaps the first portrait existing in genuine Italian art. But the remarkable thing in it is, that while it has completely the look of portraiture, & *Vasari*[2] names it as taken from the life—and there is nothing against it Chronologically —for the rule of St F's order was not finally confirmed but by Honorius, after the death of Innocent III in 1216, & Cimabue was born about 1240, and this is one of his earliest works. But it is very singular that the stigmata, which St Francis was reported to have received—wounds in his hands & feet & side like those of Christ— are there represented. And supposing it not a portrait from life, but a conjectural one, which is certainly more probable if it be Cimabue's work, it still shows how soon this tradition had taken root. Love to my mother.

<div align="right">
Ever my dearest Father,

Your most affe Son

J Ruskin.
</div>

<div align="center">

76

</div>

<div align="right">
[Florence. 1 July.][3]
</div>

My Dearest Father,

I received yesterday your pleasant letter of 21st about hay, &c, Macdonald—why don't he write to me, as I said before. You seem to have all the heat in England—it is as cool here as at Chamouni; at five this morning the air felt as fresh as if it had come off a glacier. We have news from Chamouni, & the glacr des Bossons is further advanced than has been known in the memory of man. From Coutet's house, they can't see les Ouches for it.

I was [afrai]d the Chamonix thing would turn out no go, for m[ankind] isn't turned that way, & it is very much turned every [?] way. These Italians worry me out of my life. There are only two very fine & genuine & perfect Gentile di Fabrianos in Italy and one *was* in the Academy here.[4] Yeste[rd]ay when I went there, I found three workmen as dirty as coalheavers, putting this picture on a cart, face uppermost (& it raining), and pulling—pushing—& shaking it about as if it had been old iron. One of them at last

[1] The thirteenth-century altarpiece in the Bardi Chapel (the first at the right of the chancel) of Santa Croce. It is no longer attributed to Cimabue.

[2] In the Life of Cimabue.

[3] Postmarked Florence, 1 July. Answered 12 July.

[4] *Adoration of the Magi* (the Strozzi altarpiece), now in the Uffizi.

remarking that it was raining, they threw a greasy carpet slap on to its face, & away they went. On enquiring of the custode, I found it had gone essere pulita, to the picture cleaners, who will take off all its upper colours, turn all the blues dead as Hogarth did to my Amalfi,[1] touch them all up again with the bluest paint he can buy, regild all the glories, paint the cheeks all bright red, and send it back so like a modern picture, that the Italians will be perfectly delighted with it. But as I said of Pisa, so here, the best thing that could happen for art in Florence, would be that the owl should dwell there & the satyr should dance there.[2] I was especially grieved the other day over a picture—a distance—of Perugino's[3] in which the tender lines of his pencil were just visible, & no more, in a few places, under a cartload of wonderful blue, laid on by the cleaner, & varnished so bright that you could see your face in it.

They had at the theatre yesterday affiché—"Il Vagabondo e la sua famiglia. Produzione Interessante." Quoi! (said Coutet). Est-ce que les gens paient ici pour *se* voir?

Love to my mother.

<div align="right">
Ever my dearest Father,

Your most affectionate Son

J Ruskin.
</div>

<div align="center">

77

</div>

<div align="right">
[Florence.] Wednesday, 2nd July.[4]
</div>

My Dearest Father,

I must be short again, for I have now only three days more of Florence, and I am just puzzled what to do in them. I have, luckily, completed my review of things, and *seen* as people call it nearly everything, so that I can draw for these few days, but what I know not. I am so divided in mind between M Angelo, & Masaccio, & Ghirlandajo on the one hand—and Angelico, & Gozzoli, & Giotto, on the other—& bits of landscape that I want to do as well—that I feel very like an a[ss]. I think it'll come to Giotto at last, for I can't draw Angelico.

[1] Joseph Hogarth, printseller, publisher, and mounter, 5 Haymarket. *Amalfi* is Ruskin's drawing of 1844, made for Sir Robert Harry Inglis and now in the Fogg Art Museum, Harvard; for Hogarth's spoiling of the drawing, see *Diaries*, I. 268.

[2] Isa. 13:21.

[3] *Assumption of the Virgin*, then in the Accademia, now in the Uffizi.

[4] Postmarked Florence, 3 July. Answered 15 July.

You write I suppose at present to Domo d'Ossola. Love to my mother. The Voituriers want 100 fr. to go to Bologna. I don't understand this.

You would like to see the sacristy of Sta Maria in the morning at five to eight—with its beautiful *cistern* for washing carved or cast rather by Luca della Robbia—all over lovely angels—and its press doors open where are the relics & the Fra Angelicos—and its ivory carvings above the altar—& its painted window—& azure roof— & me drawing and all the monks playing with a Kitten, that goes like the Jackdaw of Rheims,[1] into the very Cardinal's chair & nobody says it nay. Love to my mother.

Ever my dearest
Your most affe
J Ruskin.

78

[Florence.] Thursday [3 July].[2]

My Dearest Father,

Yesterday in Masaccio's chapel there was an English artist painting very successfully & I got into conversation with him— told him he had got one of his heads all wrong by way of the pleasantest information I could think of—made him put it right, fancied I saw something in his work that I knew, tried a shot— spoke of an artist w[ho] was doing a great deal in England, Eugenio Latilla.[3] Why—he said—that's myself. He's coming to take tea tomorrow. Today I drive out to the Certosa in Val d'Ema—with a poor Swiss artist[4] of very sweet character and great power—we are quite friends—like all the same things—and he has given me a sketch of a little blue eyed Swiss cousin of his—so *very* swiss it is

[1] See the verse tale by that name in Richard Harris Barham's *Ingoldsby Legends*.

[2] Postmarked Florence, 3? July. Answered 15 July.

[3] (1800?–60?), subject painter, member of the Society of British Artists.

[4] Johann Ludwig Rudolf Durheim (1811–98). He painted Ruskin's portrait during this stay in Florence (see Letter 37, note 5) and Ruskin corresponded with him for several years afterward. On 16 July, Ruskin wrote him at Florence from Milan, asking Durheim to make him watercolour copies of Dante's portrait and the kneeling Magdalen from the frescoes of the Podestà chapel and promising to write 'd'une chose qui me trouble beaucoup—c'est de trouver que j'ai perdue presque tout à fait la simplicité si precieuse de l'enfance—et que je ne puis plus m'amuser pour des heures entieres à regarder une fontaine qui fait danser des sables, ou les cailloux qui font briller ses eaux—et voila pour moi un grand malheur'. On 6 Aug. 1846, he wrote Durheim, then at Alexandria, to tell him he had received the drawings (letters in the Pierpont Morgan Library).

quite a treasure—little thing of ten or 12—he is in sad distress about his country, don't know how the troubles will end. I've a letter from Gordon, at Geneva—nearly as unintelligible as mine. Love to my mother.

> Ever my dearest Father
> Your most affectionate Son
> J Ruskin.

Had a glorious walk this morning in Cascine, never go near it at night.
I have got the Voituriers down to 80 fr.

79

[Florence.] Friday, 3rd [i.e. 4th] July.[1]
My Dearest Father,
I have your most pleasant letter of 24th June, and am sorry to hear your letters come so irregularly, but that is neither George's fault nor mine. George has not posted a *single* letter since his Pisa delinquency. I usually do so myself on my way to the Uffizii—if not, Coutet does it, and as he has never yet failed of doing *what* I told him, *as* I told him, & *when* I told him, I have no doubt he always does so correctly. One letter is posted every day at ten in the m[ornin]g—two days I waited till two, but found it in[co]nvenient. You ought to find a letter on your counting house table regularly every morning. One day only I wrote twice, on account of letter needing answer—all irregularities are post office fault.

I intend to do all the towns you mention, Parma, &c, before Padua & Venice. Parma & Piacenza, & Bologna & Milan immediately—then rest a little among Alps, then do Brescia, Bergamo, Verona, & so to Padua & Venice.

I have got a bit of carpet enough to make a rug of, of a pattern which is now making (I saw it in the loom run against the picture)[2] in a large piece for the grand duke—paid 27 pauls, about 12 shillings—it isn't pretty, but it was the prettiest there.

I shall buy some essence of Lavender to keep off musquitoes from the monks of Sta Maria Novella. Their Spezieria is I believe known for its essences all over Europe. Very glad to hear the book[3] isn't forgotten yet. I must make haste & hit again.

1 Postmarked Florence, 5 July. Answered 17 July.
2 See Letters 53 and 74.
3 *Modern Painters I.*

About window,[1] I should be very happy to make a design for a little one myself, if you will give me one to do, but it must be after my book is done.

<div style="text-align:right">

Ever my dearest Father,
your most affectionate Son
J Ruskin.
</div>

Love to my mother.

80

<div style="text-align:right">

[Florence.] Saturday, 4th [i.e. 5th July].[2]
</div>

My Dearest Father,

Only time for a word today. What surprises me in Italy just now is that even when hottest, I never feel lazy as I used to do, but though today it is so warm that I can hardly touch the paper with my damp hands, I am yet running about to the different places that I have to go to just as if it were a winters day—no weariness— & it isn't *spirit* this, for I am very sorry to leave Florence.

I am [go]ing to buy some Essences for my moth[er] of the Santa Novella monks—and send them home together with some paper & engravings through Molini.[3] You will ⟨find⟩ be surprised at the mass of paper I have sent home—it didn't suit me & I have bought other here. The engravings are bad & cheap—they are merely to be able to refer to the subjects. Love to my mother.

<div style="text-align:right">

Ever my dearest
Your most affe Son
J Ruskin.
</div>

81

<div style="text-align:right">

Florence. Sunday, 5th [i.e. 6th July].[4]
</div>

My Dearest Father,

As I hope to start tomorrow at 5, and the office is not open till 9, I cannot post any letter here tomorrow, and it is no use posting at Covigliajo, as the letter would merely follow me to Bologna or go back here, & come same day, or even after the Bologna one— the next letter therefore you have to expect will be one posted D.V. at Bologna on Tuesday afternoon and then I believe you will hear regularly again to Domo d'Ossola.

[1] A stained-glass church window. In 1844, Ruskin and his friend, Edmund Oldfield, had designed a much admired window for the new St Giles' Church, Camberwell.

[2] Postmarked Florence, 5 July. Answered 17 July.

[3] See Letter 56, p. 107, note 6.

[4] Postmarked Florence, 6 July.

8. *Cafaggiolo*

I have got for my mother a bottle of essen[ce] of Rose, Orange blossom, Orange fruit, Myrtle b[los]som, Thyme, Lemon, Ambergris, Lavender. I only bought one little bottle of each—fear of custom house—& another of Orange blossom & Lavender for myself. The rose cost 12 pauls, & I got all for 26.

Just going to Church. I was sadly tempted to go & dine with the monks of the Chartreuse instead, but I shan't have English service for good while again. Love to my mother.

> Ever my dearest
> Your most affectionate Son
> J Ruskin.

82

Bologna. Tuesday evening [8 July].[1]

My Dearest Father,

I had a letter written at Pietre Mala, but the office here shuts at three o'clock, so you will I fear be kept a day too long. I have had a delicious drive over Apennines, with thermometer at 28 Reaumur, & got two nice sketches while voiturier stopped—one of Cafaggiolo,[2] spoken of by Rogers as one of the few haunted places in Italy. "That old den, far up among the hills—Frowning on him who comes from Pietramala."[3] Eleonora [di] Toledo was murdered there by her husband, Pietro [de] Medici—and Leo X was brought up there.

Bologna looks exactly as it did, inn[4] and all. I purpose D.V. leaving Thursday for Modena. I was up at 4 this morning to see the fires of Pietra Mala,[5] & so am sleepy. Love to my mother.

> Ever my dearest
> Your most affe,
> J Ruskin.

[1] Postmarked Bologna. Received 17 July, according to his mother's letter of that date (Bem. L 1), and sent on to his father at Selkirk.

[2] Where there is a Medici villa. See Plate 8 for the drawing, now in the Fitzwilliam Museum, Cambridge.

[3] Rogers, *Italy* (1830), 'The Campagna of Florence', p. 124, ll. 20–1. See Rogers' note, pp. 268–9.

[4] Hôtel Suisse. The Ruskins had stopped there for several days at the beginning of May 1841.

[5] Gas constantly issuing from a spot of rocky ground about 8 feet across and burning spontaneously, the flames 2 or 3 feet high.

[189]

Bologna. Wednesday evening, July 9th.

My Dearest Mother,

I have but time to say I have got your delightful letter[1]—and the colours,[2] all safe, not even a crack—and that I am looking forward with as much delight as you to the time of getting home again & of setting off altogether next year—God grant us to do so—and I have a letter from my father which I shall answer tomorrow—which has set my mind very much at rest, for I was afraid he would be sadly annoyed about Murray.[3] I wi[sh I co]uld see our place as you describe it. I shall thin[k mor]e of it when I get home again. I have caught myself wishing for our green oaks & meadow more than once—amidst the dusty olives—the more so, because I have seen nothing of the garden vegetation of Italy, but have been always in dark chapels, dusty streets, marble galleries, or between dead walls. I keep looking out for your curly flower, but have not yet seen it.

By the postmark on this you will see if I have got to Modena,[4] which I hope to reach tomorrow by 10 morning. There is much more feeling in this town than in Florence, but I have soon run through its pictures. So much the worse for Raffaelle. I have been a long time hesitating, but I have given him up today before the St Cecilia. I shall knock him down, & put up Perugino in his niche. I could hardly leave the Perugino here[5]—quite heaven—and then I was so pleased to see in his portrait, painted by himself in the Uffizii *Florence*,[6] ⟨with⟩ a scroll in the right hand TIM- —*Fear God*—
ETE
DE-
UM
showing how he considered his pictorial mission.

I was up at four this morning, & all over the churches before breakfast. I get coffee at the cafés—cheap & good—& whenever I want it.

At Modena I have to look out for the palace where the tragedy of Ginevra took place. I hope the picture is there—the chest must be

[1] Letter of 28 June; see Appendix.
[2] See Letter 63.
[3] See Letter 84, p. 142, note 1.
[4] Postmarked Modena, 10 July.
[5] *Madonna Appearing to Four Saints*, which, with Raphael's *St Cecilia*, is in the gallery of the Accademia di Belle Arti.
[6] Now held to be his portrait of Francesco delle Opere.

gone of course.[1] I trust to get to Parma Friday, & perhaps leave it Monday. I am in haste now to get to Alps.

Ever my dearest mother,
Your most affectionate Son
J Ruskin.

Your letter is quite elegant in its affection—it is a model of a mother's letter.

84

Parma. Thursday, July 10th.[2]

My Dearest Father,

Here I am, after running the gauntlet of more douaniers than I can venture to guess at without counting. Let me see.
1. Gate of Bologna—going out. Passport, & pay.
2. Bridge—half a mile on. Pay.
3. Dogana, two miles on. Leave Papal states. Passport, & pay.
4. Dogana, a quarter of a mile on. Enter duchy of Modena. First dogana man, then passport man. Both to pay.
5. Gate of Modena. Entrance. Dogana, pay. Passport, pay.
6. Gate of Modena. Going out. Passport, pay.
7. Gate of Reggio. Dogana, pay. Passport, pay.
8. Gate of Reggio. Go out. Passport, pay.
9. Change horses, farther on. Passport,—
10. Enter duchy of Parma. Bridge, pay. Dogana, pay. Passport, pay.
11. Gate of Parma. Dogana, pay, passport, pay.

Giving a total of 16 different stoppages, losing on the average three minutes and a franc at each—more. I find I am minus 21 fr. & a half —the Modena Dogana man wouldn't be quiet under five pauls, and the pope's man at Bologna said it wasn't consistent with his conscience to leave anybody unsearched under a piastre. It is rather worse than the Hastings turnpikes, because there is something so sneaking & contemptible in the whole system. George, like all people of a certain class, was quite in a rage, and if a thunder

[1] See Rogers, *Italy* (1830), 'Ginevra', pp. 92–6. The poem bids the visitor to Modena to stop at a palace near the Reggio gate to see Ginevra's portrait by Domenichino. Below the portrait is a chest carved with scripture stories. The tale is told of Ginevra's disappearance on her wedding day and the discovery of her skeleton, fifty years later, locked in the chest.

[2] Postmarked Parma, 11 July.

shower hadn't luckily come & wetted him to the very marrow, I
don't know how he would have got over it. It is not as if the thing
were at all left to *you*. The Doganiere comes & puts his dirty hand
on the carriage, & there it stays until you put the franc in it—or he
searches you.

At Bologna I got your kind letter about Murray,[1] which has made
me very comfortable, for I was afraid you would be sadly annoyed.
It is indeed better to concentrate myself at present on the book.

I am not surprised at the lines being so far inferior,[2] but I do not
think I have lost power. I have only lost the exciting circumstances.
The life I lead is far too comfortable & regular, too luxurious, too
hardening. I see nothing of human life, but waiters, doganiere—&
beggars. I get into no scrapes, suffer no inconveniences—and am
subject to *no* species of excitement except that arising from art,
which I conceive to be too abstract in its nature to become produc-
tive of poetry unless combined with experience of living passion.
I don't see how it is possible for a person who gets up at four, goes
to bed at 10, eats ices when he is hot, beef when he is hungry, gets
rid of all claims of charity by giving money which he hasn't earned—
and of those of compassion by treating all distress more as pictur-
esque than as real—I don't see how it is at all possible for such a
person to write good poetry. ⟨The other day⟩ Yesterday, I came
on a poor little child lying flat on the pavement in Bologna—
sleeping like a corpse—possibly from too little food. I pulled up
immediately—not in pity, but in *delight* at the folds of its poor little
ragged chemise over the thin bosom—and gave the mother money—
not in charity, but to keep the flies off it while I made a sketch. I
don't see how this is to be avoided, but it is very hardening.

[1] On 26 June his father had written: 'I seal & forward your Letter to Murray
[see Letter 61] which is all right—you cannot do more than get food enough for
the work you have bound yourself to do—& when you have finished your present
course of study you will be a much better writer for Quarterly as far as fine arts
go. . . . The Book has told & it is important to pour into the opened Ear of the
public, all you have to say—boldly—surely & determinedly beyond contra-
diction as far as full knowledge of the subject can protect anyone from Contra-
diction' (letter in the Beinecke Library, Yale University).

[2] *Mont Blanc Revisited.* In his 26 June letter his father had written: 'I am to
speak truth disappointed in the last Lines sent home—& you see by enclosed
Harrison is of same opinion. The Scythian Banquet Song [1838, *Works*, II. 57–
69] which you think little of was the greatest of all your poetical productions—
all the Herodotus pieces show real power—& have a spice of the Devil in them.
I mean nothing irreverent but the fervour & fury & passion of true poetry.
It is cruel in me to ask you to write for me—you should never write Poetry but
when you cannot help it. . . . The first Verse of Mt Blanc Revd *Oh Mount
beloved*—seems feeble. Your poetry at present has got among your prose & it
may be well to leave it there till the important Book be done which I am certain
will overflow with poetry.'

Nevertheless, I believe my mind has made great progress in many points since that poetical time. I perhaps *could* not—but I certainly would not now write such things. I might write more tamely, but I think I should write better sense—& possibly if I were again under such morbid excitement, I might write as strongly, but with more manly meaning. I believe however the time for it has past.

I perceive several singular changes in the way I now view Italy. With much more real interest—I take a far less imaginative or delightful one. I read it as a book to be worked through & enjoyed, but not as a dream to be interpreted. All the romance of it is gone, and nothing that I see ever makes me forget that I am in the 19th century.

With this change, has come another. I am much more patriotic. I found myself looking today, with entire indifference, at a very lovely chain of Apennines. I looked—& looked again, with vain efforts to enjoy them. What the D-l is the matter with those hills, thought I, that I don't care for 'em a bit? And after thinking a little more, I found it was because they weren't Cumberland nor Scotch!!! This is one reason why I love Chamouni so much—that I have very early associations there—but isn't this a great change in me? I don't know i[f it] b[e] a good one. I think I am getting altogeth[er] more co[mmonpla]ce.

But I [haven't] time to say any more tonight. I hope you had a pleasant tour[1]—so far off one only hears of things when they are over. I intended to have slept at Modena tonight, but it was so fearfully dull that I hurried on. Imagine Stutgard ruined & you have Modena. I hope to leave for Piacenza on Monday, perhaps even Saturday. On Monday the 21st, D.V. I shall be at Domo d'Ossola. Love to my mother.

<div style="text-align: right">

Ever my dearest Father
Your most affectionate Son
J Ruskin.

</div>

85

Parma. Friday, July 10th [i.e. 11th].[2]

My Dearest Father,

I have today your delightful letter from Chester with account of Haymaking & dogs, which quite cheered me in this dullest & most woeful of towns. I am afraid Hero[3] will be claimed by somebody

1 His father had left for Liverpool and Edinburgh on 26 June.
2 Postmarked Parma, 12 July.
3 A large black dog, a stray, that his father had just acquired.

[143]

before I come back, or else I shall be very glad of him. Tug will soon make friends & be happier than before. Sorry to hear so shady a report of Twig.

Very sorry to have missed so delightful a haymaking, the account of which sounds all the pleasanter that I have been almost all the summer in streets & churches instead of the fields. I am hastening to the Alps at last—not that I feel it too hot, but that I want a little nature to recover tone of mind. The habit of criticising hardens one. I am off for Piacenza tomorrow, for this is without exception the dullest & ugliest town I have seen except Modena—it gives one the horrors—and I am so disgusted with Correggio that I know not what to say or do for indignation. (Confound their Italian tables. I laid this paper for a moment on the table of the Salle a manger, & look at it—or through it, rather. I hardly dare lay a drawing down anywhere, except on the bed.) But for Correggio—I always thought little of him, but of all vulgar, coarse, obscure, paltry, petty desecrations of sacred subject I ever cast eyes on, his frescos beat. They are rank blasphemy. I have had a hard scramble today over the tiles of the cathedral to peep in at the little windows of the cupola[1]—just to be sure of my game—and then, have at him.

I have pretty well now arranged my scale of painters. I may shift about here & there a little—I am not sure of the places of all—but I ⟨rather⟩ regard them pretty nearly in this order, and I shall not alter very much.

Class 1st.

Pure Religious art. The School of Love.

1. Fra Angelico. Forms a class by himself—he is not an *artist*, properly so called, but an inspired saint.
2. Perugino.
3. Pinturicchio.
4. Francia.
5. Raffaelle, in his early works.
6. X Duccio.
7. John Bellini.
8. Simon Memmi.
9. Taddeo Gaddi.
10. Fra Bartolomeo.
11. Lorenzo di Credi.
12. X Buffalmacco.

[1] Where are Correggio's frescoes of the *Vision of St John*.

[144]

Class 2nd.

General Perception of Nature human & divine, accompanied by more or less religious feeling. The School of the *Great* Men. The School of Intellect.

1. Michael Angelo. 2. Giotto. 3. Orcagna. 4. Benozzo. 5. Leonardo. 6. Ghirlandajo. 7. Masaccio.

Class III. The School of *Painting* as such.

1. Titian. 2. Giorgione. 3. John Bellini. 4. Masaccio. 5. Ghirlandajo. 6. P. Veronese. 7. Tintoret. 8. Van Eyck. 9. Rubens. 10. Rembrandt. 11. Velasquez.

Class 4th. School of Errors and vices.

1. Raffaelle (in his last manner).
2. The Caraccis.
3. Guido.
4. C. Dolci.
5. Correggio.
6. [Muri]llo.
7. [Carava]ggio. With my usual group of landscapists.

You see two or three come into two classes. Bellini was equally great in feeling & in colour. The first class is arranged entirely by the amount of *holy expression* visible in the works of each, not by art. Otherwise F. Bartolomeo must have come much higher, & Duccio much lower.

I am ashamed to send you this bit of paper, but haven't time to rewrite. Love to my mother, & thank her for her line sent with yours. I will do all she desires—which seems to be pretty nearly to take my own way in everything.

Ever my dearest
your most affe Son
J Ruskin.

86

Parma. Sunday, 13th July.[1]

My Dearest Father,
Here I am still. I found I wanted a little more study of the Coreggios in the gallery. Leave early tomorrow, D.V. I never saw such desecrations of sacred subject. One of them, a Madonna with

[1] Postmarked Piacenza, 14 July.

[145]

Christ on lap,[1] painted for a widow lady—pleased her very much, say the traditions—and I daresay it would, for the Christ Kicks and crows in a most lively and healthy manner, and the angel who is teaching him to read laughs at him to such an extent that as Vasari says, ne lo vede persona di natura melancolica, che non si rallegri.[2] Add to this the most lascivious youn[g M]agdalen conceivable—all the sensuality [of] Etty[3] re[fined] & beautified and white fleshed & so[ft] and gold[en] haired till it is quite poison—and yo[u] have the main points of the Chef d'oeuvre.

There is a large fresco in the library, the Crowning of the Madonna in heaven by Christ (a constant & favourite subject with sacred painters), but Correggio's Madonna turns her back to Christ, and folding her hands and arms a la Taglioni (she being a young nymph of a very sweet Bacchanalian type), bends her head languishingly back over her shoulder, in a manner which Cerito[4] would do well to come to Parma to study, for it beats her hollow. As for the Christs here, of his, they are downright blasphemy. I dare not look at them—and his apostles are the coarsest Birmingham buttonmakers—buried in whiskers—with a touch of the murderer and the rake, here & there, and a general infusion of beggarliness. It is monstrously lucky I came here, as I should have been terribly out in what I said of Coreggio, and I see it to great advantage after the pure study of Perugino & Angelico I have had lately.

It is a nasty climate this Italy, always thundering or doing something out of the way in the afternoon. Please God I shall be on my way to Domo d'Ossola tomorrow week. Love to my mother.

<div style="text-align:center">

Ever my dearest
Your most affecte. Son,
J Ruskin.

</div>

I am puzzled about Lady B's[5] note—don't know how to do without naming places—or districts, which would be worse.

[1] *Madonna with the Magdalen and St Jerome* in the Galleria of the Palazzo della Pilotta.

[2] 'No one of a melancholy nature sees it who is not cheered.' See Vasari's Life of Coreggio.

[3] William Etty, R.A. (1787–1849), at the time the outstanding British painter of the nude.

[4] Marie Taglioni (1804–84) and Francesca (Fanny) Cerito (1817–1909) were two of the most celebrated ballerinas of the day.

[5] Lady Blessington; see Letter 59, note 4.

Pavia. Tuesday [15 July].[1]

My Dearest Father,

Set off at 6 yesterday from Parma, after getting up to the top of Cathedral at four, in hopes of Alps—no go—down again—level road—no doganas—got to Piacenza (my hands are all over black lead—spoil paper)—P. horrid place—ruined—filth—misery—ran about, ordered horses—came in here last night before sunset—this interesting—very. I have been out sinc[e] 5 drawing an old house[2] with Asp of Visconti all over it (Quartiere della Biscia it is called [since]), & there is *such* a heavenly bit of marble—Madonna with an asp above and another below—and now I am off to do a bit of the Church where the Lombard Kings were crowned[3]—& so Certosa[4] in afternoon & Milan. Love to my mother.

Ever my dearest
your most affe Son
J Ruskin.

I forgot. Post office *shut* all Sunday at Parma—couldn't put in letter.[5]

Milan. Wednesday morning [16 July].[6]

My Dearest Father,

Here I am fairly in sight of the Alps and out of marshes. I was afraid I should have been pulled up at Pavia in the rice, thanks to Mr Hopkinson—he has given me such bad wheels that all the wood wore out at the place where the axle turns, and then the wheel lost its position and leaned out so that the box that holds the linchpin was forced off, & we lost it. I don't know how far we went without it,

[1] Postmarked Pavia, 15 July.

[2] *Pavia: Courtyard* (Catalogue 1280), now at Brantwood (No. 970), inscribed by Ruskin 'Pavia morning July 15th'. Cook and Wedderburn date the drawing 1846, but Ruskin was in Genoa on 15 July of that year (see the typescript copy of his father's letter to W. H. Harrison, 14 July 1846, Bodleian Library, MS. Eng. lett. c 32).

[3] San Michele.

[4] Five miles north of the city, on the Milan road.

[5] See Letter 86, p. 145, note 1.

[6] Postmarked Milan, 16 July.

but we heard the creaking at last & found our wheel nearly off—just twenty miles from Pavia, and 10 from Piacenza, the day before yesterday, in the most marshy bit of ground of Italy. If it had fairly come off we should have been in a nice fix. We had to keep throwing water on it, & to keep at the slowest possible trot—on one side of the road—and by mere good luck, the wood which is above the wheel and on which it bore, held out, though half worn away—and we got into Pavia—and there we had the centre filled with fresh wood & put a stronger linchpin—& so got on here well enough. I was afraid I should have had to stop at Pavia to make a new box for the wheel—if they could—and if, here, they can't, I hardly know how we shall manage, perhaps have to put new wheels—it is a shame in Mr H to give me such a villanous old rotten thing, made of touchwood, at *his* price—the whole thing isn't worth 10 pounds, & he charges us 50 for the loan of it. I saw an excellent new English carriage at Pisa of the very same kind, bought for 25£, and I don't believe Mr H would give 5 pounds for this, if it were *ours*. I am very angry indeed about it.

The Certosa which I saw yesterday afternoon is, in elaborateness and quantity of labour, far more marvellous than my recollection of it. In *quality* of art, far inferior. Its style is singularly bad—it has no monasterial feeling—it seems built for *ornament*—it reminded me of the architectural designs of things impossible in the royal Academy. It has a nasty, English, Chelsea hospital, Hampton court twang about it—and the details, whose labour is quite overwhelming, only nauseate one from their profusion without ever giving a single bit of good, pure, great art. After what I have been among in Florence, it looks all derivative & diluted—and made me sick, like the metrical version of the Psalms.[1] It is not *barbarous*. It is an attempt by people without mind or feeling to imitate what is good. But it is all done to be *fine*, nothing for a simple or great purpose. One little bit of a Florentine cypressed cloister is worth a thousand such buildings—and one little bit of Orcagna is worth centuries of work in such sculpture. I never was so overwhelmed with mediocrity. But I begin to feel the effects of the violent excitement of the great art at Florence—nothing gives me any pleasure at present, and I shall not recover spring of mind until I get on a glacier. I am sitting here as quietly—waiting till Coutet brings me your letter—as if Milan Cathedral were a thousand miles off.

One thing however I regret very much. I find that while my mind has become so far developed and manly, that I can now judge of the greatest things, & desire them, and have pleasure in nothing that is

[1] It was still in general use in Scotland.

fictitious or second rate, yet for this I have sacrificed the energy & joyousness of the childish time. I do not wake in the morning with the feeling of delight in everything that I used to have, nor can I amuse myself as I used to do, with the pebbles on the sea beach or lake shore for hours together. I think much of the blessed imaginative power of childhood is gone from me—and nothing can pay for it.[1]

Coutet brings me your nice letter from Liverpool. I will send note on Conflans[2] immediately. I am very sorry you sat up to write me when so fatigued—don't do so no more—however I should have missed your letter very much if it hadn't been here.

Write to Vogogna, Val d'Ossola. It is a stage nearer Anzasca than Domo d'Ossola—which I didn't think of.

> Ever my dearest
> your most affectionate Son
> J Ruskin.

Love to my mother.
I haven't written to any friends, except a word to H. Acland to ask him to come to Val Anzasca.

89

Milan. Wednesday Evening [16 July].[3]

My Dearest Father,

I was glad to find today that I liked the Cathedral as well as ever—or even better—it is the noblest piece of work in the world—and I saw a bit of the Monte Rosa from it that did me good—but the weather is wretched. Today till two it was sunny, but with raw, cold, gusty wind blowing the dust about—at 1/2 past one a great black cloud rose up out of the west, & came on & on till it covered us all up, then came some terrific lightning, & finally a shower of hail like that of Egypt, the stones averaging from the size of filberts to large walnuts, here, and on the ramparts bigger than hens eggs. I never saw anything more terrific than the way it tore the leaves off the oleanders and crushed them down into the court—and the trees on the ramparts are half stripped, the roadway green.

[1] Cf. his letter to Durheim of this date, Letter 78, note 4.
[2] A note to be printed with *Written Among the Basses Alpes*; see Letter 93.
[3] Postmarked Milan, 17 July.

The stones were all crystallized in the most beautiful way—like the iron at Dover, en rose, thus, first fell, but ⟨when⟩ they their edges rounded off—one of I brought in to examine it melt- first measured its circumference, it had lain so long in the yard as angles—it then measured round,[1] when they soon got the finest ing, having but not till to lose its

I have only a braccia rule, and so cannot tell in Engl. inches, but it is 5 1/4 Italian. As it melted it showed its beautiful internal structure, becoming first a. on opposite page, and then b. But two hours after it was all over, I found on the ramparts where it fell largest, some remains of which the largest stone c. measured[2]

in circumference, and was of the remarkable shape given at c., evidently formed by a segment of a small one joined to that of a

large, but the curious thing is that this should have been the case from the beginning of the stone, for you see in the centre of it the little white crescent & circle, which are the root of both fragments. I have more careful drawings, for I put the stones on the paper & drew round to be sure of size, but these will give you an idea of the thing.

I must be up at four tomorrow to look for the Al[ps]—good night. Love to my mother.

<div style="text-align:center">

Ev[er] my dearest
your most affectionate Son
J Ruskin.

</div>

[1] The original line is 5¼ inches.
[2] The original line is 5⅝ inches.

Milan. Thursday, 17th [July].[1]

My Dearest Father,

I doubt not I can finish my work here by Saturday, though it is an interesting town, and I then propose starting for *Como* by Monza, where I intend to see the iron crown of Charlemagne, spend Sunday at Como, cross to Lago Maggiore on Monday, and so Tuesday to Macugnaga. I like this Milan as I always did—it is far more Italian in the *people* than Florence—one is not disgusted or interrupted at every turn—the w[omen] wear the black veil and are prettily coiffées, and [the m]en are honest & busy—and the air is cool—a little too much that way perhaps in the early morning. I saw the Mont Rosa, Finster Aarhorn, Simplon, St Gothard, Jungfrau, all clear this morning at 5. But there is too little snow on the Italian side. They are best at sunset, dark against the rays. You see I am short enough now, but there are some churches here which I can only see in the bright light of early morning, & I must to bed.

Ever my dearest
Your most affectionate Son
J Ruskin.

Love to my mother.

[Milan.] Friday Evening [18 July].

My Dearest Father,

I have had some beautiful views of the Alps here—they are all very good indeed and unmask in the kindest way—even Mont Blanc, though so far off that he gets very little credit for his pains and looks so low that even *I* at first took Monte Viso for him—and only found out my mistake by considering bearings. Monte Viso looks very noble, and my dear ol[d fr]iend on the Simplon, the Fletschhorn, comes very [p]owerful indeed. The Finsteraarhorn sho[ws] also to great advantage. Still, it is from the North that they are best seen, for as the sun sets *precisely* behi[nd] Monte Rosa at this season, she can be seen only by the morning light, and in the evening dark against the sky, when though she looks very grave and solemn, there is of course only the effect of any high dark

[1] Postmarked Milan, 18 July.

mountain without snow. It sounds odd to say She, but Monte Rosa is certainly feminine, for her proper name is La Rosa della Italia. I had a beautiful walk in chase of her this morning from six to nine. Formerly a fast walk of three hours before breakfast would have given me a headache for the whole day, but it has now no effect on me whatsoever, except giving me an appetite. Off to Como tomorrow at eleven—finished gallery today very nicely. A Titian[1] there I wouldn't have missed for twopence. Love to my mother.

<div align="center">

Ever my dearest Father
Your most aff. Son
J Ruskin.

</div>

You must begin to prepare now for irregularities. Tomorrow this letter will, I hope, be posted before I leave,[2] but the Office at Como *may* be shut on Sunday. I shall have to leave Como early on Monday morning. I may not arrive at Baveno early, and if I post the letter (which I shall do) at Varese, it will probably have to come to Milan to get on the road to you, so that you *may* now be three, or even four days without a letter. You must not be anxious now, for it is impossible to be sure of letters going from mountain places. I will take great care, shall climb very little, & go on no glaciers except the high ones which are perfectly safe.

<div align="center">

92

</div>

<div align="right">

Como. Sunday Morning [20 July].[3]

</div>

My Dearest Father,

Here I am again—long time since we were here[4]—but I have been peeping into the old room and it is just the same. I wish other things were. If you look into the continental annual, you will find a pretty view of Prout's City & Port of Como.[5] Such it *was*. I took a high bet with myself yesterday that they would have pulled down

[1] *St Jerome* in the Brera Gallery.
[2] Postmarked Milan, 19 July.
[3] Postmarked Como, 20 July.
[4] In 1835.
[5] *The Continental Annual and Romantic Cabinet* (London, 1832), with 13 illustrations by Samuel Prout engraved by various hands. The Como is opposite p. 181. The original drawing is reproduced in *Works*, XIV, Plate 10.

those blessed old houses. Behold it as it *is*. Tell Mr Prout if he paints an inch thick, to this favour he must come.[1] These precious Italians—I thought we English were bad enough, but we are the very Genii of the Arts compared to them. Yesterday at Monza, I found an old church[2] which had been covered with the most radiant frescoes, which if not by Giotto himself, are among the very finest & purest of his 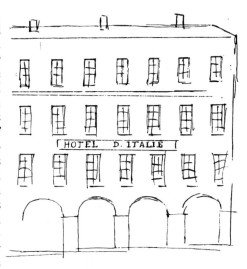 immediate school. They had been covered an inch thick with *plaster*, and what I judge by is the bare outline which where weather & rough usage have torn this plaster away, shows feebly on the rent wall. One little bit of colour, an annunciation only remained—and though I was not sure of its being Giotto's, yet, at a venture, I offered the priest to pay masons work, and give a couple of Napoleons to the church, if they would let me peel off a foot square of the old stucco. But they said it depended on the archbishop of Milan, and as of course there was no chance of getting at him, I had to leave Giotto to his fate.

I never saw anything in my life so fearful as the state to which Italy has fallen. I have not met with one of the nation whom I could look upon as of the same order of beings as myself. I am obliged to think of them as St Francis of the Cicalas, wolves, and sparrows, and say—Italiani, miei fratelli—as an exercise of the most deep Christian humility. It makes me quite happy to see the dogs come into the churches, for I think they are the only creatures ⟨here⟩ that are fit to be there. It is curious that their own great men, even in their great times, speak of them with indignation or grief. Dante speaks scorpions. Vid. Purgatorio, Cant. 6th,[3] Fiorenza mia, ben puoi esser contento, &c, and inferno, 26th beginning, and many such places, besides the tremendous one of the Purgatorio, 14. 43, Tra brutti porci, piu degni di galle che d'altro cibo fatto in uman

[1] *Hamlet*, v. i. 213.
[2] Probably San Michele.
[3] Line 127 ff.

uso,[1] and Michael Angelo, with less bitterness, more melancholy, speaking in the person of his own Night—

Grato m'è'l sonno, e *piu* l'esser di sasso
Mentre che il danno, e la vergogna dura.
Non veder, non sentir, m'è gran ventura
Pero non mi destar. Deh—parla basso.[2]

Beautiful lines—& too true.

I ought to have put a large steamer painted red & green in front of the house on the first page. It has just smoked out of the little port, after nearly blowing us all up with its bother of a gun—choke full of pleasure seeking English from stem to stern. The day of judgment *must* be coming certainly, but if I were the devil, I wouldn't buy these Italians to roast at a farthing a pound—they smell so abominably already—the English in the Steamer will be a better bargain.

This is a lovely place however, & the road to it through [Mon]za heavenly, but I can't write any more—[i]t threatens rain, and I must go & take a little walk. Love to my dear Mother.

<div style="text-align:right">

Ever my dearest Father
Your most aff Son
J Ruskin.

</div>

I begin to want very much to be at home again. I am getting quite wicked here with vexation.

93

<div style="text-align:right">Como. Sunday Evening, 19th [i.e. 20th July].</div>

My Dearest Father,

Will the note on the opposite page do for Lady B?[3] I had nearly forgotten her.

I did not tell you anything this morning about Monza (which

[1] 'Among brutish swine, worthier of acorns/Than of other food made for human use.'

[2] 'Sweet to me is sleep, still more to be of stone,/While injury and shame endure./Not to see, not to feel, is my good luck;/And therefore wake me not; speak low.' Michelangelo's epigram was written in reply to one by G. B. Strozzi on the statue of Night in the Medici Chapel.

[3] Lady Blessington. The note at the end of the letter, with minor changes, was printed with *Written Among the Basses Alpes* in Heath's *Book of Beauty* for 1846. For the copyist, therefore, John James Ruskin cancelled the note, writing below it: 'printed in Book of Beauty'.

⟨was the⟩ place that was the cause of my coming here for the Sunday instead of to Arona or Baveno) except about its Giotto frescos, but those were an accidental discovery. I went for the sake of the Jewels of Queen Theodolinda—and the Iron Crown.[1] The latter is different from what I should think most people imagined it, being as you see, more like a bottle holder than anything else—it is of pure beaten gold with three jewels on each bar, and takes its name from a thin ring of iron in the inside, said to have been beaten out of one of the Nails of the Cross. It is on this account kept as an holy relic, together with a piece of the Sponge, a thorn of the crown, some fragments of the pillar of scourging, and a piece of the reed. All these relics are put into a massy cross of silver gilt of which the crown is put in the circular centre at a., the reed up the middle, the other reliques in the arms. This cross is kept within a bronze door over the transept altar, which door is 12 feet from the ground, and has five enormous locks—so that to get out the cross, as it is too heavy for a man on a ladder, they have to erect a scaffold—and as it is so precious a relique this scaffold has to be hung with tapestry, and while two priests reverently take it out, two more have to stand below and burn incense all the time. Hence you will guess it costs more than the Tower to get at it. I had to pay 10 francs altogether, including Theodolinda's treasury. The latter however was alone well worth the money, for it contains I suppose some of the oldest jewellery now existing—cotempory with our Saxon dynasties— and they take the pieces out & let you touch them, so that there is no mistake about their *stones*, all is real & true, and the richness very marvellous. I was especially pleased with a cross for holding the Sacred Wafer (which however is more modern than the rest), surrounded by ears of corn of beaten gold, and masses of vine leaves, also of gold, laden with swinging clusters, loose, of purple & white grapes, the former rubies & the latter pearls.

Just at the time that Mr Moore[2] was beginning his sermon to you today, I was sitting down to rest on a rock under the shade of some scented thickets of young chesnut trees—2000 ft above the lake of Como—looking down into it, it seems a narrow, dark *fosse*, very gloomy, very sublime. We made our way to a peak which I see the map says is 3700 ft above the sea—considering it as merely a Sabbath days journey—not a walk but a saunter—and the view

[1] The crown of the Lombard kings is in the cathedral, as is the Treasury of Theodolinda (d. 628), the celebrated Lombard queen.
[2] See Letter 13, p. 33, note 1.

was very noble. Alps under cloud, but the lakes of Iseo, Pasiano,[1] Como, Varese, & Maggiore, ⟨in the⟩ with the vast plain of Lombardy & the lower promontories of the Alps were quite enough. Off early tomorrow for Vogogna or Baveno. I purpose posting this at Baveno,[2] for if I did so at Varese it would only come back here & go to Milan, but it will probably be a day late—either way.

Love to my Mother.

<div align="right">Ever my dearest Father
Your most affectionate Son
J Ruskin.</div>

It is not among mountain scenery that human intellect usually takes its finest temper, or receives its highest development. But it is at least there that we find a consistent energy of mind and body—compelled by severer character of agencies to be resisted & hardships to be endured; and it is there that we must seek for the last remnants of patriarchal simplicity, and patriotic affection—the few rock fragments of manly character that are yet free from the lic[heno]us stain of over civilization. It must always, ⟨be⟩ [the]refore, be with peculiar pain, that we find as in the district to which the following verses allude, the savageness & seclusion of mountain life without its force or faithfulness, and all the indolence & sensuality of the most debased cities of Europe, without the polish to disguise, the temptation to excuse, or the softness of natural scenery to harmonize with them.

<div align="center">94</div>

<div align="right">Vogogna, Val d'Ossola. Tuesday, 22nd July.[3]</div>

My Dearest Father,

I have your four delightful letters of the 5th, 8th, 9th & 12th, with accounts of Scotland &c, and you will by this time I hope have received some letters of mine in which nearly the same feelings are expressed—though I can't quite come up to the Calton yet, as *the* thing.[4] I wished for you sadly yesterday as I was driving from the lake of Varese down to Laveno, opposite Baveno—you cannot *conceive* anything so beautiful as the winding of the lakes, five or six seen at once among the mulberry woods and tufted crags. But

[1] i.e. Pusiano.

[2] Postmarked Vogogna. At the top of the outer page of the letter there is a cancelled fragment in Ruskin's hand: 'are worthy of the highest period of art'.

[3] Postmarked Vogogna.

[4] His father had written (9 July, letter in the Beinecke Library, Yale University) that Calton Hill in Edinburgh 'commands the finest View in Europe'.

as I said to myself at the time, it was only the more beautiful because it was more like Windermere, or rather like many Windermeres. After crossing the lake, I came on here in the afternoon, and I was more struck than ever with the heavenly richness & majesty of the landscape above Baveno. People had much better do as we did last year—see the Borromean islands & go back. There is in the south nothing half so Italian—nothing half so lovely. After the stunted olives of Florence the grand chesnut woods of Baveno come with the greater effect, and I am going back there, after finishing the Val Anzasca, for 10 days to get studies. Everything is there that suits my purpose, wood, water & the finest possible mountain forms, so that there is not the slightest need for my going to the Val d'Aosta, and I *certainly* shall not go near it, more especially after your expressing so strong a wish on the subject.[1]

Certainly my *mission* has to do with rocks more than with walls. I fancied I was enjoying myself at Florence & Pisa, but I wasn't at all. It was quite new life this morning to wake in a little tiled room, and see my window blocked with the green hill side, & watch the clouds floating & changing upon it as I dressed. And then breakfasting with a dog on one side & a hen on the other. Not that I got thinner or weaker in Florence as my mother imagines. On the contrary, I find myself in perfect training, and have put myself through a little work this morning, with the greatest ease, preparatory to my walk to Macugnaga tomorrow if the weather be fine.

Letters I find come twice a week half way up the vally & the post master at Domo d'Ossola is to send me them up. I shall send George down & post yours, but you must never be anxious as all sorts of irregularities may take place. I shall take the greatest care. When one is on foot, one is always safe enough, & there are no mules to be had there. I am very sorry for Dr Grant,[2] very; especially as it may make him fearful of going in such places again. Thanks also for your account of his niece. I should have thought the pious lady[3] would have been above, or below, pride, but it is the closest sticking

[1] See his father's letter, 9 July: 'I am relieved by your not going to Val D'Aosta at present. It is such a sink of Disease, so savage & so out of the way of human beings.'

[2] George Grant of Terrace Hill, Richmond, family physician and friend. On a trip into the West Highlands with his stepdaughters, he had fallen off his pony and broken his collar bone (see his father's letter, 12 July, Beinecke Library).

[3] Miss Augusta Sidney, Dr. Grant's elder stepdaughter. His niece from Hawick, a poor relation, had been taken along on the Highlands trip, but Augusta disapproved of her staying on with them in Glasgow after the accident and she was sent home.

sin of all. Talking of Macdd,[1] *why* don't he write to me? I wonder how much of his levee would stay by him, if they could be of any use to him. The difference of feeling with which you regard Scott's & the La Scala ⟨family⟩ monument[2] is easily accounted for. All modern Gothic is uninventive and over loaded. Compare the la Scala arch simple & all its orna-the material fitter this tomb of the a man who and there is the widest with anything modern & see how chaste & severe it is—and so with all its orna-ments. Add the richness of there, and consider how much peculiar baronial manner is for the Great Dogs of the Scala, than for mad [*sic*] his nobility by his pen, I think enough to account for possible difference of feeling. The people both here and at Como are far finer in race than those of the south, and as Coutet said of the hills this morning as compared with Florence, Au moins, on n'y voit pas de paresseux, et il y a un autre *odeur*.

<div style="text-align:right">

Ever my dearest Father
your most affe Son
J Ruskin.

</div>

Love to my mother & best thanks for her notes.[3] By the by I don't like M. Ulrich & Co. at Milan—the[y] have a disagreeable manner and only gav[e me] 249 dollars + 4 fr. for my 50 pounds. It o[ugh]t to have been 253.

<div style="text-align:center">

95

</div>

<div style="text-align:right">Macugnaga. 24th July.</div>

My Dearest Father,
 In the enclosed letter to my mother[4] you will find some account of my domicile—its *only* disadvantage being that it is just 18 miles[5] from the Post office,[6] and that even the office so attained

[1] His father had written from Edinburgh on 5 July: 'I have only been here a few hours but have found Mrs Farquharson [Macdonald's mother] MacDonald & Sister. . . . I found the Farquharsons alone but was not in 3 minutes when Gentleman after Gentleman & Lady after Lady, Mothers with their Daughters &c were ushered in—a perfect Levee' (letter in the Beinecke Library).

[2] On 5 July his father had complained of the recently completed Scott monument in Edinburgh that it was 'thorough Twelfth Cake stile' and wondered 'why I find fault with this Monument, when I see nothing wrong at Verona in La Scala'. Of the three Scaliger monuments in the churchyard of S. Maria Antica, the arch here is from that of Mastino II.

[3] Added to the letters of 5 and 8 July.

[4] Letter 96. [5] Kilometres, and so below. [6] At Pontegrande.

only carries letters three times a week. That you may be sure of getting this & knowing I am all right, I send George with it to Vogogna, but as this is 30 miles, I cannot send him there constantly, and I shall be obliged to risk the letters at the 18 mile one—the road to which being nice up and down, & in good hill air, he can very well get there & back in a day, three times a week. My letters are to come there from D. d'Ossola. But you must not get anxious, as it is imp[ossib]le to have any certainty about letters at such Post offices. I shall climb but little here, and only so far as I find necessary to get mountain illustrations—and so stop to draw. It is not at all a place for you or my mother, for besides that the inn is smaller & more rustic than Zermatt, and that the loneliness & seclusion is greater, nothing of the mountain is to be seen without climbing a little, Montanvert height, about, by steep footpaths. There are no views of interest in the valley, nothing grand or striking, no chasms, peaks or precipices—plain rocky hill side or pine forest. In the valley of Anzasca below this I am especially disappointed. But, although not quite what I want for drawing, the place is a perfect Paradise for *feeling*, and the want of the Zermatt sublimity makes it even more delicious to live in, all hay fields & cascades.

George posts this tomorrow at Vogogna[1]—returns next day. I must then give him a days rest, & if the following day should be the post day at Grand Pont, & he be too late for it, you will be four, perhaps 5 days, without a letter, but after that I hope they will come regularly 3 a week. I hope I shall hear a good account of Dr Grant in your next.

<div style="text-align:center">

Ever my dearest Father
your most affectionate Son,
J Ruskin.
</div>

Continue writing to Vogogna.

I begin to feel indeed, as you say, I have been a *sad* long time away, but it will be all the merrier coming home again, I hope.

In my mother's letter I say less *desolate* than Zermatt. It is more lonely, but not so savage.

[1] Postmarked Vogogna. Received 2 Aug., according to his father's letter of 5–6 Aug. (Bem. L 3).

Macugnaga, Val Anzasca. Thursday, 24th July.
My Dearest Mother,

Here I am at last in my *own* country, in great luxury & rejoicing—out of the way of everybody—out of Italian smells & vilenesses, everything pure & bright. It is very like Zermatt, but less desolate, & more pastoral—we have arrived in the middle of the haymaking and the whole air is sweet. I guess by the look of the vegetation it is about 1000 ft higher than Chamounix, i e, very nearly the elevation of the village of Simplon—on one side there is nothing but a semi-circle of perfectly bare rocks & waterfalls—[o]n the other pines and a few stunted acacias—the brooks, not glacier torrents (only one of those in the middle of the valley), but clear fountain bred ones, come tumbling down about my cottage over blocks of granite and sing to me all night;—the air is crisp, clear & delicious—and the peaks of the Monte Rosa all round rising over the pines. I call it *my* cottage, for there is no one in it but us, the landlord being up at a chalet for convenience of hay making—and a thorough Swiss cottage it is, much smaller than the Zermatt one, and by itself in a field, approached over a pine bridge and rocky path. As for living, we shall have everything soon—& the cream is like Devonshire, & the wild strawberries perfection. It is not quite however so pictur-esque as Zermatt, nor so available for my purposes, owing to its want of the horrors—there are no chasms nor precipices to speak of, nor powerful torrents, nor ancient woods—the energies of Mont Rosa are turned the other way—and I was grievously disappointed in the *valley* itself, Anzasca. There is nothing in it but thorough commonplace. I must indulge myself however with a fortnight of this, in order to see the Mont Rosa well from the upper peaks, and these views I have no doubt will answer well for my mountain illustrations—for my near foreground studies I must go down to Baveno. My Father says you imagined by the way I spoke I was getting thinner. I am stouter if anything, and indubitably stronger. I walked up here from Vogogna, which is the same as Visp to Zer-matt. Started at 1/2 past 5—got in at 1/2 past 4, resting about two hours—at more than three miles an hour, and all up hill—without the slightest trace of weariness. Stopped to make hay in a fresh cut field just an hour before getting in.

I don't understand the way you speak of your letters—as if you were ashamed of them, or thought I didn't like them. They are the greatest possible pleasure to me & I wouldn't part with a line of them at *any* price. You say in your last that *some letters* of mine gave you great pleasure—please particularize what about, next

time, for I can't tell by the dates & forget all about them. Poor little Louise. I am very glad she was pleased with my letter.[1] I don't wonder at your liking her. I think the Miss T.s education of her as near a model of education as well may be.

<div style="text-align:center">

Ever my dearest Mother
Your most affectionate Son.

</div>

<div style="text-align:center">

97

</div>

My dearest Father,

I am leading a most delicious hermit life here. I sometimes stop on the bridge over the torrent at the door, in coming home, to wonder at myself, and at the realization of all my childs ideas of felicity. Living in a chalet—among chalets and rocks—& nothing else—at 5200 feet above the sea, so the height is given by Keller[2]— with only one pan in the house, so that if there is a soup, there can be no boiled meat, except what was in it, nor anything else requiring a pan—with not a soul near me to whom I can speak except George and Coutet—not another stranger in the valley, so that the peasants all know me already and wish me Guten Abend as I pass home—with mountains of all sizes within the stretching of an arm, and a glacier not half a mile off—and the roar of cascades without number all about me—and power of limb to get up wherever and as far as I like—and time to do it. I should really have to seek for some drawback to all this, but that I have to think of the way you are missing me at home, and that I feel lonely myself when I am not actually at work—for want of you—and that my book keeps me rather worried & fidgetty, and that George brought a horrible report from Vogogna that there was an English "party" coming up. I shall send him down to Grand pont to reconnoitre, and if they come, I shall buy up the meat in the valley & starve them out.

Coutet, to his other accomplishments, here adds that of Cook, for the landlord being blind, and the landlady rarely having seen

[1] See Letter 69. In a note added to his father's letter of 8 July, his mother had written that his letters to Anna Anderson and Louise Ellis had been 'received with equal delight and gratitude. I like the one to Louise best and I think I like of your two young friends Louise best too. She read your letter to me with such spirit and understanding.' The ladies Ruskin refers to are Henry Telford's maiden sisters, with whom Louise was staying at Widmore, Bromley, Kent.

[2] Heinrich Keller, *Original von Kellers Zweiter Reisekarte der Schweitz*, 1844.

<div style="text-align:center">

[161]

</div>

meat in the course of her life, the chops would be prettily managed between them, but for Coutet's interference. George too made me today a very fair, though rayther buttery, rice pudding and we are going to try our hands at the bilberries tomorrow, which are most superb here, if we can get some flour.

George walked down on Friday to Vogogna with your letter, which I hope went right, and returned yesterday by three o'clock, having left at four in the morning. 60 miles in two days is pretty well for him. He went to bed directly after getting his dinner, slept till 7, and woke thinking it was Sunday morning.

<div align="right">8 o'clock, Evening.</div>

The English have floored me—here they all are—two gents and a lady—query American?—but they are going—or *say* they are going—over the Monte Moro tomorrow—a good high pass, & they must walk. I asked Coutet this afternoon whether he thought the lady would ever get up. "Si elle montera?—je crois bien qu'elle montera—c'est une nouveau mariée—voyage de noces. Oh!—la premiere année, elles font *tout*. *Apres*—ah—il leur faut une femme de chambre!"

The monte Rosa was clear tonight for the first time, and I took a little turn of 2000 ft or so up the Monte Moro to look at it. It won't do—o' this side. It is steep, without being sublime or peaked in form, but *so* steep that the snow falls or melts half off it with the south sun—no rich domes of snow, no aiguilles, no noble glaciers, nothing but a black heavy form patched with snow. The Mont Rosa has but one side, properly speaking, and that is Zermatt way— it is there only that it is fine. I shall be very sorry to leave my hermitage here, but I see I must in a week or so, and go down to study at Baveno, for there are no fine forms to be had here. I shall then go across to Como by Lugano, and so by lakes of Iseo & Guarda to Venice, returning by Brescia & Bergamo, and bolt over Simplon or Cenis home—merely calling at Chamonix to drop Coutet & pick up a flower book which Payot[1] is making for William,[2] and another of the rarest plants for myself, on an extensive scale. I say to drop Coutet, for though after I leave Baveno, he will not be of any further use to me except to pay the postboys, my mother said she should be anxious if I did not take him. After my stay at Baveno, I shall have to send to Milan for money. I must give George my passport—no—I won't, neither. Coutet has one of his own. George might be stopped, or lose it, but if I give Coutet the notes of Coutts

[1] Probably Pierre Joseph Payot, or perhaps his son Venance (1826–1902), who became a naturalist.

[2] William Richardson (d. 1875), Ruskin's Perth cousin, a London physician.

& letter of credit, and a letter also with my signature. I suppose he will get the money. ⟨He'll⟩ He can go by steamer & be back next day.

With all that I have written above about the romance of the *life* here—and nothing can possibly be more after my own heart—yet all my old ideas about this *Valley* have been woefully knocked on the head. I fancied it a kind of Rasselas place, and that the Mont Rosa ran round it in lovely waves of [pure?] snow. Whereas the Mont Rosa is an ugly black hea[p] at one corner of it, and ⟨the⟩ it is a mere piny ravine among black hills of commonplace for[m]. As for the beauty of the inhabitants, poverty & labo[ur] set the same marks pretty fairly all over the world, & I hav'nt yet found the place where the "village maidens" dress in satin, or the peasants in fancy jackets & conical hats. But the thing that I chiefly miss here is the charm of early association, the home feeling that I have at Chamonix, owing to my early visits there. All is comparatively cold without this, and though you speak with pain of your early Edinburgh recollections,[1] I am persuaded that even these have infinite power of endearing the places they inhabit, for however childhood may suffer, it is a period of entire trust, hope, & insouciance, approaching nearer to a state of perfect felicity than any other of life. I cannot now dabble in a streamlet for hours together because now I count the days. I feel life going. I am stingy of moments, & must always be doing something. This is unhappy. Life seems infinite to the child, and what he chooses not to do today he hopes to do tomorrow. Probably he does more, according to his strength, in this way, than the *man*, who measures his time.

Perhaps you will be kind enough to read, seal, & forward the enclosed letter.[2] Is the gentleman doing anything—if he isn't, tell him he may as well come here & catch fish and climb hills with me.

I send this to Grand pont,[3] 18 miles down—it will be two days before you can have another letter. Love to my mother.

Ever my dearest Father
Your most affecte Son
J Ruskin.

[1] In each of his father's letters of 5, 8, and 9 July there is a remark that those recollections of his native city are unpleasant.

[2] A letter to Turner (see John James Ruskin's letter of 5–6 Aug., Bem. L 3).

[3] Postmarked Pontegrande. Received 5 Aug.; answered 6 Aug.

Macugnaga. Tuesday, 29th July.[1]

My Dearest Father,

It blows such a hurricane that I fear George will not be able to get to Grand Pont tomorrow—rain does not matter, but it is quite a storm, and there would be danger in some of the narrow passes. It would be difficult to conceive a more miserable season than this has been—since I entered the valley there has not been one *hour* of settled weather—all kinds of inconvenience—hot sun, the rainy intolerable heat, desperate wind, cold rain—the poor English people I told you of are nailed here as we were at the Grimsel[2]—they are superior people, these Oxford men—oldish, one first class, and the wife of one of them. They have done nothing but get themselves wet through & dried again, except that by way of variety last night, the married gentleman, having got close into the back hollow of the fireplace—and congratulated himself exceedingly on his comfortable birth—found on getting up to go to bed that he had been sitting all night with his coattails in the frying pan. As he had been very lively, and had stirred them about a good deal, and the coat was a light one, which took up all the dripping it could get, the effect was exceedingly improving. It was done quite brown & crisp.

Coutet is quite in his element, cooking the dinner, going out to gather strawberries for tea, mulling wine in the evening, & encouraging everybody all day like Mark Tapley[3]—not *me*, for though I complain of the weather in the abstract, it is for my present purposes the very thing I want—the rain has swelled the torrent before my window and put it into a condition so like Turner's St Gothard[4] that I got a capital study of it[5] to engrave as a parallel with the bit I took from Turner, and the cloud effects on the mountains are to me worth all the fine weather in the world. Still I don't like to be kept in all day neither, for my room is none of the biggest.

I hope the letters go right *from* Grand Pont. George enquired there on Monday, but found none—perhaps the post master at D. D'Ossola has not forwarded them.

I find this sojourn in the mountains already doing me great good. I had got my head perfectly puzzled in Italy with the multitude of new masters & manners and I was getting a little adrift from my own proper beat, & forgetting nature in art—now I am up in the

1 Postmarked Pontegrande. Received 9 Aug.
2 In Aug. 1835; see *Diaries*, I. 51.
3 Martin's manservant in *Martin Chuzzlewit*; see chapter 15.
4 The drawing Ruskin had bought in 1843 (see Letter 42, p. 83, note 2).
5 Catalogue 1774.

clouds again, I see my way. Titians all very well, but I don't see anything like him here. It is all Turner, and Turner *only*, nobody else. Monte Rosa showed off tonight, brilliantly, like a good creature as she is. I've nothing to say against *her*, mind, it is only the weather that is bad. Monte Rosa does all she can for me.

Are there no news yet of my Turners?[1] The things that I see here make me quite thirsty for them.

Gordon wrote me from Geneva he should drop down on me here some day soon—perhaps he is pastured up by the weather at Saas. I hear nothing from any of my friends—one would fancy they were all dead—please blow up Macdd when you next write to him.

It is a shame to send you this big sheet with nothing on it,[2] but the wind blows hard in at the ill fastened windows, and I must to bed out of its way. My bed's too short, and that's the only inconvenience here—nice clean house and good, honest, amiable, pitiable, blind, humpbacked, quiet landlord—and a landlady who *would* do everything, but is wise enough to leave it to Coutet—and a little red cheeked, red capped, grey frocked picture of a peasant girl—would make a splendid sketch, but I amn't up to the life yet. The Anzascan cap is high & *Greek* like, and very picturesque. There it goes again. Through the sharp hawthorn blows the [cold] wind. I shall take Edgar's advice.[3] Goodnight. [Love] to my mother.

<div align="right">

Ever my dearest Father,
your most affectionate Son,
J Ruskin.

</div>

99

<div align="right">

Macugnaga. Friday, 1st August.[4]

</div>

My Dearest Father,

I received yesterday your nice long letter from Preston about the lakes &c, posting at the same time one for you, which I hope will go right. I am grieved at your report of Ulleswater.[5] I was disappointed in the same way myself in Wales after coming from Switzerland—nevertheless I think with a little time one might come to feel them again—proportion and form are the great things, not bulk. At least half the bulk in Switzerland is lost—it only makes your journey

[1] See Letter 47.

[2] This sentence begins the second sheet of the letter.

[3] 'Go to thy cold bed and warm thee', *King Lear*, III. iv. 47–8.

[4] Postmarked Pontegrande. Received 12 Aug.

[5] 'I was utterly taken aback [&] disappointed—here indeed were Lake & Mou[nt]ain & bright Skies but it was not Switzerland . . . The Mountains are naked & bony the Vegetation is mere Rags' (letter of 15–16 July in the Beinecke Library).

longer, but adds not to the effect of scene. I should like to try the height of an English hill, after my Swiss training. I suppose I could climb Skiddaw & Helvellyn both in the same day. On Wednesday I was up about Buet-height, 10,000 ft—the English people whom I told you of were going over the Moro, so as the weather was pretty fine, I went up with them to see how they got on. They managed very well—they got four stout Valaisans to carry the lady in a basket, and got up easily enough. The snow was in capital condition, soft so that the bearers did not slip, or they would have had more trouble—but fresh snow had fallen the night before which was delicious walking, only it was mighty cold. I have not often felt a more bitter wind than blew over the top of the pass. There I left them, and as it was pretty clear I went up the highest peak of the range, on the east of the pass, whence I saw the Sesto Calende end of the Lago Maggiore, and all the plains of Italy & chain of the Apennines. It is a rare thing to see the plains of Italy from the central chain of the Alps (the peak of the Moro being like that of the Simplon, a link of the great range). This was all very well, but the Monte Rosa part of the view is ugly, shapeless & desolate, as well as the valley of Saas which one sees down, as far as Visp. I shall therefore stop here only to finish a few little pastoral bits, which are to be found here in great perfection, and then I must go in search of something more available for my present purposes. I had nearly forgotten that as I shall have to speak much of the Torrent Turner, I must see its actual scene, that I may know what is composition & what is verity. It is at Dazio Grande below Airolo, but I am afraid to sleep at Bellinzona at this season. Therefore I shall go to Domo d'Ossola and thence walk up part of the Gries pass, see the fall of the Toccia, descend the val Bedretto to Airolo & Dazio Grande. I believe there is an inn among the stones there, at least so says Coutet, and I shall probably find all I want either there or on the Gries. I shall then return for the richer studies to Baveno, and so start for Venice.

I had not seen the inscription in Melrose Churchyard[1]—many thanks for it—it is very interesting. There is a great deal of pretty feeling about their chapels here—all painted, some of them well, with Madonnas and saints—but alas, the religion is pure Marian. Coutet was giving me an account of the sermon last Sunday, with great indignation—the curé had been insisting on the necessity of masses for the dead. Diable—said Coutet—comme ça, je ferai tout le mal que je veux dans la vie, puis je ferai payer mon salut à mes

[1] 'The Earth goes on the Earth glistering like Gold/The Earth goes to the Earth sooner than it wold/The Earth builds on the Earth Castles & Towers/The Earth says to the Earth, all shall be ours' (letter of 15–16 July).

heritiers! Si je suis riche n'importe ce que j'ai été—je fais dire des messes, et je vais tout droit aux cieux—si je suis pauvre, je travaille toute ma vie, pour faire manger à ma famille—je meurs—je n'ai rien—je vais au diable la tete la premiere. Nevertheless, though the people are miserably taught, they are well disposed & industrious— they salute you invariably, and neither man, woman or child has yet begged of me.

I never found out till tonight that Coutet was at the great Tyrolese battle above Bautzen,[1] where Hofer[2] defended the Brenner by the rocks let fall. I fancy he does not much like speaking of it. He was with the French, and they had had seven hours march in rain before they came to the pass. His company numbered 130 in the morning, only 35 came off the field. I suppose it was then he learnt cooking—though it was in a rough way, for he says they used sometimes to put gunpowder into their brandy, to increase its stupifying power—however he cooks capitally now, to the great edification of the English who were here, on whom his various accomplishments made a most favourable impression. If it had not been for him, they would have gone away again without seeing the Moro.

You may now for 10 days address Baveno, and after that Venice. I don't think I shall delay long after I leave the mountains. I only go to Venice to see John Bellini & Titian, and though this is necessary, yet as my opinion about both is made up, they will not take me long, and I am in a hurry to get home now. This morning, as I was walking under the dull grey clouds before breakfast, through the wet meadows about the brook, I caught myself wishing "that these were the Dulwich fields & I ⟨was⟩ were going home to breakfast in the library with papa & mamma." And this is saying a great deal for *me* in the heart of the Alps. But I don't know how it is— the romance of these countries is gone, & I only care for them for their intrinsic beauty, which however great, still leaves the home feeling unsatisfied. I can't write any more however, for I have got some flowers by me to [dr]aw, which I certainly could not have found in the Du[lwich] fields—the Saxifraga pyramidalis, & some nameless on[es of] great beauty from the pastures near the glacier, where the Turkscap lilies, purple & scarlet, & the white lilies, & the bluebells & forget me nots, are now blowing as in a flower garden. Love to my mother, from whom I have a line in the interstice of your letter.

<div style="text-align: center">

Ever my dearest father,
Your most affectionate Son
J Ruskin.

</div>

[1] Botzen (Bolzano).
[2] Andreas Hofer (1767–1810), leader of the Tyrolese revolt of 1809.

[Macugnaga. 6 Aug.][1]

My Dearest Father,

I enclose a letter to Clayton,[2] which after reading please seal with my seal & send. I have yours of the 23rd & am very glad to see you safe back in London & with Mamma again. Sad account of Hero[3]— don't let poor Tug be annoyed—turn the new one off, if he won't behave. I fully feel the truth of what you say about the excitement & malaria of Italy,[4] but the change is not one of mere apathy—it is a different direction of likings. Formerly I hated history, now I am always at Sismondi. I had not the slightest interest in polit[ica]l science, now I am studying the constitutions of Ital[y with] great interest. If my course of study at college were to [come] over again *now* I should enjoy it beyond—no, not beyond everything, but very much—not the college *life*, mind you, but the college *reading*— the histories & mysteries, and myths, which were a mere task, would now be a subject of real pleasurable investigation—my mind is strangely developed within these two years, but it is developed into something more commonplace than it was, into a quiet, truth-loving, fishing, reasoning, moralizing temperament—with less passion and imagination than I could wish, by much. Talking of passion & imagination, you send me no word of Turner, either drawings or liber Studiorum[5]—the latter is precious to me beyond all I could conceive—there is no art like it in the world—and as I told you, everything I see here makes me more thirsty for his drawings, for they are the only things that have downright truth in them.

I have been sadly put out here in my work by the weather— whenever it does not rain, there is a wind that almost lifts the stones off the house—today I have been trying to do something, in vain— hot sun, cold wind, in gusts, blowing *all* ways & everywhere— could hardly even walk in it with safety, for it always came sharp

1 Postmarked Pontegrande. Answered 18 Aug.

2 The Rev. Edward Clayton (1817–95), Ruskin's friend from his Christ Church days. He was at this time curate to the Hon. R. W. Sackville-West (later 7th Earl De La Warr), rector of the parish church of Withyham, Sussex. The letter, printed in *Works*, I. 498 ff., is chiefly an apology for not being able to meet Clayton's request for a presentation to Christ's Hospital.

3 The recently acquired stray continued to run away and battled with Tug (see letter of 23 July in the Beinecke Library).

4 His father's letter characterizes the change in himself Ruskin had complained of in Letter 88 as 'the mere depression & exhaustion after strong excitement followed by the dull ordinary routine of Life: & very like a malaria affection'.

5 See Letter 11, p. 23, note 1.

round a corner whenever I got warm. I have throughout this journey had everything against me, of all sorts—men, winds, & fortune—from the passage of the Jura to this evening, August 6th.

I shall not be able to get your letters while I am at Airolo, but I hope you will get mine. Love to my mother.

> Ever my dearest Father
> Your most affectionate Son,
> J Ruskin.

101

Macugnaga. Sunday evening [10 Aug.].

My Dearest Father,

I hope after this you will get your letters a little more regularly, for I am about to leave my hermitage. I should have done so four days back, but I lost *six* by the bad weather. When I say lost, of course I worked indoors, but to all out of door purposes they were lost, and what was worse, they did not come altogether, but every third day, so as to keep the ground soaked. Still, bad weather is far better in the mountains than anywhere else, otherwise I should have been down before now. I was mightily tempted tonight, at the foot of Monte Rosa, to stop tomorrow in order to cross the glacier at its foot, which would give some solemn snow scenes, but I have not time now—ten days will be little enough at Baveno. Besides I know you don't like glaciers, and though I have had a good many little rambles upon it here & there in the quiet places, yet there might be some awkward bits in the middle, and as Joseph[1] & I don't like turning back when we are once enga[ged], it is more prudent not to go. Joseph was half blinded yesterday. [I had] not got the forms of the Alps that I wanted from the Mont [Moro], & yesterday being the *first* day that we have had that had the least appearance of settled weather, I went up again—but we found the uppermost thousand feet (perpetual snow) covered two feet deep with fresh snow in large crystals of the most dazzling kind, not only white, but flashing like spar. My spectacles which I had made on purpose at Charing cross—extra thick, & as black as pitch—served me well. George had a pair too, but Joseph had not brought his from Chamouni, and before we got up, the slope being very steep, he was

[1] Couttet.

[169]

obliged to walk behind me in my steps, being utterly unable to see. It is singular what power the rays have in the thin air, to blind & scorch. The wind was northerly at the top, and Hamlet's dialogue with Osric is the only fit or true description of the state of things[1]— our faces burning like ⟨our⟩ cooks on a company day, and our fingers half bitten numb by the north wind. Under the stones however, where we had scraped away the snow, it was delightful, & I stopped 5 hours, watching the various effects of cloud over the plains of Lombardy, after getting the forms of the mountains that I wanted above the valley of Saas.

I was afraid to tell the Vogogna post master to send your letters here, for I expected to be down before—tomorrow I hope to get to Grand Pont, where I post this.[2] Tuesday to Vogogna, get your letter, and to Domo d'Ossola—arrange for mule excursion that evening. Wednesday to the inn above fall of Toccia. Thursday to Dazio Grande. Stay there as long as I find necessary, then down the Val Maggia to Locarno, & so to Domo d'Ossola by the Valle dei *Cento valli*, which Joseph describes as being all rocks and Spanish chesnuts, which is what I want precisely, & thus avoid Bellinzona & see two routes entirely new to me, besides the head of the L. Maggiore.

Today is I believe an important time for the Swiss—some grand question to be decided in the Pays de Vaud.[3] I asked Joseph if there would be any disturbance. Sans doute—said he—vers les cinq heures—on aurait bu quelques bouteilles de Vin blanc.

I am sorry to leave my pretty torrent here, but the mountains are unprofitable & shapeless, & I can't waste more time on them. Now write to Venice. Love to my mother.

<div style="text-align:right">

Ever my dearest Father
Your most affecte Son,
J Ruskin.

</div>

[1] *Osr.* I thank your lordship, it is very hot.
Ham. No, believe me, 'tis very cold. The wind is northerly.
Osr. It is indifferent cold, my lord, indeed.
Ham. But yet methinks it is very sultry and hot, for my complexion—
Osr. Exceedingly, my lord. It is very sultry, as 'twere—I cannot tell how.
(v. ii. 97–104.)

[2] Postmarked Pontegrande. Received 19 Aug.; answered 21 Aug.

[3] There was a vote on the new Constitution of the canton.

Domo d'Ossola. Tuesday [12 Aug.].[1]

My Dearest Father,

Post going—only time to say I have your two delightful letters to Vogogna with enclosed letters[2] & news of pictures.[3] Mr Moore[4] & Mr Dale[5] shall have letters instantly, and you shall have a beautiful upright to replace Nash[6]—love to my mother—all well. I will take every c[are o]n water, never sail.

ever my deare[st]
your most affe Son
J Ruskin.

Airolo. Friday morning [15 Aug.].[7]

My Dearest Father,

Here we are at the old place,[8] after two days good hard walk from D. D'Ossola, ten hours Wednesday & nine Thursday. I find the post goes early here, 8 o'clock morning, so I must send off a mere line again. I am going down to Turner's place today—Dazio grande —ten or twelve miles. I can't get your letters from Vogogna, must leave them there till I get back. The Val Formazza which we [wa]lked up on Wednesday is quite divine, and we [had a] good day —yesterday a bad day, but a good lunch, to wit—Three slices of

[1] Postmarked Domodossola, 12 August. Received 20 Aug., according to his father's letter of 20 Aug. (Bem. L 3).

[2] His father's letter of 26 July (Bem. L 3) enclosed one from W. H. Harrison and one from 'J. MCracken Belfast a buyer of one of the Lovely Dreams of Turner No 162 in Rl. Academy' (see Letter 42, p. 82, note 4). A. J. Finberg, *Life of Turner* (2nd edn.), pp. 405, 408, identifies the latter as Francis McCracken, but if John James Ruskin is correct, he was probably John W. McCracken, insurance agent and member of the firm of Francis McCracken & Co., Belfast.

[3] His father's letter of 30 July–1 Aug. (Bem. L 3) reported that Turner had told him he could only do the first three of the ordered watercolours (see Letter 47) and that they would be ready in a month or so.

[4] See Letter 13, p. 33, note 1.

[5] The Rev. Thomas Dale (1797–1870), vicar of St Bride's, Fleet Street, canon of St Paul's, and formerly Professor of English Language and Literature first at University College and then at King's College. Ruskin had briefly attended his private school in Camberwell.

[6] The letter of 26 July requested that Ruskin 'do an oblong like Scisseurs', elsewhere in the letter called 'Nash's Sisseurs', to go above the piano in the Ruskins' drawing room. The drawing referred to is perhaps of the church of Gisors by Joseph Nash (1807–78); see Plates 6 and 7 of his *Architecture of the Middle Ages* (London, 1838).

[7] Postmarked Airolo, 15 August. Received 20 Aug.; answered 21 Aug.

[8] The Ruskins had been at Airolo in Aug. 1835.

beef fried. Two, d., cold. Two penny rolls & butter. A Dish of fried potatoes. Half a bottle of wine. That's pretty fair for me. What George did I know not, but I imagine something respectable, for as Coutet says, Afin que George aille bien, il faut lui donner à manger *souvent*, et beaucoup *à la fois*. Not a bit tired. Love to my mother.

<div style="text-align: right">
Ever my dearest Father

Your most affe Son

J Ruskin.
</div>

104

<div style="text-align: right">Faido, St Gothard. Friday afternoon 15th Aug.</div>

My Dearest Father,

At last I have time to say a few words in a rational manner. I must go back to Macugnaga. I walked half way down the valley on Monday, in order to see it better—the weather before was too bad. Slept at Ponte Grande, got down early next morning to Vogogna (three women carrying our baggage). You would like the first ascent of the valley, near Vogogna—beyond that there is nothing— at Vogogna I found your letters—many thanks for all they con- tain—a little encouragement, like that of the letter of inquiry,[1] &c, does me a great deal of good, for I sometimes when I find how little I can do of what I wish & feel, lose courage to a painful extent. I am very glad you have got the Prout & Hunt,[2] the latter will be of exceeding value to me, and gladder to hear that Turner is at work. I have found his subject, or the materials of it, here; and I shall devote tomorrow to examining them and seeing how he has put them together. The Stones, road, and bridge are all true, but the mountains, compared with Turner's colossal conception, look pigmy & poor. Nevertheless Turner has given their act[u]al, not their apparent size—but of that tomorrow. Pray tell Mr [Griffi]th, if he is asked about Harding's book, that excep[t] the first five or s[ix ch]apters, I have not even seen it, and that I have not even in those suggested one single idea or word, though I marked a sen- ten[ce] or two which I thought doubtful.[3] I put my name down as a subscriber to it & if a copy does not come, please write & remind

1 From McCracken; see Letter 102, note 2.
2 See Letter 41, p. 80, notes 1 and 2.
3 See his father's letter of 30 July–1 Aug. (Bem. L 3): 'Griffith says he is asked if you did not help Harding very much in writing his Book which is thought better than he is capable of doing.' The book is J. D. Harding's *The Principles and Practice of Art* (London, 1845), just published; Ruskin's remark is curious, since the book has only seven chapters.

Harding, as it would look unkind in me, if he has forgotten that I did so. I quite forgot the passage about Holland in my book[1] when I mentioned his improvement to Mr Harrison—here is more good done, and I am very grateful to have been able to do so much— poor Holland writes singularly good humouredly,[2] for I was very hard upon him. I hope he will enable me to treat him more kindly after this—he has the power, but he seems to me to be a little too much selftaught & to want discipline. I will take great care of boats at Baveno, merely using them in calm afternoons for exercise. Sestri was the place. How you would have enjoyed my evening rows there, and in the gulph of la Spezzia, with good, English like, sea worthy boats, and the cloudless sun burning green over the green sea, with its golden swells breaking & lurching in among the purple rocks, and the porpoises plunging in circles like huge water-wheels and the snowy mountains far off in the amber sky.

I find I must post this before 8 o'clock this evening,[3] so as I am just going out for my afternoons ramble & sketch, I must seal my letter—it is safer to put it in at once—and I will send account of what I have been about, tomorrow. I stay here tomorrow, probably next day. I never thought of looking in Coutts circular letter if Domo d'Ossola were mentioned, for I supposed it too small, but if it be, I shall not have to send to Milan. I have left the circular letter in the carriage at D. D; the notes I have here. Love to my mother.

<div style="text-align:center">

Ever my dearest father,
Your most affe Son
J Ruskin.

</div>

[1] James Holland (1800–70). In *Modern Painters I*, after briefly praising his watercolours of seven years before, Ruskin had added: 'But he has since that time produced worse pictures every year; and his fate appears irrecoverable, unless by a very strong effort and a total change of system' (*Works*, III. 529). The sentence was deleted from the 3rd edn. (1846).

[2] The letter of 30 July–1 Aug. includes a copy of a letter of Holland's to Harrison: 'Your note in which you tell me that John Ruskin had seen the Suffolk St. [Exhibition of the Society of British Artists, opened 24 Mar.] gave me much pleasure. . . . I am delighted to be understood & proud of his praise for excepting a few Painters he is the one whose admiration is most to be coveted. You know I consider M. P. to contain many anomalies, yet take it all in all it is the finest piece of writing on Landscape art EVER produced. I feel the language is fine, I know the principles are Truths of Nature, but I mean to convince that same Graduate that I am not sinking into a mere Dauber of Canvass. To be snubbed by a man of such Judgement is most painful to me but I owe him thanks his remarks have made me resume my own feeling & I shall adopt my own mode of rendering the Conceptions I have. I have painted many bad pictures to please my *friends* many of an hour believed they knew much better how pictures ought to be painted than the artist.'

[3] Postmarked Faido, 15 August. Received and answered 21 Aug.

<div style="text-align:center">

[173]

</div>

Faido. Friday evening [15 Aug.].[1]

My Dearest Father,

I wrote to you this afternoon that I should stop here tomorrow & perhaps next day, meaning of course Monday. I wish I could stop longer, for I like the people both here & at Airolo, and the Inns are quite luxury compared to what I have been used to, but I shall have better materials at Baveno. When I came down to Vogogna on Tuesday, George heard some one enquiring for me in the passage, who turned out to be young Cotton[2] who had been directed by H. Acland to Macugnaga in search of me (Acland being in the Shetland isles). He was going up the Valley, but hearing that his family were going on over the Simplon, I recommended Zermatt instead, to which I believe he has gone. I took tea with his father, mother & sisters, who seem nice enough people as the world of London goes nowadays.[3] They started for the Simplon next morning, and I for Formazza, though I was kept till 8 o'clock by the lazy Italians, who at first couldn't be got to bring the horse, & then brought no luggage harness—we got off at last, and the morning was *very* lovely on the Val d'Ossola, and the rocks of the Ponte Crevola, where we left the Simplon road;—and the entrance to the Val Formazza is full of beauty, all churches & vines with a *clear* river among rocks. But it was mighty hot, up hill all the way, and they give you large measure of horses, allowing about four miles to them. We walked steadily till two, and stopped to dine in a heavenly place. I would give a great deal to be able to carry you there. I think you & my mother might manage it on mules, though the road is very stony, but I doubt if you could put up with the inn, though it was perfectly clean. After dinner I walked on quietly by myself. I never like to walk too fast just after dining, & every step I went I wished for you more & more. All lovely pasture with chesnuts under solemn precipices—no desolation—all the waters clear—and splendid cascades at every quarter of a mile. But I couldn't stop. I had rested an hour, and I saw the ten hours were likely to be eleven, and it is dark now at 1/2 past seven. So I waited, taking a note in my book, till Coutet came, and told him I should go ahead, for I wanted to see the Toccia fall before dark—and then I began to walk in

[1] Postmarked Faido, 16 August.

[2] Henry Cotton (1821–92), later Sir Henry and a judge. He and his elder brother, William, had been at Christ Church and Henry Acland married their sister, Sarah, the following year. Their father, William Cotton, was a director and governor of the Bank of England.

[3] John James Ruskin cancelled 'who seem . . . nowadays'.

earnest. I find my best time for walking is after about seven hours of it, having had my dinner, rested a little, & worked off the stiffness.

I went on at a great pace till 1/2 past seven & then I pulled up to look about me. I knew by the look of the hills that the fall of the Toccia must be at least an hour farther on, and I knew by the pace I had come that Coutet & the horse must be nearly an hour behind me, which would give 1/2 past nine for their arrival at the fall, the inn being according to report just beyond it. I didn't know what to think—the last peasant had wished me gute nacht, as he went home with his rake on his shoulder, the candles twinkled from the cottages in the valley beneath, the roar of the Toccia came louder & louder as the night became quiet, the wind blew cold & shrill from the glaciers of the Gries before me, and the moon, nearly full, rose over the St Gothard mountains confusing the stones of the path with its deep shadows. I sat down on a rock and watched the glittering of the stream in it for a little while, but it grew cold, and I wanted some tea, and didn't know when I should get any. I was afraid to go on for fear of losing my way, there being now no marked path among the moorlands, and at last I thought there must be some mistake & turned back to meet the rest. I had not walked above a quarter of an hour before I heard Coutet's whistle far down the valley—we met in ten minutes more—they had thought it better to stop at Formazza, the horse got so slowly over the rock path, and Coutet had come in search of me. I found candles lighted & tea ready in the little wooden cabin at Formazza, & we had pretty sound sleep that night. Next day bad weather again, but I was afraid of worse & pushed on, after waiting till nine to see if it would clear. It did partially, until the top of the pass into the val Bedretto, & a nasty pass it is—two hours walking in a bog, and sleet, at 7000 ft above sea. I thought we should never get to the end of it. But the end came, and on descending to the little inn of Bedretto I was ready for the prodigious lunch I told you of. We got into Airolo at a little after 7, resting an hour on the road, and a horrible stony road it is—it cut my feet considerably, so that I took a char down here next day, and now we are all right again.

I have got two sketches[1] today of Mr Turner's subject (Saturday) and a specimen of the stones of the torrent—gneiss coloured by iron ochre proceeding from decomposing garnets. The road on the left is the *old* one, which has been carried away in the pass, and that on the right is the new one, which crosses the stream by the shabby temporary bridge. It has been carried away twice, so that there are the remains of two roads & two bridges, & three new bridges, of wood, which Turner has cut out, keeping the one he wanted. The

[1] Catalogue 644, 645; the latter is in the Fogg Museum, Harvard University.

[175]

gallery on the left is nearly destroyed—it protected the road from ⟨the line of⟩ a cataract, which has now taken another line & has left the worn channel you see.

The road has also been entirely carried away where I sketched below Airolo, 10 years ago, and it is now carried by four galleries through the rocks above the chapel, seen behind it in my sketch— vide old pen and ink purple book, 1835. I hope to write to Mr Moore tomorrow.

<div align="right">
Ever my dearest Father

your most affe Son

J Ruskin.
</div>

[Love] to my Mother.

106

<div align="right">
Faido. Sunday, 17th [Aug.].[1]
</div>

My Dearest Father,

I haven't any paper to spare, carrying very little on one single mule & so I am obliged to send this, which has been crushed in my colourbox, as well as dyed. I enclose a note for the picture man[2]— it wants a blank seal. I can't make out his direction, is it Belfast? I send the date back for you to decipher.

As I was sitting taking my quiet tea in the table d'hote last night, an English family arrived en voiturier—gentleman in a cap, & lady, & elderly daughter. They fixed their rooms, & then the gentleman came in & took off his cap, & behold, Dr Wootton of Oxford,[3] travelling I am sorry to say for his health—he has a bad cough, has been to Milan only, five weeks out, now on his way home, says he is better, but they seem rather a slow party on the whole.

It is [a lov]ely day and I am going to take a little walk. I think I sh[all hav]e to send Mr Moore's letter straight to him, but I have no doubt he will show it you. On looking at my two sketches made yesterday I find them wonderfully like the picture, but it is beautiful to see the way Turner has arranged & cut out. I never should have dreamed of taking such a subject. George didn't recognize it at first, and on my showing him how it had been adapted—"Well— he *is* a cunning old gentleman to be sure—just like Mrs Todgers— dodging among the tender pieces with a fork." (Vide Martin Chuzzlewit)[4]

[1] Postmarked Faido, 17 August.
[2] McCracken; see Letter 102, note 2.
[3] John Wootten (1800–47), physician to the Radcliffe Infirmary.
[4] Chapter 9.

I am off tomorrow D V for Locarno, and hope to see four other Turner subjects—one on the road—three at Bellinzona. I hope to be settled at Baveno Thursday evening. Still write to Venice. Love to my mother.

Ever my dearest Father,
Your most affe Son
J Ruskin.

Remember me to Mr Harrison—much obliged by the hopes of another letter.

107

Faido. Sunday Evening [17 Aug.].

My Dearest Father,

I must have this ready to post at Bellinzona as I pass tomorrow,[1] for if I go up the Valley of a hundred vallies, it will be two days before you can again hear. My mountain rambles will then be over, for my stay at Baveno is only for drawing, and you have only the month for Venice & Padua to look forward to, & then I am on my way home as fast as I can. I shall not I think even call at Chamouni. I should not like to go there merely to go away again—shall make them bring my books[2] to Martigny to be ready as I pass, and so straight by Vevay over Jura, not even touching Geneva.

This St Gothard valley is very beautiful, & the people are very pleasant—pure Romanism—and of a degraded kind but still *living*, not, as at Florence, a mere mode of getting money for the priests, but a religion that operates & teaches. The people and the horses are very clean, and I have seen more pretty girls—pretty because innocent, good tempered & lively in expression—here than in any other Italian—and if you and my mother would like to see the valley, I can strongly recommend the inns both here & at Airolo—you might stop any time. At Airolo I had a cutlet with my tea, eggs with breakfast, double bedded room for myself, & another for Coutet & George, & for *all* the bill was seven fr.

You never told me that Croly had done with Roberts before your last letter.[3] Who is to do the Egypt?

[1] The initial postmark is illegible, but the subsequent ones suggest the letter was posted at Faido, 18 July.

[2] The flower books Payot was making; see Letter 97.

[3] The letter of 26 July. The Rev. George Croly (1780–1860), author, rector of St Stephen's, Walbrook, and friend of the family, wrote the letterpress for the first four parts of Roberts' *The Holy Land* (see Letter 30, p. 60, note 9), but the letterpress for the last two parts, Egypt and Nubia, was written by William Brockedon.

What a lazy old gentleman Turner is. But he has done work in his time—and may be pardoned. I want to write to Stanfield,[1] but know not if he be in town.

Ever my dearest Father
your most affectionate
J Ruskin.

Love to my mother.

108

My Dearest Father,

You will be glad I think to see the above date, & I am very glad to be here. At Bellinzona I made some enquiries about the Cento Vallis, and found so little encouragement, the inhabitants having bad character, & the road worse, that I gave it up, & instead of two days hard work at twenty fr. a day, which mule & man cost, and a days posting besides, I took four hours before breakfast out of steamer for eleven francs, & here we are all right—as the clown says[3]—with the knowledge that neither you nor I need trouble ourselves hereafter about Bellinzona or the head of the lago Maggiore. It is ugly and unhealthy—Bellinzona fine in form, but Turner's single sketch[4] [is] worth the whole valley with all the towns in it. All that [is fine] is at Faido & above it, & *here*, or in the Vals d'Ossola & [For]mazza.

I have your letter[5] with Harding & McDonald—for the former I am very grateful, but he does not say when he is coming, and I don't know what to do. I shall send a letter for him to Domo d'Ossola, but he probably may not inquire there. Macdonald's head is too much taken up with business, but his letter as far as it goes is very pleasant. I am fidgetty about Harding, for I have missed Gordon, who is now on his way home—and Acland is at the Shetland islands—and I want to see somebody. I have been a little too

[1] W. Clarkson Stanfield, R.A. (1793–1867), landscape painter.

[2] Postmarked Stresa.

[3] It was the clown's traditional shout at his entrance. See 'Astley's' in *Sketches by Boz*.

[4] *Bellinzona from the Road to Locarno*, shown by Turner in 1842 (see *Works*, XIII. 209) and now in the British Museum, Turner Bequest, CCCXXXII. 25.

[5] Of 7–8 Aug. (Bem. L 3).

much alone. I send to Vogogna for your letter[1]—thanks for extracts from Arnold,[2] & encouraging account of Turner, G Richmond[3] &c—best love to both of them. Dearest love to my Mother.

<div style="text-align: right">

Ever my dearest father
Your most affe Son
J Ruskin.

</div>

You are very naughty, however, to begin plaguing yourself about letters again, when I gave you such fair warning.

<div style="text-align: center">

109

</div>

<div style="text-align: right">

Baveno. Aug. 21.[4]

</div>

My Dearest Father,

I missed the post yesterday, thinking it was the same that took the letters from Vogogna, but they go from here to Arona much earlier. I was vexed at it, for fear you should think I had caught a fever at Bellinzona, or something.

There is no place like this—atall—it is delicious beyond imagination. I feel far more in Italy than I did at Florence, and the effects on the lake and mountains are so lovely that they make me quite miserable—because I can't do them. Here is another change in me. I am now just what you were when we used never to agree which way we should go—this soft shore & quiet lake and curved mountain are more pleasant to me than the savageness of Macugnaga—not but that I enjoy a *thoroughly* wild & sublime bit as much as ever, but it must have something more than mere desolation to please me, and on the whole, [I like] this sort of thing rayther better, for I have here all the sublimity of [the] Alps in the distance, and a foreground of Paradise. I ought to be w[hi]pped if I don't do something pretty

[1] His father had written: 'I shall send a single line to Vogogna merely to say I write to Baveno.'

[2] His father had copied out three passages from the 2nd volume of Stanley's *Life and Correspondence of Thomas Arnold* (1844): the long passage beginning, 'A great school is very trying' (p. 137); a passage on the beauty of Italy, but the superior moral destiny of England (pp. 366–7); and the sentence, 'A thorough English gentleman—Christian, manly and enlightened—is more, I believe, than Guizot or Sismondi could comprehend; it is a finer specimen of human nature than any other country . . . could furnish' (p. 377).

[3] 'Griffith today tells me he is every day expecting to see Turner walk in with your 3 drawings. George Richmond on whom I called was all beautiful Kindness—he had yr Letter [see Letter 74, p. 132, note 3] 3 weeks ago & had sat down to answer but as yet you must take the Will for the deed.'

[4] Postmarked Stresa.

<div style="text-align: center">

[179]

</div>

here—the Val d'Ossola mountains are decidedly the finest I have yet found, and I have had a pretty hard search.

Mr Francis Oldfield[1]—the Indian one—sent in his card the night before last. I have sent him up to Zermatt, but shall I believe see him again on his return from Lago d'Orta.

The people here are not disagreeable—they seem more industrious than most of the Italians, and therefore more good tempered. I always take Coutet with me, but I conceive there would be no fear here in going about by oneself—which is more than I could say at Pisa or Florence. I am very glad you like the liber Studiorum, but pray don't lock it up—keep it in your bedroom and look at it often. I wish I had had that plate of the source of the Arveron[2] with me— it would have helped me much. Still I am quite convinced now, that nothing is to be done in landscape without continual alteration and adaptation, and that's just what I can't come. I am getting to be able to render what I see with tolerable accuracy, but I can't change—what I alter I spoil. Figure painting is child's play to it.

You may still write to Venice. I shall leave it I suppose about the 25th September & run straight for home. Here is a fine day at last & I must be off & make the most of it.

<div style="text-align: right">
Ever my dearest Father

your most affe Son

J Ruskin.
</div>

Love to my mother.

110

rightBaveno. Thursday, 21st [Aug.].[3]

My Dearest Father,

I was hard at work till four o'clock today up the valley towards Domo, and on rowing back to dinner I had quite a treat in your four letters, three brought by George from Domo & Vogogna (6th, 8th, 9th), and that here (13th), which are full of most interesting subject, and are more especially agreeable as setting my mind at ease respecting the Vogogna & Ponte Grande letters—which I was sadly afraid might not go right—and I am very glad to hear of Harding's coming, for if he comes straight [here] I cannot miss

[1] Lieutenant in the 3rd Bombay Light Cavalry, on furlough since 1844, probably the brother of Ruskin's friend Edmund Oldfield.

[2] Plate 60 of the *Liber Studiorum*, whose delivery his father had announced in his letter of 30 July–1 Aug.; see Letter 11, p. 23, note 1.

[3] Postmarked Stresa.

him, and if I even had to wait a day or two longer, it would not matter, for the air and the scenery here suit me precisely. It is the first place where I hav[e] had the least summer enjoyment. I dared not be out in the twilight at Florence, and in the day time it was all heat & dust, but here the air is quiet & mild. I can be out when I like, have the windows all open, & yet no oppressive heat, lake a very book full of all sorts of effects, mountains glorious, the healthiest possible—they are all granite here, and dry in ten minutes after rain—mountain torrents clear & lovely & not too big—one can dabble in them without being in danger of your life if you fall in. Even the delta where the Toccia enters the lake, on the other side of the granite quarries, is not, as most deltas are, a poisonous grey marsh, but a lovely district of green meadows & tall trees, which however I am mighty shy of. I wanted a drawing there, but I shan't take it—no use running the risk of a fever for a sketch. But it is amazingly useful to me in the distance—& there I shall keep it.

I am delighted to hear of Mr Severn's good fortune[1]—pray remember me to him most kindly. Harding I will thank for his book myself.[2] I shall certainly want Armytage[3] all November & December. I would send home some things for him at once, but am afraid of losing them & have not time to make copies. I am afraid Harding will not like anything that I have done, for I have entirely left his manner, and have been following Titian and the liber studiorum—often into peat bogs and other bogs—but certainly with greater benefit & increase of knowledge, than brilliancy of result. Harding won't understand my drawings of ilex leaves counted, and I am afraid he will think my studies have been very brown. I thought Stanfield would have been out of town, or I should have written to him.

Many thanks for all about Newton[4] & Prout, &c—remember me always most affectionately to Mr Prout. Love to my mother.

<div style="text-align: right">

Ever my dearest father
your most affe Son,
J Ruskin.

</div>

1 Joseph Severn (1793–1879), the painter. A reference, no doubt, to the news that, though he had not won a prize in that year's cartoon competition, he was, with others, to be given some rooms in the House of Lords to decorate; see the *Athenaeum* for 2 Aug., p. 771.

2 See Letter 104. According to his father's letter of 7–8 Aug., Harding had presented Ruskin with a copy 'with your name written in it & proof plates'.

3 James Charles Armytage (1820?–97), engraver. For the plan to provide engravings for the second volume of *Modern Painters*, see Letter 30, p. 60, note 2.

4 Charles Newton (1816–94), archaeologist, friend from Ruskin's Christ Church days, then in the department of antiquities of the British Museum.

Always bad weather, rain again. I send off this morning a letter to Mr Moore, though a sad short one, with nothing in it.

I can't tell exactly what money I want, but if Coutts bills are good for 100, the fifty at Venice[1] will bring me back at any rate to Martigny—then I have to pay Couttet about 36 napoleons, for he won't take his money, except four fr. a day for board—says he can't carry it—so I owe him four fr a day from 12th April. I don't go to Geneva—if you send me a credit to the bankers at Vevay it will be all right.

I don't understand about the Coutts bills—you say, give Couttet only *one* of the ⟨notes⟩ bills. I have got four for 25—do they want *two* to give you 25 of cash? I see in the letter[2] it is said sur *double* acquis. At all events I have given Couttet the four with orders to bring me 50 pounds for *two* if he can—& if he can't to present the others. In case of my[3]

111

Baveno. Saturday morning, 23rd [Aug.].[4]

My dearest Father,

I am certainly becoming a very commonplace sort of person. Here is a fine day at last and I got up early to have a morning walk in Isola Madre, and I enjoyed it quite as "the public" do. I liked the aloes and the laurels and the stone pines and the regular gravel walks and the "vedutas" cut through the foliage, and everything, and didn't want to be up in the snow, though I saw the Simplon peaks in the blue sky. I am certainly going all wrong, and I can't help it—must ask Mr Harding about it. Coutet went off to Milan yesterday, & when George came in this morning rubbing his eyes just as I was calling for the boat and drinking my cup of coffee, I was going to scold. Please Sir—said George—I've been enjoying the *two* beds, Coutet's & mine. He has a good deal of fun about hi[m] in his way, but he is intensely stupid[5] for most *purposes*—honest however & good tempered, [&] that is all one wants.

I have a letter from Gordon—he is going home from Lucerne. We missed each other in a most clumsy way, but it was more his fault than mine, for he never told me in his letter from Geneva where to write to him, so that I couldn't tell him where I should be—

[1] On his letter of credit.
[2] Coutts' *lettre d'indication*.
[3] The rest of the letter is missing.
[4] Postmarked Stresa.
[5] These two words are cancelled, no doubt by John James Ruskin.

the consequence was that he arrived at Milan on the Sunday, I having left on the Saturday—he followed me to Como on Tuesday, by accident, saw my name in the book as off for Val Anzasca, & went off the other way, for Venice—and he would have been at Milan on the Saturday but that he got out of the steamer at Arona by mistake for Sesto Calende.

You needn't be afraid of railroads. I shan't trouble their dirty ironwork. Thank heaven it isn't finished across the lagune yet, and I trust once more to have the pleasure of the quiet float to Venice without being transported to Greenwich or Liverpool in unsweetened imagination. I seem to have puzzled in [*sic*] you in one of my back letters by writing Domo in mistake for Vogogna— it was from the latter place they did not send my letters. I am going out for a good days work I hope, & can't write any more—love to my mother.

<div style="text-align: right">

Ever my dearest Father,
your most affecte Son
J Ruskin.

</div>

112

<div style="text-align: right">

Baveno. Sunday, 24th Aug.[1]

</div>

My Dearest Father,

I had a delicious day yesterday—the third fine one I have had since leaving Bologna—and it looks settled & sweet this morning. No news of Harding yet, but I have left a letter for him with the landlord at Vogogna in case of his asking for me there.

I have been looking over the extracts you sent me from Arnold,[2] which are very full of sound sense, that respecting public schools especially—the more I see of boys the more I dislike them—their very motion is an impudent affectation, a shallow, unfeeling, uncharitable, unthoughtful swagger of ridiculous independence— and I know what a fool I was when I was one. That respecting the incomprehensibleness of English gentlemen to Messrs Guizot & Sismondi is very good also, & yet as the servant says of Coriolanus,[3] there is more in Sismondi than I could think—he is a good deal in the right in several points. His great theory is the necessity of giving men at some period of their life a high & ungoverned position, in order that the preparation for it & expectation of it may give the utmost dignity & energy to the individual character—and of this there can indeed be no dispute, that men become new creatures

[1] Postmarked Stresa.
[2] See Letter 108, p. 179, note 2.
[3] *Coriolanus*, IV. v. 166-7.

altogether according to the responsibilities entrusted to them, & forces and faculties are developed in them of which they themselves were before altogether unconscious. Sismondi most truly says[1] that in Florence, where every citizen of common respectability, down to the lowest tradesman, had the chance, the probable chance, of becoming one of the twelve Anziani, of supreme authority, the struggle to obtain this position, to make themselves fit for it, and the faculties developed in the possession of it gave to the whole nation such force of character, for a time, as no other ever exhibited. But I conceive it to be a morbid excitement, & one essentially involving the necessity of following reaction & degradation. Such a government cannot subsist, it can have no settled principles, it is an admirable school for the people, but a miserable instrument in its own proper function—besides, even in the former end it must fail, more or less, according to the scale of the nation—in a city divided into twenty companies, it works well, but it is absurd altogether in a Kingdom divided into twenty provinces. Independent *cities* have some reason in being republican, but it must be at the expense of continual jealousies, wars, & seditions. Peace can only be secured by fixed positions of all ranks, and settled government of the whole. I want to study the English people under Elizabeth, for the development of intellect was then great under an absolute monarchy, & the King love of Shakespeare is very glorious, but with that exception, there is nothing that the world has ever *shown* that can stand, intellectually, beside the power of mind thrown out by the fighting, falling, insane republicanism of Florence —in Giotto, Orcagna, & Dante, alone, its first fruits, with all the clusters of mighty ones their satellites, ⟨and⟩ without reckoning the impulse given to the national mind going on in Ghiberti & Brunellescho & Masaccio & Ghirlandajo, and gathering all into one great flash to expire under the Medicis in M Angelo—nothing can be set beside this I say, except the parallel republicanism of fighting & falling Athens, giving us Æschylus & Phidias & Aristophanes & Thucydides. But then there are such wide specific differences in republicanism. That of Florence is more opposed to that of America than our monarchy to the spirit of the French revolution. The government of Florence was one of the most tyrannical in Italy— while it lasted—sweeping everything away that opposed it, banishing, executing, razing houses of rebellious families to the ground on the slightest provocation, and that with so strong a military arm that the people could not have the slightest power over it, its popularity consisting solely in this, that every citizen had his two

1 Not, it seems, a reference to a particular passage, but a summary of several passages, e.g. *Histoire des Républiques Italiennes* (Paris, 1840), X. 361–2.

months turn at it, but no popular movement, no sedition, no clamour could affect it in any way—it was iron bound and rock built, & nothing could overthrow it internally—when it fell, it fell by the loss of a battle equivalent to the annihilation of the state, though it is to be observed that this battle was brought on by the rashness of two of the popular members of the council. But surely there is something widely different between this Kingly & authoritative republicanism and the "liberty" of America, where the nation is too vast to let its members have any share in the government, & therefore they have none at all.

I cannot conceive anything finer, as a school, than the Florentine system. Suppose you yourself knew that in a certain time you would be, during two months, one of twelve persons, who without any appeal or restriction, in a secret council, without the nation even knowing the object of their deliberations, could make or unmake laws & execute every measure they chose to adopt on the instant—would not this give you other views & thoughts than you have, & make you in every respect a greater man—while on the members of the government there was always the check of knowing that in two months, they were to sink again into entire ⟨subjection⟩ obedience, to be subjected without appeal to the laws they th[em-se]lves had made and the authority they had exercised, w[ith] the remembrance of the good or evil they have done attached to their name. This is very different again, even from the popular assembly of Athens—a government of mob entirely, liable to be led by every demagogue, incomparably weaker & wilder than that of Florence, but developing intellect in the same way, owing to the minds of the people being all brought practically to bear on political matters. Both these governments, in their brilliant instability, one may oppose to that of Venice, where we have the tyrannical government of Florence made hereditary—the moment it is so, the formation of an aristocracy makes it consistent, stable & powerful, but with the stability and power, ceases the development of intellect. Venice leaves us no writers, and in art she leaves us a school entirely devoted to the musical part of it, not to the intellectual—of *art* per se she is mistress, but of art as a medium of mind, she ⟨leaves⟩ knows nothing. The stable monarchy-forms of Austria and Sardinia seem nearly parallel cases. England leaves more appeal to the people, & draws more brains, but even she produces nothing great except in war-time. Nothing can come of nothing—the French revolution brought out all the little intellect they had, and it was all froth & fury. Egypt, in old times is a curious instance of a people of enor-mous powers of mind kept entirely dormant in a fixed condition, by unchangeableness of ranks & an authoritative monarchy &

priesthood—we shall soon see in Bavaria, the utmost result of mind that can be obtained by the fostering power of monarchy, without inherent energy in the people.

Here is a long rigmarole for you, but I wanted to explain what I meant by saying a letter or two back, that I was getting more republican. I didn't, you see, mean more of a liberty man—of all curses that poor, vicious, idiotic man can suffer, liberty is perhaps the greatest, but if one can be made to govern oneself, the exertion required to do so brings out a fine creature. Of all governments I have ever seen at work, that of Florence seems to me, at present the worst—and it is in its form, not in its head, for the Duke is a good sort of person enough. The people are *quiet* under him, & happy—so are the frogs & the lice—and there is about as much mind & worthiness in the one as the other. I have heard it said that if the fields of a country are well cultivated, and the markets well supplied (and they are at Florence), the government was assuredly good. But it is *not* enough to make a government good, that its markets be well supplied—if it has turned its people into vegetables. Love to my mother.

Ever my dearest Father,
your most affecte Son,
J Ruskin.

113

Baveno. Sunday, 24th August.[1]

My Dearest Mother,

As I received on the 22nd[2] a letter of my Father's dated 13th August, I trust that this will either arrive on, or before, the second of September—in time to assure you of my most affectionate remembrance of you, and my hope that I shall not be away from you on any more birthdays. I am already in a hurry to get home— even from this delicious place—and I only go to Venice because I *must* see the pictures there before I write, or else I should run direct & directly for Denmark hill, & be with you instead of this letter. I think there is such a change come over me lately that there will be no more disagreements between us as to where we shall go or what we shall do, for my childishnesses are, I am (in one respect) sorry to say, nearly gone, & now, wherever I am, in church, palace, street, or garden, there is always much that I can study & enjoy— and although I am just as selfwilled as ever, yet my tastes are so much more yours, & my father's, that I think we shall travel more

<hr>

[1] Postmarked Stresa. [2] 21st; see Letter 110.

happily than we did[1]—nothing can come wrong to me, & if even you were to desire a sojourn at Wiesbaden or Baden Baden, I believe I should find enough to employ myself withal—and I think in other places, you will find me a little more of the cicerone than I used to be, and perhaps something of a guide where I was formerly only an incumbrance. I am looking forward with infinite delight to the prospect of showing my father all my new loves, making him decipher the sweet writing of Simon Memmi in the Campo Santo, and leading him into the dark corners of the cloisters of St Mark, where my favourite Fra Angelicos look down from the walls like visions, and into the treasuries of the old sacristies, lighted with the glass that glows "with blood of queens & kings."[2] And I think I shall have something for *you* too—when I show you the children of Mino da Fiesole—such sweet, living, laughing, holy creatures that I am afraid you will wish they were yours instead of me. And then I can draw something better than I could, & I draw now less for the picture & more for the interest of the thing, so that when my father wants a sketch of anything I shall be better able to do it than when I thought merely of a certain kind of picturesqueness—and I think we shall agree something better in our notions of subject too. Indeed I have made myself now a kind of Jack of all trades. I have had a try at Angelico, ⟨with⟩ the most refined drawing of which the human hand is capable, at Tintoret & Titian, ⟨with⟩ the boldest & most manly. Architecture I can draw very nearly like an architect, and trees a great deal better than most botanists, and mountains rather better than most geologists, and now I am going actually to draw some *garden* for you out of Isola Madre,[3] and study some of its bee haunted aloes tomorrow morning if it be fine—it is sweet to see the aloe with two or three hives of bees about it making its yellow blossoms yellower. And besides all this I have got more patriotic too as I told you before, so that if we go to Scotland, I shall enjoy *that* more than I used to do—and in short it does not now much matter where I go, for I shall always find something to do & to please me. And so I have only to pray you to take care of your sight & to make yourself comfortable in the idea of my being soon home again—only four weeks more you know, after you receive this, & I assure you it will not be longer than I can help—not even Venice will keep me longer than is absolutely necessary—& then I hope I shall write a very nice book and one that I needn't be ashamed of. I have done some good to art already, and I hope to do a great deal more. Only I cannot write any more

1 'I think . . . we did' is heavily cancelled by John James Ruskin.
2 Keats, *The Eve of St Agnes*, xxiv. 9.
3 Catalogue 894.

today, for I have written a long letter to my Father too—about certain new opinions of mine which I was afraid he would misinterpret—& I shall miss the post if I don't take care. I intended to have written this much better than I have, but I have been thinking of all we have to see together, & not of my writing—& so my dearest Mother, with every prayer for your long preservation to me, believe me your most affectionate Son

<div align="right">J Ruskin.</div>

Love to my Father.

I suppose that Ann will seize upon this letter from the post[man] & bring it in proudly, recognizing the badness of the hand. I received a message from her by George the other day for which I am much obliged, remember me most kindly to her, & to them all.

<div align="center">114</div>

<div align="right">Baveno. 25th Aug.[1]</div>

My Dearest Father,

Here is Mr Harding all right, though somewhat fatigued with his journey—came in at eleven o'clock last night. I have just seen him for five minutes, having been out since six o'clock drawing in Isola Madre—he has to finish some letters, as I this, & then we shall arrange something—the fine weather seems to have come on purpose for him—it is beautiful today.

You will perhaps see in the papers the loss of a guide on the Monte Moro—the Englishman who was with him came here yesterday. Poor fellow, the fresh snow which blinded Coutet, and half skinned me, was of worse effect to him, for being of Lucerne, [&] not knowing the mountain, he went up what appeared the [sm]oothest part of the glacier, but which he ought to have known, as anybody used to the Alps would have known in a moment, was cut by cross crevices. I saw the lines of them marked as if with the trace of a camels hair pencil by the light indentation of the fresh snow—and even if I hadn't I should have known they must be there by the lie of the glacier. However, he wasn't minding what he was about—didn't even know he was off the road, the snow was so smooth—and down he went. The Englishman returned to Saas, being behind him, & got some people and ropes, but it was no good— there was "no voice nor any that answered."[2] It is curious how stupid & rash the bad guides are—far better have none—the guide is often half drunk, & the traveller is off his guard. Things of this

[1] Postmarked Stresa.
[2] I Kings 18:26.

kind can't happen if you keep your wits about you, but as Coutet says—si vous marchez les yeux fermés—crac—c'est fini. I wish you had heard Coutet's account of the Swiss riots this morning—it was very fine. I'll try & put it down tomorrow—haven't time today. Mr Harding gave me your letter. I think I have all the Vogogna ones. Love to my mother.

<div align="right">Ever my dearest Father
your most affe Son
J Ruskin.</div>

<div align="center">115</div>

Baveno. Tuesday evening, 26th [Aug.].[1]

My Dearest Father,

I sent you a nice letter this morning, especially considering the pleasant one I had just received of yours with Mr Phillott's,[2] for which I am exceedingly obliged. I am very glad to have Harding with me—& we are going to Venice together—but I am in a curious position with him, being actually writing criticisms on his works for publication, while I dare not say the same things openly to his face—not because I would not, but because he does not like blame, & it does him no good. [And ye]t on *my* side, it discourages me a little, for Harding do[es such] *pretty* things, such desirable things to have, such pleasan[t thi]ngs to show, that when I looked at my portfolio afterwards, & saw the poor result of the immense time I have spent, the brown, laboured, melancholy, uncovetable things that I have struggled through, it vexed me mightily, and yet I am sure I am on a road that leads higher than his, but it is infernally steep, & one tumbles on it perpetually. I beat him dead however at a sketch of a sky[3] this afternoon—there is one essential difference between us. His sketches are always pretty because he balances their parts together & considers them as pictures—mine are always ugly, for I consider my sketch only as a written note of certain *facts*, & those I put down in the rudest & clearest way as many as possible. Harding's are all for impression—mine all for information. Hence my habits of copying are much more accurate than his, & when, as this afternoon, there is anything to be done which is not arrangeable nor manageable, I shall beat him, but when I looked over my sketches last night—I am afraid you will be sadly, sadly disappointed. I

1 Postmarked Stresa.
2 The Rev. Henry Wright Phillott, at Christ Church with Ruskin and at this time Assistant Master of Charterhouse. For John James Ruskin's letter, see Letter 116.
3 Perhaps Catalogue 162; reproduced in *Works*, II, Plate 8.

<div align="center">[189]</div>

am going to try, now, to get a few a little more agreeable and less full of struggle & effort.

Coutet says there will soon be a row in Switzerland. Dès que les Anglais se seront sauvés, et que les pommes de terre sont tirés, il faut que le *poin* se *baisse*. Les voila, trois et quatre ensemble—"à present, nous n'avons rien à faire. Causons la politique—hé bien, il faut boire une bouteille de vin nouveau—la bouteille est finie—il faut boire une autre"—*voila deja quatre du meme avis*. Apres, ça chauffe—le gouvernement veut ça—veux pas, moi—faut faire des balles. Alors ils vont faire des balles, puis—"Moi j'ai pour cent coups de cara-bine—Moi pour cent cinquante—faut faire pour deux cents— v'la pour deux cents—qu'est-ce qu'il faut faire—faut les tirer"— ils cassent les vitres aux magistrats—les magistrats se sauvent—et c'en est fait.

Coutet makes a capital figure to sit on a stone. Harding caught at him immediately & made two sketches. Coutet sat very quietly & coolly, & when they were done, walked up to look at them. Comment trouvez vous ça Coutet, said Mr Harding. Oh, ce n'est pas mal, said Coutet. I wish you had seen Harding's face. Coutet had told him before that I was much improved—to Harding's great amusement— but Coutet knows my good sketches from my bad. When he saw my Abram from the Campo Santo—"Ah, c'est un tableau touchant, que ça"—which I considered a great compliment. Love to my mother.

<div style="text-align:right">

Ever my dearest Father,
Your most affe Son
J Ruskin.

</div>

Messrs Ulrich, by the by, seem to have been more polite to Coutet than to me, for they not only gave him the money at once, but as he said—"Il avait l'air si bonhomme, je crois qu'il me l'aurait donné sur rien." I find my two notes were enough, so that I have a hundred pounds at Venice.

116

<div style="text-align:right">

Baveno. Thursday, 28th [Aug.].[1]

</div>

My Dearest Father,

I have been quite discouraged on looking over my work with Mr Harding, to find how little I have done. There was certainly a month at Florence, and more at Parma, Bologna & so on, spent in mere seeing, not having a moments time for drawing—and I have been quite thrown out by the weather, at Macugnaga—but still

[1] Postmarked Stresa.

the result looks very shameful considering the amount of time & convenience I have had. It is owing partly to the number of things I have been studying. I have been broken to pieces among them— had I been able to devote myself to one thing alone, I should have got an incomparably larger amount. Here it is pouring of rain again, as usual.

I have never answered your nice letter with its account of the Brit. institution[1]—which you never told me anything about before. Your account of Calcott[2] is admirable, my very feelings about him in every respect. Gainsborough is certainly very streaky, and never draws well, but in colour he is marvellous. Lawrence I know less about than any other English painter. West I detest nearly as much as Maclise,[3] only he is less rakish & glaring. I enclose a little note to Phillott, for it is kind in him to write to me, which says something more.

As for dress, I have a great idea I shall have to buy a coat at Venice, for I am in the very circumstances Sir John would object to[4]—for the rest I shall do well enough. I damaged my dress chiefly at Florence by getting up into cupolas of churches, on tiles, behind altars &c—once at St Mark's I found myself kneeling on something soft when I expected a deal board. I found the *cushion* was composed of dust & flue.

Just after finishing the enclosed, I recollected P. was "going to leave on Friday"—however there may be something in the letter to interest you, & so I send it, & you can leave it for him at Charter-house when he comes back. Dante's comparison about the ants[5] is very fine. Coutet and I have watched them on their paths a thousand times—if you lay a stick on their nest, they run to the end of it, and in coming back, meeting the rest, always stop an instant nose to nose ("ammusano")—as Coutet says of them, Les voila qui se

[1] Letter of 17 Aug. (Bem. L 3). The annual British Institution Exhibition of Ancient Masters had opened 16 June.

[2] 'Good *gentlemanly* bits of work—chaste—cold as the Icicle that from Diana's Temple. . . . His *paint* is cleanly laid on—nicely with white gloves on—thin but not clear—a little like Pyne [J. B. Pyne (1800–70)] which means not divine—& yet exhibiting skill, education, even great knowledge pictures even these to push Backhuysen & Vandeveltd & company out of society & durable pictures too I reckon—but look you I say *paint*, not colours. I see neither colour nor atmosphere to satisfy & surely neither he nor Master Collins [see Letter 57] are at all punctilious about perspective.'

[3] Daniel Maclise, R.A. (1806–70), subject painter.

[4] A reply to his father's offer to send him clothes to Geneva, and to the injunction: 'only don't come thro' all France if you think Sir John would not march through Coventry with you.' The reference is to Falstaff's outrage at the ragged condition of his soldiers in *I Henry IV*, iv. ii. 24 ff.

[5] *Purgatorio*, XXVI. 34–6.

demandent d'ou ils viennent. "Je vais aller au bout." "Moi j'y ai été." Qu'est-ce qu'il y a? Il n'y a rien. Moi je veux aller voir. How watchful a great man is of little things. Love to my mother.

> Ever my dearest
> your most affectionate Son
> J Ruskin

117

[Baveno.] Friday, 29th [Aug.].[1]

My Dearest Father,

I received last night your kind letter of the 20th—when I told you to write to Baveno I calculated on ten days post at least—and now I am kept here by the rain, having to finish some studies, and it pours all day, so that I shall be some time before I get your letters [at] Venice. I am glad to hear of Macdonald's starting s[o co]mfortably for Pau[2]—and sorry to hear so bad an account of Newton,[3] whom I shall scold when I come back. I am glad & sorry to hear of Turner's gallery being so cleared.[4] I am sure nobody ever worked to less selfish ends than I. I will do all I can in the next book to extinguish the former one.[5] I wish I could draw a little better first, but I think I shall make the people understand what I mean. I am surprised at Harding's power of recollection—two or three

[1] Postmarked Stresa.

[2] According to his father's letter (Bem. L 3), Macdonald and his sister were about to leave 'in a £320 chariot of Hopkinson'.

[3] 'If I had a tenth of Newton's talent or Information, I would make all I met with say I was the pleasantest fellow in the world—all are half shocked at Newton's affectations, abstraction & assumption of Elbow Room—but I like his Head & fun & if he has no heart, he will not die of a Heart complaint.'

[4] On 26 July his father had written: 'Griffith told me yesterday that Turner's Gallery is clearing', and, in connection with McCracken's letter (see Letter 102, note 2), 'You sell his pictures.' On 20 Aug. he wrote: 'Foord says, he has packed off 1 Large picture to America & another large one to Munich . . . you have cleared him out as I told you.' The two pictures were *Staffa* (R.A. 1832, now in the collection of the Hon. Gavin Astor), sold to James Lenox of New York, and *The Opening of the Walhalla* (R.A. 1843, now in the Tate Gallery), loaned to the Congress of European Art exhibition.

[5] A reply to his father's report: 'You certainly are not without encouragement if talk of your Book is so. It comes to me in all directions I mean its fame & superiority to all works on Modern Art & Smith Elder &c anxiety to reprint the present Work & the enquiries already made at them for the second part shows the hold you have of the public mind.'

scratches are enough for him to recollect a whole group of figures by, & so he gets motives and thoughts which are utterly out of my reach —as much as the moon—for I can do nothing unless the figures stand still. Love to my mother.

<div align="right">
Ever my dearest Father

Your most affe Son,

J Ruskin.
</div>

I read your account of Callcott to H, who was in raptures with it. But alas, people always find blame a great deal more "capital" than praise. It is mighty difficult to praise anybody in a style that pleases anybody else.

<div align="center">

118

</div>

<div align="right">
[Baveno.] Sunday, Aug 31st.[1]
</div>

My Dearest Father,

I believe we shall leave Baveno tomorrow driven away by perpetual rain—we have done nothing & can do nothing, and I have found all the places where I wanted to draw, dangerous in some way or other, always marsh, or damp, or dead leaves, or something wrong—we just have got into the middle of the hemp harvest, & as the hemp is cleared of its outer coat by keeping it for days under water & then rotting it off in the sun, it is impossible to approach the lake shore in many parts—the stench is insufferable— we should have been off before, but the rai[n is] far too heavy even to travel in—howe[ver], I suppose my next letter may be from Bergamo or Lecco—it will probably be two days after this, for if we leave tomorrow it will be before post office opens.

Harding tells me there is a chance of George Richmond's meeting me at Venice—this would be delicious. I should have written to him again, but if he is coming he must already have left town. Harding is gone over the lake to draw, & I stop at home to read, though I may perhaps walk up a hill in the afternoon. Harding seems never to have been on a hill in his life—he can't walk a bit when the ground slopes an inch or two. He would have been badly off if I had got him in the Val Anzasca—he could not have gone where the cows go. Love to my mother.

<div align="right">
Ever my dearest Father,

Your most affe Son,

J Ruskin.
</div>

[1] Postmarked Stresa.

<div align="center">
[193]
</div>

Desenzano. Saturday morning, 7 [i.e. 6 Sept.].

My Dearest Father,

You recollect the view from the window here,[1] & the diver ducks, plunging—it is just the same at this moment, ducks and all, only the clouds more heavy and melancholy. I am quite sick of Italy— the people are too much for me—it is like travelling among a nation of malignant idiots, with just brains enough to make them responsible for their vices—they have taken the whole feeling of the country away from me. I look upon all Mr Rogers sentiment as entire humbug. Italy is no more to me than a place where one must go to draw ilexes & crooked tiles. We got into Bergamo during the great fair there, that lasts a month, and of course in Murray's guide[2] there was all sorts of nonsense about contadinas in full dress, and assemblages of the higher classes in their carriages of state, and ancient associations with Punchinello & Arlecchino. But I saw nothing but brazen faced viragos, with their hair hanging about their ears, & table spoons at the back of it, and some wax dolls with black, immoral, unwomanish beads of eyes, lolling in tea chests painted blue. The higher women *do* dress their heads mighty well, certainly, and make themselves look as like barbers blocks as can be, for there is not a single shade of womanly feeling in the faces.

By the by I am afraid you were three days without a letter, for though my last[3] was prepared to put in at Bergamo, we stopped drawing so long on the road that the office was shut. Our drive from Como to Bergamo was as far as stones & trees were concerned, very divine, especially the first part of it. We were fortunate in getting a clear view of the Alps from the Simplon to Mont Iseran on the little St Bernard, including Monte Rosa & Mont Blanc—we stopped the horses, and divided our labour. Harding undertook the town of Como, the lake, and the foreground, and I took the chain of the Alps—and we got it all. Harding is going to paint it seven or eight ft long.[4] The descent to Lecco is also superb—soft, and sublime, & perfect in detail, the finest thing I have yet seen in Italy, but all is spoiled by the people. I am getting sadly shaken in my love of despotism—it is all very well when each nation has its own king, but the Austrians here are a very millstone about the neck—

[1] The Ruskins had been in Desenzano in 1835; see *Diaries*, I. 191.

[2] *Northern Italy* (1842), pp. 245–6.

[3] A missing letter, probably the 'few sweet lines' written to his mother on 2 Sept., her birthday, and received 10 Sept. (see John James Ruskin's letter of 10–13 Sept., Bem. L 3)—though perhaps a letter to his father, also missing.

[4] Harding did have in the R.A. 1848: 'The high Alps as seen from between Como and Lecco: the town and lake of Como at their base' (No. 494).

besides being a nasty, mean, annoying government to strangers. They wouldn't let one of my books in without examination by some governor or other, which would have kept us a day. I had to send them all back to Baveno, even my rolls of engravings, & late in the evening yesterday, in a hurry to get through Brescia, we were stopped at the gate of entrance—again passport to order horses, and again for a quarter of an hour at the sortie. There is something most thoroughly contemptible in all this. I never was once asked for my passport from Montreuil to les Rousses, except leaving it in the bureau at Meurice's, & I think the landlord asked to see it at Sens, but never at a gate or at any place where it was a hindrance. I think the government here a thoroughly rascally one. I see nothing but measures for its own security by degrading the people.

We go on, I hope to Verona, today, & then, as Harding is in a hurry, I imagine he will go by railroad to Venice tomorrow. I shall overtake him there on the Tuesday evening, having just seen at Padua what time I shall require there in returning. I hope to post this at Verona this afternoon.[1]

Harding does an amazing amount of work, but he confesses that he gets thin upon it, & that his sketching is the greatest labour that he has to go through. Besides, there is an energy in a *months* escape from London to Italy which I find will not support one through *six*. I still look back to Lucca & Pisa as the pleasantest parts of my journey, and I am now in a hurry to get home. If I find Richmond at Venice it will make the last week or two very happy. Will you be so good as to tell Mr Molini[2] I want a good edition of the works of Savonarola, and to have one ready for me when I come back. I imagine it may be difficult.

I think the lake of Garda, just now, looks more like Chelsea reach than anything else—the mountains are all covered and one sees nothing but the dead, poplary flat. I must seal this—no—I won't neither, for I can do it in the carriage if I want, and I may fill my paper if we stop anywhere.

<div align="center">4 o'c[lock].</div>

Oh, this beautiful Verona—unspoiled as yet, thank God—love to my mother—just going out—fine day—music trickling through every balcony—good bye, my dearest,

<div align="right">your most affe
J Ruskin.</div>

[1] Postmarked Verona, 6 September.
[2] Charles Frederick Molini, importer of Italian books and general commission agent, 17 King William Street, Strand.

Verona. Sunday, 7th Sept.[1]

My Dearest Father,

As I find it absolutely necessary both for my writing and drawing, to alter the way I hold my pen, you will probably have my letters at present even more illegible than usual. I was a little premature in my rejoicing over Verona. I had only seen the great market square & principal street, which with the La Scala monuments, and the greater part of the palaces on the north side of the chief street, are as yet safe. Some few of the older houses have been repaired & whitewashed, and one or two whose frescos were very lovely have been made stables of, but on the whole, things are tolerably right. But, on the south of the great street, in the square surrounded by the most ancient public buildings of Verona, the Italians are in all their glory. I am just in time to see the last of the rich weeds and waving ivy on the massy brick tower,[2] just in time to catch one idea of the grand range of Venetian arches in its inner court. Down they all go—or are being bricked up, the mouldings dashed off the walls, and all made smooth & white with fresh stucco, and nice square window frames, regular Mr Snell[3]—in a month or two more it will be all in order, and as tidy as Waterloo place, only the architecture not so good. Now, if I could put these Italians in a waterbutt with the top on, or roast them in sulphur a little, or wash them in steepdown gulfs of liquid fire,[4] or in any other way convey to them a delicate expression of opinion, it would do my heart good, but as it is I am so sick that I believe I shall have to give up art altogether. There will always be plants & stones to study in peace, but in ten years there will I believe be neither landscape nor picture left of any historical value whatsoever. However, I am going to make a little effort for my poor dear, beloved Verona, about which I have always thought, and I feel it still, that there is more poetry than about any other city whatsoever in Europe—Venice itself not excepted, for Venice at its best, had a twang of manufacture and trade about it which noble Verona was free from, and moreover it has been so hackneyed & overdone that one thinks of it more with reference to art than to anything else, and its streets are almost *too* showy—they look intentionally & violently so, as if they had been built more to be seen than to live in. The palaces here are much poorer, but there is *therefore* a dignity about them that I love exceedingly, and I am going to make careful studies of some of the

[1] Postmarked Verona, 7 September. [2] Torre dei Lamberti.
[3] Of William and Edward Snell, upholsterers and house agents, 27 Albemarle Street and 1 Belgrave Road, Pimlico.
[4] *Othello*, v. ii. 279–80.

most solemn bits, and to get the architectural details thoroughly. It is true this will take me a day or two more than I intended, but if I don't do it now, all may be lost before I come again. I went last night and got a Juliet corner, a balcony which I recollect you wanted to me [*sic*] draw before, but I wouldn't because there was nothing else that came in with it. But now, the blank, grand space of stone wall beside it, is the very thing that touches me, and I think moreover, if I can do it rightly, it will touch every body else. There is also a palace with dark, rich Venetian windows, the *deepest* I think I ever saw—so— and all the space between them filled with frescos of purple and gold—and this I shall have to make two careful studies of, one in colour, and one of the archl. details, for these frescos are the leading point of distinction between the architecture of Verona & Venice, and I am dreadfully partic- ular about my details now. I have no pleasure in architecture at all unless I have all the designs of it, so that this will take me some little time. And then there is a street view—which you wanted me to take when I was last here—which is indeed very beautiful & I must have it, [on]ly as I can't keep Harding, and as perhap[s] Richmond m[ay] be waiting for me at Venice, I shall go on there, and when I have done there I shall finis[h] here in greater comfort. But I purpose drawing little architecture, if any, at Venice—the bit that I promised Mrs Cockburn[1] I imagine she will like quite as well at Verona—and the architecture here is less known & more solemn. I am happy to find that it impresses me as much as ever, if not more, and is incalculably superior to all I have seen at Florence or elsewhere. The draperies too over the balconies are delicious, and the constant tinkling or swelling of Bellini & Donizetti through their apertures is also very delightful, and the people are quite a different race, evidently amiable compared to the southern Italians and more industrious & human—the children have sweet playful faces, and their remarks on one's drawing are much more clever than is usual, though sufficiently free, I assure you. Harding got a pretty view here too— though raggy & taggy—so we are both pleased. Tomorrow, I hope to get early to Padua & post my letter in time there, for we shall leave here before the office is open, but if H. stops to draw at Vicenza, which is probable, I shall post there. I believe H. will go from Padua by railroad. I go by post as usual. Love to my mother.

<div align="right">

Ever my dearest Father
Your most affe Son
J Ruskin.

</div>

1 The wife of Robert Cockburn, the wine merchant; see Letter 74, p. 133, note 1.

Venice. 10th Sept. Hot. d. l'Europe.[1]

My Dearest Father,

It is past eleven o'clock at night, but I am not sleepy. I wish I were, for I never before so fully felt Buonaroti's beautiful stanza—

> Grato m'è'l sonno, e piu l'esser di sasso
> Mentre che'l danno, e la vergogna dura.
> Non veder, non sentir, m'è gran ventura.
> Perche non mi destar. Deh—parla basso.

I quoted it before,[2] I think, but I have seen enough tonight to put everything out of my head. I went to Mestre in order to recall to mind as far as I could our first passing to Venice.[3] The Afternoon was cloudless, the sun intensely bright, the gliding down the canal of the Brenta exquisite. We turned the corner of the bastion, where Venice *once* appeared, & behold—the Greenwich railway, only with less arches and more dead wall, entirely cutting off the whole open sea & half the city, which now looks as nearly as possible like Liverpool at the end of the dockyard wall. The railway covered with busy workmen, scaffolding & heaps of stones, an iron station where the Madonna dell' Acqua used to be, and a group of omnibus gondolas, so. When we entered the grand canal, I was yet more struck, if possible, by the fearful dilapidation which it has suffered in these last five years. Not only are

two thirds of the palaces under *repair*—we know what that means —but they could not stand without it—they are mouldering down as if they were all leaves & autumn had come suddenly. Few boats about—all deathlike & quiet, save for the scaffolding & plastering. Danieli's is peculiarly remarkable in this respect—*he* has done the thing thoroughly. All its rich red marble front is covered with a smooth, polished, bright white stucco, painted in stripes—so [see Plate 2],[4] in imitation of marble, with the grand big blue sign in brilliant relief. But to return to the grand canal, it began to look a little better as we got up to the Rialto, but, it being just solemn twilight, as we turned under the arch, behold, all up to the Foscari palace—*gas lamps*! on each side, in grand new iron posts of the last

[1] Postmarked Venice, 11 September. The hotel occupied the Ca' Giustinian, opposite the Dogana.

[2] See Letter 92.

[3] In 1835.

[4] Pen and ink drawing with watercolour.

Birmingham fashion, and sure enough, they have them all up the narrow canals, and there is a grand one, with more flourishes than usual, just under the bridge of sighs.

Imagine the new style of serenades—by gas light. Add to this, that they are repairing the front of St Mark's, and appear to be destroying its mosaics.

I will not write more tonight, for I want to see if I can get a little sleep, for I do not know that I have felt more thoroughly downhearted since my unhappy times in 1840. I could not get your letters tonight, for the post office shuts at 3. What makes me sadder is, that the divine beauty of the yet uninjured passage about the Salute & Piazzetta has struck me more intensely than ever. I have been standing (but the moment before I began this letter) on the steps at the door—the water is not even plashing in the moonlight, there is not even a star twinkling, it is as still as if Venice were beneath the sea, but beautiful beyond all thought.

<div align="right">

11th S[ept].

</div>

I have all your kind letters & am especial[ly deli]ghted that my mother got hers[1] on the right day, though I am sure I can't tell what ther[e] was in it to please her so much, for it was mighty shor[t]. I quite shuddered at Gordon's adventure, which I have never heard of before, but he ought to have had more sense. I knew better than that at 14. All is pleasant in your nice letters—as for Munich, Dresden, &c, they are utterly valueless to me. *Perugia* indeed, and Assisi, & in many points Rome, I shall miss sadly, but for Germany, I have done with these despotic governments. Of all the fearful changes I ever saw wrought in a given time, that on Venice since I was last here beats. It amounts to destruction—all that can be done of picture now is in the way of restoration. The Foscari palace is all *but* a total ruin—the rents in its walls are half a foot wide. The interior court of the Doges palace, especially the part I drew,[2] is being *repaired*, covered with scaffolding, & as a preparatory step they have already knocked off the heads of the statues. The area is already ⟨surrounded⟩ on one side barred by iron railings of this pattern, the heads being painted *orange yellow*, the rest *black*, austrian colours you know—the front of St Mark's is being fitted with grand new windows, and the exterior arcade of the Doges palace has been brilliantly whitewashed inside, splashing the capitals all over, breaking most of them, and

1 Letter 113.
2 Catalogue 1874; reproduced in *Works*, IV, Plate 2.

<div align="center">

[199]

</div>

of course attracting the eye in a forcible manner to the black &
yellow sentry boxes now in bright relief, which are agreeably con-
trasted with a mass of green
& white built exactly before
the palace in the water.

Now, although there is now
no pleasure in being in Venice,
I must stay a week more than
I intended, to get a few of the more precious details before they are
lost for ever. I think you would like me to do this, if I could ask
you, but I can't write more now, for H. is waiting again. I will tell
you more tomorrow, love to my mother.

<div style="text-align:right">

Ever my dearest Father,
your most affe Son
J Ruskin.

</div>

I am very, *very* glad you are not disappointed with your Turners,
but I am frightened lest Foord[1] should have persuaded you to
mount them—he is always trying at that, confound him, & they
may be half spoiled if you let them go.

122

<div style="text-align:right">

Venice. Thursday evening [11 Sept.].[2]

</div>

My Dearest Father,

Harding & Coutet & the landlord and the waiter were all in the
room together as I finished my letter this morning, & I never said
how sorry I was to hear of your inflammation in the eyes, because,
though you do not say so, I am afraid it may have been the painful
affection of the ball itself again, and[3] that you have [be]en over-
working yourself—pray take care—why should you [d]o so, unless
I am running away with too much money here, and indeed I have
been very extravag[ant]. But you must *not* try your eyes now, or
you may lose much enjoyment. I am very cautious of mine, but
find they depend more on stomach than on work. I cannot draw
here for the tears in them. Tyre was nothing to this. I never was so
violently affected in all my life by anything not immediately relating

[1] Ruskin's framemaker. The Turners are the three ordered drawings; see
Letter 47.

[2] Postmarked Venice, 12 September.

[3] John James Ruskin cancelled 'it may . . . and'.

to myself, as by landing at a palace today now turned into a timber yard. Of the whole interior court there remains only one shattered brick wall with the vestiges of the insertion of the marble arches, the well in the centre, and a few capitals of the columns beside it, & one noble claw of a supporting lion. Two turkeys were wandering among the weeds, where the garden had been, but not a leaf now remaining except grass & nettle. The front of the palace is I believe only propped by the timber, & will be gone for ever before I come again. I must positively get a few of the materials of them, or else, when I can paint well, Venice is lost to me. Can't write more tonight. I was up at 1/2 past four this morning. Love to my mother.

<div align="right">

Ever my dearest
your most affe Son
J Ruskin.

</div>

123

[Venice.] Sunday Morning, 14th [Sept.].[1]

My Dearest Father,

I have made up my mind that of all ignoble faculties and pursuits music is the lowest, for these rascally Italians, who so far as I can see are fit for nothing else on earth but to be made surgeons subjects of, can still sing & sing sweetly—one hears very perfect music through the casements. I am tired of writing, as doubtless you are of receiving accounts of calamities—how painful it is to be in Venice now I cannot tell you. There is no single spot, east or west, up or down, where her spirit remains—the modern work has set its plague spot everywhere—the moment you begin to feel, some gaspipe business forces itself on the eye, and you are thrust into the 19th century, until you dream, as Mr Harding did last night, that your very gondola has become a steamer. Just below the bridge of sighs, a bright brick house is building, square as a Margate lodging house. I am but barely in time to see the last of dear old St Mark's. They have ordered him to be "*pulito*," and after whitewashing the Doges palace, and daubing it with the Austrian national distillation of coffins & jaundice, they are *scraping* St Mark's clean. Off go all the glorious old weather stains, the rich hues of the marble which nature, mighty as she is, has taken ten centuries to bestow—and already the noble corner farthest from the sea, that on which the

1 Postmarked Venice, 14 September.

[201]

sixth part of the age of the generations of man was dyed in gold, is reduced to the colour of magnesia, the old marbles displaced & torn down—what is coming in their stead I know not—you know there used to be a noble old house at *a*, in the corner, falling in with the facade of St Mark's place. I was going to draw it once & was driven away by rain. It is stuccoed over and painted with calico stripes to imitate alabaster.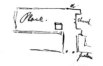

Another loss that I bitterly regret is of the old bridges. They have laid the gaspipes over them, and in so doing have performed the following transformation on them,

Old *New*

the new one having, you see, patent iron railings. One only consolation I have—the finding, among the wrecks of Venice, authority for all that Turner has done of her. I am not indeed surprised to find with what care he has noted, & with what dexterity he has used every atom of material, to find his baskets in the water, his heads of boats out of it, his oranges and vines hanging over their loaded sides, but I *was* a little taken aback when yesterday, at six in the morning, with the early sunlight just flushing its folds, out came a fishing boat with its *painted* sail full to the wind, the most gorgeous orange and red, in everything, form, colour & feeling, the very counterpart of the Sol di Venezia[1]—it is impossible that any *model* could be more rigidly exact than the painting, even to the height of the sail above the deck. All his skies are here too, or would be, if man would let them alone, but yesterday as I was trying to note some morning clouds, a volume of smoke from a manufactory on the Rialto blotted everything as black as the Thames. By the bye,

[1] Turner's *The Sun of Venice Going to Sea* (R.A. 1843), now in the Tate Gallery.

I expected some most heavenly light in the water of the Lake Lucerne & I see you say it is there. What has he done with the sky & hills of the Schwytz? If there is any reasonable means of getting any more of these modern drawings, pray don't miss them.

I will mind about seed of harricot. I hav'nt had any of those beans lately. I will ask for them when I get ashore again. Ashore! I am ashore now—you can walk from Venice to the land—on this.

 If they [had] but put up a decent bridge, but imagine th[e] above in re[d br]ick, or rather tan colour.

I have been in such a state of torment since I came here that I have not even thought of Titian's existence, but I will get my picture work soon done—as matters stand the out of door is the most important. The thing I have to do at Vicenza is a piece of palace in the last stage of decay, of the most perfect architecture I ever beheld, with the *French* motto—nulle rose sans epine.[1] I must find out its history—if I do not do it now it will be all gone ere I can come back, and I cannot lose it. It will take me three days of hard work from six to six, an hour & a half for dinner & breakfast.

I hope your eyes are better. Love to my mother.

<div align="center">

Ever, my dearest Father

your most affectionate Son

J Ruskin.

</div>

<div align="center">

124

</div>

[Venice.] Sunday Evening [14 Sept.].[2]

My Dearest Father,

As our regular time for starting to work is 1/2 past 5, I cannot write much at night. I can only tell you the delight I have had, as well as the sorrow, in examining tonight the architecture of St Mark's which is going to be destroyed. Every capital of its thousand columns is different, and their grace inimitable—and these are in the *renewed* parts, either scraped down, or cleaned with an acid which has so destroyed the carving that it is not eve[n] legible— as I said before, I am just in time & no more. [Th]e occurrence of *rope* patterns is very singular, and ornaments derived from shipping —to give you an ide[a] of the rich *finds* I have had, I discovered

1 The Casa Pigafetta; see *Works*, VIII. 228.
2 Postmarked Venice, 15 September.

<div align="center">

[203]

</div>

that the *corner stone*, the huge capital of the Doges palace, at the gateway (*a*—vide Prout's sketch),[1]

is throughout a type of Justice. On the front of it is JVSTITIA, enthroned—on her right hand, Moses receives the tables of the law—on her left, some Emperor does JVSTITIA ALLA VEDOVA.[2] Next comes one with the heads who were then in relation with Venice, TVRCHI, GRECHI, &c. written over their heads—next to this, one with all foreign & native fruits in baskets, *their* names written also, on the fillets of the capital, PIRI, UVE, [the centre be]ing CERISIS. Next come all sorts of beasts, each [with his food] in his mouth—the bear has got a honey comb and it may give you some idea of the delicacy and preservation of the carving of these capitals when I tell you that every cell is still hexagonal. Then comes a capital with all the trades of Venice—and then one devoted to Sculpture alone, in which she is seen cutting figures, capitals, & columns. Physick is in the centre of the trades, & the apothecary[3] is beating the pestle into the mortar with a hammer. I can't go on, for I haven't time, but I am going to look out to-morrow for some good young German draughtsman. I shall make him draw all these capitals with severe, true lines, under my own eye, and I shall then take his outline & dash in the light & shade myself, & so I shall do *some* good at least, in the midst of the wreck. Love to my mother.

Ever my dearest
your most affect So[n]
[J Ruskin.]

Monday, 10 o'clock.

I have just your most kind letter with Severn's, but haven't read latter yet—very glad my mother & you are better. Money all right— got. I don't want any more, thank you.

[1] Samuel Prout, *Sketches in France, Switzerland and Italy* (London, 1838), Plate 18, Piazzetta San Marco, Venice.

[2] Trajan doing justice to the widow is actually on her right and Moses is next after Trajan; Aristotle giving laws is on her left.

[3] A mistake; the figure represents a lapidary.

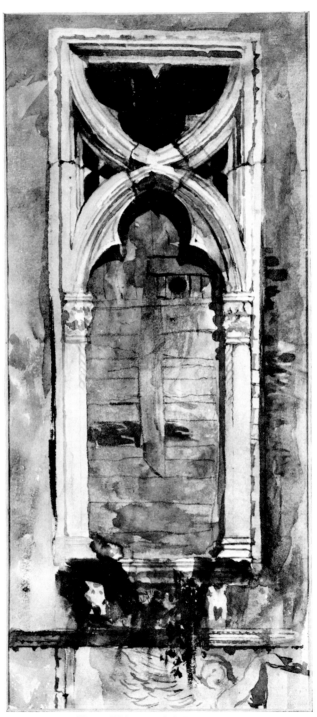

9. *Upper Window, Ca' Foscari, Venice*

[Venice.] Tuesday, 16th [Sept.].[1]

My Dearest Father,

I was surprised this morning on going to Messrs Holme to draw some money by their total denial of having received any letter of credit. I had to use therefore a couple of my notes at Schielin's bank, but it might have been awkward if I had depended on the credit. I suppose the letter has miscarried, for it cannot be Glynn's[2] fault, as all was right at Genoa, Nic[e], Florence, & Milan. In case of my runnin[g] short, it will be as well to send me a credit to Verona, for this is rather expensive work here, gondola all day. I had a lovely float by moonlight last night after 10 o'clock—went down the grand Canal, which looks like itself by night, neither decay visible nor repairs, & then crossed the city to the lagoon of Murano, Turner's favourite subject, and got over to the island at a little before 12, getting the whole city far over the sea dark against the moonlight. It was lightening gloriously too over the Lido, every flash showing the long red wall & churches of Murano in wan light. But I can't get time to note things enough—the materials are so immense & the work to be done so various. I find more to instruct one in out of door art here than in all the rest of Italy together—the colours are marvellous. Love to my mother.

Ever my dearest Father,
your most affe Son,
J Ruskin.

[Venice.] Wednesday evening, 17th [Sept.].[3]

My Dearest Father,

Messrs Holme wrote today to say they had discovered there was a credit open—they had overlooked it owing to the length of date. I hope therefore you may not have taken any trouble yet about it.

Harding & I shall do the Foscari pretty well between us. I have got the architecture—mouldings, capitals & all.[4] I began it small. Harding said I should frighten the Daguerr[eoty]pe into fits, and

[1] Postmarked Venice, 17 September.
[2] See Letter 8, p. 16, note 1.
[3] Postmarked Venice, 18 September.
[4] See Plate 9, drawing of an upper window of the Ca' Foscari (Catalogue 1818) now in the Victoria and Albert Museum; another of the same subject occurs in his notebook (Bem. 5A). See also Catalogue 1821 and 1825.

Coutet said—Ça ne le ressemble pa[s], c'est la meme chose. I found it impossib[le] however to accomplish it so completely, & I am therefore takin[g] large studies of the most interesting parts, leaving the rest to sketch in lightly. You may see by the way I write I have had hard work today, & am sleepy—love to my mother.

<div align="right">

Ever, my dearest Father,
Your most affectionate Son,
J Ruskin.

</div>

127

My Dearest Father,

I have today yours of the 10th, for which many thanks. I have been over to Torcello, a decent distance, but most interesting church,[2] about the best preserved of its age—8 or 900—that I have seen, but in a horrible marsh. All the lagoon round Venice is now nearly filled up, & when the tide is down, there is ⟨only⟩ water only in the canals—it looks most black & comfortless.

I am not in want of clothes except frock coat. I had only two with me—both are pretty nearly done, but I wear a short coat in the tables d'hote, and can get to Paris perfectly wel[l].

I think y[o]u have heard me state the difference in the spi[rit] of Gothic & Greek architecture as Laing does,[3] but I l[ook] not to the mere fact, which any body may see, but to the feeling—the one is aspiration the other endurance the one faith, the other philosophy. I meant by extinguishing former book[4] that I would try to outshine it, not to contradict it. I have nothing to retract, except the implied over praise of landseer.[5] I am very glad to hear that you like two of the Turners

[1] Postmarked Venice, 19 September.

[2] The cathedral.

[3] Samuel Laing, *Notes of a Traveller, on the Social and Political State of France, Prussia, Switzerland, Italy* (London, 1842), p. 471: 'It is the predominating, characteristic, and distinctive principle of Gothic architecture to seek its effects by extensions in the height; and that of Grecian architecture, on the contrary, to seek its effects by extensions parallel to the horizon. These two distinct principles will be found to govern all the details, as well as the general masses, of each of these two distinct styles of architecture . . . to run through all their parts, and to govern the whole ideal of the structure in every pure and complete specimen of either style.'

[4] See Letter 117.

[5] For Ruskin's praise of Landseer in *Modern Painters I*, see *Works*, III. 88–9 and 339, note. The first two sentences of this paragraph are cancelled by John James Ruskin.

so well & that there is beauty in the third—a forest scene would be very lovely & delicious, but I doubt if he will do any thing now but what pleases his fancy. I wish he would make one a little water colour of Venice—his ideal of it is superb—it makes me quite pine for it *here*, that I may feel it more. Venice *itself* is now nothing, barring always the fishing boats. We have had a regular days work out of two of them—tied the gentlemen to posts in the lagoon with their sails set, & so, as Harding says, "booked 'em"— at least *he* did, for I can't draw boats yet. I have now had a good try at everything. Architecture, foliage, human figure, mountains, & sky, and I am of decided opinion that next to water itself, the most difficult thing to draw in the world is a boat, and the easiest, the human figure, up to a certain point. Love to my mother.

<div style="text-align:center">

Ever, my dearest Father,

Your most affe Son

J Ruskin.

</div>

<div style="text-align:center">

128

</div>

Venice. Sept 20th.[1]

My Dearest Father,
 I have been hunting up the churches a little, and find them in the most awful condition—stonemasons everywhere, monuments torn down & pavements up, the cloisters everywhere turned into barracks and the carvings defaced or repainted, pictures either gone to be restored, or put behind candles & crucifixes in the darkest corners to be found. I don't like what I have seen of Titian yet—much faded & burned & retouched. I have found one good John Bellini, which for all the good I shall get of it might as well be in the bottom of the lagoons as in the black hole where it is. However [a]ll this shortens my picture work mightily, [for] John & Gentile Bellini are the only people I care about stu[dyin]g here, my opinions about Titian & Veronese are formed, and I have only to glance at their pictures that I may know what there are, & choose the best instances. The outside drawing takes me a terrible time, for it is no use to me unless I have it right out & know all about it. I have gone so far as to gather and draw the weeds that grow on the old Foscari.[2] There are

1 Postmarked Venice, 20 September.
2 Catalogue 1824.

some wonderful & beautiful churches on the islands too, far better preserved than any at Venice except St Mark's. Love to my mother. Harding always desires his compliments.

<div style="text-align: right">

Ever my dearest Father
Your most affe Son
J Ruskin.

</div>

129

<div style="text-align: right">Venice. Sunday, 21st [Sept.].</div>

My Dearest Father,

I have today your most amusing letter about the dogs and cows,[1] and am delighted to hear of the accession of Twig & Mungo to the establishment, and of their well being. I am afraid poor Tug will never be quite right, but we can't discard him. We have a little dog here belonging to the gondolier, who attends us every where—his master is good to him, and we like him therefore—indeed the Venetians [are f]ar superior to the rest of the Italians, as far as one can ju[dge of th]em by external appearances & expression of feature—t[hey ar]e more amiable & more busy, though this is saying but little, and as for brains, or feeling for anything good or venerable about them, it is quite hopeless. I am sorry that you are expecting me to leave Venice so soon, & far more sorry that I cannot do so—be assured it is misery to me to stop here, but every hour is destructive of what I most value, and I must do what I can to save a little. On the Ca' d'Oro, the noblest Palace of the grand Canal, the stonemasons are hard at work, and of all its once noble cornice there remains one fragment only. Had that gone, as in a day or two more it will, all knowledge of the contour of this noble building would have been lost for ever, for I can find no architectural drawings of anything here. I suppose other people have got something, but I can't trust to the chance. It is near post time.[2] I have been up late

[1] Letter of 10–13 Sept. (Bem. L 3), reporting on the good health of the terrier Twig, who had come to them sickly, on Tug's return from Prince Albert's veterinarian at Windsor, and on the acquisition of Tug's son 'by a Russian Retriever, whom I have named *Mungo* for it is the veriest little african—such woolly head & ears & large rolling white & black Eyes the very picture of a Black man that waited upon me at the adelphi or Star & Garter Liverpool. . . .' The letter also contains an account of the picturesqueness of the four cows recently acquired as much for ornament as for use and the information that 'our Italian structure our Cow Palace is about finished'.

[2] Postmarked Venice, 22 September. Received 30 Sept.

these two nights back drawing plants, or I should have had a letter for you. I have told Harding about missing letters. I never thought of coming home with him[1]—you will wish I did. Love to my mother.

> Ever my dearest Father,
> Your most affe Son,
> J Ruskin.

130

My Dearest Father,

You cannot imagine what an unhappy day I spent yesterday before the Casa d'Oro, vainly attempting to draw it[2] while the workmen were hammering it down before my face. It would have put me to my hardest possible shifts at any rate, for it is intolerably difficult, & the intricacy of it as a study of colour inconceivable—if I had had the whole grand canal to myself to do it, it would have been no more than I wanted—but fancy trying to work while one s[ees] the cursed plasterers hauling up beams & dashing i[n the] old walls & shattering the mouldings, & pulling b[arge]s across your gondola bows & driving you here & there, up & down & across, and all the while with the sense that *now* one's art is not enough to be of the slightest service, but that in ten years more one might have done such glorious things. Venice has never yet been painted as she should, never, & to see the thing *just* in one's grasp, & snatched away by these—"porci battizati,"[3] as I heard a Jew call out with infinite justice the other day—it is too bad, far too bad. The beauty of the fragments left is beyond all I conceived, & just as I am becoming able to appreciate it, & able to do something that would have kept record of it, to have it destroyed before my face. That foul son of a deal board, Canaletti—to have lived in the middle of it all & left us *nothing.*

But I can't write more today—only I am surprised on looking over your letters to find no notice either of Mr Moore's having my

1 His father had informed him: 'I have seen Mrs Harding today who had written to Baveno twice, Como, Milan, Verona & Venice but Mr Harding misses Letters by not calculating time 3 weeks between. By what Mrs H. says if you attempt coming home with Harding you will be sadly driven, hurried & over-fatigued.'

2 Catalogue 1817, now in the Ruskin Galleries (Bem. 1590).

3 'Baptized pigs'.

letter, nor of a letter that I sent for the man who wrote enquiring about the Turner he had bought[1]—neither of my stones coming from Pisa, nor my prints & paper from Florence. Love to my mother.

<div align="right">

Ever my dearest Father
your most affe Son,
J Ruskin.

</div>

<div align="right">

Venice. Tuesday, 23 [Sept.].[2]

</div>

<div align="center">

131

</div>

<div align="right">

Venice. Tuesday evening [23 Sept.].[3]

</div>

My Dearest Father,

I am sending you shabby letters, but the small work requires rest of the eyes in the evening. I have been quite overwhelmed today by a man whom I never dreamed of—Tintoret. I always thought him a good & clever & forcible painter, but I had not the smallest notion of his enormous powers. Harding has been as much taken aback as I have, but he says he is "crumbled up" while I feel encouraged & excited by the good art. I think however Harding has enjoyed the Venetian pictures & that they will do him good. I had another very sufficient staggerer in Titian's large Assumption[4]—which is a complete Turner, only forty feet high. Tintoret's is 60 by 24. I had altogether forgotten the Academy here—it is full of treasure—⟨but⟩ it is marvellous lucky I came here, or I might have disgraced myself for ever by speaking slightly of Tintoret. I look upon him now, though as a less *perfect* painter, yet as a far greater man than Titian ipse. I am vexed at finding nothing of Giorgione anywhere, but I am going to look at some palaces tomorrow, Harding's last day. I hope he will give you a good report of me. He has been very kind in giving me all the instruction & assistance he could, besides the drawing of the Foscari, & the only return we can make will be to send Mrs Harding some very nice Paxarete.[5] I find she is glad of a little sweet wine, being an invalid, and I think if my mother will tell Keel to make up a pretty bunch of flowers, that Miss Harding will be very glad of it. I have saved Harding something in coach fare perhaps, but I have quite counterbalanced that by the expensive way of living in the inns. He has been very tiresome by always

[1] See Letter 106.

[2] Postmarked Venice, 23 September. Received 1 Oct.

[3] Postmarked Venice, 24 September. Received 2 Oct.

[4] Then in the Academy, returned in 1919 to the apse of the Frari; it is $22\frac{1}{2}$ feet high. Tintoret's is probably the *Paradise* (Ducal Palace, 26×80).

[5] A Spanish wine supplied by Domecq and sold by his father.

<div align="center">

[210]

</div>

insisting on having the worst room, but I couldn't help it. I wish his time were not so limited, for as you will see, he has been making some valuable studies in Venice, & I wish he could *paint* them here as well. I have a letter on the stocks for Mr Severn, but haven't been able to drive a nail—they are driving too many about me. The weather has been everything that I could wish. St Mark's place last night was a perfect drawingroom, or rather like an immense square theatre—you could not believe you were in the open air— in the afternoon everybody had been at Lido, it being the Festa di Lido, & when I got into such a state of vexation at my drawing, I went there to see what they were doing. Hopeless sensuality—not a single fine face nor kindly look nor appearance of wholesome enjoyment. The crowded gondolas were pretty on the lagoon, but the people have lost all national character whatsoever—no costume, only vulgar imitations of France and England. The men were chiefly employed in singing Bacchanalian songs, seated on casks, as in our inn signs, but none of them were drunk, only riotous. I remarked this to Coutet. C'est tres bien, said he, mais je vous dirai une chose— qu'on a beaucoup de peine à s'enivrer ici. Que le vin ne soit pas tant mauvais, et tous ces gens la sont couchés par terre!

I see a horrible account in Galignani[1] of a workhouse investigation—bone gnawing—has anything been done about it—it is quite enough to set the lower classes all mad together. Love to my mother.

<div style="text-align: right">

Ever my dearest Father
Your most affe Son
J Ruskin.

</div>

132

[Venice.] Wednesday [24 Sept.].[2]

My Dearest Father,

I have had a draught of pictures today enough to drown me. I never was so utterly crushed to the earth before any human intellect as I was today, before Tintoret. Just be so good as to take

[1] *Galignani's Messenger*, an English language newspaper published daily in Paris and distributed on the Continent. On 16 Aug. it reprinted a *Times* report that the master of the Andover workhouse had been cheating the paupers of their proper food allowances and that the paupers, employed in crushing bones, 'were in the habit of gnawing them like dogs to appease their hunger'. *Galignani's* carried further accounts of the case on 25 and 29 Aug. and on 17 Sept. reported that, after taking testimony for thirteen days, during which the master had been accused of drunkenness, assault with improper intention, embezzlement, and misapplication of food and clothing, the Poor Law Commissioners had abruptly stopped the inquiry and refused to rule on the case. On 20 Sept. it reported that the inquiry was to be resumed.

[2] Postmarked Venice, 25 September.

my list of painters,[1] & put him in the school of Art at the top, top, top of everything, with a great big black line underneath him to stop him off from everybody—and put him in the school of Intellect, next after Michael Angelo. He took it so entirely out of me today that I could do nothing at last but lie on a bench & laugh. Harding said that if he had been a figure painter, he never could have touched a brush again, and that he felt more like a flogged schoolboy than a man—and no wonder. Tintoret don't seem to be able to stretch himself till you give him a canvas forty feet square—& then, he lashes out like a leviathan, and heaven and earth come together. M Angelo himself cannot hurl figures into space as he does, nor did M Angelo ever paint space itself which would not look like a nutshell beside Tintoret's. Just imagine the audacity of the fellow—in his massacre of the innocents[2] one of the mothers has hurled herself off a terrace to avoid the executioner & is falling headforemost & backwards, holding up the child still. And such a resurrection as there is—the rocks of the sepulchre crashed all to pieces & roaring down upon you, while the Christ soars forth into a torrent of angels, whirled up into heaven till you are lost ten times over. And then to see his touch of quiet thought in his awful crucifixion—there is an *ass* in the distance, feeding on the remains of strewed palm leaves. If that isn't a master's stroke, I don't know[3] what is. As for *painting*, I think I didn't know what it meant till today—the fellow outlines you your figure with ten strokes, and colours it with as many more. I don't believe it took him ten minutes to invent & paint a whole length. Away he goes, heaping host on host, multitudes that no man can number—never pausing, never repeating himself—clouds & whirlwinds & fire & infinity of earth & sea, all alike to him—and then the noble fellow has put in Titian, on horseback at one side of one of his great pictures,[4] and himself at the other, but he has made Titian principal. This is the way great men are with each other— no jealousy there. I am going to calculate the number of feet square he has covered with mind in Venice. There are more than 4000 square feet in three of his pictures, & I have seen about 60, large & small—no, many more it must be, but I am afraid to say how many. I am going back today—Thursday, 24th (or 5th)—to set to work on them in earnest, one by one. Harding left me last night at eight and I suppose will be in England almost as soon as this letter. He says he is going to call on you instantly. You may write after receiving this, to Verona, then to Domo d'Ossola, Brieg or Vevay.

1 See Letter 85.
2 This and the following paintings are in the Scuola di San Rocco.
3 John James Ruskin altered to 'I know not'.
4 The *Crucifixion*.

I shall ask at all places. I must stop two days at Paris as I come back. I don't care a farthing who's there or who isn't. Love to my mother.

<div style="text-align: right">

Eve[r m]y dearest Father,
Your most affe Son
J Ruskin.

</div>

Dear Richmond,[1]

I believe you will like to hear now & then what I am about—even at the price of deciphering my oracular manuscripts—and I intended to have written a fortnight ago, when I heard from young Cotton that you had spoken of coming abroad this year, to ask if it were not possible for you to come & help me a little at Venice, but I was buried immediately among the hills, and now it is too late unless you are on the road, for I shall have to leave Venice about the 25th of September or so.

I didn't see this on t'other side when I began.

133

<div style="text-align: right">

[Venice.] Thursday Evening, 25th [Sept.].[2]

</div>

My Dearest Father,

Is this really the twenty-fifth? I don't know at all what to do. I am so divided between Tintoret & the grand canal. I had a good two hours sit before him this morning[3] & it did me mighty good & made me feel bigger—taken up into him as it were. I am in a great hurry now to try my hand at painting a real, downright, big oil picture. I think I am up to a dodge or two that I wasn't—and I must have some trees in it. Tintoret has shown me how to paint leaves—[my w]ord, he does *leave* them with a vengeance. I think y[ou] would like to see how he does the trunk to[o] with two strokes, one for the light side & one for the dark side, all the way down, and then on go the leaves—never autumn wind swept them off as he sweeps them on—and then to see his colossal straws, and his sublime rushbottomed chairs, and his stupendous donkey in the flight into Egypt—such a donkey—such a donkey—with ears that look as if they heard the massacre of the innocents going on in Palestine all the way from Egypt—and well he might if it had been Tintoret's instead of Herod's. I looked at it today till I heard the women shriek. There they are, tumbling all over each other, executioners, swords,

1 On the back of the letter is this cancelled fragment of a letter to George Richmond, written at Baveno about 26 Aug. (see Letters 105 and 118).

2 Postmarked Venice, 26 September.

3 In the Scuola di San Rocco.

& all, one mass of desperation & agony—nothing disgusting, nothing indecent, no blood, no cutting of throats, but the most fearful heap of human grief and madness, & struggle, that ever man's mind conceived. But my eyes are tired & I must to bed. Love to my mother.

<div style="text-align: right">

Ever my dearest Father
your most affe Son
J Ruskin.

</div>

134

Venice. Friday, 26th [Sept.].[1]

My Dearest Father,

I met today at the Academy Mr Boxall[2] the artist, who is a great friend of Richmond's & is uncommonly like Richmond himself, & that is saying something for him. He came over to make a copy from the head of Christ (Leonardo's) at Milan (to be engraved),[3] & he has done it most beautifully, but unluckily he has brought it with him to Venice, & the Aust[rian] government won't let him take it *out* again—he is in a dead fix. By sea it might be managed, but he is in a hurry to get it engrav[ed] & there are some two or three months lost by the sort of sea conveyance they have here. We had a glorious chat over the John Bellinis ⟨today⟩, which did me much good. But Venice is horribly full of English & musquitoes at this season, & he has got poked into a miserable little inn at the back of the town—comes to dine at the Europa.

I lost my days *work* yesterday (Saturday morning), but I got a great deal from him which was well worth it, and I wanted a little good sympathy, for Harding called John Bellini's angels "nasty little wretches" and I had nothing for it but to go & draw boats & cucumbers with him.

It pours of rain today, for the first time, but I hope I shall have light enough to draw at the scuola of Tintoret. I suppose I shall soon get another letter now, scolding me for stopping here, but I can't help it. I want sadly to get home, but I can't get my work done. As for the aspect of things at home be assured they will be cheerful enough to me, winter and all, after the misery here. Love to my mother.

<div style="text-align: right">

Ever my dearest
your most affe Son
J Ruskin.

</div>

[1] Postmarked Venice, 27 September.

[2] William Boxall (1800–79), subject and portrait painter, Director of the National Gallery, 1865–74.

[3] For the engraving, published in 1850, see *Works*, XXXV. 373, note.

[Venice.] Sunday morning [28 Sept.].[1]

My Dearest Father,

I find no letters yet at Post office, but expect some soon. I never saw such rain since Naples[2] as we had yesterday, but today pays for it in pure gold. I have been very lucky in meeting Mr Boxall who is a great friend of Wordsworth and is another George Richmond only without the wit. Mrs Jameso[n][3] is here t[oo] and wants to see me—she is writing something about old art, but I believe don't kno[w] much about it. I believe I shall meet her today, but don't know. If Mr Boxall can get his picture clear of dogana he goes tomorrow, but there is much doubt. I hope he won't for a day or two, for I like him.

There is a glorious John Bellini which the priests are burning to pieces with their candles—in San Zacheria.[4] Would you give the price of an oil Turner to get it to England? I am not quite sure that it mightn't be done.

I found today the palace from which Bianca Cappella escaped.[5] It is very, very grand. I shall get a bit or two of it probably, but I am quite in despair at the little *I can* do and the much that bricklayers can do. Love to my mother.

<div style="text-align:right">

Ever my dearest Father
your most affe Son
J Ruskin.

</div>

136

[Venice.] Sunday Evening [28 Sept.].[6]

My Dearest Father,

I am sleepy tonight. I cannot write much, having been talking a good deal in the course of the day. Met Mrs Jameson by appointment at the Academy. She is as like Ann[7] as can be, & is just what Ann would have been with a good education. She has some tact &

[1] Postmarked Venice, 28 September.

[2] The Ruskins had been there in the winter of 1841.

[3] Anna Jameson (1794–1860), popular writer on art. A collection of her articles in the *Penny Magazine* on the Italian painters was published in 1845 and that January her magnum opus, *Sacred and Legendary Art*, began appearing in the *Athenaeum*.

[4] *Madonna and Child with Four Saints.*

[5] See Letter 53, p. 103 note 3. Daughter of a Venetian patrician, she became the mistress of a Florentine and, when the liaison was discovered, fled with him to Florence. For the palace, see *Works*, X. 295, and XI. 365.

[6] Postmarked Venice, 29 September.

[7] Ann Strachan, the Ruskins' servant.

cleverness, & knows as much of art as the cat. You will have a tolerable idea of her by hearing what three people said of her. Sh[e di]ned with us at the table d'hôte here. Boxall & I had on[l]y our own two seats reserved. Mrs J. had kept us late, & Boxall gave the seat by her to me, and went to another part of the table. The lady who sat next him had not perceived that he belonged to us, and in the course of the dinner, said, turning to her daughter, Look at that woman my dear. She's an authoress. I'm certain of it. She's the very type of a great class.

Boxall had been enquiring of his landlady, when first he came, about Mrs J. with perhaps a little more empressement than the hostess seemed to think the case deserved. Ah, signor, she remonstrated, non è bella. E vecchia—rossa.

Finally, the gondolier today begged me to change my place in the boat, remarking that, "La padrona *pese* molta." She is hard & feelingless & somewhat affected. I am too sleepy to write a word more. Love to my mother.

<div align="right">

Ever my dearest
Your most affe Son
J Ruskin.

</div>

137

<div align="right">

[Venice.] Tuesday, 30th Sept.[1]

</div>

My Dearest Father,

Mr Boxall left Venice last night. I gave him a letter to you at Billiter St. as I thought you might like to see a person who had been with me, and I am sure you will like him. He has made a lovely copy of the Leonardo, & though I don't recollect his exhibition works, I am sure there must be good in them, though he complains sadly of having to do them (portraits). I think if you ask him & Richmond together they will enjoy an evening at Denmark hill exceedingly. And will you be so good as to tell him that [the] person who made so good a shot about Mrs J. [was] Lady de Clifford,[2] whose servants Ann will recollect at Rome, as they very well recollect *her*.

Mrs J is Ann over again in all respects, and I would quite as soon take Ann's judgment of a picture.

I have had a delicious morning at Lido—got some shells, rowed

[1] Postmarked Venice, 30 September.
[2] Sophia Russell, Baroness de Clifford (1791–1874).

the greater part of way there & all the way back, *with* my gondolier Antonio, of course. I can't come the stern oar, but the fore one is delightful, so different from the clumsy English oar—it switches so from its delicate thinness of blade. We came from Lido to the Madonna della Salute in 25 minutes & that is very fair.

The gondoliers sing perhaps more than they did when I was here before, but not Tasso. One is seldom out late at night however without hearing a bar or two of the Mira o Norma, from some boat or other—it is the crack thing with them at present—it *rows* well, just the gondola stroke in it. Love to my mother.

<div align="right">

Ever my dearest,
your most affe Son,
J Ruskin.

</div>

138

<div align="right">

Venice. Sept 30th.[1]

</div>

My Dearest Father,

I send you a scrawled and sulky letter to Mr Severn.[2] I am half ashamed to send it, but cannot delay longer. I don't want to damp him, but it is monstrously absurd in him to speak of inoculating England with the love of *Fresco* as if that were all she wanted, and men could be sublime on a wall who were idiots on canvas. Fresco does indeed afford glorious *room* for a man who wants it—it is a [sple]ndid sea for the strong swimmer—but you might as well throw a covey of chickens into the Atlantic as our R-A's into fresco. We shall make such Judy FitzSimmons's of ourselves[3] as never were.

I have got some things of Venice that you will like, I believe, but all I can do is nothing in the gulph of general destruction. Love to my mother. When you see Harding, will you thank him very much for me for his long letter from Milan, received yesterday.

<div align="right">

Ever my dearest
Your most affe Son,
J Ruskin.

</div>

[1] Postmarked Venice, 1 October.

[2] Printed in *Works*, IV. 393–5.

[3] Interestingly, Eric Partridge's *Dictionary of Slang and Unconventional English*, 4th edn. (New York, 1953), calls the expression Anglo-Irish and dates it 1932.

<div align="center">

[217]

</div>

[Venice. 1 Oct.][1]

My Dearest Father,

I am thoroughly thrown on my back with the Palazzo Foscari—don't know what the deuce to do with it. I have all its measures & mouldings, & that is something, but I can't get on with the general view. I began it as it *should* be done, taking plenty time, and Harding said I should "frighten the Daguerreotype into fits," and Coutet said on being asked if it was like—"Ça ne lui *ressemble pas*—c'est la meme chose." But this wouldn't do at all. I should have taken a month to do it & now I can find no expedient nor mode of getting at it that will give me what I want. To ta[ke t]he outline is what has been done a thousand times—th[e bea]uty of it is in the cracks & the stains, and to draw these out is impossible and I am in despair. St Mark's too sets me aghast every time I go near it—since I have been studying architecture carefully, I see things about five times as beautiful as I used to do, and as I can't draw much better, I am reduced to knocking my fists together and moaning. I shall come away soon now I think—it's no use stopping. Love to my mother.

<div style="text-align:right">

Ever my dearest Father
Your most affe Son
J Ruskin.

</div>

140

<div style="text-align:right">

Venice. Thursday, Oct 1st [i.e. 2nd].[2]

</div>

My Dearest Father,

I am ashamed of staying so long here & doing so little. I work very unsatisfactorily at present. I suppose it is a warning not to stay longer from you and indeed I shall start soon now, though ⟨indeed⟩ it hurts me sadly to look on St Mark's—*old* St Mark's—for the [last] time, for the sort of thing they are scrapin[g] out of i[t is qu]ite good for nothing. What would I not give to have back again ten years, & to be set, with my present powers & feelings, in St Mark's place, as it was when I sketched the little clock dial vignette in my white paper & pencil book of 1835.

Another thing that much vexes me is the evident increase of mud in the lagoons. When the tide is down there is now hardly any water

1 Postmarked Venice, 2 October.
2 Postmarked Venice, 3 October.

about Venice, except just between it and Lido, and in the canals of Fusina, Mestre, &c. All the rest is mud or green weed. I should have thought unwholesome, but they say it is so only in August. I like Mr Valentine, the partner in Holme's house, very much—gentle & sensible, very young. Love to my mother.

<div style="text-align: right">

Ever my dearest Father,
Your most affece. Son
J Ruskin.

</div>

<div style="text-align: center">

141

</div>

Venice. Saturday, Oct. 4th.[1]

My Dearest Father,

I have at last got what I consider a good & useful drawing of part of the outside of St Mark's,[2] but I fail 3 times out of four, I suppose from trying to do too much, & yet it is just this too much that I want, for as to taking common loose sketches in a hackneyed place like Venice, it is utter folly. One wants just what other artists have not done, & what I am as yet nearly unable to do. The splendid feature they have always omitted, as I said before, is th[e] fresco painting of the exteriors. Whole houses have been covered by Titian, Giorgione, & Paul Veronese, and as all these painted brighter and better in fresco than oil, especially the latter, imagine what Venice must have been with their hues blazing down into the sea & up again. There ⟨is⟩ are a fragment or two of Giorgione left yet on one palace[3]—purple & scarlet, more like a sunset than a painting —& I was much pleased by two or three grey figures of Veronese. Titian has perished—through ill treatment only. Salt ⟨&⟩ wind & rain do nothing compared to men.

I shall soon be off now I trust, though I am less miserable than I was, because I have seen the extent of the *present* evil & made up my mind to it. How much of Venice may remain when I come back is another affair. Love to my mother.

<div style="text-align: right">

Ever my dearest Father
Your most affe Son,
J Ruskin.

</div>

[1] Postmarked Venice, 4 October.
[2] Perhaps Catalogue 1939.
[3] The Fondaco dei Tedeschi, now the post office; see *Works*, III. 212. All that remains is a dim fragment now in the Academy.

<div style="text-align: center">

[219]

</div>

Venice. Tuesday, Oct 7th.[1]

My Dearest Father,

As I still get no letters I have made up my mind that the one I sent asking you to send two more to Venice must have miscarried.[2] I hope the rest have *not*, at least to any great average. The tiresome thing is that I shall still remain without news for a fortnight, for if I wrote to Vevay or Brieg I might just miss the letters at Verona (especially if I left before the time [I] have named which is not improbable), for the posts are very badly regulated here, and all kinds of delays occur as I found with Harding's.

I have been lucky enough to get from a poor Frenchm[an] here, said to be in distress, some most beautiful, though small, Daguerreotypes of the palaces I have been trying to draw—and certainly Daguerreotypes taken by this vivid sunlight are glorious things. It is very nearly the same thing as carrying off the palace itself—every chip of stone & stain is there—and of course, there is no mistake about *proportions*. I am very much delighted with these and am going to have some more made of pet bits. It is a noble invention, say what they will of it, and any one who has worked and blundered and stammered as I have for four days, and then sees the thing he has been trying to do so long in vain, *done* perfectly & faultlessly in half a minute, won't abuse it afterwards.

I enclose a letter to Gordon which perhaps may interest you a little. I don't want to tell *all* I have found out of the mystical in Tintoret till I have it in print, but he is the artful, & no mistake. Love to my mother.

Ever my dearest father
Your most affecte Son
[J Ruskin.]

[Venice.] Wednesday, Oct. 8th.[3]

My Dearest Father,

I am quite delighted with my Daguerreotypes—if I can get a few more I shall regularly do the Venetians, book them in spite of their te[et]h. I'm very sorry to leave after all—it is a blessed place and agrees with me and the rowing does me good. I've only today

[1] Postmarked Venice, 7 October.
[2] A missing letter, evidently of 12 Sept.; see Letter 153.
[3] Postmarked Venice, 8 October.

& two days more and then I hope you will hear of my being regularly on the road home. Very busy. Love to my mother.

> Ever my dearest
> your most affect son
> J Ruskin.

144

Thursday morning. Venice. 9th Oct.[1]

My Dearest Father,

I have been more over my time here than anywhere, and yet leave with less of what I wanted—but I have done a good deal too, & I find I can now do in ten minutes what took me half an hour when I left home.

All [w]ell. Weather heavenly beyond desc[ript]ion. Love to my mother.

> Ever my dearest
> Your most affe Son
> J Ruskin.

145

Venice. Friday, Oct 10th.[2]

My Dearest Father,

I find I shall save time by going the great Milan road instead of the Como one, and I have been studying Tintoret till I find I hav'nt half studied him enough, so I stop here till Monday, and then I intend D V, to make it—Monday, Padua—Tuesday, Vicenza—Friday Verona—Saturday Cremona—Monday Milan—Tuesday—stop, I forgot. Monday's the 13th. [I] don't like to set off for home on 13th. I must wait till Tuesday, but it won't make an[y] difference. D V, I shall be at Vevay on Sunday the 26th, at Paris Sunday the 3rd, and at home Sunday the 10th. I have been quite upset in all my calculations by that rascal Tintoret—he has shown me some totally new fields of art and altered my feelings in many respects—or at least deepened & modified them—and I shall work differently, after seeing him, from my former method. I can't see enough of him, and the more I look the more wonderful he becomes. Weather as bad today as it was beautiful yesterday. Love to my mother.

> Ever my dearest
> your most affe Son
> J Ruskin.

[1] Postmarked Venice, 9? October. [2] Postmarked Venice, 10 October.

Venice. Saturday Evening, Oct 11th.[1]

My dearest Father,

I have had a very glorious week of it, take it all in all, and am closing my Venetian sojourn very satisfactorily, though I daresay you think it is high time. Joseph says so too, for he is not pleased with me, says I work too hard, and that if it were to continue, "il ne le souffrirait pas." He always looks very curiously into my face of a morning, and I find it is to look for a little blue vein that appears under the eye when I am wearied. I couldn't think how it was that he found out when I was tired, but he always says—Monsieur, ça ne va pas aujourdhui. Faut vous aller promener.

I have had a good day today however—wound up a drawing very nicely, & found some things that I liked. I have been looking always into the shops as I passed to find something for little Louise Ellis, and I can't find anything that she and I both should like. Their jewellery & knickknackery is all vile—their bead work I hate. I was looking for a little antique cross, and I was recommended to a shop where they sold antiques only. I found it a palace on the grand canal, full of old things, & two such nice French people as never were. I suppose it is having had nothing to do with anybody but these lost Italians lately, but the French manner & expression of the lady—for she *was* almost a lady—warmed my heart in a minute, & so the manner & voice of French women always will— though it's a cursed nation for all that, & they've pulled down the churches here by wholesale,[2] so they have. However, I was quite delighted to get a french woman to speak to, and she was so simply & prettily dressed, and her hand white & small. I didn't find any crosses, but I was determined to find something to buy of her, & at last I found a whole cupboard full of old Venice glass, the real old defy-Tophana[3]—you know they couldn't cut glass then—it is all blown, & they couldn't make two things alike. She showed me several whole services made of the same pattern & there wer'nt two glasses of the same height, and it is of a totally different stuff from modern glass—half as light again. I bought in the first place, six *little*, little, very little glasses for you to bring your grand Napoleon in when

[1] Postmarked Venice, 12? October.

[2] According to Murray's *Northern Italy* (1842), p. 328, during the French occupation of Venice (1797–8 and 1806–14) 166 churches were demolished.

[3] See Rogers, *Italy* (1830), 'The Campagna of Florence', p. 123: 'The Great/ Drank only from the Venice-glass, that broke,/That shivered, scattering round it as in scorn,/If aught malignant, aught of thine was there,/Cruel Tophana.' According to Rogers' note (p. 267), Tophana was 'a Sicilian, the inventress of many poisons'.

Mr Turner comes to dinner—and there is a beautiful glass salver to match for Lucy to bring them on, only she must mind very much what she's about. Then there's a thing of this shape—which is particularly odd, for its cover at *a* is all of one piece, and whatever you put into it must be poured in through the *spout*. Then I've two large light glasses for you & my mother to drink hock or anything light in, and I've a *painted* mug—much of their glass was painted—and another nondescript thing, and all for 37 francs. But I'm afraid I shall be in for more than 37 franc[s] before I've [done]. They showed me among other things a picture from a palace on the place of St Paolo. It was dark today & I couldn't see well, but I think i[t] is indeed what it professes to be—a noble portrait by my dear Tintoret. They want twenty Napoleons for it, and if I like it as well in the light as I did in the dark, I'm a Jew if I don't have it, but I'm going to take an artist whom I have scraped acquaintance with, to look at it first, for though I know pretty well what o'clock it is, wiser folks than I have been bitten with old pictures—but it is a grand thing, a splendid Doge like head in burning cloth of gold, & a dark sky, and Venetian galleys behind. I can't bring it with me but I shall make my artist friend see it packed, & send it by sea, & you shall ensure it for me for twenty pound. But I hav'nt got it yet—it may be a vile copy when I see it by good light, but if it *be* the real thing, shan't I be pleased when I get a Tintoret into our house at home. I find the "old fox" as Harding calls Turner, has got more out of Tintoret's poultry yard than everybody else's put together. I find he has been nibbling at him all over—in fact Tintoret is the only man whom I could ⟨say⟩ be certain Turner had studied with devotion. Usually I trace Turner in nature only, but I have caught him at the feet of Gamaliel[1] at last. Love to my mother.

> Ever my dearest Father
> Your most affectionate Son
> J Ruskin.

1 Acts 22:3.

Venice. Monday, two o'clock [13 Oct.].[1]

My Dearest Father,

I've seen my Tintoret again—no go—won't bear sunlight—only a good copy. Off tomorrow D V, early, & mighty sorry I am. Venice does look so very lovely—today intense sun on everything, and I've found out such lots of lovely things—sad work. Love to my mother.

Ever my dearest
Your most affe Son
J Ruskin.

148

Padua. Oct. 14th.[2]

My Dearest Father,

Here we are at last, regularly on our way home—high time, for it is getting quite chilly in the evenings, and the Alps are getting silvered fast. But I was intensely sorry to leave Venice—murder and Irish and all—chiefly however because I know that I shall never so see it any more. They are painting all the marble white as fast as they can afford it, and as for poor St Mark's, I th[ought] they had only scraped it, but alas, I got [up to] look at it, & found that what I had taken for scraped marble was indeed painted stucco, over the bricks where the marble *had* been. They are filling up the canals too as fast as they can—to get rid of the smell! As if a narrow alley would not be more filthy with their beastly habits, when it is dry, than when the salt sea washes it. Well, I am on my way home, and glad I shall be to get there.

Love to my mother.

Ever my dearest Father
Your most affe Son
J Ruskin.

149

Padua. Oct 15th.[3]

My Dearest Father,

The weather has turned abominably cold, so that I shan't be able to get my drawing at Vicenza—it is a mighty bore. I never saw the like of this Italy—it is tenfold more treacherous than our climate. I have had delicious weather at Venice, however, & must

[1] Postmarked Venice, 13 October.
[2] Postmarked Padua, 15 October. [3] Postmarked Padua, 16 October.

not complain. I shall not stop at Paris as I come home, as I am sure you would feel it tantalizing and I have [been looki]ng over what I have got and I find I shall do well enough without. So, D.V. I shall get home on Wednesday or Thursday, the 6th or 7th Nov. This place is the only town in Italy in which I have found no important change, and there is in consequence still a sweet and feeling character about it, and it is associated moreover with all my childish pleasure in going to Venice, so that I always shall love it. It is curious that we best love those places where we *hope* most—almost better than those where we enjoy. I have regards for Calais that are different from those I bear to any other place abroad.

Well, among all the mechanical poison that this terrible 19th century has poured upon men, it has given us at any rate *one* antidote, the Daguerreotype. It's a most blessed invention, that's what it is. I have been walking all over St Mark's place today, and found a lot of things in the Daguerreotype that I never had noticed in the place itself. It is such a happy thing to be able to depend on *every*thing—to be sure not only that the painter is perfectly honest, but that he *can't* make a mistake. I have got the Palazzo Foscari to its last brick, and booked St Mark's up, down, and round about. Love to my mother.

<div align="right">Ever my dearest Father,
Your most affect Son
J Ruskin.</div>

<div align="center">150</div>

<div align="right">Brescia. Sunday, 19th Oct.[1]</div>

My Dearest Father,
I can't think how I was so stupid as not to ask for letters in passing Vicenza. I have no doubt you had left some there for me, and I have written to have them sent to Vevay, but my head was full of Verona, because you had told Macdonald to write there, and I thought that Harding must hav[e] got home and told you I was staying at Venice an[d] that you would take a shot at Verona. I was mighty disappointed to find nothing, and should have been more but that I thought of the chance of Vicenza. Still I am getting worried a little, because I can't tell whether you or Prince Metternich have got my Venetian letters. Not a word from Macdonald neither—not a word from my German friend at Florence,[2] who was to write to Verona—and I haven't heard of your receiving any of my parcels or packages from Florence or Pisa.

1 Postmarked Brescia, 19 October.
2 Probably Durheim, actually a Bernese; see Letter 78, note 4.

I hope to get to Brieg on Thursday at any rate & hear something—perhaps Wednesday. Very lovely weather, but cold. Love to my mother.

> Ever my dearest
> Your most affe Son
> J Ruskin.

151

Milan. Oct 20th.[1]

My Dearest Father,

I couldn't write today, for I didn't get here in time for post, and I hav'nt time to write two words tonight, for I want to be up early to see a Raphael[2] that Mr Boxall told me of—quite well—love to my mother.

> Ever my dearest
> your most affect [Son]
> J Ruskin.

I had hoped to get to Domo to[morro]w but find it's too far—only Arona or Baveno. Simplon for Thursday D V.

152

Village of Simplon. Oct 22nd.

My Dearest Father,

Here we are—and here I am, in my own *pays*, by a glorious wood fire, and rejoicing in your letter received today at Domo d'Ossola of the 7th with notice of Harding's kindness in coming so soon, for which I think both you and I are much obliged to him. I see my Venice letters have miscarried. I suppose the Austrian govt has got them, much good may they do it. I couldn't write yesterday because I was all day long getting from Milan to Baveno, and I thought it so important to get the fine weather for the Simplon that I would not stop at Arona. I heard at Milan that the Simplon was *just* open, having been again destroyed by a storm. I found it quite true, and I pushed on lest it should be shut again by another rainy day. It was destroyed this day fortnight, by the wet weather that bothered me at Venice. Two bridges were carried away in the *Val* d'Ossola itself, the level bit of road from the grand last bridge to Domo d'Ossola being cut into three, and the road from Iselle

[1] Postmarked Milan, 21 October.
[2] Probably the *Sposalizio* in the Brera Gallery.

downwards is now little better than the bed of the torrent in most places—however, though we found the road bad, the weather has been glorious. I never saw the Simplon so ⟨glorious⟩ lovely, and coming from Milan yesterday I had the Monte Rosa the whole way to Sesto Calende, as clear as crystal. I never had two more delicious days, and it bids fair to be as fine tomorrow—and the autumn colours of the meleze[1] and the mountain vegetation are something more than dazzling, mountains all covered with purple fire, only I couldn't think at first why the Gondo ravine seemed much wider than before. It is having been used to the narrow chasms of canal at Venice.

Apropos of Venice, I overfatigued and overvexed myself there, and I had a bit of a fright at Padua. I forgot the difference between salt water and fresh, and as I had been used to stop out till long after sunset ⟨at⟩ on the lagoons, I was running about in the twilight at Padua on Tuesday without thinking of the stagnant canals. I found when I went to bed I had a pain in my side; and when I woke in the morning I couldn't stir. Lived on chicken broth for two days & didn't stir out, & starved him out—but I was monstrously frightened at first, and I didn't get rid of feverish feeling till Brescia, where I saw there was a good high hill outside the town, so I got out on Sunday morning, climbed it, put myself into a violent heat, caught sight of the Monte Rosa, and came down quite well. But it cost me my house at Vicenza, & my review of Giotto at Padua,[2] and a good deal at Verona. I didn't dare venture out anywhere, to pictures till Milan, and then I had a good long review of the gallery yesterday morning. One remembers so much better by digesting for a month, & then ramming down.

I have been thinking that I can't spend my Sunday at Vevay or else I shall be thrown till the 6th or 7th for home, because I can't get to Dijon from Vevay in two days. I purpose pushing down the Valais tomorrow either to Sierre, or if I can, Sion, then getting next day to Bex or Villeneuve, then breakfasting at Vevay. I shall get my letters &c., enquire about distances, and be able to go on to Morges or Nyon. I want to get to Beauvais by the next Saturday, D. V. From the height of the Alps I look back on my Italian route, very thankful not to have either done or suffered wrong in the vile country. Tomorrow early, down, and goodbye to summer skies and winds for this time.

Many thanks for your kind approval of what *I might* have done in the picturedealing way at Venice. I feel just as grateful for it as if I had my John Bellini[3] packed at the top of the carriage. But it's no go. There's nothing good to be bought now a days except Turners.

[1] Larch. [2] His frescoes in the Arena Chapel. [3] See Letter 135.

I hope to post this at Brieg tomorrow.[1] I shall read my letters [as] I trot down to Sion, and have answer ready for [Ville]neuve—love to my mother.

<div align="right">
Ever my dearest Father

Your most affecte Son

J Ruskin.
</div>

153

<div align="right">
Martigny. Oct 23rd.
</div>

My Dearest Father,

Well, for an October day, I call from the Simplon Inn to Martigny a very fair piece of work, but then there is such a difference between Swiss & Italian postilions. They drive here at twice the rate, and for the same money wish you bon voyage and merci, for which an Italian grumbles and swears—and looks ready to murder you. If you look through the Italian or any other dictionary, and pick out every epithet that means anything bad, and make one compound epithet of them all, it won't be strong enough for the modern Italians—lazy, lousy, scurrilous, cheating, lying, thieving, hypocritical, brutal, blasphemous, obscene, cowardly, earthly, sensual, devilish. I felt on the Simplon as if I were escaping to the mountain out of Gomorrah.[2] But such a walk as I had this morning up from the village. I was out before breakfast to see the dawn on the Fletschhorn, and there isn't the least doubt that if anyone wants to see the Alps in perfect glory, he must come in October. There hasn't been a cloud nor a shadow all day—every peak radiant, and the low sun keeps touching them all day with *morning* effects—long slanting rays catching the red forests along the tops and gleaming & glancing over the edges of the snowy summits—not the garish, see everything, downright summer sun, but just what one wants, mysterious & dewy & bringing out all the promontories one behind another. I hadn't *any idea* of the Valais till today—now I've *seen* it for the first time. And at the Simplon top, though it was hard frost, and all the rocks covered with ice, it wasn't a bit cold—no wind, and the most lustrous, paradise like panorama you ever dreamed of. I got up there at eight o'clock, and started from Brieg after getting your two letters at 12 precisely, but I stopped some time at the top to make observations—one could learn more in an hour today than in a week of summer. I only found two letters at Brieg—one

1 Postmarked Brigue, 23 October.
2 Gen. 19 : 17.

all full of explanations about the Venice no letters. I was only fidgetty till I found that you hadn't got my letter saying where to write—perhaps I wrote so badly that you took Venice for Verona, but I most certainly wrote about the 12th or 14th Sept. saying to send two more letters to Venice & one to Verona afterwards, and it was therefore that I got anxious—for at Pisa I knew my letters were at Florence, but at Venice and Verona I expected them & therefore began fancying all sorts of things. There is a great deal in the other letter,[1] and it is almost too late to answer tonight, but I want to post this at Vevay tomorrow[2] and so must run through it. You seem surprised at my stopping at Venice:—first I did not know you were going there next year. I knew of Annecy & Carrara, but of no where else—secondly, if I had, I should still have staid, for one of the windows of the Ca d'Oro was destroyed before my eyes, the scaffolding is now all over it, and the Foscari palace is threatened in a *month*, and though probably the Italians will procrastinate as usual, and you may have a good *chance* of seeing it in statu quo next year, I could not risk it. Add to this the total surprise I had with Tintoret, the having all of a sudden to make myself acquainted with a mighty genius of whose *existence* I was not aware before, and add to that, that although Harding's visit and companionship was of the greatest use to me in the *long run*, yet it was quite out of my way at this time, and the studies that I had with him of boats & figures were quite beside the mark as related my *object* [a]t Venice, and you will see that the twenty days I too[k] beyond the time I named were little enough. But, as for what I am to do when I get home, it will not in the least interfere with our tour next year. I am ready at any time to go wherever you and my mother will most enjoy yourselves, and if the book be not then done, it will in no wise be interrupted by my doing so—it will be thoroughly set a going, and I can direct it as well abroad as at home. Hurried it cannot be, but on it shall go steadily & will be out at the same time, whatever that time be, whether I stay at home or go abroad. I have such a mass of confused materials by me at present that I know not where to begin—whether they will arrange themselves fast or slow I know not, but they must be arranged quietly and well or I shall make some blunders again. I can't hurry or bind myself to time, but I will do it as soon as I can, and think of nothing else till it be done. Poor Richard.[3] I'm very glad I happened to write him from Brescia, but

[1] Of 15–19 Sept.; see Appendix

[2] Postmarked Vevey, 24 October.

[3] His father had written: 'Poor Richard Fall [see Letter 56, p. 110, note 1] has taken it into his head that you thought he could have gone with you & are angry that he did not & therefore have not written. Send him a Line if you can.'

I'll send him another line. I am very much obliged to you for your present of your beautiful Caligula's bridge, and am delighted that you like the Mercury & Argus[1]—both are beautiful but I like the big one best. Thanks for your account of picture arrangement[2]—all very nice. I am vexed you think the Turners poor however, and vexed at all the row with Bicknell.[3] That it is very wrong in Turner to raise his price upon us I think, but I am in no way *bound* to take two at eighty even—much less at a hundred. I never made any promise or agreement whatsoever, but on the contrary an express stipulation that I might draw back when I chose.[4]

I suppose you will get this with my Brieg letter, but it is as well to let you know I am getting on. Love to my mother.

<div style="text-align:center">

Ever my dearest
your most affe son,
J Ruskin.

</div>

It is rather cold in the open corridor of the old convent inn here.[5] I had such a curious feeling in looking at one of my Daguerreotypes of St Mark's place (where a fortnight ago I was eating ices out of doors at ten o'clock at night) beside the wood fire here.

[1] Large engravings from Turner oil paintings. *Caligula's Bridge* (R.A. 1831) was engraved by Edward Goodall (24¼ × 15¾) and published in 1842 by Thomas Griffith. *Mercury and Argus* (R.A. 1836) was engraved by J. T. Willmore (15¼ × 20⅝) and published in 1840 by F. G. Moon. His father's letter reports that he has hung *Caligula's Bridge* (which he had bought in Aug. 1844 for 12 gs. and which had been in his bedroom) in his son's study in exchange for his son's *Mercury and Argus*.

[2] The letter details his father's re-arrangement of the pictures in various rooms at Denmark Hill.

[3] Turner's row with Bicknell concerned the engraving of his *Fighting Téméraire* and the retouching of his *Whalers*.

[4] Of the three commissioned drawings, Ruskin had apparently bound himself to take one at 80 gs. and to take the other two only if he liked them. According to his father's letter, Griffith, Turner's agent, tried to get £100 each for those two, but his account book (Bem. MS. 28) shows that he paid only 80 gs. each.

[5] Hôtel de la Poste, once a convent; see *Works*, XXIX. 475.

Nyon. Oct 25th, Saturday.[1]

My Dearest Father,

I wrote hurriedly this morning from Vevay,[2] for I was just setting off, and was a little taken aback by the *two* deaths.[3] Before speaking of the other matters alluded to in your letter I must trouble you with a little business of *mine*, though I am sorry to do so, for you must be much engaged at present. When I went to the post office yesterday at Vevay, I was surprised to find no letters, as yours of the 19th *September* announced one of Mr Moore's to be sent there, as well as a Coutts note. Coutet has been in the habit all the way of paying the posting & bringing me his account on the Saturday. At Martigny I found myself 15 napoleons in his debt, and as I had only that in my desk, with a Coutts bill, I brought him on to Vevay intending to clear off all debts there except the great one, which I saw I should be obliged to send him. But when I found no letters I was afraid they had been opened & the note taken—& as even 45 napoleons were almost too little to carry me home I was obliged to let Coutet go, without paying him anything. I therefore now owe him—Service, April 12th to Oct. 26th, 198 days,

call it 200	=	Fr. 800.
Posting from Milan,		295
Plants bought from *Payot*,[4]		80
Paid to Francois Despland,[5]		
(who is dead)		35.

Francs, 1210.

This sum you will know best how safely to remit to him, and whether he ought to have any additional present. I have promised him nothing. He left me at six o'clock this morning. His address is simply Chamonix, but I suppose his money must be sent to Geneva. Perhaps also a sovereign sent to Despland's family might be of use. The potatoes have failed here too.

I am now at the little village, Nyon, which I first reached on descending from the Jura seven months ago, and where I think I

[1] Postmarked Nyon, 27 October.

[2] A missing letter.

[3] The deaths were those of his Croydon cousins John George Richardson (see Letter 41, p. 81, note 5), and Mary Bridget (Richardson) Fox (b. 1814), who had just died in Australia; see *Diaries*, I. 321.

[4] See Letter 97.

[5] A Chamonix peasant. The payment was probably for some moss-agates John James Ruskin had ordered for his wife; see his letter of 26 July (Bem. L 3).

may fitly pass the Sunday in thankfulness. You have spoken of the general tone of your letters during the time as perhaps not sufficiently serious. I did not expect them to be other than they have been, for if the advice, or the education which is better than advice, had not been given before I left home, it would have been too late afterwards. I did not suppose you would be at all anxious respecting my conduct, for you knew that I was exposed to no temptations—not going into society, I see not what wrong I *could* have done, unless of the very coarsest & most wilful kind, which I was not likely to fall into, were it only as a matter of taste. I should think that art was indeed a miserable pursuit, if all my love for it could not keep me from common vices. I think there is every excuse for young men who without many sources of enjoyment, without strong family affections, without much subject for thought, without much depending on them except their own prosperity, are thrown, imperfectly educated into an atmosphere of temptation. All I wonder at is that there is not *more* vice and misery among the struggling youth of such a capital as London. But I conceive that with my powers, training, and opportunities of free enjoyment of every kind, any seeking after it from illicit sources would be a sort of second fall of man which the devil must come the old serpent again very subtle indeed to bring about, and which there could be no palliation of. You see I have had so little need of any pleasures beyond my vocation that I have not once entered the doors of any public place of amusement. I was tempted at *Bergamo*—you know *Rubini*[1] has a villa on the lake of Como, and he was coming to sing for two nights in his native city. I should have liked to have seen his reception, and heard his voice for the last time in his own mountain air. I should have gone, but I should have lost a day at Bergamo besides the Sunday—he was to sing on Saturday evening— and I could not pay so dear.

That I should have had pleasure in receiving a few serious letters from you is certain, but I had as much in perceiving that you did not think them necessary, and that your fears for me wer[e o]f material, not moral danger.

In one way I have been remiss enough. I have let my money go in a very careless way. I began most economically and arithmetically, and went on to Nice counting sous, but at Nice I found myself short by six five-franc pieces, & after puzzling over the matter for two hours I had to give it up, which disgusted me with my accounts, and when I got into pauls and batz and all sorts of rubbishy incalculables, I gave it up in despair, and threw it all into Coutet's

[1] Giovanni Battista Rubini (1795–1854), the greatest tenor of his time, had retired that year.

hands. You will wonder what became of my money at Venice, but I have the Europa bills to show you. I spent five francs a day for my gondola, as I had it from six morning till, sometimes, eleven at night. I could not get it for less, & I paid twenty napoleons for Daguerreotypes alone.

By the by I forgot to mention a thing which might make you uncomfortable. In my letter of Tuesday[1] the 15th Oct., you will see I say I have been working hard on Titian's frescos,[2] and if you compare my letter from the Simplon & see that I did not stir out all day, you might think I had been white-lying. Both statements are perfectly true—on Tuesday evening I made a hasty sketch from the fresco, in doing which I probably caught the cold, and on the Wednesday morning as soon as I *could* get up, I copied this and prepared it for the engraver that I might have something to say in my letter—and a very *hard* piece of work it was, too, for I could hardly sit up in my chair to do it.

Well, here I am, thank God, all right, and if nothing happens to prevent me, my days are now fixed to home—ie, tomorrow,[3] Champagnole, then, Dijon, Mont bard, Sens, Paris, Beauvais, Sunday, Abbeville, Calais on Tuesday the 4th—if you ascertain the time of tide and when the trains leave afterwards you will know about what time on Wednesday the 5th to expect me at London bridge. You cannot I think answer this except to Calais, or perhaps Abbeville. I shall enquire at Paris for letters in case of your having sent any there and at all the other places if I *can*, but in general I shall be off too early & arrive too late for the post offices. If there are letters at Dijon, I shall get them, and I shall enquire at Paris, Abbeville & Calais. Love to my mother—my next letter will be to her, at Denmark Hill.

<div style="text-align:center">

Ever my dearest
your most affe son,
J Ruskin.

</div>

I shall probably post my mother's letter at Les Rousses tomorrow, or St Laurent.

I will take care of Mr Storie[4] at Paris. I shan't have much chance

[1] i.e. Wednesday. The letter is missing.

[2] In the Scuola del Santo, Padua. The drawing he made is probably the one, from the background of *St Anthony Granting Speech to an Infant*, engraved by J. C. Armytage (Catalogue 1674) and published in *Modern Painters III* (1856). The engraving is reproduced in *Works*, V, Plate 16.

[3] Monday the 27th.

[4] The Rev. John George Storie (1797?–1858), Vicar of Camberwell (1823–46), for whose church, St Giles', Ruskin and Edmund Oldfield had designed a stained glass window in 1844.

of meeting him between nine night & ten morning. I got a letter from Macd. at Vevay—he seems better. I see you say in a note that my letter of the 10th from Venice, *dismayed* you by putting off my departure. It didn't put it off more than a day, did it—and I think I fixed the same time as before for Vevay—did it dismay you very much? I was finishing a drawing that had cost me much labour, & a wet day came & I couldn't work, so I was obliged to stop.

155

Dijon. Oct. 28th.

My Dearest Father,

I dare say you will have almost too many letters just now, for I hardly can tell when the malle poste has passed me, but at any rate even if you get two together you will be glad to know I am getting on.

It is the greatest blessing conceivable to see the bright faces and clean caps of the French, after the sulkiness & filth of Italy, and t[o] hear the pleasant "merci m'sieur" for one's fiv[e] sous instea[d] of the growl with which the Italian postillion, who has driven you at 3 miles an hour, receives three times as much as he ought. I never heard one Italian speak to another except with the snarl of a wild beast, nor to a foreigner without the sneaking, scoundrelly obsequiousness which would cut his throat if it could. Here one has the clean cottage, the indulged and docile horse (barring the neigh and the kick to express its delight at having done its work), instead of the exhausted and cruelty hardened brute of Austria— here one has the nod of the head and the pleasant smile from the people at the doors to the postillion as he passes—or better still, one sees him touch his hat to the Lady of the village in her morning walk, and hears him shouted after merrily by the little boy who holds her hand, to beg for a ride on the big saddle as he comes back. I never felt the contrast so forcible between a living & a dead nation. I had rather by half travel on this dull Dijon road than ⟨on⟩ through the loveliest district of Italy, merely on account of the inhabitants. I sent a package of letters to my mother yesterday from St Laurent[1] which I hope she has got. This I purpose posting before I leave here,[2] for I shall be late at Mont Bard.

[1] Missing.
[2] Postmarked Dijon, 29 October.

I'm sorry to hear poor Cy is gone. I could have better spared a better man.[1] Love to my mother.

<div align="right">
Ever my dearest

Your most affe Son

J Ruskin.
</div>

<div align="center">

156

</div>

<div align="right">
Paris. Friday Evening [31 Oct.].[2]
</div>

My Dearest Father,

Here we are—and here we go, for I'm off tomorrow for Beauvais, D V. I have your two letters here, and shall leave careful orders with Mr Cailliez[3] about the Verona letters, plague take their post offices. I sent first Coutet & then George at Verona, & had letters turned twice over. I couldn't go myself, for I was afraid [to] stir out. At Padua I only got on the *second* day [the] letter which must have been lying there 10 days at least. But I didn't leave word at the Post offices to forward, because I had no idea being so much behind my time that there would be any letters *behind* me.

I have been taking care about fast travelling by taking no dinners. I have come from Dijon without tasting meat, soup, eggs, or wine, but I was mighty glad of a bit of roast chicken when I got here. I am getting I find very much into your way of being able to do most fasting. I found that at Macugnaga neither meat, wine, coffee, nor brandy were half so good to climb hills upon as a Seidlitz powder— but I don't think this is a healthy system, and it won't do for us, with whose naturel it happens to agree, to preach it to all the world. I believe George would get thoroughly ill if he were kept two days without his dinner.

I am glad Boxall won't see the Turners without me. How is Mr Runciman?[4] I ought to have written to him.

I suppose you will hardly be able to answer this to France, but please send me a line to Ship Hotel, to say whether, if the steamer, or the Customhouse, keep me beyond eleven, you wish me to stay at Dover that day & wait for the morning train on Thursday.

I have had no end of trouble with Mr Hopkinson. At Champagnole we found our wheel coming all to pieces, and I have had to jolt over the pavé with it all tied up, from spoke to spoke, and at Mont Bard all the bolts of the dickey came out & George was within a hairs

[1] *I Henry IV*, v. iv. 104. For Cyrus, see Letter 56, p. 110, note 5.

[2] Postmarked Paris, 1 November.

[3] B. Caillez, proprietor of the Hôtel Meurice.

[4] Charles Runciman, Ruskin's drawing master for several years during his boyhood.

breadth of being pitched into the road with his box on the top of him. The landlord at Melun today obligingly quieted his mind by saying that he wouldn't go to Paris in that seat for fifty francs. George among all his defects, has good carriage qualities—he watches it well, finds out what is wrong & gets it properly mended. His vocation is among carriages & horses. Love to my mother.

<div align="right">
Ever my dearest

your most affe Son

J Ruskin.
</div>

157

<div align="right">Beauvais. Sunday Evening [2 Nov.].</div>

My Dearest Father,

I have had a very quiet happy Sunday here, with the Cathedral on one side of me, and the pretty St Etienne on the other—and I was glad to have an hour or two to sit in the interior of Beauvais choir, because I wanted to compare the effect of the pure Gothic with the Byzantine and Lombard schools I have been used to lately. The northern Gothic shows decidedly barbaric after them, but not less religious, and always most beautiful, and I am surprised to find the quickness of eye I have gained by my six months study. I saw more in Beauvais in ten minutes today than in all the times [I ha]ve been here.

I purpose p[osti]ng this as I pass Abbeville tomorrow.[1] I hope to sleep at Montreuil. I shall only write again if I find myself kept at Dover or Calais by weather or anything else, otherwise I hope to be at Denmark Hill on Wednesday evening—you will know what time to have the horses for me at London Bridge. You must not expect me to look quite as flourishing as when I came down from Macugnaga, for I was pulled something down at Venice, and more at Padua, and I have had in several ways rather a worrying journey home,[2] but I am quite well, thank God, & I fancy look as nearly as possible as I did when I bid you goodbye—dearest love to my mother.

<div align="right">
Ever my dearest Father

Your most affectionate Son

J Ruskin.
</div>

[1] Postmarked Abbeville, 4 November.

[2] According to a diary entry of Jan. 1847, he had experienced, between Nyon and Paris, a numbness in the throat and a corresponding despondency that caused him a good deal of anxiety; see *Diaries*, I. 322, note 2.

Dover. Wednesday Evening [5 Nov.].

My Dearest Father,

I was glad to receive your letters when I got here, as I was afraid you would be expecting me in vain at London Bridge. I didn't get over till half past 3, but a most delightful passage, mild south-west wind. I am provoked my mother has not got a letter I sent from St Laurent, which was important.

I find there is a mail train at 1/2 past 9, arriving at London bridge at one. I am not quite sure if they take carriages on to London bridge, but as there is no advice to the contrary in the bills I suppose so. I shall therefore, D V come by that train. This letter I shall post myself, & I have no doubt you will get it properly tomorrow morning. They made me luxuriously comfortable at Mr Dessin's,[1] and desired their respects to you at home.

I shouldn't think there would be much delay in taking off the carriage, but perhaps the one horse clarence would not be amiss as it is full of lumber and moreover hardly safe. I have been expecting my hind wheel to come to pieces all the way from Paris, and part of the axle is broken in front too. I have had beautiful weather all the way from Venice, and luckily too, for both cold & wet come in mercilessly through the unfitting carriage windows.

I intended sending a note to my mother, but as Ann is to be at Billiter St it might only puzzle her, so I send this only.

Ever, my dearest Father,
Your most affectionate Son
J Ruskin.

See Letter 2, note 2.

APPENDIX

The five letters below have not been published before. The original of the first letter to Harrison is in the John Rylands Library, Manchester (English MS. 1250); the original of the second is in the Ruskin Galleries, Bembridge (Bem. B XII); both are addressed to 2 Langport Place, Camberwell, London. The original letters from Margaret and John James Ruskin are in the Beinecke Library, Yale University.

TO W. H. HARRISON

Brescia. Oct 19th.[1]

My Dear Sir,

I should have written to you long ago, had I been capable of writing anything to amuse or interest you, but as I found my letters to my Father never consisted of anything but complaints and execrations, I was afraid to inflict myself on any one else. I think with you I should have ventured, because I was quite sure you would be glad to hear from me, but I was afraid you would give too much attention to my jaundiced report of things and that I might hurt some of your fairest and favourite visions. I don't know how it is, but I am getting mighty like Peter Bell when a primrose by a rivers brim, a yellow primrose was to him[2]—i e, vile and earthy, & prosaic in the way the finest things affect me—and one of the things that I have most longed for on this journey was to have with me a fresh and unprejudiced mind, to which I could present for the first time, what had ceased strongly to affect me, and so recover in sympathy what I had lost of actual pathos. I think you yourself for instance would very marvellously have enjoyed both the humour and the loveliness of much which has been dead matter to me, and many times when I have been passing listlessly through scenes which ought powerfully to have affected the imagination, I have very ardently wished for you, as one of the few persons in whom the faculty has remained strong even without its proper food, and who are partly lost because kept in too confined a scene. And yet you may thank heaven my wishes were not granted always, for I recollect wishing for you on the top of the

[1] Postmarked Milan, 21 October.
[2] Wordsworth, *Peter Bell*, 248–9.

[238]

Monte Moro, where had you been once transported, I doubt if—
but stop, you shall judge for yourself.

There we are, you see, you and I;
at the top, pole in hand—admiring the
prospect—the question is only, how we
are to get down to dinner? ab. is a
slope of snow, which we may slide
down *if we like* when we get to it.
c., which is out of sight, is a very
hard glacier at the bottom. d., which is much
farther out of sight still, is dinner in perspective.
But, except in a few such awkward positions as the
above, I should have been truly glad to have had
you beside me, for I know no one in whom the
blessed spirit of enjoyment is so fresh—it is not
exactly *enthusiasm*—you see a little too much of the comic side of
things for that—but it is a wholesome, thankful, childlike enjoy-
ment—most right and most enviable.

I sometimes think that art, unless one has a very powerful head
indeed to give to it, is apt to put no little rigidity and coldness into
the way one looks at things. One looks at them too definitely and
dissectingly, one asks oneself how the thing is to be *done*—that is
to say, by what jugglers trick one is to convey the impression of the
inimitable—and down one drops directly. If it were not so, the
prosaic views of most painters, even the greatest, would be in-
conceivable. That men should be looking hard at nature all their
days, and yet take the vulgar thoughts out of her that they do,
& have done, would be utterly inexplicable if we did not allow for
the peculiar hardening effect of the constant struggle in leger-
demain. It requires a gigantic mind to stand under it—and I think
one could hardly name a painter who in the ratio in which he
progressed in *art*, did not diminish in sentiment. By the bye, though
I'm not a painter yet, but in the squash before 'tis a peascod[1]
st[ate], I am myself a signal exception to that general rule, for my
art is both better & more sentimental than it was, and it is very
odd that while my feelings are, as I think, colder, and certainly less
enthusiastic and enjoyable than they were, yet what I put on
paper has far more feeling than it used to have. I haven't put much—
more's the pity. I have done nothing this journey but disgust
myself—if it had not been for Coutet, who encourages me and
says—"ce n'est pas mal." "Voila qui est bien rendu"—*occasionally*,
when he sees me knocking up, I don't know how I should have got
on at all.

[1] *Twelfth Night*, I. v. 166.

I am sitting by my *fire*, for though in Italy, one wants one already, o' nights, meditating over the past campaign, and anticipating the pleasure of seeing you by a better fire at Denmark hill—nor long neither after you receive this, for I hope to reach home on the 5th of next month. Meanwhile remember me most heartily to all round *your* fireside—and with renewed thanks both for your letter, and for all the trouble you have had in looking over poems, &c, believe me most sincerely Yours

J Ruskin.

I am glad you have seen Turner's gallery, more especially as I believe he has been lately clearing it out mercilessly. I was much gratified by Holland's letter[1]—he must be a good fellow, downright & no mistake.

TO W. H. HARRISON

Beauvais. Sunday Evening [2 Nov.].[2]

My Dear Sir,

I must before I reach home send you a line to thank you for your kind answer to my worthless scrawl—which arrived most opportunely, at Paris, after I had been fatigued by a long run in a fortnight (Brescia to Paris), and I read it over my coffee in the evening & enjoyed it particularly—not the less that I have hardly had a word from any of my friends all the way, which is very cruel. People when they are at home, always say—I won't write to him—he don't write to me, and he has a great deal more to write about than I have—there are no news here. But they don't consider how much more people *want* letters in one's solitary inn than by one's home fireside.

I was much shocked to hear of Barham's death,[3] which your letter first announced to me. I see no papers, and knew not even of his illness. I am very, very sorry.

What you say of Croly's[4] eloquence is perfectly true—and it is indeed the reason why he does not draw—but one must ask again, Why is his eloquence *not* passionate, or rather *can* that be eloquence which is not passionate? It may be oratory, but not eloquence, for eloquence means the *out*speaking of that which is in the heart. Now Croly's heart is a good one, but he has nothing *at* it. He loves

1 See Letter 104, p. 173, note 2.
2 Postmarked Abbeville, 3 November.
3 The Rev. Richard Harris Barham (1788–1845), author of the *Ingoldsby Legends* and a friend of Harrison's, had died on 17 June.
4 The Rev. George Croly; see Letter 107, note 3.

[240]

his children and his wife, and he is kindly intentioned towards every one, but he has no great, earnest, overruling desire of good, to govern his life or his speech. On the contrary, his chief ends, his chief hopes, centre in himself, and he looks to earthly honour and aggrandizement as his object in life. Now he cannot have a *passion* for these, for he is too great a man to love such things passionately, and yet he looks to nothing higher, and so remains without a passion—impersuasive, because you cannot sym*pathize* with a man who suffers no *pathos*. I know this to be so, by what he has said to me himself. He looks upon high worldly position not as a demand upon exertion, but as a reward for it—he looks not to its duties, but to its decorations. Whenever he is advising me as to my book business, he says—why don't you write this or that which would be new—which would *make* a *sensation*—why don't you do this which would be *fine*, or that which would be startling, or the other which would be amusing, &c. He never says, There is an evil there, attack it—there is a coldness there, excite it—there is a danger there, declare it—a treachery here, denounce it. He has none of the great Loves or Hopes that dignify men—he is a philosopher, and abhors Quixotism, and therefore, he is always unhappy when he is not successful. In conversation he prefers saying a fine thing to a true one—in his writings, he perpetually betrays the want of earnestness by exaggeration of phrase. He is all hurry & accumulation, all heat and heap, thunder and turf—he cannot for the life of him speak low or touch lightly. And until he has been taught to feel differently, he will do no good in his generation—he will have no happiness in himself. I much fear he is incapable of an earnest feeling & that he will blaze and crackle himself to nothing, not knowing the

> Sad, *wise* valour, is the brave complexion
> That leads the van & swallows up the cities.[1]

I see you say he has latterly superadded profound illustration of evangelical truth to his former acuteness & oratory. If he does this he will fill his church, though I much doubt if he will ever become a truly great man.

And so I shall never get you up the Rothhorn—shan't I? Well, I wouldn't answer for you—after a little training—with your real love & enjoyment of nature—your affair of the gooseberry bush the other day might have been as serious as any accident you could meet with there. One never knows where one is in real danger—commonly one is in most when one takes least care. I am very glad you have been at Armadale—it is a lovely place, and full of sweet old English character, and I am sure would do you a great deal of

[1] George Herbert, *The Church Porch*, xlii. 1–2.

good. As for me I am enjoying the simplicity & cheerfulness of the French country life more than I ever did—the filth & discontent & desolation of Italy are a capital preparation for it. I think the whole time I was in Italy I never saw a happy child—the little wretches gamble and fight & swear, & steal, & cringe, and beg, and abuse, but I never saw them *play*—nor smile, except with the vicious smile of mockery, the baldhead smile.[1] Here they are hopping & skipping, & scampering, & shouting, and running after the carriage, and throwing each other down, and frightening me and their mothers out of their wits, and doing everything that they shouldn't in the most blessed way imaginable. And the people are clean and look contented, and like human beings, not hybrids between wolves and polecats—and the women, though not exactly and altogether what one calls in English quite modest, are not mere animals—they look as if they *had* some sense of decency & propriety, and one sees sweet faces and sweet expressions very often, a little shallow perhaps, but marvellous pleasant to see. One thing they are inferior in—the music in the Italian churches beats them hollow. I used to think music was an *art*, but I am sure now it is nothing but an instinct, since those brutes of Italians have it in what God has given them as a substitute for souls.

Remember me again most kindly to all round your fireside & believe me ever affectionately Yours,

J Ruskin.

FROM MARGARET RUSKIN

Denmark Hill June 28th 1845

My Dear John

One of the reasons of my not writing is, that, in your father, you have so much more able a correspondent, another that as I consider all your letters as addressed equally to us both so I take for granted you consider your father's letters as coming equally from us both— others ⟨reasons⟩ arising from my deep love for you, which even in part could not be expressed to satisfy me and yet the not being able to do so, render me as incapable of writing, as I should be of speaking, with equal fullness of heart. You are doing all in your power my beloved to lessen the pain of your absence and give us pleasure and we have ⟨indeed⟩ rejoiced in your happiness and enjoyed with you. For myself I can say that I have never for an moment wished you had not taken this journey or that you should not remain abroad as long as you find it necessary and think it right to

[1] II Kings 2:23.

do so. I have the most perfect confidence in you—that you will use all prudent means to avoid what is hurtful. And I trust you will be brought home in health, with increased powers for enjoying all that the Almighty has with so unsparing a hand bestowed upon you. Your letters are a source of continuel joy and thankfulness to us. Your last letter to me is a most delightful one but as I have said before I consider all sent to your father as equally sent to me so do not mind writing to me. If it please God to give us health you cannot conceive how much of enjoyment I anticipate from our proposed tour next Spring. I have sent to town for your colours. I hope you may get them useable.[1] I wish you could see this place at present. I do not think, be where you will, you can look on any thing more beautiful, the very cold, and late Spring, kept all back so late, that there has been no check and the foliage is luxuriant beyond all my former remembrances—the same cold destroyed insects and the Roses are uninjured, and are in fullest bloom, and beauty—the white of our Cows is so purely white, and the green of the grass so brightly green that no landskape can be more lovely than that seen at present from your[2] study window. God bless you my best love and give you all you need for good, in body, mind, and Spirit

<div align="right">Prays unceasingly your
Affect Mother
Margaret Ruskin</div>

FROM JOHN JAMES RUSKIN

<div align="right">London 23 July 1845.[3]</div>

My dearest John

I wrote last about 15/16 July of my progress from Scotland. I have now your Letters from Florence very amiably going (I mean you not the Letter) to English Service in place of Chartreuse:[4] from Bologna to your Mother who reads your compliment to her mode of expressing her affection with great delight or as befits the theme *Con amore*—your Letter Bol* to me says you had a delicious drive with Therm at 28. This is nearly 100 & shows you stand heat well. Your Italian Custom Houses are well appointed as to numbers. Hughes[5] & George are the parties to admire this greatly. I am glad you feel full confidence in your undiminished powers of Composition because they are worth cultivating: yet am I sorry to see the

1 This spelling is inserted above 'usable'.
2 The word is written twice, at the end of the page and then on the next one.
3 Postmarked London, 23 July.
4 See Letter 81.
5 Thomas Hughes, Ruskin's valet before George, who had accompanied the family on their tour of 1840–1.

Romance dissipating. Your patriotic feelings I must tell Macdonald of who grieves for your neglect of Scotland. Your Letters from parma, pavia & Milan are received & I will now address Vogogna. I have sent 4 Letters I believe to D. Dossola but you get them very regularly. I fly from subject to subject in answering your above Letters as they came. The stranger Black Dog is unclaimed but I fear like many Beauties he is not overburthened with sense. Benjamin[1] finds him at Camberwell always running away & not to be called back but pursued with much trouble. This accounts for his being a lost Dog when we got him. How we are ever to get peace established betwixt these two Black potentates I know not: Keel had constant skirmishing & occasionally tremendous Battles till he bought muzzles & now they only don't bite because they can't. The least notice of Tug sets Hero to growling & I am puzzled to know how you can safely notice either on your return, should the stupid Hero be still here. I am sorry Parma disappoints you so much & I was just wishing as it is the strong hold of Corregio & as Corregio has a strong hold on multitudes of amateurs & as you had gone so far, that you had given more than a few hours to parma, when your second Letter came & said you were doing so. I thank you for your Scale of painters which is extremely interesting. Your note for conflanz will be probably too late—we had Harrison here with the four proofs which he has corrected—his quotation is quite note enough to Conflanz. Two go to Book of Beauty, 2 to Keepsake & they all read very well, viz *Conflanz*, *Mont Blanc*, The *Arve* at Cluse & *Glacier*. Harrison has a long tale in Keepsake he says written in two nights & he thinks very good. He has a few pretty good Lines to a portrait in Book of Beauty. It is very vexatious to have your Carriage in such a plight & Hopkinson is much to blame unless it got turned to Tinder in standing in the Sun all the time you were at Florence, but I fear there is no virtue extant among Coachmakers for the one I went to Westr Bridge to get repairs cheaper done has used bad Iron, & my wheels get denuded of their Iron by wholesale. I will discuss or propound at Hopkinsons but this will not aid you. I only wish Hopkinson who is very fat had travelled himself with such a Carriage—you must get everything done that safety requires & bring home Coachmakers accounts because H. must pay for all. I think there is no reason nor sufficient time for the great change you suppose to have taken place in yourself from the joyous delight & energy of youthful feelings to the sober & colder estimate of all things induced by age. It seems the mere depression & exhaustion after strong excitement followed by the dull ordinary routine of Life: & very like a malaria affection. It is the peculiar tendency of

[1] A servant.

[244]

the climate of Italy especially in the marshy parts such as near Pavia to cast down the strength of mind with that of the Body. I believe many persons of delicate frame have first in Italy known what it was to view the world with a jaundiced Eye: but I cannot consider the springs of your healthy enjoyments wrongly called simple & childish, as destroyed but merely relaxed. Your ver[y] getting up at 4 in the morning is enough with the heat & the [fa]tigue to bring temporary depression [of?] consider[able] extent—go to the Mountains & keep rather to 6 o'Clock to 9 & do not overfatigue yourself & the Cloud will be dissipated & the pebbles will again resume their beauty. Tired with travelling, worried with your carriage, afraid of detention in unwholesome fens, satiated with the Marble of Certosa, I do not see any thing unusual in your quietly sitting down & letting Milan Cathedral wait for a few hours or a day & you should remember that the want of power to enjoy at some place or time does not prove the power to be blunted. When I remember the state in which you appeared going through the palace at portici I might have thought your energies withered forever but how quickly at Llanlaburg did you cast off the slough of morbid feeling & become a child again.[1] Wordsworth may prove to you that not at six & twenty nor at six & sixty need the "eye be dim nor the natural force abated."[2] I hope yet to join you in some excessively childish doings, altho it behoves me to bear in mind that the last time I danced the polka about a month ago with these young Ladies of 50 the Watsons[3] I somewhat strained the tendons of our Heels.

I found your Mama looking on my return as if her countenance was become a reflector of all the Beds of Roses seen from her Window—not red but really fine pink & white but I found her the other morning not being able to complain of complexion, in some chagrin because time alters her figure she says for the worse. She & Mary[4] send their Love. I am my dear John

<div align="right">yr most affect Father
J J R</div>

John Richardson of Glasgow[5] has just lost his wife by Rheumatism ending in Consumption.

[1] A reference to the tour of 1840–1; see *Diaries*, I. 141 and 195–6.

[2] Deut. 34:7.

[3] The sisters of his chief clerk, Henry Watson. For an account of them, see *Works*, XXXV. 171 ff. The polka, recently introduced, was then all the rage.

[4] Mary Richardson (1815–49), Ruskin's Perth cousin, who had been living with the Ruskins since she was fourteen.

[5] Another Perth cousin, Mary's brother, whom John James Ruskin established as a wine agent in Glasgow.

FROM JOHN JAMES RUSKIN

London 15/19 Septr 1845[1]

My dearest John

I have your interesting Letters from Verona & I thank the kind Italians for driving you home—when you read this you will be out from amongst them but you will be better off still when you have passed through the Gate of St Maurice & find yourself in the Canton de Vaud—better still over the Jura out of the hands of the Swiss.

We have just hung & hooked our pictures making the necessary changes & wonderful to tell all I did in Mama's absence for I studied my time met with entire approbation. That you may know where to run to or where to look & as I do not like surprises of any kind I will explain to you how matters are for your Reception. You know Mama always regretted the poverty of Wall in Drawing Room facing Window so it now stands thus

You see I make Cox change sides with Cattermole & all the other pictures show well facing Light—now on Fireplace side are precious half dozen

all Turner & Lewis on this side.

I have given old Jennings another trial of selling Barrett's[6] Richmond a clumsy Vulgar Drawing & Allen's[7] Caen street of no

[1] Postmark illegible.

[2] *Lisieux*, No. 13 in the 1879 exhibition of Prout and Hunt (*Works*, XIV. 403, 414 and Plate 15), now at Brantwood.

[3] David Cox (1783–1859). His *Going to Plough*, see below, was bought for 10 guineas by John James Ruskin at the Old Water Colour Society Exhibition that year. It was apparently No. 146, *River Wye, near Chepstow*.

[4] George Cattermole (1800–68), watercolour painter.

[5] John Frederick Lewis (1805–76). The drawing was no doubt *After the Vintage*, reproduced in *Works*, XII, Plate 16.

[6] George Barret (1774–1842), watercolour painter.

[7] Joseph William Allen (1803–52), landscape painter.

mark or liklyhood.[1] I bring down Fielding's rather fine Snowdoun *small* & put above a Cox of same size, *Going to plough*, a very fresh & vigourous thing, with a White Horse as good for a plough as Wouvermans[2] & a man on it in attitude more of an actual man going to plough than you will catch alive—then above Harding's little Viterbo comes the Light Tayler *Take me up*. The Damsel does well in this Dark Corner being a fair Drawing & over piano. From Dining Room I subtract Nasmyth[3] & Campion[4]—& between the great Northcotes,[5] prout's St Quentin over Tayler's Rabbit shows capitally—where Nasmyth was at Window comes Hunt's Stable outer Building, & as I see you like a piece of a dark wall at Verona I hope this picture whose chief merit is dead wall will not displease. Lucy first enquired what in the world it was & then thought it very fine adding *Mr John will like that very much*. These are the public alterations. From my Bedroom I give Mama Covenanters & French Beggars & place on side of my picture,[6] Nasmyth & Campion Edinr & Highland Glen, & finding Turner's large plate Italy too fine for Bason stand, I change for your Black Mercury[7] which suits beautifully form of Recess & you cannot imagine how fine the large Light Turner makes your study over Fireplace with the light paper. If you cannot want Mercury & argus, you will have to get another for setting aside oblong suiting my Bedroom Recess. I never saw such a plate & picture. I never got up to the Italy.

19 Sepr. I have just got your first Venice Letter. I feared all this was coming on us. These Railroads will ruin every place & people will lose all poetic feeling. In this Country people become quite hardened & sheer Gamblers, in Railroads. Glad we saw these Continental Towns before this mania began. You need not fear Foord mounting Turner. I had them locked up as they came from Turner & framed at home. Now they are hung up I see great Loveliness & a perfect *Infinity* on the paper but they are not executed like the [Lan]ds End nor like Ehrenbreitsten.[8] In pecuniar[y va]lue, they must be reckoned lower & there[fore] Griffith [does] wrong in trying to advance to £100 & in fact dissolves Engagements—for

1 *I Henry IV*, III. ii. 45.
2 Philip Wouwerman (1614–68), Dutch landscape painter.
3 Probably Alexander Nasmyth (1758–1840), landscape painter, with whom he had studied drawing in Edinburgh.
4 George B. Campion (1796–1870), watercolour painter.
5 Two large oil portraits of Ruskin as an infant, by James Northcote, R.A. (1746–1831); reproduced in *Works*, XXXV, Plates 2 and 3.
6 Probably his own watercolour drawing of Conway Castle; see *Works*, XXXV. 38.
7 For these engravings, see Letter 153, p. 230, note 1.
8 *Coblentz*; see Letter 42, p. 83, note 2.

agreeing to 160 Gs, when you are told of 200 or he may be going to 500 it might be inconvenient. Finding the pictures so lovely alone, not stand Comparison so well hung up I asked Bicknell to come in & say what he thought. He thinks them lovely but raw & thinks they have been so hurried that he is going to cancel if he can his Orders for three Drawings—still they are bits of marvellous Beauty. They do not grow upon you so much as the others. I find Ehrenbreitsten the most beautiful piece of Colour I have ever had my eye upon. Bicknell is quarrelling with Turner on two points—he gave him 120 Gs for loan of Temeraire to engrave & Turner besides demands 50 proofs.[1] Bicknell resists & sends 8. Then he found Water Colour in Whalers[2] & rubbed out some with Handky. He went to Turner who looked Daggers & refused to do anything, but at last he has taken it back to alter. Roberts admires the picture but all say it is not finished. They account for his hurry & disregard for future fame by putting Water Colours by his stronger passion, love of money. I am sorry he sacrifices his great fame to present effect & object. I shall send £25 to Vevay. I may write again to Brieg if I see time.

There is a cruel article in Britannia against Severn by I presume friends of the rejected.[3] I shall keep it as it is on art generally. Mama & I are pretty well. Don't venture too much about Brieg Rocks—with Mama's most affect Love I am my dearest John

<div align="right">Yr most affect Father

J. J. Ruskin</div>

I have a very long Letter for you of Revd D. Moore which I shall send to Vevay as I fear this may be mislaid at Brieg. Take care of Mr Moore's Letter as I should like to see it.

Poor Richard Fall has taken it into his head that you thought he could have gone with you & are angry that he did not & therefore have not written. Send him a Line if you can.

[1] The engraving of Turner's *The Fighting Téméraire* (R.A. 1839), by J. T. Willmore, was published by Joseph Hogarth. That Bicknell financed the enterprise has not heretofore been noted.

[2] Presumably No. 77 in the R.A. 1845, now in the Metropolitan Museum, New York.

[3] The long article condemning the Royal Commission of Fine Arts in *The Britannia* for 13 Sept. (p. 587) included attacks on the four artists the Commission had selected to do the fresco decorations in Parliament. Severn's latest cartoon was ridiculed as the product of an 'ignorant and unimaginative mind' and he was polished off with the remark that 'he has exhibited in the Royal Academy, but his pictures have always been lost amid the host of mediocre performances with which they have been properly classed'.

INDEX

Bell, Sir Charles, 1, 20 n., 115
Bellini, Gentile, 62, 207
Bellini, Giovanni, 144, 145, 167, 207, 214, 215, 227
Bellini, Vincenzo, 197, 217
Bellinzona, 166, 170, 177, 178
Benedetto da Maiano, 96 n.
Benjamin, servant, 244
Benozzo Gozzoli, *see* Gozzoli
Beresina, battle of the, 46
Bergamo, 162, 193, 194, 232
Bernay, 4
Bex, 227
Bible, Acts, 223; Deut., 245; Eccles., 129 n.; Exod., 149; Gen., 65, 67–8, 128, 228; Isa., 56, 135; John, 68; I Kgs., 188; II Kgs., 242 n.; Luke, 67–8; Matt., 113 n., 129; Ps. (metrical version), 148; Rev., 89
Bicknell, Elhanan, 11, 31, 99, 230, 248
Birmingham, 146, 199
Birmingham City Art Gallery, 103 n.
Birmingham, John, 1
Blackwood's Magazine, 99
Blake, William, 80
Blanc, Mont, 15, 84, 122, 151, 194
Blessington, Lady, 112, 146, 154
Blue Beard, 121
Bocchetta Pass, 48
Bodleian Library, 1 n., 9 n., 23 n., 147 n.
Bologna, 71, 139, 140, 142; letters from, 139–41
Bolzano, Botzen, 167
Bonhomme, Col du, 42
Bonneville, 19
Book of Beauty, 69 n., 112 n., 154 n., 244
Borghetto, 48; Pass, 42, 46
Borodino, battle of, 46
Borromean Islands, 157; *see also* Isola Madre
Borrowdale, 19, 22 n.
Bossons, Glacier des, 134
Boston Museum of Fine Arts, 90 n.
Bourg, 7
Bourg d'Oisans, 25
Bourges, 42
Bowder stone, 22
Boxall, William, 214, 215, 216, 226, 235
Bracco, 46
Brantwood, Coniston, 80 n., 147 n., 246 n.

Breadalbane, Marquis of, 91 n.
Brenner Pass, 167
Brenta Canal, 198
Brescia, 162, 195, 227, 229; letters from, 225–6, 238–40
Brévent, Mont, 27
Bridgewater Treatises, 1 n.
Brig, 212, 220, 226, 228, 248
Bristol, 77, 78
Britannia, 248
British Institution, 16 n., 80 n., 191
British Museum, 83 n., 90 n., 99 n., 178 n., 181 n.
Brockedon, William, 177 n.
Brown, Dr. John, 23 n.
Brunelleschi, 88, 94, 122, 184
Buet, Mont, 166
Buffalmacco, 73, 131, 144
Buffon, Comte de, 11 n.
Bunyan, John, 17–18, 33–4, 40
Byron, Lord, 48

Cafaggiolo, 139
Cagnes, 36
Caillez, B., 235
Calais, 2, 3, 4, 107, 225, 233, 236; Hôtel Dessin, 3 n., 237; letter from, 3
Callcott, Sir A. W., 80, 191, 193
Camberwell, Camden Church, 33 n.; Langport Place, 238; St Giles' Church, 138 n., 233 n.; St Paul's, Herne Hill, 110 n.
Campbell, Mr., 133
Campion, G. B., 247
Campo Santo, *see* Pisa
Canaletto, 209
Cappello, Bianca, 103, 215
Capraia, 84
Capri, 84
Caracci, the, 91, 145
Caravaggio, 145
Carlisle, 125 n.
Carlone, E., et Cie., 35, 81
Carrara, 48, 49, 50, 81, 103, 229; S. Andrea, 49
Cary, Rev. H. F., 56 n., 122
Castellane, 33
Castruccio Castracani, 67
Cattermole, George, 246
Cellini, Benvenuto, 88
Cenis, Mont, Pass, 42, 162
Centovalli, Val, 170, 177, 178
Cerito, Francesca, 146

Dogs, 11, 100, 110, 127 n., 143–4, 153, 157, 168, 208, 244
Dolci, Carlo, 145
Dôle, 12–13
Domecq, John Peter, 117 n., 210 n.
Domenichino, 141 n.
Dominicans, 53, 82 n., 108
Domodossola, 157, 159, 164, 166, 170, 171, 173, 178, 180, 212, 226; letter from, 171
Donizetti, Gaetano, 197
Douro, Marquis of, 2 n.
Dover, 1–2, 150, 235, 236; letters from, 1–2, 237
Draguignan, 31, 33, 35–6
Dresden, 199
Duccio, 96 n., 144, 145
Dulwich, 167
Durance, river, 28
Durheim, J. L. R., 136–7, 149 n., 225 n.
Dutch painters, 80, 91

Eastlake, Sir C. L., xvi–xvii
Eastnor, Viscount, *see* Somers
Edinburgh, 123 n., 126 n., 128 n., 130 n., 132 n., 133 n., 143 n., 158 n., 163; Calton Hill, 156; Scott Monument, 158
Egypt, 67, 149, 185–6
Ehrenbreitstein, 24
Eleonora di Toledo, 139
Elgin marbles, 101, 114
Elizabeth, Queen, 184
Ellis, Louise, 31, 110, 127, 161, 222
Ellis, T. F., 31 n.
Empoli, 49
English, the, at Florence, 92, 100, 112, 114, 118–19, 122, 129; government, 184, 185; painting, 8–9, 38, 91; taste, 6
Engravers, Engravings, Italian, 61, 78, 84 n., 120–1, 126, 138, 195, 210, 225
Estérel, L', 36
Etty, William, 146

Faido, 174, 177, 178; letters from, 172–8
Fall, Richard, 110, 229–30, 248
Farquharson, Mrs. James, 158 n.
Ferret, Col, 42
Fielding, A. V. Copley, 16, 81, 247
Fiesole, 95, 106, 116, 120–1, 129; convent, 124; road, 93

Finale Ligure, 36
Finberg, A. J., *Life of Turner*, 133 n., 171 n.
Findlay, Rev. John, 68 n.
Findlay, Robert, 68
Finsteraarhorn, 151
Finstermünz Pass, 116
Fireflies, 85, 124
Fireworks, *see* Illuminations
Fitzwilliam Museum, 139 n.
Fletschhorn, 151, 228
Florence, Arno at, 88; Cascine, 116, 137; countryside, 103, 114, 157; during the republic, 129, 184–5; the English at, 92, 100, 112, 114, 118–19, 122, 129; English Church, 106, 139; Festival of S. Giovanni, 124, 126–7; government, 120, 129, 186; Hôtel d'Italie (Balbi's), 59 n., 60, 87–8, 94, 101, 106; illumination at, 124–5, 126; JR's lodgings, 94, 100, 101–2, 106, 111; the people, 88, 100, 114, 116–17, 118, 127, 129, 158; Ponte Vecchio, 109, 126; religion at, 177; restoration, 88–9, 119, 127; Schneiders Hotel, 59, 86; theatre, 114, 135; the town, 114, 116–17, 118–19, 148, 180, 181
Particular buildings:
　Accademia, 96, 97, 106, 134, 135 n.; Vita di Cristo, 120 n.
　Albizzi Palace, 121 n.
　Baptistery, 118 n.
　Bargello, 100 n., 122, 136 n.
　Campanile, 88, 92, 94, 109, 119
　Cathedral, 105, 127; cupola, 88, 94, 122, 125, 133; Giotto's tomb, 87, 88; illumination of, 126; windows, 105
　Certosa, Val d'Ema, 136, 139
　Ferroni Palace, xx
　Forte di Belvedere, 123 n.
　Galileo's villa, 86, 103, 105, 116
　Guadagni Palace, 114 n.
　Loggia dei Lanzi, 88 n.
　Medici Chapel (S. Lorenzo), 92, 106, 154 n.
　Medici-Riccardi Palace, 121
　Misericordia, 119
　Or San Michele, 89, 92
　Palazzo Vecchio, 126–7
　Pitti Palace, 86, 103, 106, 107, 113, 129, 130, 131, 133; pictures in, 105, 109, 122

[252]

Gozzoli, Benozzo, 108, 109, 135, 145; frescoes in Florence, 121; frescoes in Pisa, 63, 65, 67–8, 86
Grand Duke of Tuscany, *see* Leopold
Grande Chartreuse, 11, 23
Grant, Francis, 99 n.
Grant, Dr. George, 157, 159
Grassi, Ranieri, 84 n.
Greek architecture, 206; sculpture, 73, 101
Greenwich, 183, 198
Grenoble, 23–4, 81, 87; letter from, 23–4
Gries Pass, 166, 175
Griffith, Thomas, 83 n., 99, 172, 179 n., 192 n., 230 n., 247–8
Grimsel Pass, Hospice, 164
Guidebooks, Italian, 74 n., 78–9, 89; *see also* Murray's *Northern Italy and* Valery's *Italie confortable*
Guido Reni, 63, 91, 145
Guinigi, Paolo, 55
Guizot, F. P. G., 179 n., 183
Gutzkow, Karl, 83 n.

Hailstones, 149–50
Halsted, Francis, 43 n.
Hampton Court, 95 n., 148
Harding, J. D., 28 n., 91, 125, 172–3, 178, 180–1, 182, 183, 194 n., 217, 220, 223, 225, 226, 247; Miss Harding, 210; Mrs. Harding, 209 n., 210; *Principles and Practice of Art*, 172, 181; *Sketches at Home and Abroad*, 28; sketching, 189, 190, 192–3, 194, 195, 197, 205, 207, 210, 211, 214; travels with JR (Baveno to Venice), 188, 189, 190, 193, 195, 197, 200, 201, 205, 208, 209, 210–11, 212, 214, 218, 229
Hardinge, Charles Stewart, 25 n.
Hardinge, Lady Emily, 25, 31, 35
Hardinge, Sir Henry, 25 n.
Hare, Julius Charles, 60 n.
Harrison, W. H., 81, 91, 93, 112, 113, 142 n., 147 n., 171 n., 173, 177, 244; JR's letters to, 238–42
Hastings turnpikes, 141
Hawick, 25, 157 n.
Hayter, Sir George, 80 n.
Heath, Charles, see *Book of Beauty* and *Keepsake*

Helvellyn, 166
Herbert, George, 8, 17–18, 30, 33–4, 108; *Church Porch*, 241; *Discharge*, 104; *Temper*, 34
Hero, dog, 143–4, 168, 244
Herodotus, 142 n.
Hobbs, Anne, 60 n.
Hobbs, John, xiii, 1, 5, 14, 18, 21, 22, 23, 28, 29, 31, 34, 36, 39, 46, 60 n., 64, 66, 69, 73, 75, 78, 94, 96, 102, 107, 112, 113, 121, 132, 137, 141–2, 162, 169, 172, 174, 180, 188, 235–6, 243; catches sea urchins, 47; characterized, 182, 236; cooks at Macugnaga, 162; cost of his food and lodging, 20, 52–3, 177; fetches water, 47; kills a viper, 30; remarks, 1, 112, 176, 182; walks to mountain post office, 157, 159, 161, 162, 164
Hofer, Andreas, 167
Hogarth, Joseph, 135, 248 n.
Holland, James, 173, 240, 246
Holland, Lord, xx, 89 n., 107, 111 n., 112, 113, 115, 132
Holme et Cie., 81, 205, 219
Honorius III, Pope, 134
Hôpital, L', *see* Albertville
Hopkinson, W., 41, 147, 148, 192 n., 235, 244
Horace, 13, 104
Horsburgh, E. L. S., *Bromley, Kent*, 31 n.
Hotels, Beauvais: Écu de France, 5; Bologna: Suisse, 139; Calais: Dessin, 3 n., 237; Champagnole: de la Poste, 12, 13, 14; Como: d'Italie, 153; Digne: du Petit Paris, 32–3, 34; Dijon: de la Cloche, 11; Dover: Ship, 1, 235; Florence: d'Europe, 88, 94; d'Italie (Balbi's), 59 n., 60, 87–8, 94, 101, 106; Schneiders, 59, 86; Geneva: des Bergues, 10 n., 14; Grenoble: des Ambassadeurs, 24; Lucca: Croce di Malta, dell' Europa, Gran Bretagna, Pellicano, dell' Universo, 49 n., 52–3; Martigny: de la Poste, 230; Montbard: du Point du Jour, 10, 12; Paris: Meurice, 5, 9, 12, 195, 235 n.; Pisa: Peverada (Tre Donzelle), 60, 78; Ussero, 60; Pistoia: de Londres, 86; Sestri: Royal, 46; Venice: de l'Europe, 198, 199, 200, 214, 216,

[255]

[263]